DO NOT REMOVE
CARDS FROM POCKET

7-15-93

ALLEN COUNTY PUBLIC LIBRARY
FORT WAYNE, INDIANA 46802

You may return this book to any agency, branch,

or bookmobile of the Allen County Public Library.

DEMCO

Beyond Recognition

Beyond Recognition

Representation, Power, and Culture

Craig Owens

EDITED BY

Scott Bryson, Barbara Kruger,
Lynne Tillman, and Jane Weinstock

INTRODUCTION BY

Simon Watney

UNIVERSITY OF CALIFORNIA PRESS

Berkeley Los Angeles Oxford

The publisher wishes to acknowledge with gratitude
the contribution provided by the Associates of the
University of California Press.

University of California Press
Berkeley and Los Angeles, California
University of California Press
Oxford, England
Copyright © 1992 by
The Regents of the University of California
Printed in the United States of America

1 2 3 4 5 6 7 8 9

**Library of Congress Cataloging-in-
Publication Data**
Owens, Craig.
 Beyond recognition: representation, power,
and culture / Craig Owens; edited by Scott
Bryson . . . [et al.].
 p. cm.
 Includes bibliographical references and index.
 ISBN 0–520–07739–3
 1. Arts—Psychological aspects. 2. Politics in
art. 3. Arts, Modern—20th century.
I. Bryson, Scott Stewart. II. Title.
NX165.094 1992
700'.1'9—dc20 92–5314
 CIP

The paper used in this publication meets the
minimum requirements of American National
Standard for Information Sciences—Permanence
of Paper for Printed Library Materials,
ANSI Z39.48–1984 ∞

CONTENTS

v

PREFACE

Over the 15 years during which he was writing, Craig Owens covered a wide range of cultural practices—dance, architecture, art, literature, theory, film, performance, theater, and music. From this diverse body of work we have selected essays we feel best represent Owens's thinking on those subjects at particular times. Owens's positions changed in varying degrees and in varying ways during these years; this selection reflects the even and uneven developments of his thought.

With the desire to emphasize these developments, we have divided Owens's work into four sections: Toward a Theory of Postmodernism, Sexuality/Power, Cultures, and Pedagogy. While the first two areas are most often associated with Owens, the other two—Cultures and Pedagogy—indicate the scope of his political commitment.

We have chosen to present the work in chronological order within each section. But this is not to suggest a linear process. Owens returned to his earlier ideas, often in a spirit of self-criticism, throughout his career. He always saw the relationships among these groupings. Similarly, the frames we have established ought not to be viewed as defining and exclusive. It is our hope that this framework enlarges and alters the terms through which Owens's work is read.

<div align="right">The Editors</div>

CRAIG OWENS: "THE INDIGNITY OF SPEAKING FOR OTHERS"

Simon Watney

"It is precisely at the legislative frontier between what can be represented and what cannot that the postmodernist operation is being staged—not in order to transcend representation, but in order to expose that system of power that authorizes certain representations while blocking, prohibiting or invalidating others."

— CRAIG OWENS, "The Discourse of Others:
Feminists and Postmodernism"

"The discovery of the plurality of cultures is never a harmless experience."

— PAUL RICOEUR, quoted in "The Discourse of Others:
Feminists and Postmodernism"

The death of Craig Owens at the absurdly young age of thirty-nine robbed the United States of one of its most intelligent and important young art critics. He is best known for his significant essays and reviews in *Art in America* (where he was a senior editor), *October,* and elsewhere. He published no books in his lifetime, and this collection of his work must now stand as a tribute, among other things, to the sheer range and vivacity of his enthusiasms, as well as to his fierce engagement with the art and politics of our times. Doubtless Craig Owens would be wryly amused by the irony that he, a theorist of the fragmentary and the discontinuous, should be remembered in a single, bound volume. In fact, these writings possess a cumulative strategic coherence as interventions within the terrain of criticism and in particular art criticism—a terrain that Owens insisted is never innocent of market forces.

I did not know Craig Owens particularly well. We met a few times over the years in London, and once or twice in New York. In any case, he would have been the first to question the "truth claims" involved in writing of his work "as a friend." Certainly he took his many friendships sufficiently seriously not to allow them to become pretexts for any suspension of critical judgment. As Erica Carter has noted, his principal

political and intellectual project was always "to *engage the connections* between rarefied aesthetic debate (on postmodernism, 'the exotic,' or whatever) and a broader-based cultural politics."[1]

Craig Owens was never a person to shirk difficult issues, from the political relations between feminists and gay men—a vexed question on both sides—to the power of the art market. His trenchant critique of "pseudo Expressionism" revealed the conservatism of much of the most routinely praised art of the 1980s. His aim was always to encourage and support cultural practices that challenge the authority of the dominant Fine Art tradition, which marginalizes work produced by members of subordinated social groups—blacks, women, gay men, and others. For Owens, however, this subordination did not simply take the form of "misrepresentation." Rather, he rejected the notion that images themselves are intrinsically true or false. What interested Owens was the complex matrix of power relations that determine dominant conceptions of artistic value. He strove to analyze and expose what he termed "the studio-gallery-museum power nexus, which administers the discourse of art in our society."[2]

This is not, however, to suggest that there is any simple, internal narrative coherence to Owens's overall writings. He tended to work through particular sets of issues, raised by different artists and theorists, and his career has relatively distinct stages. His interest in theories of allegory in the late 1970s derived from his involvement with semiotics and deconstruction. In the early eighties he was influenced by Foucault and Freud. Foucault provided a theory of power which led Owens to reject the idea that images are intrinsically true or false, while Freud offered a theory of the subject which could account for both subordination *and* its resistance. Owens was more influenced by Foucault's analysis of the discursive power of institutions than by his work on sexuality. Owens's interest in Freud led in turn to his increasing involvement with feminism and feminist cultural theory and practice. It was from this perspective that he read Lacan, one of his last major intellectual stimuli. Much of Owens's work addressed the conflict between the question of representation posed in the register of aesthetics and the question of representation posed in the register of politics. In other words, he was extremely wary of any claim that representations are politically *representative* of those whom they purport to represent. He aptly invoked Gilles Deleuze on Foucault: "[Foucault was] the first . . . to teach us something absolutely fundamental: the indignity of speaking for others."[3]

As a white gay man, Owens was not in the least interested in assuming the familiar curatorial role of "representing" other people. He tried to

show how marginalized groups are subordinated in different ways. He was profoundly distrustful of liberal humanism and its claim to speak of and for a supposedly universal "human nature." In this respect he embodied the ideal of the "organic intellectual materialist," always refusing religious or metaphysical explanations for social and cultural phenomena.

Several of the pieces in this collection testify to Owens's great love of music, though he never wrote about opera, which was one of his enduring passions. He was especially fond of the English National Opera, admiring its adventurous productions and its successful attempt to establish music theater as a genuinely popular medium in the United Kingdom. Writing in 1976 of the New York City Ballet's production of *Coppélia,* he observed how:

> Balanchine continually produces new work which eludes the previous categories and definitions used to describe him. His handling of *Coppélia* is expressive of a conviction that the ballet has far more intellectual density than is usually presumed; further, that that density exists precisely at the point where dance and society intersect.[4]

He admired the production precisely because, as he pointed out, "the political implications of *Coppélia* would remain just that—implications— were they not expressed through the dancing itself."[5] It was Balanchine's vision of *Coppélia* as an emblem of the exhausted French Second Empire that Craig so admired, concluding that:

> It is fascinating to speculate, for example, about the ways in which the Tchaikovsky-Petipa ballets, especially *The Sleeping Beauty,* reflect the dominant ideology of tsarist Russia, and how this information can be conveyed in performance.[6]

It was just such speculations that would a little later fuel his early enthusiasm for Laurie Anderson's performance work. His advocacy was based not simply on her political critique of the United States, but on her use of metaphor and stage technology. In 1981, he wrote about Anderson's *United States* 2 at the Orpheum Theatre in Manhattan:

> A film of the electronic video game Space Invaders was projected over a map of the United States. The evening concluded with a portentous vision of nuclear meltdown, as a film of the American flag spinning in a washing machine—literally, being laundered—was superimposed over a negative image of the Statue of Liberty, its whites intensified, as if subjected to intense heat.[7]

He especially appreciated Anderson's foregrounding of the techno-logical means of production and her refusal of an aesthetics of direct presence—an aesthetics that has dominated performance art since its in-ception. On the contrary, her work interrupts "the fantasy of copresence that links performer and spectator by interposing electronic media be-tween them."[8] And this interposing is not merely arbitrary as it guaran-tees that she

> no longer performs directly for her audience, but only through an elec-tronic medium. While the media literally magnify her presence they also strip it from her. Her work thus extends and amplifies the feeling of estrangement that overcomes the performer who submits to a mechanical or electronic device: the film actor or recording artist.[9]

Owens's important essay "Posing," written for the controversial *Differ-ence* show,[10] articulates his interest in the politics of sexuality and rep-resentation. As Lisa Tickner argued in the catalogue:

> Both the history of the social ordering of sexuality and its psychic organi-zation oblige us to rethink the relations between sexuality and representa-tion. That is, to remove them from any conception as two distinct domains (representation and sexuality), or as a given, homogeneous, and anterior sexuality (the representation *of* sexuality), in favor of the recognition of how each is bound up in the processes of the other.[11]

Without detailing Owens's ongoing involvement with Lacan, Der-rida, and Foucault—the three most formative influences on his work—I would note that by the early 1980s he was at the same time developing a political and intellectual project involving critical support for an emer-gent body of artists. Living in New York in the 1970s and 1980s, Owens was able to talk regularly with these artists and with other critics. As he put it: "We were writing not necessarily about these critical and op-positional practices but alongside them."[12] By 1985 he was considered a major contributing figure in a productive transatlantic dialogue about the politics of identity—of individuals and collectivities. For if political identities do not spring directly from the determining factors of class, race, gender, and sexuality in people's lives, culture (in the broadest sense) emerges as the central site on which identities are formed, and where they can also be contested. It is important to remember the signifi-cance of the emphasis on subjectivity and theories of the subject in the intellectual work of the seventies and eighties, since it opened the door to the more fluid forms of contemporary postmodern politics.

In "The Allegorical Impulse: Towards a Theory of Postmodernism" (Parts 1 and 2), Owens set out the historical conditions that led to the

delegitimation of allegory in mainstream, formalist modernist art the-ory. He depicted this rejection as contrary to the texts of Baudelaire and others—texts that are frequently used to prop up the constitution of modernism as an antiallegorical project. "The Allegorical Impulse" is also a powerful meditation on the significance of Walter Benjamin in the late twentieth century and nowhere more so than in Owens's assertion—a paraphrase from Benjamin's *Theses on the Philosophy of History*—that what is most proper to allegory is "its capacity to rescue from historical oblivion that which threatens to disappear."[13] Owens insisted that:

> The allegorist does not invent images but confiscates them. He lays claim to the culturally significant, poses as its interpreter . . . He does not restore an original meaning that may have been lost or obscured . . . Rather, he adds another meaning to the image. If he adds, however, he does so only to replace: the allegorical meaning supplants an antecedent one; it is a sup-plement. This is why allegory is condemned, but it is also the source of its theoretical significance.[14]

It would be difficult to overstate the immediate influence of "The Al-legorical Impulse" on Owens's contemporaries, not least in its theoretical insistence that criticism not be tied to individual media, and that such arbitrary partitioning of the field of cultural production is incompatible with any serious engagement with either semiotics or, by implication, psychoanalysis. For as he forcefully argued:

> The allegorical work is synthetic; it crosses aesthetic boundaries. This confusion of genres, anticipated by Duchamp, reappears today in hybrid-ization, in eclectic works which ostentatiously combine previously distinct art mediums. Appropriation, site specificity, impermanence, accumula-tion, discursivity, hybridization—these diverse strategies characterize much of the art of the present from its modernist predecessors. They also form a whole when seen in relation to allegory, suggesting that postmodernist art may in fact be identified by a single, coherent impulse, and that criti-cism will remain incapable of accounting for that impulse as long as it continued to think of allegory as aesthetic error.[15]

Yet I suspect that Craig Owens would not have been content with this concluding formulation, and it is significant that the term allegory quickly passed from his vocabulary. His intellectual work in the eighties was increasingly set in the context of a contingent sexual politics com-mitted to the recognition and celebration of diversity. As he was the first to acknowledge:

> The issue of the politics of representation has been placed on the agenda of contemporary art . . . by a specifically feminist consciousness. In recent

years there has emerged a group of artists—most of them women—whose work is addressed to the question of representation and sexuality . . . These artists do not reduce all politics to sexuality; they do argue, however, that sexual inequality and domination cannot be explained exclusively in terms of economic exploitation.[16]

He thus supported art that investigates the workings of power *within* the field of visual representation. He was not interested in the idea of a "political art" which regards "politics" as if it were prior to and independent of representation. Rather, he insisted, "to represent is to subjugate."[17]

This argument also required the rejection of earlier twentieth-century notions of artistic value, in which images were considered to "represent" truthfully the position and interests of subjugated groups *outside* the arena of representation. Consequently, Owens moved toward feminist theory and toward artists whose work directly addresses the intersection of visual and verbal communication, artists whose central subject is the mode of address of art itself. Feminist theory demonstrates that the values of sexuality and gender are always at work within the field of representation, especially when they are least obvious. The work of Laura Mulvey and others made Owens aware that all cultural production has a sexual component.

He advocated cultural practices that make us conscious of the ways in which we are recruited to identify with images that appear to be natural, inevitable, universal, immutable. He especially admired art that reveals how these images promote certain stereotypes (of "youthful beauty," "tastefulness," "femininity"). As he wrote of Barbara Kruger's art, it:

engages in neither social commentary nor ideological critique (the traditional activities of politically motivated artists: consciousness-raising). Her art has no moralistic or didactic ambition. Rather, she stages for the viewer the techniques whereby the stereotype produces subjection, interpellates him/her as subject.[18]

Last but not least: "Kruger proposes the *mobilization* of the spectator."[19]

From a similar perspective, Owens also wrote about the work of Lothar Baumgarten, who draws attention to the "rhetorical strategies of ethnographic discourse."[20] Rather than simply exposing racial and ethnic stereotypes, Baumgarten explores the historical construction of Western notions of "Otherness" and "the exotic." The question emerges, not of an imagined "truth" of South America, or of South Africa, but of how Western art projects itself and its familiar vision of the world

onto the very appearance of other societies, seen within the field of Western culture. Owens's attraction to Baumgarten's project for the 1984 Venice Biennale, in which the artist superimposed the topographical structure of the Amazon Basin onto the lagoon of Venice, was based on Baumgarten's recognition of the role of language in colonial power:

> In 1499 Amerigo Vespucci, sighting the northern coast of the continent that will eventually bear *his* name, sees houses on stilts that appear to float on water or to hang suspended from trees. He is reminded of Venice and immediately names the place *Venezuela*—little Venice—thereby obliterating its Indian name and instituting in its place a *proper* (i.e. Spanish) name. Thus "Venezuela" is inscribed within a system of cultural associations and values—mercantilism, cosmopolitanism, Christianity—that is entirely foreign to it, and henceforth its name will testify to, but also cover over the traces of, the violence implicit in this—or any—historical act of denomination. By superimposing the geography of the Amazon Basin onto that of Venice, Baumgarten was, of course, commemorating this art; but he was also reversing its priorities. More importantly, because in his work these two "systems" remained transparent one to another, he was also proposing an alternative, nonviolent model of cultural confrontation in which one culture can occupy the space of another without obliterating it.[21]

In his later writings, Owens became increasingly committed to the task of unraveling the different historical narratives and sets of cultural associations that give rise to dominant images of sexual and racial "Otherness." This involved the examination of the role that representation plays in establishing and sustaining the cultural hegemony of white, male heterosexual values in Western societies. As he noted of Mary Kelly's work on motherhood:

> It demonstrates that no one narrative can possibly account for all aspects of human experience. Or as the artist herself has said, there's no single theoretical discourse which is going to offer an explanation for all forms of social relations or for every mode of political practice.[22]

Owens assumed an increasingly hostile public stance toward the dominant discourse of art criticism and art historiography. While many critics were supporting the "masterpieces" of so-called neoexpressionism, he supported work that challenges conventional representation of power and sexuality. It was especially galling to Owens that the term postmodernism was (and is) sometimes used to legitimate art that ultimately might celebrate traditional values.

Owens's work had consequences that he himself could not have foreseen, not least in the emergence of the widespread cultural activism that

has arisen in response to the AIDS crisis. The work of many individual artists and collectives has not only helped to expose and confront the representational strategies of the far Right, it has also been able to articulate the connections between misogyny, homophobia, racism, and classism which have so dramatically informed mass media accounts of the epidemic, as well as government and research policies.[23] Owens's work contributed in no small way to the development of effective activist strategies in an emergency that requires that special attention be paid to notions of "the global."[24]

Craig Owens died of complications resulting from AIDS, and I have no doubt he would have been pleased that his own work continues to be used as a resource in the international struggle to shift perceptions of the meaning of the epidemic within and between different population groups in the United States and around the world. He was a man of great moral, intellectual (and physical) stature: indeed, he once remarked to a friend of mine that the advantage of being tall was that, unlike other people, he could always see the dust on the top of their refrigerators. He was always a radical, and I think would have agreed with George Eliot's Felix Holt that "we are saved by making the future present to ourselves."[25]

Craig Owens's gift to us through his writing and his teaching was to help others share this conviction. We may best honor his memory by emulating in our lives something of the political, intellectual, and ethical rigor he brought to bear in his own work. This involves recognizing the full significance of his conviction that what matters most in contemporary culture is not the voice of "autonomy," or "self-sufficiency," or "transcendence," but rather the acknowledgment of contingency, insufficiency, the rejection of transcendence. To be of *our* times it is necessary to develop work that:

> tells of a desire that must be perpetually frustrated, an ambition that must be perpetually deferred; as such, its deconstructive thrust is aimed not only against the contemporary myths that furnish its subject matter, but also against the symbolic, totalizing impulse which characterizes modernist art.[26]

We must recognize that the future we attempt to "make present" to ourselves and to one another is not simply "out there," ready and waiting for us, but remains always to be established, always to be contested, always to be remade again. In this manner we might best emulate the example of Craig Owens in only ever speaking for ourselves.

London, August 1991

NOTES

1. Personal communication.

2. Craig Owens, "'The Indignity of Speaking for Others': An Imaginary Interview," *Art & Social Change* (Oberlin: Allen Memorial Art Museum, 1983), 83.

3. Owens, "Indignity," 85.

4. Craig Owens, "Politics of *Coppélia*," *Christopher Street* (November 1976), 52.

5. Ibid., 52.

6. Ibid., 52.

7. Craig Owens, "Amplifications: Laurie Anderson," *Art in America* (March 1981), 122.

8. Ibid., 123.

9. Ibid., 123.

10. Kate Linker was the art curator and Jane Weinstock the film and video curator of *Difference: On Representation and Sexuality* held in New York in 1985 at the New Museum of Contemporary Art, the Public Theater, and the Kitchen.

11. Lisa Tickner, "Sexuality And/In Representation: Five British Artists," in *Difference: On Representation and Sexuality* (New York: The New Museum of Contemporary Art, 1985), 23.

12. Anders Stephanson, "Interview with Craig Owens," *Social Text* 27 (1987), 63.

13. Craig Owens, "The Allegorical Impulse: Toward a Theory of Postmodernism" (Part 1), *October* 12 (Spring 1980), 68.

14. Ibid., 69.

15. Ibid., 75.

16. Owens, "Indignity," 85.

17. Ibid., 84.

18. Craig Owens, "The Medusa Effect, or, The Specular Ruse," *Art in America* (January 1984), 104.

19. Ibid., 104.

20. Craig Owens, "Improper Names," *Art in America* (October 1986), 130.

21. Ibid., 129.

22. Craig Owens, "The Discourse of Others: Feminists and Postmodernism," in *The Anti-Aesthetic: Essays on Postmodern Culture,* ed. Hal Foster (Seattle: Bay Press, 1983), 64.

23. See A. Rolston and Douglas Crimp, *AIDS Demo Graphics* (Seattle: Bay Press, 1990).

24. Owens's last project—on homosexuality and fascism—focused on the work of Jean Genet, Derek Jarman, and Pier Pasolini. Unfortunately, it was never completed.

25. George Eliot, *Felix Holt* (Harmondsworth [UK]: Penguin Classics, 1987), 365.

26. Craig Owens, "The Allegorical Impulse: Toward a Theory of Postmodernism, Part 2," *October* 13 (Summer 1980), 80.

PART I

Toward a Theory
of Postmodernism

*If you take a modernist and draw a line and say, I dare you to
cross that line, the modernist will cross it. Whereas a postmodernist
will say, Oh well, if you don't want me to cross it,
that's okay, we'll negotiate.*

— BALDWIN LECTURE, OBERLIN COLLEGE

*In postmodernist art, nature is treated as wholly domesticated by
culture: the "natural" can be approached only through its cultural
representation. While this does indeed suggest a shift from nature
to culture, what it in fact demonstrates is the impossibility
of accepting their opposition.*

— THE ALLEGORICAL IMPULSE: TOWARD
A THEORY OF POSTMODERNISM, PART 2

*Decentered, allegorical, schizophrenic . . . —however we choose to
diagnose its symptoms, postmodernism is usually treated . . . as a
crisis of cultural authority, specifically of the authority vested in
Western European culture and its institutions.*

— THE DISCOURSE OF OTHERS: FEMINISTS
AND POSTMODERNISM

*It is precisely at the legislative frontier between what can
be represented and what cannot that the postmodernist
operation is being staged.*

— THE DISCOURSE OF OTHERS: FEMINISTS
AND POSTMODERNISM

Einstein on the Beach:
The Primacy of Metaphor

If, as is frequently and strikingly attested everywhere today, bold-
ness in theater proclaims, rightly or wrongly, its fidelity to Artaud,
the question of the theater of cruelty, of its present nonexistence and
ineluctable necessity, has the force of an historical *question. His-*
torical not in its possible inscription within what we know as the
history of theater, not because it would mark a stage in the develop-
ment of theatrical forms or because of its place in the succession
of models of theatrical representation. The question is historical
in a sense that is both radical and absolute. It declares the limit
of representation.

— JACQUES DERRIDA, "The Limit of Representation,"
from *L'écriture et la différence*

Across those differences which segregate the dominant attitudes to-
wards performance in our century into either expressionistic or analytic
modes,[1] there appears a single commitment which may be associated
with neither; a challenge to the structure of representation which has
been identical with that of theater ever since Aristotle characterized
dramatic poetry as mimetic. This identification of tragedy with the imi-
tation, rather than the immediate presentation, of action posits a fun-
damental dualism at the heart of the theater. Performance and text,
representer and represented, are (it seems irrevocably) split. Theatrical
representation establishes itself in that rift which it alone creates between
the tangible physical *presence* of the performer and that *absence* which is
necessarily implicated in any concept of imitation or signification. The
imitated action (the theatrical signified) is situated outside of the closed
circuit established by the copresence of performer and spectator. Thus
what is represented is always an "elsewhere." As a result, while the per-
former is in fact both a presence and a signifier (for an absence), we
always regard him as the latter, as a representative for something else—
the actor as perpetual stand-in.

3

The major innovations in performance of the last fifty years have been addressed to this rift, either to exaggerate it (Brecht) or to annihilate it (Artaud). Both strategies shift from *re*presentation to *present*ation. Since the presence of the performer is anterior to, and a necessary condition for, any theatrical representation, the impulse which animates that shift might be characterized as modernist, a reduction to that which is unique and absolutely fundamental to the theatrical situation. Modernist performance abandons representation by establishing identity between representer and represented. The performer no longer stands for anything other than himself. (The resurgence of interest in dance at the beginning of this century was a manifestation of the same impulse. According to Yeats's formula, dance has always eluded any such dualism.)

Since the structure of representation is identical with that of verbal language—a system of signs which always substitute for nonpresence—the ambition to overturn an entrenched theatrical representationalism has frequently manifested itself in programs which would radically alter, if not eliminate, the use of speech on stage. The nonverbal spectacle is its offspring. Yet the overthrow of representation cannot be restricted to nonverbal modes, since an identical impulse has also animated the poetic theater of our century. Thus, modes traditionally conceived as antithetical become complementary. In Artaud's polemical writings on theater, it is the conjunction of the nonverbal and the poetic that constitutes the very possibility for the revivification of theater.

While Artaud's modernism is apparent in his move to disestablish the author—"the theater, an independent and autonomous art, must, in order to revive or simply to live, realize what differentiates it from text, pure speech, literature, and all other fixed and written means"[2]—it does not follow that he meant to eliminate speech from the stage altogether. If the theater was to be reconstituted outside of verbal language, the author to be replaced by the director, and the stage to become the locus of research into alternative languages of gesture and scenography which would "always express [thought] more adequately than the precise localized meanings of words,"[3] it was simply that the *authority* of the spoken word was to be undermined. Artaud advocated the overthrow of all hierarchical rankings of theatrical languages, which had assigned speech a position of preeminence, and reduced the *mise en scène* to a subsidiary role. The theater of cruelty was to be characterized by a plurality of equipollent voices: spoken, musical, gestural, scenographic. If in the spectacles he envisioned "the spoken and written portions will be spoken and written in a new sense,"[4] still, the sensuous, physical side

of language—everything which characterizes its poetic use—was to be retained:

> But let there be the least return to the active, plastic, respiratory sources of language, let words be joined again to the physical motions that gave them birth, and let the discursive, logical aspects of speech disappear beneath its affective, physical side, i.e., let words be heard in their sonority rather than be exclusively taken for what they mean grammatically, let them be perceived as movements, and let these movements themselves turn into other simple, direct movements as occurs in all the circumstances of life but not sufficiently with actors on the stage; and behold! the language of literature is reconstituted, revivified, and furthermore—as in the canvasses of certain painters of the past—objects themselves begin to speak.[5]

Artaud's ambition was thus more than the revivification of theater; it was nothing less than the complete reanimation of poetic language. Or rather, one necessarily implicated the other.[6] This poetic aspect of his enterprise extended to his instructions for the manipulation of scenic elements:

> The language of the theater aims then at encompassing and utilizing extension, that is to say space, and by utilizing it, to make it speak: I deal with objects—the data of extension—like images, like words, bringing them together and making them respond to each other according to laws of symbolism and living analogies: external laws, those of all poetry and all viable language, and, among other things, of Chinese ideograms and ancient Egyptian hieroglyphs.[7]

That Artaud's prescriptions for the stage should constitute an *ars poetica* suggests a historical filiation with a number of modern poets who also identified the stage as an appropriate locus for research into intensifying the purely physical, i.e. sonorous, movements of language. Mallarmé wrote *Igitur* for the stage. Eliot identified the poetic moments of tragedy as those at which the language reflects back into itself, becomes aware of itself as a theatrical presence. Further, in a passage reminiscent of Artaud's proposal that words be perceived as movements, he suggested that if verse drama were to be given new life, it might look to nonverbal modes of performance such as the Mass and the ballet for paradigms. Both poet and *metteur en scène* would transform language into an entirely material event. And Valéry, describing his own work for the stage as a concatenation of music and architecture, called the resultant genre "melodrama": "I found no other term to describe this work, which is

certainly neither an opera, nor a ballet, nor an oratorio." Like Eliot, he drew a parallel with religious liturgy: "To my mind, it must and does bear some resemblance to a ceremony of a religious nature." Yet he reiterated its poetic nature: "The action, limited and slight as it is, must be further subordinated to the meaning and poetic substance of each of its moments."[8]

Like Valéry's "melodrama" (which it resembled in several respects), Robert Wilson's recent spectacle *Einstein on the Beach* (in collaboration with composer Philip Glass) resists assimilation to any of the conventional genres of performance. Although *Einstein* was identified as an "opera," and while its score might be anatomized accordingly into arias, duets, choral passages, and ballets, the production lacked the correlation between music and dramatic action that defines that genre. Glass occasionally incorporated concrete aural references to the visual subject of a scene into his score, but his insistence on structure and logical progression only emphasized the independence of music from action. One was reminded of that disjunctiveness between sound and image which Cunningham brought to the dance. Action exhibited a similar autonomy: *Einstein* progressed as a sequence of highly allusive visual images that appeared to succeed one another according to an internal logic of association. They centered on the figure of Einstein. Habits of his dress and personality; mathematical and scientific models and instruments; the products of technological progress, such as trains, spaceships, and atomic explosions, coalesced to form a complex portrait by association. From scene to scene, the spectator's sense of both scale and duration was altered, perhaps in demonstration of the central hypothesis of Einstein's thinking (that dimension and velocity are interdependent). Because of the frequent arbitrariness of the selection of the images, no detail being too insignificant for inclusion, as well as the freedom with which associations were made—organization was neither chronological nor thematic—Wilson's work has been compared with dreams. If the space evoked in *Einstein* was dreamlike, one important difference must be noted. Wilson's images, unlike those of dreams, are not open to interpretation. Dream-images are the *mediated* representations of dream-thoughts; hence, their interpretability. Wilson's images are, on the contrary, immediate, presentational, resistant to analysis. This is supported by the subsidiary function assigned to speech and spoken texts in all of his works. For language is, above all, the medium of interpretation.

With *Einstein*, Wilson carries ambivalence towards language one step further. Even the published "text" for the production is nonverbal, a series of 113 charcoal sketches made by Wilson himself and reproduced

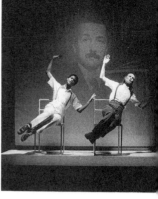

in a book which assembles musical scores, spoken texts, and choreographic diagrams. Arranged as a sequence of cinematic stills, these atmospheric drawings chart *Einstein*'s division into four acts, nine scenes and five *intermezzi* (hinges or "knee-plays") and describe three basic scenic motifs: a train, a courtroom, and a field of dancers over which a spaceship passes. This pictographic text proceeds from and extends Wilson's ambition to mount a spectacle which cannot be contained within verbal language:

> Wilson shuns recipes and this is why to write about him, who is always so loath to express judgement [*sic*] or opinions, is to risk encapsulating him in one of those airtight wrappers of culture towards which the whole of his work is directed, if not as an accusation at least as an alternative. To translate into words its expressive complexity means, in a way, to prevaricate on both the author's and the public's emotive participation. To single out a particular linear development or a new definition of theatre in his work is to misrepresent its underlying premise, *the attempt to reconstruct on the stage everything which life systematically shatters.* [italics added][9]

Wilson's theater does not intend to provoke articulate response; rather, it argues the poverty of those systems through which such a response might be formed—primarily language, but also all processes of logical thought according to which we parse, analyze, literally come to terms with experience. The ambition to stage a semblance of the unanalyzed, amorphous continuum of sensory data which is subsequently segmented by the formative action of language ("everything which life systematically shatters") involves an implicit argument that the activity of language upon that continuum is a violation of its integrity. Language inevitably produces an endless string of synecdoches which, in spite of their intention to signify, will never reproduce the original unity which is prior to all analysis, all logical thought.

This argument about the synecdochic character of language is hardly new, yet it seems to have exhausted little of its authority. While it has

Robert Wilson and Philip Glass, Einstein on the Beach, *1984. From left: Sheryl Sutton, Lucinda Childs. First performed in 1976 at the Metropolitan Opera, New York City. Photograph copyright © Paula Court.*

both psychological and philosophical ramifications—Merleau-Ponty, for example, has written that speech "tears out or tears apart meanings in the undivided whole of the nameable"—it also underpinned the revolution in linguistics which dates from the beginning of this century. Saussure's now-famous discussion in his *Cours* of the arbitrariness of the sign was rooted in the distinction between "form" and "substance"; the latter was considered a nebulous continuum anterior to language:

> Without language, thought is a vague, uncharted nebula. There are no pre-existing ideas, and nothing is distinct before the appearance of language. . . . Phonic substance is neither more fixed nor more rigid than thought; it is not a mold into which thought must of necessity fit but a plastic substance divided in turn into distinct parts to furnish the signifiers needed by thought. The linguistic fact can therefore be pictured in its totality—i.e. language—as a series of contiguous subdivisions marked off on both the indefinite plane of jumbled ideas . . . and the equally vague plane of sounds. . . . Language works out its unity while taking shape between two shapeless masses. . . . *Their combination produces a form not a substance.*[10]

While Saussure's intention was simply to restrict linguistics to the analysis of form, and despite his recognition of the fundamental unintelligibility of the prelinguistic, the effect of his formulation is nonetheless to uphold a traditional distinction between what is thought and what is expressed in language.

Saussure's notion of substance as a shapeless mass was interpreted by the Danish linguist Louis Hjelmslev as purport: an unformed mass of physical or psychical data which, while common to all languages, is nevertheless schematized differently by each.

> It is like one and the same handful of sand that is formed in quite different patterns, or like the cloud in the heavens that changes shape in Hamlet's view from minute to minute. Just as the same sand can be put into different molds, and the same cloud take on ever new shapes, so also the same purport is formed or structured differently in different languages.[11]

Hjelmslev cites as an example of purport the color spectrum, a mass of objective, physically measurable data which is segmented differently by different languages:

> Behind the paradigms that are furnished in the various languages by the designations of color, we can, by subtracting the differences, disclose such an amorphous continuum, the color spectrum, on which each language arbitrarily sets its boundaries. While formations in this zone of purport are for the most part approximately the same in the most widespread European languages, we need not go far to find formations that are incongruent with them.[12]

If thought is conceived as a shapeless mass, just as on the (pre-)phono-
logical level sounds form an indistinct continuum, then both the plane
of content (the signified) and that of expression (the signifier) will re-
quire, according to Hjelmslev, description in terms of both form and
substance. While the analysis of form belongs in both instances to lin-
guistics, that of substance lies outside its domain: "The description of
purport . . . may in all essentials be thought of as belonging partly to the
sphere of *physics* and partly to that of (social) *anthropology*. . . . Con-
sequently, for both planes both a physical and a phenomenological de-
scription of the purport should be required."[13]

Wilson undertakes such a description in *Einstein on the Beach*. A
phenomenological description of purport would presumably aim to re-
cover that unity which underlies the constantly changing appearances
of things (including linguistic objects) as they surface in experience. In
Husserl, that unity is understood to be a function of (synthetic) con-
sciousness, of a transcendental subject. *Einstein* implies both that aim
and that understanding. Each of three motifs (train, trial, and field) is
broken up into a set of images which, since homologous, may be rein-
tegrated. The locus of this process of reintegration is the consciousness
of the individual spectator. Structure is thus inborn, that is, emerges
while the work is performed as the spectator spontaneously apprehends
the relations obtaining among images. Thus, coherence is not a result
of any logical sequence of images (the series train-trial-field repeated
three times) as program notes suggest, but resides in intuitively grasped
similarities among images derived from a common motif. This is clearly
demonstrated in Wilson's text. The train, as it appears in Act II, its ob-
servation deck receding into the night, reappears as a building in Act
IV. This relationship, rather than the individual images in isolation, is
the subject of these two scenes and makes them a unit. Similarly, the
sharply delineated triangle of light projected by the locomotive's head-
light in the opening scene is congruent with that which streams from an
elevator shaft in the final scene—a visual linking of end with beginning.
And the fluorescent bed in the center of the courtroom during the trial
scenes in Acts I and III becomes, in Act IV, a column of light which
slowly ascends into the flies and which, in turn, is reminiscent of the strip
of light which painted itself down the backdrop in the first scene. These
images do not function as isolated signs; instead, their conjunction re-
veals patterns of interrelationship which make *Einstein* a complex, reso-
nant, experiential unit, or gestalt.

To the extent that Wilson generates a unified field through visual
means, his theater is nonverbal. Nevertheless, the techniques according
to which his imagery is manipulated can only be described as poetic.

Here poetic does not mean evocative or allusive, but indicates a particular process of establishing relationships between images. Wilson's manipulation of images is primarily analogical, that is, metaphoric. Metaphor, based exclusively on purely material or sensuous features, has been isolated by the linguist Roman Jakobson as the fundamental structure of all poetic texts. If the two poles of language are selection and combination, the first based on equivalence (metaphor), the second upon contiguity (metonymy),[14] Jakobson characterizes poetry as the transference of equivalence from the pole of selection to that of combination.[15] In poetic language, words are combined into rhythmic, alliterative, or rhymic sequences because of their equivalence as pure sound. In this way, new semantic relationships are established—or lost ones restored—on the basis of purely physical parallelisms.

It follows from Jakobson's characterization of metaphor that the poetic image must of necessity transcend the constraints of the signifying chain (what one might call the metonymic force) in its movement toward meaning. Metaphors are never context-sensitive. They do not reach out to other, contiguous elements of the chain that might determine their meanings. Two images standing in a metaphoric relationship are unaffected by those pressures from without which would have us perceive them as somehow absolutely different because of their different positions in a linear, i.e. horizontal, sequence. Rather, the proper direction of the metaphor is vertical, each metaphor appropriately located in a set of equivalent images. The principle of equivalence or congruence that characterizes that set and confers significance on each of its members becomes a kind of transcendent center toward which each metaphor gravitates.

If *Einstein on the Beach* describes a linear time span (roughly the lifetime of Albert Einstein), it nevertheless remains a resolutely nonlinear work. Events do not preceed or follow one another according to any (temporal) logic. As a result of their metaphorical aspect, Wilson's images resist falling into any meaningful linear sequence. The imposition of a logical scheme (train-trial-field-train-trial-field, etc.) only emphasizes the arbitrariness of *Einstein*'s temporal structure. The circularity activated by that formula effectively checks any linear development. In an analogous way, a recursive treatment of spoken texts works to neutralize the ordinary directionality of spoken language. A single text is repeated again and again, its final word being nothing more than a cue to the speaker to begin again, until that linear time in which all narrative and all spoken discourse operate is effectively suspended.

Since metaphor works to suspend the temporalizing effects of the sig-

nifying chain (its syntactic or syntagmatic dimension), it has frequently been associated with a corresponding motive. Metaphor reveals an atemporal principle of similarity (be it a result of divergence or convergence, that is, of homology or isomorphism) that constitutes the possibility of any relation of images whatsoever. That principle has, in varying contexts and to different ends, been identified as a law, a form, an essence; yet whether one grants it regulatory or ontological status, it remains that with which poetry has been principally concerned. The poet has been continually charged with the responsibility of uncovering that which renders all relationship possible. It is thus, through its metaphoric base and not its thematic content, that poetry participates in the investigations of metaphysics.

Yet this motive is operative only within a particular attitude towards language, the primary characteristics of which have been identified and analyzed by Jacques Derrida:

> *To concern oneself with metaphor—a particular figure—is* . . . *to presuppose a symbolist position.* It is above all to concern oneself with the nonsyntactic, nonsystematic pole, with semantic "depth," with the magnetizing effect of similarity rather than with positional combination, call it "metonymous," in the sense defined by Jakobson, who rightly underlines the affinity between symbolism (not only as a linguistic notion, but also, we should claim, as a literary school), Romanticism (with a more historical—that is, historicist—orientation, and more directed towards interpretation), and the prevalence of metaphor. [italics added] [16]

Certainly the arguments that everyday language is essentially synecdochic and therefore in need of rehabilitation, and that it is the function of poetic metaphor to restore language to its supposedly primary nature, may be traced to a specific body of theory articulated at the end of the nineteenth century: the poetic of the French Symbolists, particularly as enunciated in the critical and theoretical writings of Stéphane Mallarmé. According to Mallarmé, the revolution in poetry, which he dated to Verlaine, was involved in a return to "certain primitive resources in language." [17] Fascinated with speculations concerning the primal symbolization processes of mankind, he sketched *a theory of the suggestiveness of words* rooted in "a belief that a primitive language, half-forgotten, half-living, exists in each man. It is a language possessing extraordinary affinities with music and dreams." [18] This primitive language was conceived as a pictographic idiom of hieroglyphs which was the predecessor of the more abstract medium, verbal language, with which philosophic and scientific systems have been erected and which corresponded to a particular state of the world which preceded the deployment of time. [19]

For Mallarmé, the poet's task was to recover that data of prehistory. Poetry sprang from an impulse to restore to objects their original resonance or complication which logic and language had stripped from them. And metaphor (rhythm, rhyme, etc.) made that restoration possible:

> The poetic act consists of our sudden realization that an idea is naturally fractionized into several motifs of equal value which must be assembled. They *rhyme*; and their outward stamp of authenticity is that *common meter* which the final stress establishes.[20]

This conception of language remains tacitly operative in the texts of phenomenology and gestalt psychology (in which the task of reassembly and reintegration remains primary). It also persists in at least one other contemporary discipline—the structural anthropology of Claude Lévi-Strauss. Whereas phenomenology would dispense with the identification of that data with prehistory (each of us has access to it in the raw material of perception), Lévi-Strauss emphasizes its link with the primitive. His descriptions of *la pensée sauvage* center upon metaphor, which is isolated as the primary vehicle of myth:

> The effectiveness of symbols would consist precisely in this "inductive property," by which formally homologous structures, built out of different materials at different levels of life—organic processes, unconscious mind, rational thought—are related to one another. Poetic metaphor provides a familiar example of this inductive process.[21]

> Thanks to the myths, we discover that metaphors are based on an intuitive sense of the logical relations between one realm and other realms; metaphor reintegrates the first realm with the totality of the others, in spite of the fact that reflective thought struggles to separate them. Metaphor, far from being decoration that is added to language, purifies it and restores it to its original nature, through momentarily obliterating one of the innumerable synecdoches that make up speech.[22]

If, as Lévi-Strauss claims, the poetic and the mythic are essentially analogous functions, then they themselves stand in a metaphoric relation and must be conceived as a single function. If the techniques according to which myth reproduces an original, preddiscursive unity or totality are primarily poetic—i.e., intuitive rather than logical and rooted in metaphor—then it follows reciprocally that the "purpose" of poetry will be to create myths. Here, Lévi-Strauss rearticulates the operation prescribed in all of the great texts of literary Symbolism: those of Mallarmé, Valéry, and Eliot, and certainly of Artaud.[23] And the word which best describes that operation, *mythopoesis,* becomes profoundly tautological.

Einstein on the Beach, an essentially metaphoric structure, cannot be isolated from this poetic motive. Because Wilson participates in this mythopoeic impulse, his attitude towards language may be ascribed to a particular linguistic and poetic position and his formal strategies assimilated to a specific performance tradition, itself identified by its argument about language. Elsewhere, he has been quoted to the effect that Einstein was chosen as central figure because he exhibited characteristics of both thinker (physicist, mathematician, representative of the analytic) and dreamer (musician, visionary, representative of the idealistic).[24] Accordingly, Wilson's desire was to synthesize those divergent modes of performance (analytic, expressionistic) noted at the beginning of this essay. Hence, his collaboration with composer Philip Glass and choreographer Lucinda Childs, both of whom have previously worked in an analytic mode. Still, this synthetic ambition is profoundly mythopoeic, an inductive reintegration of previously distinct orders; and Wilson's desire to transcend the polarity of contemporary performance modes remained wholly contained within one of its terms. As a result, the profoundly intuitive character of the frame provided for the work of Glass and Childs qualified and at times subverted the objective nature of their styles. (At the same time, the strength of Wilson's images seemed diluted by the presence of antithetical material.) Had *Einstein* achieved encyclopaedic status the claims that have been made for it would be justified. As it is, Wilson's work, which has so frequently been hailed as totally innovative and without precedent, remains enmeshed in a particular tradition, the coordinates of which have already been mapped.

NOTES

1. "There are, in the contemporary renewal of performance modes, two basic and diverging impulses which shape and animate its major innovations. The first, grounded in the idealist extensions of a Christian past, is mythopoeic in its aspirations, eclectic in its forms, and constantly traversed by the dominant and polymorphic style which constitutes the most tenacious vestige of that past: expressionism. . . . The second, consistently secular in its commitment to objectification, proceeds from Cubism and Constructivism; its modes are analytic. . . . " Annette Michelson, "Yvonne Rainer, Part One: The Dancer and the Dance," *Artforum* 12 (January 1974), 57.

2. Antonin Artaud, "Letters on Language," *The Theater and Its Double,* trans. M. C. Richards (New York: Grove Press, 1958), 106.

3. Ibid., 109.

4. Ibid., 111.

5. Ibid., 119.

6. Susan Sontag has stressed the importance of this strategy for Artaud: "The function that Artaud gives the theater is to heal the split between language and flesh. . . . Artaud's writings on the theater may be read as a psychological manual on the reunification of mind and body." *Antonin Artaud: Selected Writings* (New York: Farrar, Strauss & Giroux, 1976), xxxv–xxxvi.

7. Artaud, "Letters on Language," 110–11.

8. Paul Valéry, "History of *Amphion*," trans. Haskell Block, *Collected Works* (New York: Pantheon, 1960), vol. 3, 220.

9. Vicky Alliata, *Einstein on the Beach* (New York: E.O.S. Enterprises, 1976). This attitude, so clearly hostile to the enterprise of criticism, has infected those who have written about the production: nearly all of the published accounts of *Einstein* to date have been content with simple description. For such description, which is not attempted here, see in particular, Barbara Baracks in *Artforum* 15 (March 1977), 30–36; and Susan Flakes in *The Drama Review* 20 (December 1976), 69–82.

10. Ferdinand de Saussure, *Course in General Linguistics,* trans. Wade Baskin (New York: McGraw-Hill, 1966), 112–13.

11. Louis Hjelmslev, *Prolegomena to a Theory of Language,* trans. F. J. Whitfield (Madison: University of Wisconsin Press, 1963), 52.

12. Ibid., 52

13. Ibid., 77–78.

14. On this twofold character of language, see Roman Jakobson, "Two Aspects of Language and Two Types of Aphasic Disturbances," in *Fundamentals of Language* (The Hague: Mouton, 1971), 90–96.

15. Roman Jakobson, "Linguistics and Poetics," in *Style in Language,* ed. T. A. Sebeok (Cambridge, Mass.: MIT Press, 1960), 358 ff.

16. Jacques Derrida, "White Mythology," trans. F.C.T. Moore, *New Literary History* 6 (Autumn 1974), 13.

17. Stéphane Mallarmé, *Selected Prose,* trans. Bradford Cook (Baltimore: Johns Hopkins University Press, 1956), 35.

18. Wallace Fowlie, *Mallarmé* (Chicago: Phoenix, 1962), 264.

19. The neo-Platonic base of this theory of language has been discussed by Gilles Deleuze in his writing on Proust, which embeds the novelist within a decidedly Symbolist tradition: "Certain neo-Platonists used a profound word to designate the original state which precedes any development, any deployment, and 'explication': *complication,* which envelops the many in the One and affirms the unity of the multiple. Eternity did not seem to them the absence of change, nor even the extension of a limitless existence, but the complicated state of time itself (*uno ictu mutationes tuas complectitur*). The Word, *omnia complicans,* and containing all essences, was defined as the supreme complication, the complication of contraries, the unstable opposition. From this they derived the notion of an essentially expressive universe, organized according to degrees of immanent complications and following an order of descending explications." Gilles De-

leuze, *Proust and Signs,* trans. Richard Howard (New York: Braziller, 1972), 44–45.

20. Mallarmé, *Selected Prose,* 39.

21. Claude Lévi-Strauss, *Structural Anthropology,* trans. Jacobson Schoepl (New York: Basic Books, 1963), 201–02.

22. Claude Lévi-Strauss, *The Raw and the Cooked,* trans. J. and D. Weightman (New York: Harper & Row, 1969), 339.

23. "The true purpose of the theater is to create myths." Artaud, "Letters on Language," 116.

24. "According to Wilson . . . what triggered the fusion was the subject itself, Albert Einstein, a mathematician, but at the same time a dreamer. . . . It is the contradiction, the interplay, and the harmony of dreams and mathematics that form the central tension of this work." Flakes in *The Drama Review,* 70.

Photography *en abyme*

Brassaï's portrait of a group of young Parisians at the *Bal des Quatre Saisons* may at first appear, like most photographs, to be a straightforward transcription of an observed reality, as if the image had already existed in the world before it was suspended in the photograph. We might therefore be tempted to raid it for clues to the inner lives of its sitters, or for memories of a long-since vanished Parisian milieu. However, the longer we contemplate the image, the more remote that kind of information becomes. A complex web of internal reduplications deflects attention away from that which, despite the status of photographs as imprints of the real, remains external to the image: the reality it depicts. Psychological and sociological details are thus displaced by the network of internal relationships between subject, mirror, and other, which structures the image.

Two groups of two couples each are the ostensible subjects of the photograph. The first occupy what reads as the "real" space of the image and are doubled by their own mirror images, while the second, except for the fragmentary detail of a bare arm cropped below the elbow, are present *only* in reflection. Doubled and yet, paradoxically, represented but once, the latter appear to have been dispossessed of their corporeal beings. Their reflections, severed from any physical connection with an object, attach themselves to the first group, so that each of the figures seated on the banquette finds a second, virtual double in the mirror reflection of the other. Details of costume, pose, and gesture reinforce this impression: the young man flanked by two women drapes one arm over

16

the shoulder of the woman to his left, a gesture that is reiterated by his mirror counterpart, who wears an identical hat. The blank expression of the woman to his left is repeated by her counterpart; further, both seem to use the same coiffeur. On the right, two other women demonstrate the same oblique gaze, one in apparent flirtation, the other to observe the making of the photograph. (This gaze also reiterates the angle of Brassaï's shot, thus implicating the photographer within the scene, as both witness and flirt.) The sequence of duplications is brought to closure on the right by two men who wear identical tweed caps and echo each other's distraction. (Brassaï cropped the figure on the extreme right out of subsequent prints, thereby eliminating this, the weakest link in the reduplicative chain.)

Because of the absolute symmetry of the two groups, the couples seated on the banquette appear as if poised between parallel mirrors mounted in series, so that the distance—both physical and psychological—that separates them in reality is collapsed. Space thus drained from the image, the effects of doubling may no longer be located within the space of the world, but only within the flatness of the photograph. The double image appears to have been generated by an act of internal du*pli*cation, a literal folding back of the photograph upon itself—the mirror suggests not only reflection, but also a literal crease in the surface of the print. To double by folding, however, also implies the leaving of a deposit or trace on the surface thus manipulated, as in those familiar symmetrical imprints of blotted ink. Thus, the duplication that occurs within this image suggests the specifics of the photographic process itself.

The image includes yet another, more obvious depiction of photography. It suggests the analogical definition of the photograph as a mirror image, that informs a great deal of the criticism of photography, especially that dating from the nineteenth century.[1] Because the mirror image doubles the subjects—which is exactly what the photograph itself does—it functions here as a reduced, internal image of the photograph. The mirror reflects not only the subjects depicted, but also the entire photograph itself. It tells us in a photograph what a photograph is—*en abyme*.

In the vocabulary of literary criticism, the phrase "*en abyme*" describes any fragment of a text that reproduces in miniature the structure of the text in its entirety. Introduced by Gide in a passage of his *Journal* from 1892, the phrase originally described the reduplicative strategy of his own work—like the "supplement" in Rousseau, it tells us in a text what a text is:

It pleases me to find, in a work of art, the very subject of the work trans-posed to the scale of its characters. Nothing illuminates the work better, or establishes its proportions more clearly. Thus, in some paintings by Memling or Quentin Metsys a small, somber convex mirror reflects the in-terior of the room in which the depicted scene is set. Also, Velasquez' *Las Meninas* (but in a slightly different way).[2]

Not only are Gide's initial examples of this textual device drawn from painting; all of them implicate the optical properties of mirror reflec-tion. In painting, however, mirrors rarely function as analogues for the painting itself and Gide, sensing this—"none of these examples is ab-solutely accurate"—substituted another analogy drawn from heraldry. The perfect emblem for the procedure was itself already an emblem:

What would be more accurate, what would state better what I wanted in my *Notebooks*, my *Narcissus* and in *La Tentative,* is a comparison with that procedure in heraldry which consists of placing a second shield within the first—"*en abyme.*"[3]

The necessity of coining a new critical term marks the radical break with the past signified by construction *en abyme.* Gide's intention was not to describe a textual device that had a historical existence, but to dis-sociate his own texts from all previous literary production.[4] Thus, the use of a visual device of ancient standing—that of a miniature blason suspended within another blason, whose external contour and internal divisions it replicates exactly. If, in subsequent commentaries, the he-raldic metaphor has fallen into disuse, the phrase which designates it has gained currency, in spite of an unconscious reversion. Perhaps because it suggests the familiar case of mirrors mounted in series to produce an infinite suite of specular effects, the *mise en abyme* and the internal mirror have become synonymous. So that it is defined, at least in its literary manifestations, as any internal mirror reflecting the totality of the work that contains it, either by simple reduplication (a fragment of a work demonstrating a relationship of similitude with the work that includes it), by reduplication to infinity (a fragment demonstrating a relationship of similitude with the work that includes it and which itself includes a fragment demonstrating . . .), or aphoristic reduplication (a fragment supposedly including the work which includes it).[5]

One reason for Gide's desire to distinguish the *mise en abyme* from classical examples of reduplication may have been the resistance to the concept which many of those texts demonstrate. Classical redupli-cation—in paintings as well as written texts—is rarely infinite, but al-most always brought to closure, suspended. The classical attitude to-

wards the possibility of infinite reduplication is perhaps best exemplified by Husserl in a passage from his *Ideas* which also relies upon a visual demonstration:

> A name on being mentioned reminds us of the Dresden Gallery and of our last visit there: we wander through the rooms, and stand before a picture of Teniers which represents a picture gallery. When we consider that pictures of the latter would in their turn portray pictures which on their part exhibited readable inscriptions and so forth, we can measure what interweaving of presentations, and what links of connexion between the discernible features in the series of pictures, can really be set up.[6]

The philosopher would, however, reduce this experience to a specific case of representation. For Husserl, every representation is a representation *of*: representations "present themselves as the modification of something, which apart from this modification would be there in its corporeal or represented selfhood."[7] In the case of potentially infinite reduplication, Husserl claims that we can penetrate through the series of levels until we arrive at a final one, at which the seemingly infinite play of reduplications is arrested: "the glance penetrates through the noemata of the series of levels, reaching the object of the last level, and there holding it steady, whilst no longer penetrating through and beyond it."[8] It is this "last level" that classical theories of representation attempt to locate. They ground the representation in its object; multiple reduplications are simply a smoke screen which may blur the outlines of the object, but can never obliterate it entirely.

Gide, however, described a textual phenomenon that is closer to the infinite play of substitution of the Derridean *mise en abyme,* as it informs the philosophy of *différance,* supplementarity.... In an early text (*Speech and Phenomena*), Derrida cited Husserl's Dresden Gallery passage, commenting:

> Certainly nothing has preceded this situation. Assuredly nothing will suspend it. It is not comprehended, as Husserl would want it, by intuitions

Brassaï, Groupe joyeux au bal musette, *1932.*

or presentations. Of the broad daylight of presence, outside the gallery, no perception is given us or assuredly promised us. The gallery is the labyrinth which includes in itself its own exits: we have never come upon it as upon a particular case of experience—that which Husserl believes he is describing.[9]

For Derrida, the *mise en abyme* describes a fundamental operation of the text—it is synonymous with textuality. It can therefore have no existence outside of texts. Since it cannot be ascribed as a property to objects, it cannot be grounded in them. The Derridean abyss—"when one can read a book within a book, an origin within the origin, a center within the center"[10] and, we might add, a photograph within a photograph—underlies the techniques of deconstructive reading, which describes, among other things, the way in which representation is staged within the text.

An entire theory of the structural necessity of the abyss will be gradually constituted in our reading: the indefinite process of supplementarity has always already infiltrated presence, always already inscribed there the space of repetition and the splitting of the self. Representation in the abyss of presence is not an accident of presence; the desire of presence is, on the contrary, born from the abyss (the indefinite multiplication) of representation, from the representation of representation, etc.[11]

The effects of the abyss—the indefinite play of substitution, repetition, the splitting of the self—are evident in Brassaï's photograph. The mirror accomplishes both the identification with the Other and the specular dispossession which simultaneously institutes and deconstitutes the subject as such. What is more, the implicit analogy between mirror and photograph ascribes these functions to photography as well. (The splitting of the subject by its photographic doubling was also depicted by Lartigue in a photograph, contemporary with Brassaï's, of the *demi-mondaine* Renée Perle in the intimacy of her dressing room. In this image, the subject turns her back upon the camera and inclines narcissistically towards her mirror image. Beside her on the dressing table is a fashion photograph for which she once posed. That photograph within the photograph functions as a second mirror which reflects, in turn, Renée herself, her mirror image, and Lartigue's photograph of her. The caption that accompanies this photograph in *Diary of a Century,* "Renée Perle contemplating the face of the most beautiful woman in the world," underscores the subject's narcissism. Through the use of a transitive verb to describe a reflexive action, it also literally describes the structure of the photograph.)

The abyss resonates throughout Brassaï's oeuvre. In his photograph of a gala soirée at Maxim's, in which an ornate Art Nouveau mirror frames exactly the same scene as Brassaï's viewfinder and is reiterated by a second mirror in the depths of reflected space, we encounter infinite reduplication. In another image, a wedge is driven through the intimacy of a lovers' embrace by two mirrors that abut one another at right angles—the two are alienated by their reflections, consigned to two separate, self-enclosed realms. Still another image, depicting the aftermath of a quarrel, shows exactly the same location as the *Group in a Dance Hall* and reiterates the three species of doubling—by the photograph, the mirror, and the other—which structure that photograph. Here, a man is doubled by his own reflection in the mirror, while his female companion is doubled by another woman's reflection which floats nebulously in the mirror above her. A small square glass cleat that marks the intersection of mirror panels obliterates one of the reflected woman's eyes, suggesting a possible psychological reading (mutilation, male fantasy, etc.). However, it is the internal structure of the image—the network of relationships that constitutes it as double—that makes any such interpretation possible. Meaning, therefore, does not reside in details of expression or gesture that are simply registered by the photograph. Rather, it is a property of the photograph itself.

Brassaï's fascination with mirrors has been explained as a derivative from painting, from Cubism in particular; and biographical data—his friendship with Picasso, his early aspirations to a painting career, and his obvious absorption of the Parisian milieu into which he was transplanted—has been mustered in support of this claim.[12] However, no appeal to painting is sufficient to unravel the photographer's predilection for reflective surfaces and complex mirror duplication. Not only does an appeal to Cubism reduce the mirror effects to a multiplication of perspectives and thus deny these images their specifically photographic character, it also ignores the frequent recurrence of the mirror in photographs throughout the history of the medium. Its first appearance as a self-conscious device coincides with that moment at which photography began to depict its own possibilities and conditions in its images.

The work of the Victorian photographer, Lady Clementina Hawarden, represents one of the earliest such attempts. (Most of Hawarden's work may be dated to the late 1850s, and the first half of the '60s.) Her obsession was the double portrait; as frequently as not, however, these images are constituted by a single subject doubled in reflection, as in a photograph that has been posthumously captioned "At the win-

dow." Here the subject seems to be suspended between two possible objects of contemplation—the view out the window and her own image in a mirror. She seems to incline towards the latter; the reticence of the image reinforces this impression. Thus, what is depicted is the process of becoming self-reflexive. The tension in the image between the different spectacles offered by the window and the mirror restates a structural tension within the medium—between photography as extrovert, a view onto the material world, and the photograph as a self-enclosed image of its own process. The inclinations of the subject depicted in this image are those of the photograph itself.

The mirror functions not only to reflect the subject; it also quite consciously pictures that metaphor which defines photography as a mirror image. The mirror reads as an image *en abyme*. The cropping of the print to echo the profile of the mirror firmly establishes this intention. This visual identification of mirror and photograph establishes a complex play between subject, mirror, and camera: not only is the subject doubled twice (by mirror and camera), but the mirror image, itself a double, is redoubled by the photograph itself.

If we speak of this image, and of others like it, as reduplicative, it is because *reduplication* signifies "to reproduce in reflection" and thus describes that kind of mechanical reproduction by analogy we impute to both mirror and photograph. Ordinary usage, however, does not register differences of degree between *duplication* and *reduplication*. The latter might be expected to be contingent upon a previous act of duplication, and thus to result in what is actually a tri- or quadruplication of an original object or quantity (the ambiguity results from the possibility of taking either the original or its double as the object of the second doubling). However, the excess implicit in the concept of reduplication has been sublimated. *Duplicate* and *reduplicate* have been reduced to synonymy; both refer to a single signified: "to double." The reduction to doubling fails not only to account for the "pli" or fold implicit in both; it also strips the prefix in *reduplication* of its signifying function. Its relationship with its stem is now that of a mirror to its object—a doubling without any corresponding semantic increment. So that *reduplication* harbors within its semantic folds the concepts of tautology, of redundancy.

However, in those disciplines which take language as their object—philology, rhetoric, and structural linguistics—*reduplication* is a technical term that describes a specific phenomenon. In classical rhetoric, *reduplication* was a species of *repetition,* distinguished by the reiteration of a word or phrase within the same part of a sentence or clause. Its function, like all forms of rhetorical repetition, was emphatic. *Reduplication* has at

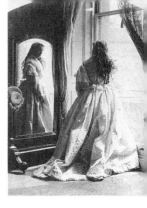

times been identified with the etymologically parallel figure *anadiplosis* (*ana*, again + *diploun*, to double) in which the final word of a phrase is repeated at the beginning of the next. *Anadiplosis* thus establishes a mirror relationship between two segments of a text, the classic example being Voltaire's

> *Il aperçoit de loin le jeune Téligny,*
> *Téligny, dont l'amour a mérité sa fille*

in which the second line stands as a mirror reversal of the first. That such a figure should have been designated as a *re*doubling suggests the classical view of language as a mirror of the real; hence the repetition of a word or phrase doubles that which is itself already double.

Classical philology describes a similar phenomenon, occurring not at the level of the sentence, but at that of the word. Linguistic, as opposed to rhetorical, reduplication (the term is again a technical one) involves the repetition of identical or quasi-identical syllables, commonly at the beginning of a word; the English *murmur* and the French *bonbon* are two examples. Such reduplications have been explained as motivated signs, originally expressing repeated or intensive action or, in some languages, plurality. In the analysis of structural linguistics, however, reduplication does not demonstrate motivation (a relationship of analogy between a sign and its referent); on the contrary, it indicates, if not arbitrariness, at least the conventional nature of an utterance.

Roman Jakobson, discussing the frequent occurrence of reduplication in infantile language, suggests that it may well be the sign of the subject's entry into a symbolic order:

> At the transition from babbling to verbal behaviour, the reduplication may even serve as a compulsory process, signalling that the uttered sounds do not represent a babble, but a senseful semantic entity. The patently linguistic essence of such a duplication is quite explicable. In contradistinction to the "wild sounds" of babbling exercises, the phonemes are to be recognized, distinguishable, identifiable; and in accordance with these require-

Lady Clementina Hawarden, At the Window, *c. 1864. Courtesy Gernsheim Collection, Harry Ransom Research Center, The University of Texas at Austin*

ments, they must be deliberately repeatable. The repetitiveness finds its most concise and succinct expression in, e.g., *papa*. The successive presentations of the same consonantal phonemes repeatedly supported by the same vowel, improve their legibility and contribute to the correctness of message reception.[13]

If repeatability is a necessary condition of those units out of which language constructs sense, then reduplication is, at its most fundamental level, the very sign of that repeatability. It signifies that an utterance is not simply a "wild sound," but that it is emitted according to a code, and thus conveys an intention to signify. Although repetition does not guarantee semiosis, it does suggest its presence and thus becomes, for Lévi-Strauss at least, the "signifier of signification":

> Even at the babbling stage the phoneme group /pa/ can be heard. But the difference between /pa/ and /papa/ does not reside simply in reduplication: /pa/ is a noise, /papa/ is a word. The reduplication indicates intent on the part of the speaker; it endows the second syllable with a function different from that which would have been performed by the first separately, or in the form of a potentially limitless series of identical sounds /papapapapa/ produced by mere babbling. Therefore the second /pa/ is not a repetition of the first, nor has it the same signification. It is a sign that, like itself, the first /pa/ too was a sign, and that as a pair they fall into the category of signifiers, not of things signified.[14]

Reduplication first occurs at the transition from babbling to linguistic performance, at the moment of the infant's entry into the symbolic order, which is contemporaneous with the mirror stage. Thus the dispossession of the subject by the mirror is also a law of language, and linguistic reduplication might also be a sign of the capture of the subject by an image.

In the concluding paragraphs of *The Raw and the Cooked,* Lévi-Strauss extended Jakobson's observation to onomatopoeic words; in this instance, reduplication functions to distinguish purely imitative sounds from signs. If the arbitrary character of most words is sufficient to indicate their status as signs, "onomatopoeic terms, on the other hand, are always ambiguous in nature because, being founded on a resemblance, they do not clearly indicate whether the speaker, in pronouncing them, is trying to reproduce a noise or to express a meaning."[15] Reduplication, then, functions to indicate that such utterances are indeed signs, and not gratuitous or merely imitative noises. Linguistic reduplication, the anthropologist concludes, may be used as an explanatory model for the structure of myths. Just as language chooses its phonemes

from a practically unlimited range of natural sounds, so too myths draw upon the whole realm of natural phenomena for their subject matter. These phenomena are not the object of myths, rather, they are their instruments of signification. The multiple isomorphisms that constitute myths function like linguistic reduplication: "the distinctive character of myths . . . is precisely emphasis, resulting from the multiplication of one level by another or several others, and which, as in language, functions to signify signification." [16]

While the linguistic character of myths has been amply demonstrated by structural anthropology, it may legitimately be asked what relevance linguistic reduplication might possibly have to photographs, if the photograph is, following Roland Barthes's "common sense" definition, a message without a code, that is, nonlinguistic. However, the terms in which Lévi-Strauss discusses the phenomenon of linguistic reduplication suggest that it may indeed function as an explanatory model for photographic reduplication as well. Both Jakobson and Lévi-Strauss distinguish the sound emitted randomly or in imitation of another sound from that emitted as language, that is, according to a code. Photography, then, at least as Barthes distinguishes it from other semiotic systems, would seem to correspond to the purely imitated sound:

> What is the content of the photographic message? What does the photograph transmit? By definition, the scene itself, the literal reality. . . . In order to move from the reality to the photograph it is in no way necessary to divide up this reality into units and to constitute these units as signs, substantially different from the object they communicate; there is no necessity to set up a relay, that is to say a code, between the object and its image. Certainly the image is not the reality but at least its perfect *analagon* and it is exactly this analogical perfection which, to common sense, defines the photograph. [17]

What then might reduplication signify within such an image? Does it not, as in language and myth, signify the existence of an underlying intention to signify *through the image,* and thus to the possibility of a photographic language? Might it not indicate, like the reduplicated syllable in the vocable /papa/, that the photograph itself was already a sign? Might it not also contest any reading of photographs according to their subject matter or captions, the reality presented by the photograph being no longer the object of the image, but an instrument of signification? Does it not indeed suggest that we may be able to speak of a *genuine* rhetoric of the image?

The argument that the properties of the photographic image are de-

rived not from the characteristics of the medium itself but from the structure of the real, registered mechanically on a light-sensitive surface, may describe the technical procedures of photography. But it does not account for the photograph's capacity to internally generate and organize meaning. However, it does seem to describe accurately the strategy according to which some photographs procure their authoritative status, those photographs in which a carefully calculated *mise en scène* mutely insists that the image is wholly dependent upon, since derived from, the external. Thus, the radical symmetry of Walker Evans's photograph of Cary Ross's bedroom (made in the same year as Brassaï's *Group in a Dance Hall*). Everything about the image is symmetrical—twin beds, a pair of identically framed impressions of the same Picasso print—everything, that is, except the photograph itself. The oblique angle of Evans's shot works to exteriorize those symmetries, to present them as properties of the real rather than the image. Had these paired objects been photographed head-on, the image would have appeared artificial, staged. Seen obliquely, however, they impute to the material world the capacity to independently create its own symmetries, to mirror itself.

Still, what we recognize in this photograph, despite its claim to transparency, is an image of the photographic process. If the camera angle works to exteriorize symmetry, it also encourages the illusion of a room divided by a mirror, and thus of a single bed and a graphic each doubled in reflection. That mirror is located by a virtual fold in the surface of the photograph along which reality is reduplicated according to the properties of the image. The paired graphics, in addition to contributing to the illusion of a mirror, suggest the duplicability of the photographic print, the theoretically unlimited number of copies that may be engendered by a single negative. Photographs are but one link in a potentially endless chain of reduplication; themselves duplicates (of both their objects and, in a sense, their negatives), they are also subject to further duplication, either through the procedures of printing or as objects of still other photographs, such as Evans's *Penny Picture Display, Savannah,* 1936. While the illusion of a mirror may be inhibited by the night table and lamp—the only supposedly single objects in the image—these, however, are also doubled by the shadows they cast on the wall. The cast shadows are an additional analogue for photography. Thus, if Evans's photograph depicts a reality outside of the photograph, that reality is nonetheless wholly conditioned by the properties of the image. This scene must have appeared as a photograph even before Evans exposed it.

An experience of the real as if it were a photograph is described by Robert Smithson in his text, "The Monuments of Passaic," in which the artist narrates the events of a day-long photographic excursion to the New Jersey suburbs. Of photographing an ordinary wood-and-steel bridge, Smithson remarks:

> Noonday sunshine cinema-ized the site, turning the bridge and the river into an over-exposed *picture*. Photographing it with my Instamatic 400 was like photographing a photograph. The sun became a monstrous light-bulb that projected a detached series of "stills" through my Instamatic into my eye. When I walked on the bridge, it was as though I was walking on an enormous photograph that was made of wood and steel, and underneath the river existed as an enormous movie film that showed nothing but a continuous blank.[18]

This narrative inverts the terms of a familiar argument about the photograph: that the vicariousness of the image is frequently overlooked, so that the photograph is mistaken for the reality for which it is nevertheless only a substitute. Smithson, standing that argument on its head, calls its bluff. If reality itself appears to be already constituted as image, then the hierarchy of object and representation—the first being the source of the authority and prestige of the second—is collapsed. The representation can no longer be grounded, as Husserl wanted, in presence. For Smithson, the real assumes the contingency traditionally ascribed to the copy; the landscape appeared to him, not as Nature, but as a "particular kind of heliotypy."[19] The result is an overwhelming experience of absence: the abyss.

To some extent, Smithson recapitulates that passage in Fox Talbot's *Pencil of Nature* in which the pioneer photographer recounts his realization that, in Hollis Frampton's paraphrase, "the 'image' he had sought to make is already there."[20] The invention of photography was thus simply a discovery of a physical or chemical means for fixing the discontinuous images of herself that Nature freely offered up. But Fox Talbot was looking into a camera lucida. Smithson confronts not an image, but an

Walker Evans, Cary Ross's Bedroom, *1932, New York. Copyright © estate of Walker Evans.*

object *as if it were an image.* What does it mean, then, to take a photograph of a photograph?

This question is also raised in a series of photographs Smithson made in 1969, and which seem to derive, at least in part, from the experience described in "The Monuments of Passaic." Within the space of these double images, a site and its own photographic likeness are juxtaposed. This *mise en abyme* endows these photographs with an apparatus for self-interpretation; their structure, defined by the juxtaposition of two images of the same motif, gives rise to commentary on the conditions of the photograph itself. Through them, Smithson deflates the myth that photographs are a means of gaining mastery and control over objects, of rendering them more accessible to consciousness. The internal photograph reduces the landscape and distances it from us. Moreover, what is true of the internal image holds for the photograph as a whole. In a photograph, Smithson casts a shadow over the presumed transparency of photographs; he raises serious doubts about their capacity to *convey* anything but a sense of loss, of absence.

What redeems the photograph, however, is its ability to generate and organize meaning *independently of its object.* Smithson frequently published and exhibited photographs of his projects; but after an experience of his double photographs, can we seriously regard *any* Smithson photograph simply as documentation? It is impossible to experience these double images as such. We are wrong to presume that the "work" in this case consists of an action performed (the placing of the photograph in the landscape) and that the photograph is transparent to that action, which it preserves in the tense peculiar to photography, the "having-been-there."[21] However, these photographs are distinguished from documents by the relationship of the internal photograph to the photograph that contains it. Not only does this relationship exist at present only in the photograph, it has *never* existed elsewhere. So that the action Smithson performed was simply an instrument, and not the object, of signification. The photograph *is* the work.

In 1969, Smithson executed a series of "mirror displacements" in the Yucatan peninsula; nine color photographs "document" that project. Although location and materials have changed—Smithson substituted mirrors for the photograph—these images reiterate the photo displacements produced that same year in a New Jersey quarry: a motif and its reflection are juxtaposed within a photograph. Of these displacements, Smithson wrote:

> If you visit the sites (a doubtful probability) you find nothing but memory-traces, for the mirror displacements were dismantled right after they were

photographed. The mirrors are somewhere in New York. The reflected light has been erased. Remembrances are but numbers on a map, vacant memories constellating the intangible terrains in deleted vicinities. It is the dimension of absence that remains to be found. The expunged color that remains to be seen. The fictive voices of the totems have exhausted their arguments. Yucatan is elsewhere.[22]

NOTES

1. Photography, in its earliest manifestations, was frequently referred to as "Daguerre's mirror." Certainly the silvered surfaces and lateral reversals of early Daguerreotypes supported this analogy. As early as 1839, Jules Janin, introducing the invention, urged his reader to "imagine that the mirror has retained the imprint of every object it reflects, then you will have a more complete idea of the Daguerreotype." Quoted from Heinz Buddemeier, *Panorama, Diorama, Photographie* (Munich: Wilhelm Fink, 1970), 207. Richard Rudisill's *Mirror Image* (Albuquerque: University of New Mexico Press, 1971) contains, as its title suggests, copious documentation for the photo-mirror analogy.

2. André Gide, *Journal 1889–1939*, "Pléiade" (Paris: Gallimard, 1951), 41.

3. Ibid.

4. Gide did cite *Hamlet, Wilhelm Meister*, and *The Fall of the House of Usher* as texts employing the device, but only to immediately disqualify their candidacy.

5. For a historical treatment of the *mise en abyme* in literary theory, see Lucien Dallenbach, *Le récit speculaire: essai sur la mise en abyme* (Paris: Seuil, 1977).

6. Edmund Husserl, *Ideas*, trans. W. R. B. Gibson (New York: Collier, 1962), 270.

7. Ibid., 269.

8. Ibid., 271.

9. Jacques Derrida, *Speech and Phenomena*, trans. David B. Allison (Evanston: Northwestern University Press, 1973), 104.

10. Quoted in Dallenbach, *Le récit speculaire*, 216.

11. Jacques Derrida, *Of Grammatology*, trans. G. C. Spivak (Baltimore: Johns Hopkins University Press, 1976), 163.

12. See Colin J. Westerbeck, Jr., "Night Life: Brassaï and Weegee," *Artforum* 15 (December 1976), 34–45.

13. Roman Jakobson, "Why Mama and Papa?" in *Selected Writings, I* (The Hague: Mouton, 1962), 542.

14. Claude Lévi-Strauss, *The Raw and the Cooked*, trans. J. and D. Weightman (New York: Harper & Row, 1969), 339–40.

15. Ibid.

16. Ibid. I have substituted my own translation from the French original.

17. Roland Barthes, "The Photographic Message," in *Image–Music–Text*, trans. Stephen Heath (New York: Hill and Wang, 1977), 16–17.

18. Robert Smithson, "The Monuments of Passaic," *Artforum* 6 (December 1967), 49.

19. Ibid., 50.

20. Hollis Frampton, "Incisions in History Segments of Eternity," *Artforum* 13 (October 1974), 41.

21. Roland Barthes, "Rhetoric of the Image," in *Image–Music–Text,* 44.

22. Robert Smithson, "Incidents of Mirror-Travel in the Yucatan," *Artforum* 8 (September 1969), 33.

Detachment:
from the *parergon*

. . . we come to this collusion: between the question ("What is art?," "What is the origin of the work of art?," "What is the meaning of art or of the history of art?") and the hierarchical classification of the arts. When a philosopher repeats this question without transforming it, without destroying its form, its form as a question, its ontointerrogative structure, he has already subjected all space *to the discursive arts, to the voice and to* logos. *We can prove it: teleology and hierarchy are prescribed in the envelope of the question.*

— JACQUES DERRIDA, "The Parergon"

In "Art as Semiotic Fact," a manifesto published in 1934, Prague linguist and aesthetician Jan Mukarovsky prescribed semiotic analysis of works of art as a necessary corrective to the misapprehensions of traditional art theories. "Lacking a semiotic orientation," he wrote, "the theorist of art will be inclined to regard the work of art as a purely formal structure or, on the other hand, as a direct reflection of the psychological or even physiological states of its creator or . . . of the ideological, economic, social or cultural situation of the milieu in question." Formalism, expressionism, ideological criticism—these are the doctrines from which the semiologist dissociates himself. By analyzing the work as a signifying structure, a system of signs, he proposes not simply to alter, but to transform totally the aesthetic field. Mukarovsky even claimed that only semiology—frequently criticized as ahistorical because of its emphasis on synchronic analysis—could account both for the structure of works of art and for the history of art: "Only the semiotic point of view allows theorists to recognize the autonomous existence and essential dynamism of artistic structure and to understand the evolution of art as an immanent process but one in constant relationship with other domains of culture."[1]

This radical ambition to break decisively with the entire history of

aesthetics motivates every semiotic approach to art. But what if it could be demonstrated that philosophy, in order to deal with art at all, has *always* dealt with it as a semiotic phenomenon? That the fundamental presuppositions that organize aesthetic discourse are identical with those upon which semiotics is based? That the visual arts have continually been subordinated to language, and that every hierarchy of the arts is based on linguistic criteria? That semiotics itself is in fact (an extension of) aesthetics?

The permanent complicity of Western aesthetics with a certain theory of the sign is the major theme of Jacques Derrida's "The Parergon," written primarily on Kant's *Critique of Judgment*. "The Parergon" is not, however, a text about art; nor is it simply about aesthetics. Rather, it represents an attempt to unmask what Derrida calls "discursivity within the structure of the beautiful," the occupation of a nonverbal field by a conceptual force. "The Parergon" thus extends to the aesthetic domain Derrida's observations concerning the permanent authority invested by Western metaphysics in speech.

This theme was already broached in Derrida's reading of Rousseau's *Essay on the Origin of Languages*, the subject of the second half of *Of Grammatology*. Rousseau's chapter "On Melody," devoted almost entirely to painting and to an analogy between painting and music, assigns color a supplementary function in the visual arts. According to Rousseau,

> the feelings that a painting excites in us are not all due to colors. . . . Beautiful, subtly shaded colors are a pleasing sight; but this is purely a pleasure of the sense. It is the drawing, the imitation, which gives life and spirit to these colors. The passions they express are what stir ours; the objects they represent are what affect us. Colors entail no interest or feeling at all. The strokes of a touching picture affect us even in a print. Without these strokes in the picture, the colors would do nothing more.[2]

Of Grammatology is of course written about the supplement, about Rousseau's claim that "languages are made to be spoken; writing serves only as a supplement to speech." The supplement, however, is not a simple addition; it also supplants. Both an increment and a substitute, it plays a compensatory role: "It adds only to replace. It insinuates itself in the-place-of; if it fills, it is as if one fills a void."[3] (The written supplement may extend the range of speech by prolonging it, but it also compensates for an absence—that of the speaker.) Hence the "danger" which the supplement comports within itself, the possibility of perversion: that its vicarious nature be overlooked, and that it be mistaken for the positivity to which it is only "superadded."

If painting is essentially mimetic, as Rousseau claims, then it must not affect us in the way that natural objects do, that is, through sensation, "sensible impression." Painting supplements Nature; it works through cultural signs. And it is drawing, the delineation of the contours of the represented object, that imitates, *signifies;* color is only an addition, an adjunct. Rousseau admits that color may contribute to the effect of the work of art, but only when perceived as a sign: "We attach too much and too little importance to sensations. We do not see that frequently they affect us not merely as sensations, but also as signs or images, and that their moral effects also have moral causes."[4] Remember that it is not colors but "the passions they express" that stir us.

This theory of expression—however much it may subordinate sensory experience to formal construction—does not constitute a formalist aesthetic. As Derrida observes, Rousseau reacts against formalism: "In his eyes formalism is also a materialism and a sensationalism."[5] Rather, to minimize the role of color and thereby to place art under the sign is to guarantee its ethical function:

> If art operates through the sign, and is effective only through imitation, it can take place only within a system of culture, and the theory of art is a theory of mores. A moral impression, contrary to a sensible impression, is recognized through the fact that it places its force in a sign. *Aesthetics passes through a semiology and even through an ethnology.* The effects of aesthetic signs are determined only within a cultural system.[6]

The supplementarity of color, its subordination to line, is not peculiar to Rousseau's discourse; nor does it define one aesthetic among others. It is in fact one of the permanent principles of Western art theory.[7] We encounter it in Alberti's *Della Pittura,* and again in Kant's *Critique of Judgment* where we are told that "in painting, in sculpture, and in fact in all the formative arts . . . the *design* is what is essential. Here it is not what gratifies in sensation, but merely what pleases by its form, that is the fundamental prerequisite for taste."[8] As in Rousseau, color is excluded from the judgment of taste because it appeals to sensation; material substance is again subordinated to formal composition.

In the third *Critique* color is one of a chain of supplements excluded from aesthetic judgment because they appeal to the senses. Immediately after his discourse on color, Kant gives some examples: the frames of paintings, the drapery on statues, the colonnades of palaces. To describe their status Kant resuscitates the Greek term *parergon*—an adjunct, and not an intrinsic component of the complete representation of an object. The *parergon* follows exactly the same logic as the supplement in Rous-

seau: added to the representation, it is never part of it. Its existence is marginal; it marks the limit between the intrinsic and the extrinsic (hence, the parergonal function of the frame). Still the *parergon,* like the supplement, may compensate for a lack within the work. It may intervene within the work "insofar as the inside is missing. Missing something and is itself missing."[9] One restriction, however, is placed on this parergonal intervention: that the *parergon* intervene by means of its form, and *only* by means of its form. As an object of sense, the *parergon* is *always* excluded. (For example, the frame is admissible if it is considered as drawing, that is, as the agency of line and angles; inadmissible if it is gilt, which represents for Kant the seductive allure of sensory content.)

Thus we encounter in the third *Critique* the effect of that "conceptual schema" which, according to Heidegger in *The Origin of the Work of Art,* governs all art theory and aesthetics: the distinction between matter and form. Heidegger's text is extremely important to "The Parergon"; Derrida cites it throughout and in "Restitutions de la vérité en pointure" admits that he "has always been convinced of the urgent necessity of Heidegger's questioning."[10] As Heidegger demonstrates, the terms of the form/matter dichotomy are far from evenly matched: form is correlated with the rational, the logical; matter with the irrational, the alogical. Thus aesthetics, as the *philosophic* investigation of art, *must* restrict itself to the analysis of form, to a specific formality which is determined as the space of aesthetics in general.

Derrida traces the effects of this "formality" in the *Critique* in detail; they cannot be local. In the Preface, Kant defines the third *Critique* as a detachment (the *parergon* is also a detachment from the work). Judgment, as the intermediary between understanding and reason (the subjects of the first two critiques, of pure and practical reason), must be dealt with "separately," even though in "pure" philosophy, i.e. metaphysics, the principles of judgment "cannot form a separate constituent part intermediate between the theoretical and practical divisions, but may when needful be annexed to one or other as occasion requires."[11] The parergonal nature of this determination is apparent: sufficient unto themselves, the first two critiques nevertheless remain incomplete without the critical examination of judgment. They opened an apparently infinite gap between the supersensible and the phenomenal, between the theoretical and the practical, so that the former seem incapable of influencing the latter—which cannot be the case. Thus, a third faculty, intermediate between understanding and reason, is required to explain their reciprocal influence.

Since judgment is that faculty, its critique inherits a specific obliga-

tion: to reconcile all of the apparently irresolvable oppositions intro-
duced by the first two critiques. Judgment must provide the "bridge"—
the metaphor is Kant's—between two absolutely heterogeneous worlds;
from the very beginning it is defined as the medium which guarantees
passage, articulation, that is, *communication*. And since Kant is concerned
primarily with *aesthetic* judgment, the work of art will also reflect this re-
sponsibility. There is analogy between the faculty of judgment and its
object, the work of art—a reciprocity which sanctions Derrida's treat-
ment of the *Critique* itself as a work of art.

Here we encounter that definition of the work of art which, according
to Derrida, organizes all philosophic discourse about art, from Plato to
Hegel, Husserl, even Heidegger: "Every time philosophy defines art,
masters it, and encloses it within the history of meaning or the ontolog-
ical encyclopedia, it is assigned the function of a medium." [12]

To assign art the function of a medium is immediately to locate it
within the semantic field mapped by the word *communication*—a field
rendered equivocal, unstable in Derrida's "Signature, Event, Context"
in *Marges de la Philosophie*. At the beginning of that text, Derrida asks
"whether or not the word or signifier 'communication' communicates
a determinate content, an identifiable meaning, or a describable value.
However, even to articulate and to propose this question I have had to
anticipate the meaning of the word *communication*: I have been con-
strained to predetermine communication as a vehicle, a means of trans-
port or transitional medium of a *meaning*. . . . " [13] This semio-linguistic
use of the word *communication* is then distinguished from its physical
sense: we say that a movement or a force may be communicated, or
that two distinct places communicate by means of a passageway or open-
ing. Questioning the relationship between these two meanings, Derrida
cautions against taking physical communication as primary or originary,
and semio-linguistic communication as a derivation or extension, a meta-
phoric displacement, "because the value of displacement, of transport,
etc., is precisely constitutive of the concept of metaphor with which one
claims to comprehend the semantic displacement that is brought about
from communication as a non-semio-linguistic phenomenon to commu-
nication as a semio-linguistic phenomenon." [14] In other words, communi-
cation as the transfer of a meaning cannot be explained through a
recourse to metaphor; it *is* metaphor.

It is this *mise en abyme*—the implication of the defined within the
definition—that Derrida refers to when he speaks of the "abyss" at the
beginning of the section of "The Parergon" translated here. The "abyss"
is, of course, the *grosse Kluft* which according to Kant separates the

theoretical principles of understanding from the practical principles of reason—a gap which art will "bridge." But it also refers to the procedures by which the theoretical and the practical communicate. If art is to be the sensible expression of the supersensible, then an entire theory of the sign and the symbol will be required to account for its function, a theory which is given in chapter 59 of the *Critique,* in which Kant distinguishes schematic from symbolic presentations. The symbol is defined as the *indirect* presentation of a concept, a concept to which, according to Kant, "no sensible intuition can be adequate." It cannot be apprehended directly, as in schematic presentations, but only by means of *analogy*:

> [In symbolic presentation] the concept is supplied with an intuition such that the procedure of judgment in dealing with it is merely analogous to that which it observes in schematism. In other words, what agrees with the concept is merely the rule of this procedure, and not the intuition itself. Hence the agreement is merely in the form of reflection, and not in the content.[15]

Thus it is a formal analogy which permits the sensible and the supersensible to communicate. The symbol is a bridge; but, as Derrida indicates, the "bridge" is also a symbol. Art is defined as analogy, but on the basis of *an* analogy with human communication.

Kant's definition of the symbol occurs in a chapter on "Beauty as the Symbol of Morality" which links presentation to the expression of an inside, and man's beauty to his morality. Kant's assertion that the beautiful is the symbol of the morally good is based upon the belief, stated in chapter 17, that the "moral ideas that govern men inwardly . . . may be made, as it were, visible in bodily manifestation (as effect of what is internal). . . ."[16] Thus Kant's is a *moral* semiotics which presupposes the presentational union of an inside and an outside and links beauty to the visible *expression* of what lies hidden.

This definition of the symbol as expressive sanctions Kant's division of the fine arts—a division which is also, as Derrida remarks, a hierarchy—according to an analogy with speech:

> If we wish to make a division of the fine arts, we can choose for that purpose, tentatively at least, no more convenient principle than the analogy which art bears to the mode of expression of which men avail themselves in speech, with a view to communicating themselves to one another as completely as possible, i.e. not merely in respect of their concepts but in respect of their sensations also.[17]

Kant immediately appends a note to this passage in which he indicates
its provisional nature: "The reader is not to consider this scheme for
a possible division of the fine arts as a deliberate theory. It is only one
of the various attempts that can and ought to be made." [18] This note
is redoubled by another which occurs a few pages later: "Throughout,
the reader is to weigh the above only as an effort to connect the fine
arts under a principle, which, in the present instance, is intended to
be that of the expression of aesthetic ideas (following the analogy of
a language), and not as a positive and deliberate derivation of the
connexion." [19]

Despite Kant's caution—perhaps because of it—Derrida argues that
this analogy with the human body, "with the human body interpreted
as language," is in fact *the* theory: "We do not see how he could have
avoided, without a massive overhaul, such a hierarchical classification of
the arts based on language and on the human body interpreted as lan-
guage, dominated by speech and the gaze. Humanism is implicated by
the entire functioning of the system, and no other derivation of the fine
arts is possible." [20]

This same theory motivates Kant's thesis that the judgment of taste
is universal. To claim that aesthetic judgments are universal is to claim
that they are universally *communicable*:

> In the universal communicability of the sensation (of delight or aver-
> sion)—a communicability, too, that exists apart from any concept—in the
> accord, so far as possible, of all ages and nations as to this feeling in the
> representation of certain objects, we have the empirical criterion, weak in-
> deed and scarce sufficient to raise a presumption, of the derivation of a
> taste, thus confirmed by examples, from grounds deep-seated and shared
> alike by all men, underlying their agreement in estimating the forms
> under which objects are given to them. [21]

The demand that aesthetic judgments transpire through speech,
through questions and answers, is therefore consistent with the funda-
mental humanism of the system.

The permanent subordination of substance to form, the recourse
to a theory of expression which defines art through an analogy with
language, the domination of the field of aesthetics by an economics of
communication: these are the uncritical strategies which guarantee the
privileged position of the human subject in aesthetic discourse. Accord-
ing to them philosophy "domesticates" the work of art and assigns it
a prescribed place within the history of speech, which, according to

Derrida, is identical with the history of philosophy. To repeat, these reductions operate not only in Kant's aesthetic; they define aesthetics in general as the investigation of the work as a signifying structure.

It is this definition of the work of art that is perpetuated by twentieth-century semiotics. Remember that Saussure, preparing the ground for a structural linguistics, also posited a rigorous distinction between (linguistic) form and (phonic) substance:

> Phonic substance is neither more fixed nor more rigid than thought; it is not a mold into which thought must of necessity fit but a plastic substance divided in turn into distinct parts to furnish the signifiers needed by thought. The linguistic fact can therefore be pictured in its totality—i.e. language—as a series of contiguous subdivisions marked off on both the indefinite plane of jumbled ideas . . . and the equally vague plane of sounds. . . . Language works out its unity while taking shape between two shapeless masses . . . *their combination produces a form not a substance.*[22]

If linguistics, as Saussure claimed, is restricted to the analysis of form, then the analogy of all cultural productions with language and the pre-eminence of a theory of communication—the two principles upon which semiotics is based—will follow like clockwork. Thus the ambitions of the semiologist of art to move beyond purely aesthetic determinations remain enmeshed in presuppositions which are identical with those of aesthetics. On the theoretical level at least, semiotics constitutes an aesthetics.

If in "The Parergon" Derrida offers no alternative theory of art, it is because the theoretical investigation of works of art according to philosophic principles is what is deconstructed. Still, "The Parergon" signals a necessity: not of a renovated aesthetics, but of transforming the object, the work of art, beyond recognition. And such a transformation has no better point of departure than that which has always been excluded from the aesthetic field: the *parergon*.

NOTES

1. Jan Mukarovsky, "Art as Semiotic Fact," trans. I. R. Titunik, *Semiotics of Art,* ed. Ladislav Matejka and Irwin R. Titunik (Cambridge, Mass.: MIT Press, 1976), 8.

2. Quoted in Jacques Derrida, *Of Grammatology,* trans. G. C. Spivak (Baltimore: Johns Hopkins University Press, 1976), 206.

3. Ibid., 145.

4. Ibid., 206.

5. Ibid., 210.

6. Ibid., 206.

7. On the supplementarity of color, see Jean-Claude Lebensztejn, "Les Textes du peintre," *Critique* (May 1974) and Hubert Damisch, *Théorie du nuage* (Paris: Seuil, 1972), 42–47.

8. Immanuel Kant, *The Critique of Judgment*, trans. J. C. Meredith (Oxford: Oxford University Press, 1952), 67.

9. "The Parergon," 21.

10. Jacques Derrida, "Restitutions de la vérité en pointure," in *La vérité en peinture* (Paris: Flammarion, 1978), 299. This text, on the "correspondence" between Heidegger and Meyer Schapiro concerning a painting by Van Gogh, concludes the volume which opens with the complete version of "The Parergon."

11. Kant, *Critique*, 4–5.

12. Jacques Derrida, "Parergon," in *La vérité en peinture*, 41.

13. Jacques Derrida, "Signature, Event, Context," trans. Samuel Weber and Jeffrey Mehlman, *Glyph* 1 (1977), 172.

14. Ibid., 173.

15. Kant, *Critique*, 221–22.

16. Ibid., 80.

17. Ibid., 184.

18. Ibid.

19. Ibid., 187.

20. Derrida, "Parergon," 133.

21. Kant, *Critique*, 75.

22. Ferdinand de Saussure, *Course in General Linguistics*, trans. Wade Baskin (New York: McGraw-Hill, 1966), 112–13.

Earthwords*

The strata of the Earth is a jumbled museum.
Embedded in the sediment is a text . . .

—ROBERT SMITHSON,
"A Sedimentation of Mind: Earth Projects"

Precisely at the center (page 67 of 133) of the first section of this collection of Robert Smithson's writings,** we encounter the following words on language, worthy of Borges or Barthes:

> In the illusory babels of language, an artist might advance specifically to get lost, and to intoxicate himself in dizzying syntaxes, seeking odd intersections of meaning, strange corridors of history, unexpected echoes, unknown humors, or voids of knowledge . . . but this quest is risky, full of bottomless fictions and endless architectures and counter-architectures . . . at the end, if there is an end, are perhaps only meaningless reverberations.

This passage, the opening of the essay "A Museum of Language in the Vicinity of Art," contains a number of topoi explored in Smithson's art: history, fiction (the fictive explanation of the origin of the Great Salt Lake, from which the form of the *Spiral Jetty* was derived), architecture (Smithson's obsession with construction), and counter-architecture (or *de-architecture*, "entropy made visible," as in the *Partially Buried Woodshed*). Yet here they radiate from a meditation on the labyrinthine, abyssal nature of language, which therefore appears to occupy both the literal and the thematic center of the book.[1]

"A Museum of Language" is, in fact, a description of what occurs when language comes to occupy the center. This text about language is thus also about the notion of the center, specifically, the dialectical relationship between center and circumference to which Smithson's non-sites were also addressed. In an interview, Smithson described the non-site, which catapults the mind out to "the unfocused fringe" where it

"loses its boundaries and a sense of the oceanic pervades," as the center, and the site itself as the fringe or edge (176). Moreover, in a footnote appended to his essay on the *Spiral Jetty*, he identified the nonsite as a "network of signs . . . discovered as you go along" (115)—that is, as a *text*. If the nonsite is also a text, "A Museum of Language" is also a nonsite; it thus propels us outward to the peripheries of Smithson's writings—circumscribed by the 1965 essay on Donald Judd and the essay on Central Park, "Frederick Law Olmsted and the Dialectical Landscape," published five months before its author's death in July 1973—and beyond, to his works.

Whenever Smithson invokes the notion of the center, however, it is to describe its loss. The nonsite is only a vacant reflection of the site; "A Museum of Language" reveals absence at the center—of Roger Corman's films (his actors reflect the "empty center"), Ad Reinhardt's *Jokes*, suburban sprawl, and finally the dots on Buckminster Fuller's *World Energy Map*, centers signifying "a concentration or dilation of an infinite expanse of spheres of energy":

> Yet the dot evades our capacity to find its center. Where is the central point, axis, pole, dominant interest, fixed position, absolute structure, or decided goal? The mind is always being hurled towards the outer edge into intractable trajectories that lead to vertigo. (78)

Paradoxically, the concept of a center can only occur within language; at the same time, language, which proposes the potentially infinite substitution of elements *at the center,* destroys all possibility of securely locating any center whatsoever. Thus what is described by Smithson in this text is that dizzying experience of *de*centering which occurred "at the moment when language invaded the universal problematic, the moment when, in the absence of a center or origin, everything became discourse."[2] If this collection of Smithson's writings testifies to anything in our present culture, it is to the eruption of language into the field of the visual arts, and the subsequent decentering of that field—a decentering in which these texts themselves play a crucial part.

All of Smithson's work effected a radical dislocation of art, which was removed from its locus in the museum and gallery to remote, inaccessible locations. This displacement is not only geographic, but economic as well: the "value" of the work of art is no longer determined by its status as a portable commodity; it is now the work itself which bestows value (upon the depreciated site where it is installed). Physical decentering is also one theme of his work: the spectator's experience of the *Spiral Jetty,* for example, is "one of continually being decentered within the

great expanse of lake and sky."[3] Yet "A Museum of Language" describes what is perhaps the most significant displacement of all—that of art from the visual to the verbal field. For this is in fact a collocation of artists who write: Dan Flavin, Carl Andre, Robert Morris, Donald Judd, Sol LeWitt. . . .

That all of these artists are minimalists is a point to which we must return, since the proliferation of artists' writings in the 1960s is clearly to be connected with minimalism. For the moment, however, I want to concentrate on the fact that all are sculptors (despite the extremely incisive argument which questions the degree to which their production can be assimilated to the rational category "sculpture").[4] Painting and writing share a common origin in inscription; sculpture, however, involved as it is in the experience of three-dimensional space, could not seem more distant from language—linear, two-dimensional, located at the intersection of two axes (of selection and combination) which describe a plane. Yet Smithson regards language as something solid and obdurate, a three-dimensional projection: "My sense of language is that it is matter and not ideas" (104). Aping Pascal, he writes: "*Language becomes an infinite museum whose center is everywhere and whose limits are nowhere*" (67). Not only does this metaphrase spatialize language by substituting it for a geometric *solid*, Pascal's infinite sphere; it also mirrors the eclipse of Nature by language which lies at the root of our modernity (Pascal: "*Nature* is an infinite sphere . . . ").[5]

Smithson's perception of language as substantial characterizes his manipulation of its signifiers—what some might call his literary "style." He frequently employs language as purely visual material, as in a pencil drawing of, literally, *A Heap of Language,* in which synonyms for *language* are piled up like rubble, thus destroying their signifying function. In this collection of writings, *A Heap of Language* is used to illustrate a press release for the 1967 exhibition *Language to be Looked at and/or Things to be Read,* a title which suggests the reciprocal translatability of verbal and visual phenomena. In the text "Strata," Smithson's "geophotographic fiction," blocks of text are presented as geological deposits on the page; lines of print read as stratified layers of verbal sentiment. At the same time, the accompanying photographs—of fossils—disintegrate, due to overenlargement, into the photomechanical "language" of the half-tone screen.

Smithson's words are thus offered to vision, and not to audition; it is this attention to the visual aspects of language that identifies him as a *writer,* and reveals the reciprocity of his visual and verbal practices: "I thought of writing more as material to sort of put together than as a

kind of analytic searchlight. . . . I would construct my articles in the way I would construct a work" (154). Here Smithson may appear to echo the poet, who is also engaged in the manipulation of purely linguistic *substance*. Yet for Smithson poetry represented the desire for totalization, the idealization of language; to it he opposed an allegorical "language of fragmentation" in which words occur as graphic, as opposed to sonorous and therefore poetic, facts:

> The names of minerals and the minerals themselves do not differ from each other, because at the bottom of both the material and the print is the beginning of an abysmal number of fissures. Words and rocks contain a language that follows a syntax of splits and ruptures. Look at any *word* long enough and you will see it open up into a series of faults, into a terrain of particles each containing its own void. (87)

What the fissures in Smithson's "earthwords" disclose is the disjunctive, atomizing principle which, according to Walter Benjamin, defines allegory. In allegory, language is broken up, dispersed, in order to acquire a new and intensified meaning in its fragmentation. But if allegory "opens up a gulf in the solid massif of verbal meaning and forces the gaze into the depths of language,"[6] it is because it is in essence a form of *writing*; allegory "at one stroke . . . transforms things and works into stirring writing" and, conversely, writing into an object: in allegory, "the written word also tends toward the visual."[7] For Smithson the appeal of the allegorical lay not only in this reciprocity of verbal and visual, but also in the fact that it offers an antidote to the totalizing impulses of art: "It is not possible to conceive of a starker opposite to the artistic symbol, the plastic symbol, the image of organic totality, than this amorphous fragment which is seen in the form of allegorical script."[8]

Smithson's admission that both his articles and his works were the result of a process of accumulation of material reveals the fundamentally allegorical nature of his aesthetic activity, whether visual or verbal. For it is the allegorist who "pile[s] up fragments ceaselessly, without any strict idea of a goal." The allegorical work is therefore "the calculable result of the process of accumulation. . . . The writer must not conceal the fact that his activity is one of arranging."[9] But Smithson's view of language as material also discloses the absolute congruence, and hence interchangeability, of writing and sculpture.

This is the recurrent theme of "A Museum of Language." Carl Andre, for example, is shown to be involved in a similarly allegorical pulverization of language which parallels his sculptural practice: "Thoughts are crushed into a rubble of syncopated syllables. Reason becomes a

power of vowels and consonants. His words hold together without any sonority. . . . The apparent sameness and toneless ordering of Andre's poems conceals a radical disorientation of grammar" (67). Not only does the observation that the poet's "words hold together without any sonority" align his activity with writing and not speech; it also reflects the sculptor's refusal to affix to one another in any way the separate integers of his work. Likewise, the lack of inflection in the poems mirrors the paratactic nature of the work, and the disorientation of the grammar of *sculpture* which results. In demonstrating that Andre deploys linguistic signifiers as he would the cinderblocks, logs, or metal plates of his sculpture, writing and work are made to confront each other like parallel mirrors mounted in series, opening onto an infinite play of reflections in which the distinctions between writing and sculpture are, in effect, dissolved.

Smithson's description of Andre's writings—or Flavin's ("a pure spectacle of attenuation"), Judd's ("a brooding depth of gleaming surfaces—placid but dismal"), for that matter, his own ("material to sort of put together")—indicates that their texts are not illuminations, explanations, or even extensions of their work, or vice versa. Their writings do not stand, despite all assertions to the contrary, in a complementary relation to their work, mutually supplying each other's lack. It is frequently maintained that it was the highly elliptical nature of minimalist production that propelled these artists toward language, which was either incorporated into the work itself, or deployed in explanation of it, in response to an absence at its heart.[10] According to this argument, Yvonne Rainer, for example, would have both written about and introduced spoken and written texts into her performances because the pared-down dance vocabulary she developed in the 1960s severely limited the possibility of expression, communication. Language, and writing in particular, is thus assigned a compensatory role; it restores to the work everything that has been eliminated from it. The artist/writer's desire would thus be the desire for content, which the reductivist tendencies of sixties production appear to preclude.

But as Rainer herself wrote, in the Introduction to her *Work 1961–73*, "Let it be said simply 'She usually makes performances and has also made a book.'"

The argument which reduces these artists' writings to a secondary, derived position vis-à-vis their work might be diagnosed as one symptom of a modernist aesthetic, specifically, of its desire to confine the artist within the sharply delineated boundaries of a single aesthetic discipline. This desire is sanctioned by an unquestioned belief in the absolute *differ-*

ence of verbal and visual art. The genealogy of modernist theory, especially of its assumption that each of the arts occupies a specific area of competence, may be traced to that moment in the eighteenth century when it appeared necessary, for complex, but always ethical, reasons, to distinguish poetry from painting and sculpture. For strategic reasons that distinction was made according to time: in Germany, Lessing, and in France, Diderot, located poetry and all the discursive arts along a dynamic axis of temporal succession, and painting and sculpture along a static axis of spatial simultaneity. Consequently the visual arts were denied access to discourse, which unfolds in time, except in the form of a literary text which, both exterior and anterior to the work, might supplement it.

Although such distinctions were made in the name of establishing the relative merits of each of the arts, and while there may have been differences concerning the superiority of either the visual or the verbal arts, the aesthetic hierarchies which followed were without exception based upon this verbal/visual polarity, and thus upon an ultimately *linguistic* criterion. It is not difficult to recognize in the temporal axis which defines poetry and in the spatial axis which defines painting and sculpture what Roman Jakobson would later distinguish as the metaphoric and metonymic poles of language. However, the linguistic origin of the principle which made distinctions between the arts, and thus modernism, possible *had to* remain unconscious; were the subordination of all the arts to language exposed, the visual arts would effectively be denied a proper territory, and the thesis that the arts are rigorously isolable and definable would be challenged.[11] Thus repressed, language became an invisible reserve which constituted, in the visual arts at least, modernism's unconscious. And the eruption of language into the aesthetic field in the 1960s would occur with all the force of the return of the repressed.

When late in that decade it was recognized that a break with modernist practice had taken place, the late modernist critic Michael Fried diagnosed it as the invasion of the static art of sculpture by duration, temporality. What his postmortem actually discloses, however, is the emergence of *discourse*: after all, the pretext for Fried's violent reaction against minimalism was an artist's *text* (Tony Smith's infamous narrative of a ride on an unfinished extension to the New Jersey Turnpike). What I am proposing, then, is that the eruption of language into the aesthetic field—an eruption signaled by, but by no means limited to, the writings of Smithson, Morris, Andre, Judd, Flavin, Rainer, LeWitt—is coincident with, if not the definitive index of, the emergence of postmodernism. This "catastrophe" disrupted the stability of a modernist partitioning of

the aesthetic field into discrete areas of specific competence; one of its most deeply felt shocks dislodged literary activity from the enclaves into which it had settled only to stagnate—poetry, the novel, the essay . . . — and dispersed it across the entire spectrum of aesthetic activity. Visual artists thus acquired a mine of new material, and the responses ranged from Morris's language *File* and the linguistic conceits of Art & Language and conceptual art, to the autobiographical perambulations of narrative or "story" art and the fundamentally linguistic concerns of performance art, such as that of Laurie Anderson (also an artist who writes). And it is within this massive return of language that Smithson's writings—and his art—are to be located.

It might be objected that artists, and modernist artists in particular, have always written, produced texts which explain their work, expound theoretical positions, engage in discussion or debate with other artists. And that, especially within modernist quarantine, these texts are indeed secondary, appended to and dependent upon visual production. The texts of modernist artists do read more often than not as responses to what had been eliminated from visual practice. They testify to a mounting sense of loss; as painting became more "pure," the desire for a supplement increased. For the modernist artist, however, writing was not an alternative medium for aesthetic practice; through it, work might be explained, but never produced. So that even if we maintain that these complements to work are essential to its understanding, Malevich's *The Non-Objective World*, Mondrian's *Plastic Art and Pure Plastic Art*, Kandinsky's *Concerning the Spiritual in Art* . . . , remain statements and not *texts*: "a text is not a line of words releasing a single 'theological' meaning (the 'message' of the Author-God), but a multi-dimensional space in which a variety of writings, none of them original, blend and clash." [12]

Smithson's writings, on the other hand, are indeed texts, dazzling orchestrations of multiple, overlapping voices; as such, they participate in that displacement of literature by the activity of *writing* which also occurs with Barthes, Derrida, Lacan. . . . This is not, however, the only value of these texts, for they also reveal the degree to which strategies which must be described as *textual* have infiltrated every aspect of contemporary aesthetic production. In his 1973 review of a Frederick Law Olmsted exhibition at the Whitney Museum, Smithson observes that "the maps, photographs, and documents in catalogue form . . . are as much a part of Olmsted's art as the art itself" (119)—which might be applied with equal validity to Smithson's art. I have already mentioned that the nonsite, a "course of hazards, a double path made up of signs, photographs, and maps," is a text. Not only does this complex web of hetero-

geneous information—part visual, part verbal—challenge the purity and self-sufficiency of the work of art; it also upsets the hierarchy between object and representation: "Is the Site a reflection of the Nonsite (mirror), or is it the other way around?"

Significantly, these remarks, which reveal the textuality of the nonsite, occur in a footnote appended to Smithson's text on the *Spiral Jetty,* itself a graphic document inscribed on the surface of the Great Salt Lake. Like the nonsite, the *Jetty* is not a discrete work, but one link in a chain of signifiers which summon and refer to one another in a dizzying spiral. For where else does the *Jetty* exist except in the film which Smithson made, the narrative he published, the photographs which accompany that narrative, and the various maps, diagrams, drawings, etc., he made about it?[13] Unintelligible at close range, the spiral form of the *Jetty* is completely intuitable only from a distance, and that distance is most often achieved by imposing a *text* between viewer and work. Smithson thus accomplishes a radical dislocation of the notion of point-of-view, which is no longer a function of physical position, but of the *mode* (photographic, cinematic, textual) of confrontation with the work of art. The work is henceforth defined by the position it occupies in a potentially infinite chain extending from the site itself and the associations it provokes—"in the end I would let the site determine what I would build" (111)—to quotations of the work in other works.

That Smithson thus transformed the visual field into a textual one represents one of the most significant aesthetic "events" of our decade; and the publication of his collected writings constitutes a challenge to criticism to come to terms with the textual nature of his work, and of postmodernism in general. That challenge is formidable, since it requires the jettisoning of most of our received notions about art; it can only be acknowledged here. I would however in conclusion like to sketch briefly the critical significance of one issue raised by Smithson's texts, and his work, and that is the allegorical impulse which shapes both. Smithson was not unaware of this impulse. His allegorical reading of the suburban New Jersey industrial landscape begins with a visual epigraph, Samuel Morse's *Allegorical Landscape.* In a previously unpublished text, "From Ivan the Terrible to Roger Corman, or Paradoxes of Conduct in Mannerism as Reflected in the Cinema," Smithson acknowledged this impulse, as well as its heretical nature:

> The very word allegory is enough to strike terror into the hearts of the expressive artist; there is perhaps no device as exhausted as allegory. But strangely enough Alan Kaprow has shown interest in that worn-out device.

Jorge Luis Borges begins his *From Allegories to Novels* by saying, "For all of us, the allegory is an aesthetic error." (214)

It was, however, from its exhaustion, its "erroneous" status, that allegory, for Smithson, derived its aesthetic potential.

I have already described the way in which allegory motivates Smithson's perception of language as material. But it is also manifest in his involvement with history as an irreversible process of dissolution and decay—his fascination with entropy and entropic systems; his attraction to both prehistoric and postindustrial ruins; his recognition of the forces which erode and eventually reclaim the work of art, for which the rust on Smith's and Caro's steel sculpture and the disorder of Central Park were taken as emblems. As Benjamin writes:

> The allegorical physiognomy of the nature-history . . . is present in reality in the form of the ruin. In the ruin history has physically merged into the setting. And in this guise history does not assume the form of the process of an eternal life so much as that of irresistible decay. Allegory thereby declares itself to be beyond beauty. Allegories are, in the realm of thoughts, what ruins are in the realm of things. . . . In the process of decay, and in it alone, the events of history shrivel up and become absorbed in the setting.[14]

Thus Smithson's desire to lodge his work in a specific site, to make it appear to be rooted there, is an allegorical desire, the desire for allegory. All of Smithson's work acknowledges as part of the work the natural forces through which it is reabsorbed into its setting. When the Great Salt Lake rose and submerged the *Spiral Jetty,* the salt deposits left on its surface became yet another link in the chain of crystalline forms which makes possible the description of the *Jetty* as a text.

This desire to embed a work in its context characterizes postmodernism in general and is not only a response to the "homelessness" of modernist sculpture;[15] it also represents and explains the strategic importance of allegory at this moment in history. For in the arts allegory has always been acknowledged as "'a crossing of the borders of a different mode,' an advance of the plastic arts into the territory of the rhetorical arts. . . . Its intrusion could therefore be described as a harsh disturbance of the peace and a disruption of law and order in the arts."[16] Thus allegory marks the dissolution of the boundaries between the arts; by proposing the interchangeability of the verbal and the visual, the integrity of both is compromised. This is why it is an aesthetic "error," but also why it appears, at present, as the organizing principle of advanced aesthetic practice.

PERM IN RUSSIA. EVAPORATION CAUSES LAND TO SHRINK. CON
ROM PERMIAN SANDSTONE IN ELGIN, N.E. SCOTLAND, DRAWN TC
ING MOVEMENT OF GLACIERS IS DUE TO THE PROPERTIES OF IC
YSTALLINE AGGREGATE (P.A. SHUMSKI). HOT DESERT CONDITI
H AFRICA. SEAS WERE CUT-OFF FROM THE OCEAN, UNTIL THEY B
ITTON IS A SPIRACLE TO A SUBTERRANEAN FURNACE. FANTAST
K.... THE NEPTUNIAN THEORY. THE SYMMETRY OF THE EARTH W
ED TO HELICOPRION. DWARF FAUNA. ONE SENTENCE DEVOTED
CHANGING LIGHT OVER RECONSTRUCTIONS OF DECIDUOUS TRE
AND GYPSUM. EQUATOR IN OKLAHOMA. SPOILED PHOTOGRAPHS
TIGRAPHIC MAP OF OIL DEPOSITS. MISPLACED BOUNDARIES. SHI
4ED. JOURNALS DEVOTED TO RADIATION DAMAGE. UNDEVELOPI
PERMIAN PRAIRIES.

GEOGRAPHY OF THE LOWER CARBONIFEROUS PERIOD SHOWN O
MITES. TERRIGENOUS CLASTIC SEDIMENTS EXTENDED TO A LINE
TURE IS NOT THE STARTING POINT. *ALL ROUND THE COAST THE*
JPS. THE BRITISH MUSEUM BUILT 1824. THE GLYPTOTHEK IN MUN

This is not simply a claim that may be made for allegory, but a structural fact. Allegory is traditionally defined, following Quintillian, as a symbol introduced in continuous series, the temporal extension of metaphor. It is useful to recast this definition in structuralist terms, for then allegory is revealed as the projection of the metaphoric, or static, axis of language onto its metonymic, or temporal, dimension. Although Roman Jakobson defined this projection of metaphor (the synchronic system of differences that defines the structure of a language) onto metonymy (the activity of combination in which structure is actualized in time), as the poetic principle,

> ... and while Jakobson goes on to associate metaphor with verse and romanticism, as opposed to metonymy which he identifies with realism and prose, allegory would cut across and subtend all such stylistic categorizations, being equally possible in either verse or prose, and quite capable of transforming the most objective naturalism into the most subjective expressionism, or the most determined realism into the most surrealistically ornamental baroque.[17]

Yet this capacity to "cut across and subtend," all aesthetic categories is due to the fact that allegory implicates the two poles, spatial and temporal, according to which the arts were distinguished at the advent of modernism.

Following the logic of allegory, then, Smithson's work stands as an investigation into what occurs when structure is actualized in time: the *Spiral Jetty,* for example, takes a particular mythic structure—the fiction of an enormous whirlpool at the lake's center—and projects it as a temporal experience. This aspect of his practice coincides with the techniques of poststructuralist theory—Derrida's deconstructive reading, for example, or Foucault's archaeology. This correspondence is not simply the result of contemporaneity, for Smithson's activity was a thoroughly *critical* one, engaged in the deconstruction of an inherited metaphysical tradition, which he perceived as more or less ruined. And the success of his enterprise may be measured by the critical rigor with which his

Robert Smithson, Strata: A Geophotographic Fiction *(detail), 1972.*

relation to inherited concepts is thought in these texts. Yet the failure of contemporary theory, which too often operates in a vacuum, to see its own realization in Smithson's practice is, and remains, a scandal.

NOTES

* This word is Smithson's, and it describes the alphabetic chasms at the conclusion of Edgar Allan Poe's *Narrative of Arthur Gordon Pym*: "His descriptions of chasms and holes seem to verge on proposals for 'earthwords.' The shapes of the chasms themselves become 'verbal roots' that spell out the difference between darkness and light. Poe ends his mental maze with the sentence—'I have graven it within the hills and my vengeance upon the dust within the rock'" (88).

** *The Writings of Robert Smithson: Essays with Illustrations,* edited by Nancy Holt, with an introduction by Philip Leider, designed by Sol LeWitt (New York: New York University Press, 1979).

1. The two sections which follow, the first devoted to interviews, the second to previously unpublished texts, are essentially appendices to the first, devoted to Smithson's published texts, which therefore constitute the book per se.

2. Jacques Derrida, "Structure, Sign and Play in the Discourse of the Human Sciences," in *Writing and Difference,* trans. Alan Bass (Chicago: University of Chicago Press, 1978), 280.

3. Rosalind Krauss, *Passages in Modern Sculpture* (New York: Viking, 1977), 280–2.

4. Rosalind Krauss, "Sculpture in the Expanded Field," *October* 8 (Spring 1979), 31–44.

5. "The threshold between Classicism and modernity . . . had been definitively crossed when words ceased to intersect with representations and to provide a spontaneous grid for the knowledge of things. Once detached from representation, language has existed, right up to our own day, only in a dispersed way." Michel Foucault, *The Order of Things* (New York: Vintage, 1973), 304.

6. Walter Benjamin, *The Origin of German Tragic Drama,* trans. John Osborne (London: NLB, 1977), 208.

7. Ibid., 201.

8. Ibid., 176.

9. Ibid., 179.

10. In Smithson's case, this absence might be construed as the physical inaccessibility of most of the work.

11. However, the almost universal ranking of poetry as the supreme art reveals, albeit in a displaced way, the priority of language in every hierarchy of the arts.

12. Roland Barthes, "The Death of the Author," in *Image–Music–Text,* trans. Stephen Heath (New York: Hill and Wang, 1977), 146.

13. See my discussion of Smithson's photographic "documentation" of his work in "Photography *en abyme*," *October* 5 (Summer 1978), 86–88.

14. Benjamin, *Origin of German Tragic Drama,* 177, 8.

15. Krauss, "Expanded Field," 33–36.

16. Carl Horst, *Barockprobleme,* quoted in Benjamin, *Origin of German Drama,* 177.

17. Joel Fineman, "The Structure of Allegorical Desire," unpublished manuscript. Throughout, I am extremely indebted to Fineman's psychoanalytic reading of allegory.

The Allegorical Impulse:
Toward a Theory of Postmodernism*

*Every image of the past that is not recognized by the present as
one of its own concerns threatens to disappear irretrievably.*

— WALTER BENJAMIN, "Theses on the Philosophy of History"

I.

In a review of Robert Smithson's collected writings, published in this
journal [*October*] in Fall 1979, I proposed that Smithson's "genius" was
an allegorical one, involved in the liquidation of an aesthetic tradition
which he perceived as more or less ruined. To impute an allegorical mo-
tive to contemporary art is to venture into proscribed territory, for
allegory has been condemned for nearly two centuries as aesthetic aber-
ration, the antithesis of art. In *Aesthetic* Croce refers to it as "science, or
art aping science"; Borges once called it an "aesthetic error." Although
he surely remains one of the most allegorical of contemporary writers,
Borges nevertheless regards allegory as an outmoded, exhausted device,
a matter of *historical* but certainly not critical interest. Allegories appear
in fact to represent for him the distance between the present and an
irrecoverable past:

> I know that at one time the allegorical art was considered quite charm-
> ing . . . and is now intolerable. We feel that, besides being intolerable, it is
> stupid and frivolous. Neither Dante, who told the story of his passion in
> the *Vita nuova*; nor the Roman Boethius, writing his *De consolatione* in the
> tower of Pavia, in the shadow of his executioner's sword, would have un-
> derstood our feeling. How can I explain that difference in outlook without
> simply appealing to the principle of changing tastes?[1]

This statement is doubly paradoxical, for not only does it contradict
the allegorical nature of Borges's own fiction, it also denies allegory what
is most proper to it: its capacity to rescue from historical oblivion that

52

which threatens to disappear. Allegory first emerged in response to a similar sense of estrangement from tradition; throughout its history it has functioned in the gap between a present and a past which, without allegorical reinterpretation, might have remained foreclosed. A conviction of the remoteness of the past, and a desire to redeem it for the present—these are its two most fundamental impulses. They account for its role in psychoanalytic inquiry, as well as its significance for Walter Benjamin, the only twentieth-century critic to treat the subject without prejudice, philosophically.[2] Yet they fail to explain why allegory's *aesthetic* potential should appear to have been exhausted long ago; nor do they enable us to locate the historical breach at which allegory itself receded into the depths of history.

Inquiry into the origins of the modern attitude toward allegory might appear as "stupid and frivolous" as its topic were it not for the fact that an unmistakably allegorical impulse has begun to reassert itself in various aspects of contemporary culture: in the Benjamin revival, for example, or in Harold Bloom's *The Anxiety of Influence*. Allegory is also manifest in the historical revivalism that today characterizes architectural practice, and in the revisionist stance of much recent art-historical discourse. T. J. Clark, for example, treating mid-nineteenth-century painting as political "allegory." In what follows, I want to focus this reemergence through its impact on both the practice and the criticism of the visual arts. There are, as always, important precedents to be accounted for: Duchamp identified both the "instantaneous state of Rest" and the "extra rapid exposure," that is, the photographic aspects,[3] of the *Large Glass* as "allegorical appearance"; *Allegory* is also the title of one of Rauschenberg's most ambitious combine paintings from the fifties. Consideration of such works must be postponed, however, for their importance becomes apparent only after the suppression of allegory by modern theory has been fully acknowledged.

In order to recognize allegory in its contemporary manifestations, we first require a general idea of what it in fact is, or rather what it *represents,* since allegory is an attitude as well as a technique, a perception as well as a procedure. Let us say for the moment that allegory occurs whenever one text is doubled by another; the Old Testament, for example, becomes allegorical when it is read as a prefiguration of the New. This provisional description—which is not a definition—accounts for both allegory's origin in commentary and exegesis, as well as its continued affinity with them: as Northrop Frye indicates, the allegorical work tends to prescribe the direction of its own commentary. It is this metatextual aspect that is invoked whenever allegory is attacked as interpretation

merely appended *post facto* to a work, a rhetorical ornament or flourish. Still, as Frye contends, "genuine allegory is a structural element in literature; it has to be there, and cannot be added by critical interpretation alone."[4] In allegorical structure, then, one text is *read through* another, however fragmentary, intermittent, or chaotic their relationship may be; the paradigm for the allegorical work is thus the palimpsest. (It is from here that a reading of Borges's allegorism might be launched, with "Pierre Menard, Author of the *Quixote*" or several of the *Chronicles of Bustos Domecq,* where the text is posited by its own commentary.)

Conceived in this way, allegory becomes the model of all commentary, all critique, insofar as these are involved in rewriting a primary text in terms of its figural meaning. I am interested, however, in what occurs when this relationship takes place *within* works of art, when it describes their structure. Allegorical imagery is appropriated imagery; the allegorist does not invent images but confiscates them. He lays claim to the culturally significant, poses as its interpreter. And in his hands the image becomes something other (*allos* = other + *agoreuei* = to speak). He does not restore an original meaning that may have been lost or obscured: allegory is not hermeneutics. Rather, he adds another meaning to the image. If he adds, however, he does so only to replace: the allegorical meaning supplants an antecedent one; it is a supplement. This is why allegory is condemned, but it is also the source of its theoretical significance.

The first link between allegory and contemporary art may now be made: with the appropriation of images that occurs in the works of Troy Brauntuch, Sherrie Levine, Robert Longo . . .—artists who generate images through the reproduction of other images. The appropriated image may be a film still, a photograph, a drawing: it is often itself already a reproduction. However, the manipulations to which these artists subject such images work to empty them of their resonance, their significance, their authoritative claim to meaning. Through Brauntuch's enlargements, for example, Hitler's drawings, or those of concentration camp victims, exhibited without captions, become resolutely opaque:

> Every operation to which Brauntuch subjects these pictures represents the duration of a fascinated, perplexed gaze, whose desire is that they disclose their secrets; but the result is only to make the pictures all the more picturelike, to fix forever in an elegant object our *distance from the history* that produced these images. *That distance is all these pictures signify.*[5]

Brauntuch's is thus that melancholy gaze which Benjamin identified with the allegorical temperament:

If the object becomes allegorical under the gaze of melancholy, if melancholy causes life to flow out of it and it remains behind dead, but eternally secure, then it is exposed to the allegorist, it is unconditionally in his power. That is to say it is now quite incapable of emanating any meaning or significance of its own; such significance as it has, it acquires from the allegorist. He places it within it, and stands behind it; not in a psychological but in an ontological sense.[6]

Brauntuch's images simultaneously proffer and defer a promise of meaning; they both solicit and frustrate our desire that the image be directly transparent to its signification. As a result, they appear strangely incomplete—fragments or runes which must be *deciphered.*

Allegory is consistently attracted to the fragmentary, the imperfect, the incomplete—an affinity which finds its most comprehensive expression in the ruin, which Benjamin identified as the allegorical emblem par excellence. Here the works of man are reabsorbed into the landscape; ruins thus stand for history as an irreversible process of dissolution and decay, a progressive distancing from origin:

In allegory the observer is confronted with the *facies hippocratica* of history as a petrified, primordial landscape. Everything about history that, from the very beginning, had been untimely, sorrowful, unsuccessful, is expressed in a face—or rather in a death's head. And although such a thing lacks all 'symbolic' freedom of expression, all classical proportion, all humanity—nevertheless, this is the form in which man's subjection to nature is most obvious and it significantly gives rise to not only the enigmatic question of the nature of human existence as such, but also of the biographical historicity of the individual. This is the heart of the allegorical way of seeing. . . .[7]

With the allegorical cult of the ruin, a second link between allegory and contemporary art emerges: in site specificity, the work which appears to have merged physically into its setting, to be embedded in the place where we encounter it. The site-specific work often aspires to a prehistoric monumentality; Stonehenge and the Nazca lines are taken as prototypes. Its "content" is frequently mythical, as that of the *Spiral Jetty,* whose form was derived from a local myth of a whirlpool at the bottom of the Great Salt Lake; in this way Smithson exemplifies the tendency to engage in a *reading* of the site, in terms not only of its topographical specifics but also of its psychological resonances. Work and site thus stand in a dialectical relationship. (When the site-specific work is conceived in terms of land reclamation, and installed in an abandoned

mine or quarry, then its "defensively recuperative" motive becomes self-evident.)

Site-specific works are impermanent, installed in particular locations for a limited duration, their impermanence providing the measure of their circumstantiality. Yet they are rarely dismantled but simply abandoned to nature; Smithson consistently acknowledged as part of his works the forces which erode and eventually reclaim them for nature. In this, the site-specific work becomes an emblem of transience, the ephemerality of all phenomena; it is the memento mori of the twentieth century. Because of its impermanence, moreover, the work is frequently preserved only in photographs. This fact is crucial, for it suggests the allegorical potential of photography. "An appreciation of the transience of things, and the concern to rescue them for eternity, is one of the strongest impulses in allegory."[8] And photography, we might add. As an allegorical art, then, photography would represent our desire to fix the transitory, the ephemeral, in a stable and stabilizing image. In the photographs of Atget and Walker Evans, insofar as they self-consciously preserve that which threatens to disappear, that desire becomes the *subject* of the image. If their photographs are allegorical, however, it is because what they offer is only a fragment, and thus affirms its own arbitrariness and contingency.[9]

We should therefore also be prepared to encounter an allegorical motive in photomontage, for it is the "common practice" of allegory "to pile up fragments ceaselessly, without any strict idea of a goal."[10] This method of construction led Angus Fletcher to liken allegorical structure to obsessional neurosis;[11] and the obsessiveness of the works of Sol LeWitt, say, or Hanne Darboven suggests that they too may fall within the compass of the allegorical. Here we encounter yet a third link between allegory and contemporary art: in strategies of accumulation, the paratactic work composed by the simple placement of "one thing after another"—Carl Andre's *Lever* or Trisha Brown's *Primary Accumulation*. One paradigm for the allegorical work is the mathematical progression:

> If a mathematician sees the numbers 1, 3, 6, 11, 20, he would recognize that the "meaning" of this progression can be recast into the algebraic language of the formula: X plus 2^x, with certain restrictions on X. What would be a random sequence to an inexperienced person appears to the mathematician a meaningful sequence. Notice that the progression can go on ad infinitum. This parallels the situation in almost all allegories. They have no inherent "organic" limit of magnitude. Many are unfinished like *The Castle* and *The Trial* of Kafka.[12]

Allegory concerns itself, then, with the projection—either spatial or temporal or both—of structure as sequence; the result, however, is not dynamic, but static, ritualistic, repetitive. It is thus the epitome of counter-narrative, for it arrests narrative in place, substituting a principle of syntagmatic disjunction for one of diegetic combination. In this way allegory superinduces a vertical or paradigmatic reading of correspondences upon a horizontal or syntagmatic chain of events. The work of Andre, Brown, LeWitt, Darboven, and others, involved as it is with the externalization of logical procedure, its projection as a spatiotemporal experience, also solicits treatment in terms of allegory.

This projection of structure as sequence recalls the fact that, in rhetoric, allegory is traditionally defined as a single metaphor introduced in continuous series. If this definition is recast in structuralist terms, then allegory is revealed to be the projection of the metaphoric axis of language onto its metonymic dimension. Roman Jakobson defined this projection of metaphor onto metonymy as the "poetic function," and he went on to associate metaphor with poetry and romanticism, and metonymy with prose and realism. Allegory, however, implicates *both* metaphor and metonymy; it therefore tends to "cut across and subtend all such stylistic categorizations, being equally possible in either verse or prose, and quite capable of transforming the most objective naturalism into the most subjective expressionism, or the most determined realism into the most surrealistically ornamental baroque."[13] This blatant disregard for aesthetic categories is nowhere more apparent than in the reciprocity, which allegory proposes between the visual and the verbal: words are often treated as purely visual phenomena, while visual images are offered as script to be deciphered. It was this aspect of allegory that Schopenhauer criticized when he wrote:

> If the desire for fame is firmly and permanently rooted in a man's mind . . . and if he now stands before the *Genius of Fame* [by Annibale Caracci] with its laurel crowns, then his whole mind is thus excited, and his powers are called into activity. But the same thing would also happen if he suddenly saw the word "fame" in large clear letters on the wall.[14]

As much as this may recall the linguistic conceits of conceptual artists Robert Barry and Lawrence Weiner, whose work is in fact conceived as large, clear letters on the wall, what it in fact reveals is the essentially pictogrammatical nature of the allegorical work. In allegory, the image is a hieroglyph; an allegory is a rebus—writing composed of concrete images.[15] Thus we should also seek allegory in contemporary works

which deliberately follow a discursive model: Rauschenberg's *Rebus,* or Twombly's series after the allegorical poet Spenser.

This confusion of the verbal and the visual is however but one aspect of allegory's hopeless confusion of all aesthetic mediums and stylistic categories (hopeless, that is, according to any partitioning of the aesthetic field on essentialist grounds). The allegorical work is synthetic; it crosses aesthetic boundaries. This confusion of genre, anticipated by Duchamp, reappears today in hybridization, in eclectic works which ostentatiously combine previously distinct art mediums.

Appropriation, site specificity, impermanence, accumulation, discursivity, hybridization—these diverse strategies characterize much of the art of the present and distinguish it from its modernist predecessors. They also form a whole when seen in relation to allegory, suggesting that postmodernist art may in fact be identified by a single, coherent impulse, and that criticism will remain incapable of accounting for that impulse as long as it continues to think of allegory as aesthetic error. We are therefore obliged to return to our initial questions: When was allegory first proscribed, and for what reasons?

The critical suppression of allegory is one legacy of romantic art theory that was inherited uncritically by modernism. Twentieth-century allegories—Kafka's, for example, or Borges's own—are rarely *called* allegories, but parables or fables; by the middle of the nineteenth century, however, Poe—who was not himself immune to allegory—could already accuse Hawthorne of "allegorizing," of appending moral tags to otherwise innocent tales. The history of modernist painting is begun with Manet and not Courbet, who persisted in painting "real allegories." Even the most supportive of Courbet's contemporaries (Prudhon and Champfleury) were perplexed by his allegorical bent; one was either a realist *or* an allegorist, they insisted, meaning that one was either modernist or historicist.

In the visual arts, it was in large measure allegory's association with history painting that prepared for its demise. From the Revolution on, it had been enlisted in the service of historicism to produce image upon image of the present *in terms of* the classical past. This relationship was expressed not only superficially, in details of costume and physiognomy, but also structurally, through a radical condensation of narrative into a single, emblematic instant—significantly, Barthes calls it a hieroglyph[16]— in which the past, present, and future, that is, the *historical* meaning, of the depicted action might be read. This is of course the doctrine of the most pregnant moment, and it dominated artistic practice during the first half of the nineteenth century. Syntagmatic or narrative associations

were compressed in order to compel a vertical reading of (allegorical) correspondences. Events were thus lifted out of a continuum; as a result, history could be recovered only through what Benjamin has called "a tiger's leap into the past":

> Thus to Robespierre ancient Rome was a past charged with the time of the now which he blasted out of the continuum of history. The French Revolution viewed itself as Rome reincarnate. It evoked ancient Rome the way fashion evokes costumes of the past. Fashion has a flair for the topical, no matter where it stirs in the thickets of long ago; it is a tiger's leap into the past.[17]

Although for Baudelaire this allegorical interpenetration of modernity and classical antiquity possessed no small theoretical significance, the attitude of the avant-garde which emerged at mid-century into an atmosphere rife with historicism was succinctly expressed by Prudhon, writing of David's *Leonidas at Thermopyle:*

> Shall one say . . . that it is neither Leonidas and the Spartans, nor the Greeks and Persians who one should see in this great composition; that it is the enthusiasm of '92 which the painter had in view and Republican France saved from the Coalition? But why this allegory? What need to pass through Thermopyle and go backward twenty-three centuries to reach the heart of Frenchmen? Had we no heroes, no victories of our own?[18]

So that by the time Courbet attempted to rescue allegory for modernity, the line which separated them had been clearly drawn, and allegory, conceived as antithetical to the modernist credo *Il faut être de son temps,* was condemned, along with history painting, to a marginal, purely historical existence.

Baudelaire, however, with whom that motto is most closely associated, never condemned allegory; in his first published work, the *Salon of 1845,* he defended it against the "pundits of the press": "How could one hope . . . to make them understand that allegory is one of the noblest branches of art?"[19] The poet's endorsement of allegory is only appar-

Edouard Manet, The Dead Toreador, *probably 1864. Courtesy National Gallery of Art, Washington, Widener Collection.*

ently paradoxical, for it was the relationship of antiquity to modernity that provided the basis for his theory of modern art, and allegory that provided its form. Jules Lemaître, writing in 1895, described the "specifically Baudelairean" as the "constant combination of two opposite modes of reaction . . . a past and a present mode"; Claudel observed that the poet combined the style of Racine with that of a Second Empire journalist.[20] We are offered a glimpse into the theoretical underpinnings of this amalgamation of the present and the past in the chapter "On the Heroism of Modern Life" from the *Salon of 1846*, and again in "The Painter of Modern Life," where modernity is defined as "the transient, the fleeting, the contingent; it is one half of art, the other being the eternal and the immovable."[21] If the modern artist was exhorted to concentrate on the ephemeral, however, it was *because* it was ephemeral, that is, it threatened to disappear without a trace. Baudelaire conceived modern art at least in part as the rescuing of modernity for eternity.

In "The Paris of the Second Empire in Baudelaire," Benjamin emphasizes this aspect of Baudelaire's project, linking it with Maxime Du Camp's monumental study, *Paris, ses organes, ses fonctions et sa vie dans la seconde moitié du XIXe siècle* (significantly, Du Camp is best known today for his photographs of ruins);

> It suddenly occurred to the man who had travelled widely in the Orient, who was acquainted with the deserts whose sand is the dust of the dead, that this city, too, whose bustle was all around him, would have to die some day, the way so many capitals had died. It occurred to him how extraordinarily interesting an accurate description of Athens at the time of Pericles, Carthage at the time of Barca, Alexandria at the time of the Ptolemies, and Rome at the time of the Caesars would be to us today. . . . In a flash of inspiration, of the kind that occasionally brings one an extraordinary subject, he resolved to write the kind of book about Paris that the historians of antiquity failed to write about their cities.[22]

For Benjamin, Baudelaire is motivated by an identical impulse, which explains his attraction to Charles Meyron's allegorical engravings of Paris, which "brought out the ancient face of the city without abandoning one cobblestone."[23] In Meyron's views, the antique and the modern were superimposed, and from the will to preserve the traces of something that was dead, or about to die, emerged allegory: in a caption the renovated Pont Neuf, for example, is transformed into a memento mori.[24]

Benjamin's primary insight—"Baudelaire's genius, which drew its nourishment from melancholy, was an allegorical one"[25]—effectively situates an allegorical impulse at the origin of modernism in the arts and

thus suggests the previously foreclosed possibility of an alternate reading of modernist works, a reading in which their allegorical dimension would be fully acknowledged. Manet's manipulation of historical sources, for example, is inconceivable without allegory; was it not a supremely allegorical gesture to reproduce in 1871 the *Dead Toreador* as a wounded Communard, or to transpose the firing squad from the *Execution of Maximillian* to the Paris barricades? And does not collage, or the manipulation and consequent transformation of highly significant fragments, also exploit the atomizing, disjunctive principle which lies at the heart of allegory? These examples suggest that, in practice at least, modernism and allegory are *not* antithetical, that it is in theory alone that the allegorical impulse has been repressed. It is thus to theory that we must turn if we are to grasp the full implications of allegory's recent return.

II.

Near the beginning of "The Origin of the Work of Art," Heidegger introduces two terms which define the "conceptual frame" within which the work of art is conventionally located by aesthetic thought:

> The art work is, to be sure, a thing that is made, but it says something other than the mere thing itself is, *allo agoreuei*. The work makes public something other than itself; it manifests something other; it is an allegory. In the work of art something other is brought together with the thing that is made. To bring together is, in Greek, *sumballein*. The work is a symbol.[26]

By imputing an allegorical dimension to every work of art, the philosopher appears to repeat the error, regularly lamented by commentators, of generalizing the term *allegory* to such an extent that it becomes meaningless. Yet in this passage Heidegger is only reciting the litanies of philosophical aesthetics in order to prepare for their dissolution. The point is ironic, and it should be remembered that irony itself

Edouard Manet, Civil War, 1871. Courtesy Bibliothèque Nationale, Salle des Estampes.

is regularly enlisted as a variant of the allegorical; that words can be used to signify their opposites is in itself a fundamentally allegorical perception.

Allegory and symbol—like all conceptual pairs, the two are far from evenly matched. In modern aesthetics, allegory is regularly subordinated to the symbol, which represents the supposedly indissoluble unity of form and substance which characterizes the work of art as pure presence. Although this definition of the art work as informed matter is, we know, as old as aesthetics itself, it was revived with a sense of renewed urgency by romantic art theory, where it provided the basis for the philosophical condemnation of allegory. According to Coleridge, "The Symbolical cannot, perhaps, be better defined in distinction from the Allegorical, than that it is always itself *a part of* that, of the whole of which it is the representative."[27] The symbol is a synecdoche, a part representing the whole. This definition is possible, however, if and only if the relationship of the whole to its parts be conceived in a particular manner. This is the theory of expressive causality analyzed by Althusser in *Reading Capital*:

> [The Leibnizian concept of expression] presupposes in principle that the whole in question be reducible to an *inner essence,* of which the elements of the whole are then no more than the phenomenal forms of expression, the inner principle of the essence being present at each point in the whole, such that at each moment it is possible to write the immediately adequate equation: *such and such an element . . . = the inner essence of the whole.* [italics added] Here was a model which made it possible to think the effectivity of the whole on each of its elements, but if this category—inner essence/outer phenomenon—was to be applicable everywhere and at every moment to each of the phenomena arising in the totality in question, it presupposed that the whole had a certain nature, precisely the nature of a "spiritual" whole in which each element was expressive of the entire totality as a "pars totalis."[28]

Coleridge's is thus an expressive theory of the symbol, the presentational union of "inner essence" and outward expression, which are in fact revealed to be identical. For essence is nothing but that element of the whole which has been hypostasized as its essence. The theory of expression thus proceeds in a circle: while designed to explain the effectivity of the whole on its constituent elements, it is nevertheless those elements themselves which react upon the whole, permitting us to conceive the latter in terms of its "essence." In Coleridge, then, the symbol is precisely that part of the whole to which it may be reduced. The symbol does not represent essence; it *is* essence.

On the basis of this identification, the symbol becomes the very emblem of artistic *intuition*: "Of utmost importance to our present subject is this point, that the latter (the allegory) cannot be other than spoken consciously; whereas in the former (the symbol) it is very possible that the general truth represented may be working unconsciously in the writer's mind during the construction of the symbol."[29] The symbol is thus a motivated sign; in fact, it represents linguistic motivation as such. For this reason Saussure substituted the term *sign* for *symbol*, for the latter is "never wholly arbitrary; it is not empty, for there is the rudiment of a natural bond between the signifier and the signified."[30] If the symbol is a motivated sign, then allegory, conceived as its antithesis, will be identified as the domain of the arbitrary, the conventional, the unmotivated.

This association of the symbol with aesthetic intuition, and allegory with convention, was inherited uncritically by modern aesthetics; thus Croce in *Aesthetic*:

> Now if the symbol be conceived as inseparable from the artistic intuition, it is a synonym for the intuition itself, which always has an ideal character. There is no double bottom to art, but one only; in art all is symbolical because all is ideal. But if the symbol be conceived as separable—if the symbol can be on one side, and on the other the thing symbolized, we fall back into the intellectualist error: the so-called symbol is the exposition of an abstract concept, an allegory; it is science, or art aping science. But we must also be just towards the allegorical. Sometimes it is altogether harmless. Given the *Gerusalemme liberata*, the allegory was imagined afterwards; given the *Adone* of Marino, the poet of the lascivious afterwards insinuated that it was written to show how "immoderate indulgence ends in pain"; given a statue of a beautiful woman, the sculptor can attach a label to the statue saying that it represents *Clemency* or *Goodness*. This allegory that arrives attached to a finished work *post festum* does not change the work of art. What is it then? It is an expression externally added to another expression.[31]

In the name of "justice," then, and in order to preserve the intuitive character of every work of art, including the allegorical, allegory is conceived as a *supplement,* "an expression externally added to another expression." Here we recognize that permanent strategy of Western art theory which excludes from the work everything which challenges its determination as the unity of "form" and "content."[32] Conceived as something added or superadded to the work after the fact, allegory will consequently be detachable from it. In this way modernism can recuperate allegorical works for itself, on the condition that what makes them

allegorical be overlooked or ignored. Allegorical meaning does indeed appear supplementary; we can appreciate Bellini's *Allegory of Fortune,* for example, or read *Pilgrim's Progress* as Coleridge recommended, without regard for their iconographic significance. Rosemond Tuve describes the viewer's "experience of a genre picture—or so he had thought it— turning into . . . [an] allegory before his eyes, by something he learns (usually about the history and thence the deeper significance of the image)."[33] Allegory *is* extravagant, an expenditure of surplus value; it is always *in excess.* Croce found it "monstrous" precisely because it encodes two contents within one form.[34] Still, the allegorical supplement is not only an addition, but also a replacement. It takes the place of an earlier meaning, which is thereby either effaced or obscured. Because allegory usurps its object it comports within itself a danger, the possibility of perversion: that what is "merely appended" to the work of art be mistaken for its "essence." Hence the vehemence with which modern aesthetics—formalist aesthetics in particular—rails against the allegorical supplement, for it challenges the security of the foundations upon which aesthetics is erected.

If allegory is identified as a supplement, then it is also aligned with writing, insofar as writing is conceived as supplementary to speech. It is of course within the same philosophic tradition which subordinates writing to speech that allegory is subordinated to the symbol. It might be demonstrated, from another perspective, that the suppression of allegory is identical with the suppression of writing. For allegory, whether visual or verbal, is essentially a form of script—this is the basis for Walter Benjamin's treatment of it in *The Origin of German Tragic Drama*: "At one stroke the profound vision of allegory transforms things and works into stirring writing."[35]

Benjamin's theory of allegory, which proceeds from the perception that "any person, any object, any relationship can mean absolutely anything else,"[36] defies summary. Given its centrality to this essay, however, a few words concerning it are in order. Within Benjamin's oeuvre, *The Origin of German Tragic Drama,* composed in 1924–25 and published in 1928, stands as a seminal work; in it are assembled the themes that will preoccupy him throughout his career: progress as the eternal return of the catastrophe; criticism as redemptive intervention into the past; the theoretical value of the concrete, the disparate, the discontinuous; his treatment of phenomena as script to be deciphered. This book thus reads like a prospectus for all of Benjamin's subsequent critical activity. As Anson Rabinbach observes in his introduction to the recent issue of *New German Critique* devoted to Benjamin, "His writing forces us to think

in correspondences, to proceed through allegorical images rather than through expository prose." [37] The book on baroque tragedy thus throws into relief the essentially allegorical nature of all of Benjamin's work— the "Paris Arcades" project, for example, where the urban landscape was to be treated as a sedimentation in depth of layers of meaning which would gradually be unearthed. For Benjamin, *inter*pretation is dis*inter*ment.

The Origin of German Tragic Drama is a treatise on critical method; it traces not only the origin of baroque tragedy, but also of the critical disapprobation to which it has been subject. Benjamin examines in detail the romantic theory of the symbol; by exposing its theological origins, he prepares for its supersedure:

> The unity of the material and the transcendental object, which constitutes the paradox of the theological symbol, is distorted into a relationship between appearance and essence. The introduction of this distorted conception of the symbol into aesthetics was a romantic and destructive extravagance which preceded the desolation of modern art criticism. As a symbolic construct it is supposed to merge with the divine in an unbroken whole. The idea of the unlimited immanence of the moral world in the world of beauty is derived from the theosophical aesthetics of the romantics. But the foundations of this idea were laid long before. [38]

In its stead, Benjamin places the (graphic) sign, which represents the distance between an object and its significance, the progressive erosion of meaning, the absence of transcendence from within. Through this critical maneuver he is able to penetrate the veil which had obscured the achievement of the baroque, to appreciate fully its theoretical significance. But it also enables him to liberate writing from its traditional dependency on speech. In allegory, then, "written language and sound confront each other in tense polarity. . . . The division between signifying written language and intoxicating spoken language opens up a gulf in the solid massif of verbal meaning and forces the gaze into the depths of language." [39]

We encounter an echo of this passage in Robert Smithson's appeal for both an allegorical practice and an allegorical criticism of the visual arts in his text "A Sedimentation of Mind: Earth Projects":

> The names of minerals and the minerals themselves do not differ from each other, because at the bottom of both the material and the print is the beginning of an abysmal number of fissures. Words and rocks contain a language that follows a syntax of splits and ruptures. Look at any *word* long enough and you will see it open up into a series of faults, into a terrain of particles each containing its own void. . . .

Poe's *Narrative of A. Gordon Pym* seems to me excellent art criticism and prototype for rigorous "non-site" investigations. . . . His descriptions of chasms and holes seem to verge on proposals for "earthwords." The shapes of the chasms themselves become "verbal roots" that spell out the difference between darkness and light.[40]

Smithson refers to the alphabetic chasms described at the conclusion of Poe's novel; in a "Note" appended to the text, the novelist unravels their allegorical significance, which "has beyond doubt escaped the attention of Mr. Poe."[41] Geological formations are transformed by commentary into articulate script. Significantly, Poe gives no indication as to how these ciphers, Ethiopian, Arabic, and Egyptian in origin, are to be pronounced; they are purely graphic facts. It was here, where Poe's text doubles back on itself to provide its own commentary, that Smithson caught a glimpse of his own enterprise. And in that act of self-recognition there is embedded a challenge to both art and criticism, a challenge which may now be squarely faced. But that is the subject of another essay.

NOTES

* This is the first of two essays devoted to allegorical aspects of contemporary art. After a schematic survey of the impact of allegory on recent art, I proceed to the theoretical issues which it raises. In a second essay I plan to extend these observations through readings of specific works in which an allegorical impulse seems paramount.

1. Jorge Luis Borges, "From Allegories to Novels," in *Other Inquisitions* (New York: Simon and Schuster, 1964), 155–56.

2. On allegory and psychoanalysis, see Joel Fineman, "The Structure of Allegorical Desire," *October* 12 (Spring 1980). Benjamin's observations on allegory are to be found in the concluding chapter of *The Origin of German Tragic Drama*, trans. John Osborne (London: NLB, 1977). On Benjamin, see 84–85.

3. See Rosalind Krauss, "Notes on the Index: Seventies Art in America," *October* 3 (Spring 1977), 68–81.

4. Northrop Frye, *Anatomy of Criticism* (New York: Atheneum, 1969), 54.

5. Douglas Crimp, "Pictures," *October* 8 (Spring 1979), 85, italics added.

6. Benjamin, *Origin of German Tragic Drama*, 183–84.

7. Ibid., 666.

8. Ibid., 223.

9. "Neither Evans nor Atget presumes to put us in touch with a pure reality, a thing in itself; their cropping always affirms its own arbitrariness and contingency. And the world they characteristically picture is a world *already made over into a meaning* that precedes the photograph; a meaning inscribed by work,

by use, as inhabitation, as artifact. Their pictures are *signs representing signs*, integers in implicit chains of signification that come to rest only in major systems of social meaning: codes of households, streets, public places." Alan Trachtenberg, "Walker Evans's *Message from the Interior: A* Reading," *October* 11 (Winter 1979), 12, italics added.

10. Benjamin, *Origin of German Tragic Drama*, 178.

11. Angus Fletcher, *Allegory: The Theory of a Symbolic Mode* (Ithaca: Cornell University Press, 1964), 279–303.

12. Ibid., 174.

13. Fineman, "Structure of Allegorical Desire," 51. "Thus there are allegories that are primarily perpendicular, concerned more with structure than with temporal extension. . . . On the other hand, there is allegory that is primarily horizontal. . . . Finally, of course, there are allegories that blend both axes together in relatively equal proportions. . . . Whatever the prevailing orientation of any particular allegory, however—up and down through the declensions of structure, or laterally developed through narrative time—it will be successful as allegory only to the extent that it can suggest the authenticity with which the two coordinating poles bespeak each other, with structure plausibly unfolded in time, and narrative persuasively upholding the distinctions and equivalences described by structure" (50).

14. Arthur Schopenhauer, *The World as Will and Representation*, I, 50. Quoted in Benjamin, *Origin of German Tragic Drama*, 162.

15. This aspect of allegory may be traced to the efforts of humanist scholars to decipher hieroglyphs: "In their attempts they adopted the method of pseudo-epigraphical *corpus* written at the end of the second, or possibly even the fourth century A.D., the *Hieroglyphica* of Horapollon. Their subject . . . consists entirely of the so-called symbolic or enigmatic hieroglyphs, mere pictorial signs, such as were presented to the hierogrammatist, aside from the ordinary phonetic signs, in the context of religious instruction, as the ultimate stage in a mystical philosophy of nature. The obelisks were approached with memories of this reading in mind, and a misunderstanding thus became the basis of the rich and infinitely widespread form of expression. For the scholars proceeded from the allegorical exegesis of Egyptian hieroglyphs, in which historical and cultic data were replaced by natural-philosophical, moral, and mystical commonplaces, to the extension of this new kind of writing. The books of iconology were produced, which not only developed the phrases of this writing, and translated whole sentences 'word for word by special pictorial signs', but frequently took the form of lexica. 'Under the leadership of the artist-scholar, Albertus, the humanists thus began to write with concrete images (*rebus*) instead of letters; the word "rebus" thus originated on the basis of the enigmatic hieroglyphs, and medallions, columns, triumphal arches, and all the conceivable artistic objects produced by the Renaissance, were covered with such enigmatic devices.'" Benjamin, *Origin of German Tragic Drama*, 168–69. (Benjamin's quotations are drawn from Karl Giehlow's monumental study *Die Hieroglyphenkunde des Humanismus in der Allegorie der Renaissance*.)

16. Roland Barthes, "Diderot, Brecht, Eisenstein," *Image–Music–Text,* trans. Stephen Heath (New York: Hill and Wang, 1977), 73.

17. Walter Benjamin, "Theses on the Philosophy of History," in *Illuminations,* trans. Harry Zohn (New York: Schocken, 1969), 255.

18. Quoted in George Boas, "Courbet and His Critics," in *Courbet in Perspective,* ed. Petra ten-Doesschate Chu (Englewood Cliffs, N.J.: Prentice-Hall, 1977), 48.

19. Charles Baudelaire, "Salon of 1845," in *Art in Paris 1845–1862,* ed. and trans. Jonathan Mayne (New York: Phaidon, 1965), 14.

20. Cited in Walter Benjamin, "The Paris of the Second Empire in Baudelaire," in *Charles Baudelaire: A Lyric Poet in the Era of High Capitalism,* trans. Harry Zohn (London: NLB, 1973), 100. Lemaître's remark appears on p. 94 of the same text.

21. Charles Baudelaire, "The Painter of Modern Life," in *Selected Writings on Art and Artists,* trans. P. E. Charven (Baltimore: Penguin, 1972), 403.

22. Paul Bourget, "Discours académique du 13 juin 1895. Succession à Maxime Du Camp," in *L'anthologie de l'Académie française.* Quoted in Benjamin, *Charles Baudelaire,* 86.

23. Benjamin, *Charles Baudelaire,* 87.

24. Benjamin quotes the caption; in translation it reads: "Here lies the exact likeness of the old Pont Neuf, all recaulked like new in accordance with a recent ordinance. O learned physicians and skillful surgeons, why not do with us as was done with this stone bridge" (*Charles Baudelaire,* 88).

25. Walter Benjamin, "Paris—the Capital of the Nineteenth Century," in *Charles Baudelaire,* 170.

26. Martin Heidegger, "The Origin of the Work of Art," in *Poetry, Language, Thought,* trans. Albert Hofstadter (New York: Harper & Row, 1971), 19–20.

27. *Coleridge's Miscellaneous Criticism,* ed. Thomas Middelton Raysor (Cambridge, Mass.: Harvard University Press, 1936), 99.

28. Louis Althusser and Etienne Balibar, *Reading Capital,* trans. Ben Brewster (London: NLB, 1970), 186–87.

29. *Coleridge's Miscellaneous Criticism,* 99. This passage should be compared with Goethe's famous condemnation of allegory: "It makes a great difference whether the poet starts with a universal idea and then looks for suitable particulars, or beholds the universal *in* the particular. The former method produces allegory, where the particular has status merely as an instance, an example of the universal. The latter, by contrast, is what reveals poetry in its true nature: it speaks forth a particular without independently thinking of or referring to a universal, but in grasping the particular in its living character *it implicitly apprehends the universal along with it.*" Quoted in Philip Wheelwright, *The Burning Fountain* (Bloomington: Indiana University Press, 1968), 54, italics added. This recalls Borges's view of allegory: "The allegory is a fable of abstractions, as the novel is a fable of individuals. The abstractions are personified; therefore in every allegory there is something of the novel. The individuals proposed by

novelists aspire to be generic (Dupin is Reason, Don Segundo Sombra is the Gaucho); an allegorical element inheres in novels" ("From Allegories to Novels," 157).

30. Ferdinand de Saussure, *Course in General Linguistics,* trans. Wade Baskin (New York: McGraw-Hill, 1966), 68.

31. Benedetto Croce, *Aesthetic,* trans. Douglas Ainslie (New York: Noonday, 1966), 34–35.

32. This is what sanctioned Kant's exclusion, in the *Critique of Judgment,* of color, drapery, framing . . . as ornament merely appended to the work of art and not intrinsic parts of it. See Jacques Derrida, "The Parergon," *October* 9 (Summer 1979), 3–40, as well as my afterword, "Detachment: from the *parergon,*" 42–49.

33. Rosemond Tuve, *Allegorical Imagery* (Princeton: Princeton University Press, 1966), 26.

34. Cited in Borges, "From Allegories to Novels," 155.

35. Benjamin, *Origin of German Tragic Drama,* 176.

36. Ibid., 175.

37. Anson Rabinbach, "Critique and Commentary: Alchemy and Chemistry," *New German Critique* 17 (Spring 1979), 3.

38. Benjamin, *Origin of German Tragic Drama,* 160.

39. Ibid., 201.

40. Robert Smithson, "A Sedimentation of Mind: Earth Projects," in *The Writings of Robert Smithson,* ed. Nancy Holt (New York: New York University Press, 1979), 87–88. On Smithson's allegorism see my review in *October* 10 (Fall 1979), 121–30.

41. Edgar Allan Poe, *The Narrative of Arthur Gordon Pym* (New York: Hill and Wang, 1960), 197.

The Allegorical Impulse: Toward a Theory of Postmodernism, Part 2

We write in order to forget our foreknowledge of the total opacity of words and things or, perhaps worse, because we do not know whether things have or do not have to be understood.

— PAUL DE MAN, *Allegories of Reading*

Here is the beginning of an allegory, a brief parable of reading from the opening of Laurie Anderson's *Americans on the Move*.[1]

> You know when you're driving at night like this it can suddenly occur to you that maybe you're going in completely the wrong direction. That turn you took back there . . . you were really tired and it was dark and raining and you took the turn and you just started going that way and then the rain stops and it starts to get light and you look around and absolutely everything is completely unfamiliar. You know you've never been here before and you pull into the next station and you feel so awkward saying, "Excuse me, can you tell me where I am?" . . .

This passage, with its images of driving (Anderson's metaphor for consciousness: "I am in my body the way most people drive in their cars") and obscurity, is reminiscent of the opening of *The Divine Comedy* ("Nel mezzo del cammin di nostra vita mi ritrovai per una selva oscura/ che la diritta via era smarrita. . . . Io non so ben ridir com' io v'entrai,/ tant'era pieno di sonno a quel punto/che la verace via abbondonai"[2]), or rather of that state of perplexity which initiates so many allegories. And Anderson's night driver soon encounters her Virgil in the guise of a grease monkey, who reveals that her befuddlement is the result of her failure to "read the signs"—a failure which is not, however, attributed to a subject who has either neglected or misread directional signals, but to the fundamental unreadability of the signs themselves. Commenting on a projection of the image that was emblazoned on the Pioneer spacecraft—a nude man and woman, the former's right arm raised at

70

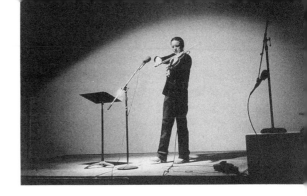

the elbow, palm proffered—her Virgil in overalls inquires: "In our country, we send pictures of our sign language into outer space. They are speaking our sign language in these pictures. Do you think they will think his hand is permanently attached that way? Or do you think they will read our signs? In our country, good-bye looks just like hello."

Two alternatives: either the extraterrestrial recipient of this message will assume that it is simply a picture, that is, an analogical likeness of the human figure, in which case he might logically conclude that male inhabitants of Earth walk around with their right arms permanently raised. Or he will somehow divine that this gesture is addressed to him and attempt to read it, in which case he will be stymied, since a single gesture signifies both greeting and farewell, and any reading of it must oscillate between these two extremes. The same gesture could also mean "Halt!" or represent the taking of an oath, but if Anderson's text does not consider these alternatives that is because it is not concerned with ambiguity, with multiple meanings engendered by a single sign; rather, two *clearly defined but mutually incompatible* readings are engaged in blind confrontation in such a way that it is impossible to choose between them. It is, of course, in allegory that "one and the same object can just as easily signify a virtue as a vice,"[3] and this works to problematize the activity of reading, which must remain forever suspended in its own uncertainty.

"In the illusory babels of language," Robert Smithson wrote, "an artist might advance specifically to get lost."[4] Anderson is such an artist, and her performances are narratives of losing one's way in labyrinths of signs. Although she employs, in addition to lyrics and spoken texts, photographs, drawings, films, and music, all of these are implicated in a general thematics of reading that extends far beyond the limits of the written text. For Anderson, the world is a vast network of signs and, as such, continually elicits reading, interpretation. Consciousness, being in the world, is in fact identified with reading—an identification which is not, however, unproblematic, for the legibility of signs is always un-

Laurie Anderson, Americans on the Move, *1976. Presented at The Kitchen Center for Video, Music, and Dance. Courtesy Laurie Anderson.*

certain. And it is to the problem of *illegibility* that Anderson's work is addressed.

Americans on the Move continually returns to the fundamental ambivalence of signs and to the barrier they thereby erect in the path of understanding. A photograph of a woman shrugging her shoulders, palms turned upwards, elicits the conundrum: "Does this woman think its raining? Or do you think it's all the same to her?" An earlier version of the work included the following story about consulting a palmist (a *Reader and Advisor*) in Albuquerque:

> The odd thing about the reading was that everything she told me was totally wrong. She took my hand and said, "I see here by these lines that you are an only child . . . " (I have seven brothers and sisters) " . . . I read here that you love to fly . . . " (I'm totally terrified of planes) and so on. But she seemed so sure of this information that eventually I began to feel like I'd been walking around for years with these false documents permanently tattooed to my hands. It was very noisy in the house, family members kept walking in and out speaking a high clicking kind of language that sounded like Arabic. Books and magazines in Arabic were strewn all over the carpet. Suddenly I realized that maybe it was a translation problem—maybe she had been reading from right to left instead of left to right—and thinking of mirrors, I gave her my other hand. She didn't take it, but instead, held out her own hand. We sat there for a minute or two in what I assumed was some sort of strange participatory, invocatory ritual. Finally I realized that her hand was out because she was waiting . . . waiting for money.

In this passage, which treats the metaphor of communication as economic exchange—the exchange of meaning balanced by an exchange of currency—Anderson proposes that the same "text" read backwards and forwards might engender antithetical meanings. It thus recalls her palindromes, which rarely read the same in both directions: in her *Song for Juanita,* the first syllable "Juan-" is reversed into "no," producing a rhythmic oscillation "no-one-no-one"; morphemes are thus revealed to contain the seed of their own contradiction.[5] Palindromes, puns, and "translation problems" recur throughout Anderson's works, allowing us to identify them as what Paul de Man, in his recent *Allegories of Reading,* calls "allegories of unreadability." De Man recognizes allegory as the structural interference of two distinct levels or usages of language, literal and rhetorical (metaphoric), one of which denies precisely what the other affirms. In most allegories a literal reading will "deconstruct" a metaphorical one; recalling medieval schemas of textual exegesis, de Man identifies such readings as tropological. Yet because literal lan-

guage is itself rhetorical, the product of metaphoric substitutions and reversals, such readings are inevitably implicated in what they set out to expose, and the result is allegory.

> The paradigm for all texts consists of a figure (or a system of figures) and its deconstruction. But since this model cannot be closed off by a final reading, it engenders, in its turn, a supplementary figural superposition which narrates the unreadability of the prior narration. As distinguished from primary deconstructive narratives centered on figures and ultimately always on metaphor, we can call such narratives to the second (or third) degree allegories. *Allegorical narratives tell the story of the failure to read* whereas tropological narratives . . . tell the story of the failure to denominate. The difference is only a difference in degree and the allegory does not erase the figure. Allegories are always allegories of metaphor and, as such, they are always allegories of the impossibility of reading—a sentence in which the genitive "of" has itself to be read as a metaphor.[6]

De Man illustrates his thesis of allegorical illegibility with examples drawn from both literary and philosophical discourse (although allegory tends to blur this distinction), from Rilke and Proust to Rousseau and Nietzsche. The way in which attention to the incongruence of literal and figurative language upsets our presumed mastery of canonical texts is succinctly demonstrated in his introductory reading of Yeats's "Among School Children," which concludes with the famous line "How can we know the dancer from the dance?"—a line frequently quoted as testimony to the indissoluble unity of sign and meaning that characterizes the (symbolic) work of art. Yet this "meaning" hinges upon reading the line as a rhetorical question, that is, as a rhetorical *statement* of their indissolubility. But what if we read it literally, de Man asks; and the result, not surprisingly, is allegory—the distance which separates signifier from signified, sign from meaning:

> It is equally possible, however, to read the last line literally rather than figuratively, as asking with some urgency the question we asked earlier in the context of contemporary criticism: not that the sign and referent are so exquisitely fitted to each other that all difference between them is at times blotted out but, rather, since the two essentially different elements, sign and meaning, are so intricately intertwined in the imagined "presence" that the poem addresses, how can we possibly make the distinctions that would shelter us from the error of identifying what cannot be identified? The clumsiness of the paraphrase reveals that it is not necessarily the literal reading which is simpler than the figurative one . . . ; here the figural reading, which assumes the question to be rhetorical, is perhaps naive, whereas the literal reading leads to greater complication of themes

and statement. For it turns out that the entire schema set up by the first reading can be undermined, or deconstructed, in terms of the second, in which the final line is read literally as meaning that, since the dancer and the dance are not the same, it might be useful, perhaps even desperately necessary—for the question can be given a ring of urgency, "Please tell me, how *can* I know the dancer from the dance"—to tell them apart. But this will replace the reading of each symbolic detail by a divergent interpretation. . . . This hint should suffice to suggest that two entirely coherent but entirely incompatible readings can be made to hinge on one line, whose rhetorical mode turns the mood as well as the mode of the poem upside down. Neither can we say . . . that the poem simply has two meanings that exist side by side. The two readings have to engage each other in direct confrontation, for the one reading is precisely the error denounced by the other and has to be undone by it. Nor can we in any way make a valid decision as to which of the readings can be given priority over the other; none can exist in the other's absence. There can be no dance without a dancer, no sign without a referent. On the other hand, the authority of the meaning engendered by the grammatical structure is fully obscured by the duplicity of a figure that cries out for the differentiation that it conceals.[7]

I have quoted this lengthy passage in full not only because it illuminates the structure of Laurie Anderson's art and allows us to identify it as allegorical, but also because it demonstrates that modernist texts such as Yeats's contain within themselves the seed of their own allegorization. Allegory can no longer be condemned as something merely appended to the work of art, for it is revealed as a structural possibility inherent in every work. In modernism, however, the allegory remains *in potentia* and is actualized only in the activity of reading, which suggests that the allegorical impulse that characterizes postmodernism is a direct consequence of its preoccupation with reading. It is not surprising, then, that we should encounter Robert Rauschenberg, on the threshold of postmodernism, executing works which transform our experience of art from a visual to a textual encounter, and entitling these works *Obelisk, Rebus, Allegory*.

The displacement enacted by Rauschenberg's art was first acknowledged by Leo Steinberg, who identified it as a shift from nature to culture.[8] But Steinberg presumes the nature/culture opposition to be a stable one, a presupposition that postmodern artists—not to mention their poststructuralist counterparts—are determined to subvert. In postmodernist art, nature is treated as wholly domesticated by culture; the "natural" can be approached only through its cultural representation. While this does indeed suggest a shift from nature to culture, what it in

fact demonstrates is the impossibility of accepting their opposition. This is the point of a recent allegorical project by Sherrie Levine, who has selected, mounted, and framed Andreas Feininger's photographs of natural subjects. When Levine wants an image of nature, she does not produce one herself but appropriates another image, and this she does in order to expose the degree to which "nature" is always already implicated in a system of cultural values which assigns it a specific, culturally determined position. In this way she reinflects Duchamp's readymade strategy, utilizing it as an unsettling deconstructive instrument.

This reference to Duchamp suggests that the postmodernist "shift" should not be characterized as from nature to culture, but as a shift in elocutionary mode, from history to discourse, the terms which Émile Benveniste uses to distinguish between impersonal, third-person narration and direct address, which he associates with the personal pronouns *I* and *you*.[9] In her "Notes on the Index . . ." Rosalind Krauss demonstrates that this shift of pronominal emphasis is characteristic of all of Duchamp's work, and that it signals a "tremendous arbitrariness with regard to meaning, a breakdown of . . . the linguistic sign."[10] All of Duchamp's works read as messages addressed to the spectator—explicitly in *Anemic Cinema* and *Tu m'* and *To Be Looked At (from the Other Side of the Glass) with One Eye, Close to, for Almost an Hour*; implicitly in the readymades *Fountain* and *Trébuchet*[11]—and it should be remembered that allegories are frequently exhortative, addressed to the reader in an attempt to manipulate him or to modify his behavior. It is on the basis of this shift to a discursive mode that a reading of what Duchamp himself identified as the "allegorical appearance" of the *Large Glass*—itself an elaborate *psychomachia*—should proceed.

This shift from history to discourse, from a third- to a second-person mode of address, also accounts for the centrality which postmodernist art assigns to the reader/spectator;[12] significantly, Steinberg frequently refers to Rauschenberg's reorientation of the conventional picture field from a horizontal to a "flatbed" position as a form of "spectator modifi-

Marcel Duchamp, Fountain, *1917*.

cation." Krauss observed that Rauschenberg's art follows a discursive model by compelling a part-by-part, image-by-image reading that is temporal in character.[13] Yet it remains impossible to read a Rauschenberg, if by reading we mean the extraction from a text of a coherent, monological message. All attempts to decipher his works testify only to their own failure, for the fragmentary, piecemeal combination of images that initially impels reading is also what blocks it, erects an impenetrable barrier to its course. Rauschenberg thus confounds the attitude towards reading as an unproblematic activity—which persists, as we know, under the dubious banner "iconography" in art-critical and art-historical discourse, which are thereby paralyzed when confronted with his work, and with postmodernism in general—substituting for it something remarkably similar to Roland Barthes's "stereographic" view of the text:

> A text is made of multiple writings, drawn from many cultures and entering into mutual relations of dialogue, parody, contestation, but there is one place where this multiplicity is focused and that place is the reader, not, as was hitherto said, the author. The reader is the space on which all the quotations that make up a writing are inscribed without any of them being lost; a text's unity lies not in its origin but in its destination. Yet this destination can no longer be personal: the reader is without history, biography, psychology; he is simply that *someone* who holds together in a single field all the traces by which the written text is constituted.[14]

Here, then, is Rauschenberg's *Allegory,* a "combine painting" executed in 1959–60, exactly one year after the artist began his series of illustrations for *The Divine Comedy* (the project during which the transfer process characteristic of his subsequent work was "discovered"). Couched in its flatbed surface there is a random collection of heterogeneous objects: a red umbrella, stripped from its frame and splayed like a fan; rusted sheet metal, crumpled into a cascade of metallic drapery and mounted on mirrors; red block lettering, apparently from a broadside that has been ripped apart and dispersed; swatches of fabric; bits of clothing. It is difficult, if not impossible to discover in this inventory any common property that might coherently link these things, justify their bedding down together. The only metaphor that suggests itself is that of a dumping ground, and it is hardly a new one: with his customary precision of language, Steinberg described Rauschenberg's typical picture surface as "dump, reservoir, switching center." Krauss also characterizes Rauschenberg's art in terms of place: discussing the "equal density" which disparate images acquire in *Small Rebus,* she is "struck by the fact that the surface of this painting is a *place,* a *locale,* where this kind of equalization can happen."[15] Both Steinberg and Krauss describe

the work in this way in order to analogize it to the human mind; Rauschenberg's works thus become allegories of consciousness or, perhaps, the unconscious.

Is this then what makes *Allegory* an allegory? By making works which read as *sites,* however, Rauschenberg also seems to be declaring the fragments embedded there to be beyond recuperation, redemption; this is where everything finally comes to rest. *Allegory* is thus also an emblem of mortality, of the inevitable dissolution and decay to which everything is subject. But can we in fact be certain that this is an allegorical image; might it not be an image of allegory itself, of the disrepute into which it has fallen? All three readings are correct, but only in part; if, however, we were to superimpose them then the work would become the narrative—the allegory—of its own fundamental illegibility.

In his essay "On the Museum's Ruins," Douglas Crimp proposes another locale suggested by Rauschenberg's art: the museum, the dumping grounds of culture.[16] If we accept for the moment—and I believe we must—this identification of Rauschenberg's works as "museum paintings," in the sense that Michel Foucault attributes to Manet—painting as "a manifestation of the existence of museums and the particular reality and interdependence that paintings acquire in museums"[17]—then it follows that they will acquire their fullest measure of significance only when seen *in situ.* Rauschenberg's art remains *in potentia* until it is seen in the museum, where it opens a dazzling *mise en abyme* reminiscent of Husserl's Dresden Gallery passage in *Ideas*:

> A name on being mentioned reminds us of the Dresden Gallery and of our last visit there: we wander through the rooms, and stand before a picture of Teniers which represents a picture gallery. When we consider that pictures of the latter would in their turn portray pictures which on their part exhibited readable inscriptions and so forth, we can measure what interweaving of presentations, and what links of connexion between the discernible features in the series of pictures, can really be set up.[18]

The illegibility of a Rauschenberg, however, works to deny the possibility of precisely such "links of connexion" as Husserl proposes, which

Robert Rauschenberg, Allegory, *1959–60. Courtesy Leo Castelli Gallery, New York City.*

hinge on the *readability* of the "inscriptions." There is no escape from this situation, no clear route back to the "reality" it purports to describe, as Jacques Derrida, in his Borgesian critique of this passage, indicates: "The gallery is the labyrinth which includes in itself its own exits."[19] The acquisition of Rauschenberg's canvases by museums of modern art is thus their final, ironic triumph. They become that term in the series of works exhibited there that permits the allegorization of the entire series. But this triumph is ultimately an equivocal one, for in order to function as deconstructions of the discourse of the museum, of its claims to coherence, homogeneity—the ground of its alleged intel-legibility—they must also declare themselves to be part of the dumping ground they describe. They thus relapse into the "error" they denounce, and this is what allows us to identify them as allegorical.

What I am imputing to Rauschenberg, then, is a peculiar form of site specificity: museum painting for the museum. This gesture is both economic and strategic, for if, in his works, Rauschenberg enacts a deconstruction of the museum, then his own deconstructive discourse—like Daniel Buren's—can take place only within the museum itself. It must therefore provisionally accept the terms and conditions it sets out to expose. This is of course the constraint to which any deconstructive discourse is subject, as the deconstructors themselves frequently remind us: Derrida, for example, speaks of the methodological necessity of preserving as an instrument a concept whose truth value is being questioned. (Significantly, his example is Claude Lévi-Strauss's ethnographic discourse, which must utilize the nature/culture opposition even while rejecting it.[20]) There is thus a danger inherent in deconstruction: unable to avoid the very errors it exposes, it will continue to perform what it denounces as impossible and will, in the end, affirm what it set out to deny. Deconstructive discourses thus leave "a margin of error, a residue of logical tension" frequently seized upon by critics of deconstructionism as its failure. But this very failure is what raises the discourse, to use de Man's terminology, from a tropological to an allegorical level:

> Deconstructive readings can point out the unwarranted identifications achieved by substitution, but they are powerless to prevent their recurrence even in their own discourse, and to uncross, so to speak, the aberrant exchanges that have taken place. Their gesture merely reiterates the rhetorical defiguration that caused the error in the first place. They leave a margin of error, a residue of logical tension that prevents the closure of the deconstructive discourse and accounts for its narrative and allegorical mode.[21]

Reading Rousseau's *Second Discourse* as the narrative of its own deconstruction, de Man concludes:

> To the extent that it never ceases to advocate the necessity for political legislation and to elaborate the principles on which such a legislation could be based, it resorts to the principles of authority that it undermines. We know this structure to be characteristic of what we have called allegories of unreadability. Such an allegory is metafigural; it is an allegory of a figure (for example, metaphor) which relapses into the figure it deconstructs. The *Social Contract* falls under this heading to the extent that it is structured like an aporia: it persists in performing what it has shown to be impossible to do. As such, we can call it an allegory.[22]

The "figure," then, deconstructed in Rauschenberg's work is that which proposes the substitution of the "heap of meaningless and valueless fragments of objects [contained within the museum] . . . either metonymically for the original objects or metaphorically for their representations."[23] Exposing this substitution to be impossible, Rauschenberg imputes the same impossibility to his own work, thereby opening it to criticism that it merely perpetuates the confusion it sets out to expose. Postmodernist art is frequently attacked on exactly this point; for example, it is said of Troy Brauntuch's reproductions of Hitler's drawings that, because they lack captions or identifying labels that might inform us of their origin, the work remains mute, meaningless. It is, however, precisely this opacity that Brauntuch sets out to demonstrate, and this is what enables us to identify his works as allegories. Whether or not we will ever acquire the key necessary to unlock their secret remains a matter of pure chance, and this gives Brauntuch's work its undeniable *pathos,* which is also the source of its strength.

Similarly, Robert Longo's work, which treats the aestheticization of violence in contemporary society, participates of necessity in the activity it denounces. In a recent series of aluminum reliefs, entitled *Boys Slow Dance* and generated from film stills, Longo presents three images of men locked in . . . deadly combat? amorous embrace? Like Anderson's parables, Longo's images resist ambiguity; they might, in fact, serve as emblems of that blind confrontation of antithetical meanings which characterizes the allegory of unreadability. Suspended in a static image, a struggle to the death is transformed into something that "has all the elegance of a dance."[24] Yet it is precisely this ambivalence that allows violence to be transformed into an aesthetic spectacle in photographs and films, and on television.

Longo's manipulation of film stills calls attention to the fact that, despite its suppression by modern theory—or perhaps because of it— allegory has never completely disappeared from our culture. Quite the contrary: it has renewed its (ancient) alliance with popular art forms, where its appeal continues undiminished. Throughout its history allegory has demonstrated a capacity for widespread popular appeal, suggesting that its function is social as well as aesthetic; this would account for its frequent appropriation for didactic and/or exhortative purposes. Just as Lévi-Strauss's structural (allegorical) analysis of myths reveals that the function of myth is to resolve the conflicts which confront primitive societies by maintaining them in paralogical suspension,[25] so too allegory may well be that mode which promises to resolve the contradictions which confront modern society—individual interest versus general well-being, for example—a promise which must, as we know, be perpetually deferred. The withdrawal of the modernist arts from allegory may thus be one factor in their ever-accelerating loss of audience.

The Western, the gangster saga, science fiction—these are the allegories of the twentieth century. They are also genres most intimately associated with film; that film should be the primary vehicle for modern allegory may be attributed not only to its unquestioned status as the most popular of contemporary art forms, but also to its mode of representation. Film composes narratives out of a succession of concrete images, which makes it particularly suited to allegory's essential pictogrammatism. (As stated in Part 1 of this essay, "In allegory, the image is a hieroglyph; an allegory is a rebus, writing composed of concrete images.") Film is not, of course, the only medium to do so, as Barthes has indicated:

> There are other "arts" which combine still (or at least drawing) and story, diegesis—namely the photo-novel and the comic-strip. I am convinced that these "arts," born in the lower depths of high culture, possess theoretical qualifications and present a new signifier. . . . This is acknowledged as regards the comic-strip but I myself experience this slight trauma of *signifiance* faced with certain photo-novels: "*their stupidity touches me*." There may thus be a future—or a very ancient past—truth in these derisory, vulgar, foolish, dialogical forms of consumer subculture.[26]

Borges condemned allegory as "stupid and frivolous"; yet for Barthes its very stupidity functions as an index to its potential "truth." He goes on to designate a new object for aesthetic investigation: "And there is an autonomous 'art' (a 'text'), that of the *pictogram* ('anecdotalized' images, obtuse meanings placed in a diegetic space); this art taking across

historically and culturally heteroclite productions: ethnographic picto-
grams, stained glass windows, Carpaccio's *Legend of Saint Ursula, images
d'Epinal,* photo-novels, comic strips."[27]

These remarks on the pictogram occur in a footnote to the essay
"The Third Meaning: Research Notes on Some Eisenstein Stills," in
which Barthes attempts to locate and define the specifically "filmic,"
which he discovers not in the movement of images, but in the still.
Despite the essentialist undertones of this project, and whether or not
we agree with Barthes's characterization of film as static in essence, or
with his interpretation of Eisenstein's work, this essay remains extremely
important because, in order to describe the still, Barthes elaborates a
three-fold schema of interpretation highly reminiscent of the three- and
four-fold schemas of medieval textual exegesis—a parallel of which
Barthes himself is not unaware. This schema is necessitated by a des-
cription of the still in terms traditionally associated with allegory: it is
a fragment, a quotation, and the meaning it engenders is supplemen-
tary, excessive, "parodic and disseminatory." An arbitrary cut, the still
suspends not only motion but also story, diegesis; engendered by the
syntagmatic disjunction of images, it compels a vertical or paradigmatic
reading. ("Allegory is the epitome of counter-narrative, for it arrests
narrative in place, substituting a principle of syntagmatic disjunction for
one of diegetic combination. In this way allegory superinduces a vertical
or paradigmatic reading of correspondences upon a horizontal or syn-
tagmatic chain of events"—Part 1.)

In Barthes's allegorical schema, the first level of meaning is infor-
mational, referential, to make its parallel with exegesis more apparent,
literal. This is the level of anecdote, and it comprises setting, costume,
characters, and their relations. It unproblematically assumes the reality
of what it denotes, that is, that the sign is transparent to a referent. The
second level is *symbolic* —Barthes calls it obvious, relating it to theology,
in which, "we are told, the obvious meaning is that 'which presents itself
quite naturally to the mind.'"[28] Significantly, Barthes describes this level
in terms that allow us to identify it as *rhetorical*: "Eisenstein's 'art' is not
polysemous, it chooses the meaning, imposes it, hammers it home....
The Eisensteinian meaning devastates ambiguity. Here, by the addition
of an aesthetic value, emphasis, Eisenstein's decorativism has an eco-
nomic function: it proffers the truth."[29] Rhetoric, which is always em-
phatic, is both decorative and persuasive, a system of tropes frequently
employed in oratory to manipulate the listener, to incite him to action.
All of the Eisenstein stills analyzed by Barthes function simultaneously
on both rhetorical levels: a clandestinely clenched fist, for example, a

metaphoric synecdoche for the proletariat, is meant to inspire revolutionary determination.

In contradistinction to the literal and rhetorical meanings, the third, or "obtuse" meaning is difficult to formulate; Barthes's description of it is elusive, vague:

> The obtuse meaning is a signifier without a signified, hence the difficulty in naming it. *My reading remains suspended* between the image and its description, between definition and approximation. If the obtuse meaning cannot be described, that is because, in contrast to the obvious meaning, it does not copy anything—how do you describe something that does not represent anything? [30]

Nevertheless, the third meaning, Barthes tells us, has "something to do" with disguise; he identifies it with isolated details of make-up and costume (which properly belong to the literal level) which, through excess, proclaim their own artifice. If Barthes refuses to assign such details a referent, he does accord them a function: they work to expose the image as *fiction*. Barthes's reluctance, even inability to specify obtuse meaning cannot be considered an evasion, a ruse; it is a theoretical necessity. For as de Man observes:

> What makes a fiction a fiction is not some polarity of fact and representation. Fiction has nothing to do with representation but is the absence of any link between utterance and a referent, regardless of whether this link be causal, encoded, or governed by any other conceivable relationship that could lend itself to systematization. In fiction thus conceived the "necessary link" of the metaphor [of the symbol, we might add, recalling Coleridge] has been metonymized beyond the point of catachresis, and the fiction becomes the disruption of the narrative's referential illusion. [31]

The obtuse meaning differs not only in kind (since it refers to nothing, copies nothing, symbolizes nothing) from the literal and the symbolic; it is also *sited* differently: "Take away the obtuse meaning and communication and signification still remain, still circulate, still come through." [32] The *absence* of obtuse meaning is, in fact, the very condition of communication and signification, but its presence works to problematize these activities. Since the obtuse meaning has no objective, independent existence, it depends upon the literal and the rhetorical, which it nevertheless undoes. An unwelcome supplement, it exposes the literal level of the image to be a fiction, implicating it in the web of substitutions and reversals properly characteristic of the symbolic. The actor is revealed as the (metaphoric) substitute for character; his facial contortions, the emblem of grief, not its direct expression. Hence every image

that participates in what photography criticism calls the directorial, as opposed to the documentary, mode is open to the intervention of obtuse meaning. And the symbolic dimension of the image, which depends upon the univocity of the literal, is thereby disfigured; erected upon an unstable base of substitutions and displacements, it becomes metafigural, the figure of a figure. The "necessary link" which characterized it as metaphoric is rendered contingent, "metonymized," as de Man has it. The projection of metaphor as metonymy is one of the fundamental strategies of allegory, and through it the symbolic is revealed for what it truly is—a rhetorical manipulation of metaphor which attempts to program response.

> The presence of an obtuse, supplementary, third meaning . . . radically re-casts the theoretical status of the anecdote: the story (the diegesis) is no longer just a strong system (the millennial system of narrative) but also and contradictorily a simple space, a field of permanences and permuta-tions. It becomes that configuration, that stage, whose false limits multiply the signifier's permutational play, the vast trace which, by difference, com-pels . . . a *vertical* reading, that false order which permits the turning of the pure series, the aleatory combination (chance is crude, a signifier on the cheap) and the attainment of a structuration which *slips away from the inside*.[33]

Insofar as Barthes claims that the third meaning is that in the image which is "purely image," and because he identifies it with the "free play" of the signifier, he is open to charges that he is merely reiterating, in semiological jargon, aesthetic pleasure in the Kantian sense, delight in the form of a representation apart from the representation of any object whatsoever. And since the concept of a "signifier without a signified" presupposes that the referential function of language can, in fact, be sus-pended or bracketed, Barthes in fact repeats the postulate that lies at the base of every formalist aesthetic. The obtuse meaning does indeed appear reducible to the aesthetic; but I am interested in what motivates Barthes to insert it into the slot left vacant by the allegorical in an ancient interpretive scheme.

Barthes's interest in the theoretical value of the film still is paralleled today by several artists who derive their imagery from stills—Longo and James Birrell, who work to isolate that in the image which is purely image—or whose works deliberately resemble stills—Suzan Pitt's Disney-esque treatments of surrealism; Cindy Sherman's "untitled studies for film stills." These latter treat the subject of mimesis, not simply as an aesthetic activity, but as it functions in relation to the constitution of the

self. Sherman's works are all self-portraits, but in them the artist invari-
ably appears masked, disguised: she first costumes herself to resemble
familiar female stereotypes—career girl, ingenue, sex object . . .—and
then photographs herself in poses and settings reminiscent of the cine-
matic culture of the 1950s and '6os. Her "characters" frequently glance
anxiously outside the frame at some unspecified menace, thereby imply-
ing the presence of a narrative even while withholding it. This—the
"still"—effect prevents us from mistaking Sherman's women for particu-
lar human subjects caught up in narrative webs of romance or intrigue
(a reading which would correspond to Barthes's first, or literal level,
which indicates the position of the image in the anecdote). Instead it
compels a typological reading: Sherman's women are not women but
images of women, specular models of femininity projected by the media
to encourage imitation, identification; they are, in other words, tropes,
figures. (In works which appropriate images of maternity from popular
magazines, Sherrie Levine deals with the same rhetorical function of
images: it is the picture which inspires imitation, mimesis, not the other
way around.)

And yet the uncanny precision with which Sherman represents these
tropes, the very perfection of her impersonations, leaves an unresolved
margin of incongruity in which the image, freed from the constraints
of referential and symbolic meaning, can accomplish its "work." That
work is, of course, the deconstruction of the supposed innocence of the
images of women projected by the media, and this Sherman accom-
plishes by *re*constructing those images so painstakingly, and identifying
herself with them so thoroughly, that artist and role appear to have
merged into a seamless whole in such a way that it seems impossible to
distinguish the dancer from the dance. It is, however, the urgent neces-
sity of making such a distinction that is, in fact, at issue.

For in Sherman's images, disguise functions as parody; it works to
expose the identification of the self with an image as its dispossession,
in a way that appears to proceed directly from Jacques Lacan's funda-
mental tenet that the self is an Imaginary construct, "and that this con-
struct disappoints all [the subject's] certitudes. For in the labor with
which he undertakes to reconstruct this construct *for another,* he finds
again the fundamental alienation which has made him construct it *like
another one,* and which has always destined it to be stripped from him
by another."[34] (Significantly, in *The Four Fundamental Concepts of Psycho-
analysis,* Lacan describes mimicry, mimesis, as the mechanism whereby
the subject transforms himself into a picture.) By implicating the mass

media as the false mirror which promotes such alienating identifications, Sherman registers this "truth" as both ethical and political.

But there is also an impossible complicity inscribed within Sherman's works, a complicity which accounts for their allegorical mode. For if mimicry is denounced in these images, it is nevertheless through mimetic strategies that this denunciation is made. We thus encounter once again the unavoidable necessity of participating in the very activity that is being denounced *precisely in order to denounce it*. All of the work discussed in this essay is marked by a similar complicity, which is the result of its fundamentally deconstructive impulse. This deconstructive impulse is characteristic of postmodernist art in general and must be distinguished from the self-critical tendency of modernism. Modernist theory presupposes that mimesis, the adequation of an image to a referent, can be bracketed or suspended, and that the art object itself can be substituted (metaphorically) for its referent. This is the rhetorical strategy of self-reference upon which modernism is based, and from Kant onwards it is identified as the source of aesthetic pleasure. For reasons that are beyond the scope of this essay, this fiction has become increasingly difficult to maintain. Postmodernism neither brackets nor suspends the referent but works instead to problematize the activity of reference. When the postmodernist work speaks of itself, it is no longer to proclaim its autonomy, its self-sufficiency, its transcendence; rather, it is to narrate its own contingency, insufficiency, lack of transcendence. It tells of a desire that must be perpetually frustrated, an ambition that must be perpetually deferred; as such, its deconstructive thrust is aimed not only against the contemporary myths that furnish its subject matter, but also against the symbolic, totalizing impulse which characterizes modernist art. As Barthes has written elsewhere:

> It is no longer the myths which need to be unmasked (the doxa now takes care of that), it is the sign itself which must be shaken; the problem is not to reveal the (latent) meaning of an utterance, of a trait, of a narrative, but to fissure the very representation of meaning, is not to change or purify the symbols, but to challenge the symbolic itself.[35]

NOTES

1. *Americans on the Move*, a performance by Laurie Anderson, was presented at The Kitchen Center for Video, Music, and Dance in April 1979. Several texts from it were published in *October* 8 (Spring 1979), 45–57. All quotations are taken from this source.

2. "In the middle of the journey of our life I came to myself within a dark

wood where the straight way was lost. . . . I cannot rightly tell how I entered there, I was so full of sleep at that moment when I left the true way . . ." *Dante's Inferno*, trans. John D. Sinclair (New York: Oxford University Press, 1939), 23.

3. Karl Giehlow, *Die Hieroglyphenkunde* . . . , quoted in Walter Benjamin, *The Origin of German Tragic Drama*, trans. John Osborne (London: NLB, 1977), 174.

4. Robert Smithson, "A Museum of Language in the Vicinity of Art," in *The Writings of Robert Smithson,* ed. Nancy Holt (New York: New York University Press, 1979), 67. I discuss the centrality of this passage to Smithson's enterprise in my review, "Earthwords," *October* 10 (Fall 1979), 121–30.

5. Laurie Anderson, "Song for Juanita," *Airwaves* (recording, New York: One Ten Records, 1977). Liner notes by the artist.

6. Paul de Man, *Allegories of Reading* (New Haven: Yale University Press, 1979), 205, italics added.

7. Ibid., 11–12.

8. Leo Steinberg, "Other Criteria," *Other Criteria* (New York: Oxford University Press, 1972), 84f.

9. Émile Benveniste, "Les relations de temps dans le verbe français," *Problèmes de linguistique générale,* I, 237–50. There is an interesting application of Benveniste's distinction to film theory in Christian Metz, "Histoire/Discours (Note sur deux voyeurismes)," in *Le signifiant imaginaire* (Paris: Union Générale d'Editions [Collection 10:18], 1977), 113–20.

10. Rosalind Krauss, "Notes on the Index: Seventies Art in America," *October* 3 (Spring 1977), 77.

11. In *Passages in Modern Sculpture,* Rosalind Krauss describes the readymades' interrogative structure: "The readymades became . . . part of Duchamp's project to make certain kinds of strategic moves—moves that would raise questions about what exactly is the nature of the work in the term 'work of art.' Clearly, one answer suggested by the readymades is that a work might not be a physical object but rather a question, and that the making of art might, therefore, be reconsidered as taking a perfectly legitimate form in the speculative act of posing questions" (New York: Viking, 1977), 72–73.

12. Consider Krauss's treatment, in *Passages,* of the emblem in abstract expressionism: "All these qualities—frontality, centralization, and literal size and shape—characterize the developed work of most of the abstract-expressionist painters; even those who, like Pollack and Newman, eventually dropped some of these emblematic features continued to work with the most central aspect of the sign or emblem. And that is its mode of address. For while we can think of a traditional picture or a photograph as creating a relationship between author and object that exists independent of an audience, addressing no one in particular, we must think of a sign or emblem as existing specifically in relation to a receiver. It takes the form of a directive addressed *to* someone, a directive that exists, so to speak, in the space of confrontation between the sign or emblem and the one who views it" (Ibid., 150, 152). Like de Man's reading of "Among School Children," Krauss's passage suggests that abstract-expressionist painting may indeed contain the seed of its own allegorization.

13. Rosalind Krauss, "Rauschenberg and the Materialized Image," *Artforum* 13 (December 1974), 37.

14. Roland Barthes, "The Death of the Author," in *Image–Music–Text*, trans. Stephen Heath (New York: Hill and Wang, 1977), 148.

15. Krauss, "Rauschenberg," 41, italics added.

16. See *October* 13 (Summer 1980).

17. Michel Foucault, "Fantasia of the Library," in *Language Counter-Memory, Practice*, trans. Donald F. Bouchard and Sherry Simon (Ithaca: Cornell University Press, 1977), 92.

18. Edmund Husserl, *Ideas*, trans. W. R. B. Gibson (New York: Collier, 1962), 270.

19. Jacques Derrida, *Speech and Phenomena*, trans. David B. Allison (Evanston: Northwestern University Press, 1973), 104.

20. Jacques Derrida, "Structure, Sign, and Play in the Discourse of the Human Sciences," in *Writing and Difference*, trans. Alan Bass (Chicago: University of Chicago Press, 1978), 282 ff.

21. de Man, *Allegories of Reading*, 242.

22. Ibid., 275.

23. Eugenio Donato, "The Museum's Furnace: Notes toward a Contextual Reading of *Bouvard and Pécuchet*," in *Textual Strategies*, ed. Josué V. Harari (Ithaca: Cornell University Press, 1979), 223.

24. Douglas Crimp, *Pictures* (New York: Artists Space, 1977), 26.

25. Claude Lévi-Strauss, "The Structural Study of Myth," in *Structural Anthropology*, trans. Claire Jacobson and B. G. Schoepf (New York: Basic Books, 1963), 229. Lévi-Strauss, however, seems to consider this suspension of contradiction to be perfectly logical: "The purpose of myth is to provide a logical model capable of overcoming a contradiction (an impossible achievement if, as it happens, the contradiction is real)." Rosalind Krauss, however, has properly described it as "paralogical" ("Grids," *October* 9 [Summer 1979], 55). On the allegorical character of structuralist analysis, see Joel Fineman, "The Structure of Allegorical Desire," *October* 12 (Spring 1980), 47–66.

26. Roland Barthes, "The Third Meaning: Research Notes on Some Eisenstein Stills," in *Image–Music–Text*, 66.

27. Ibid.

28. Ibid., 54.

29. Ibid., 56.

30. Ibid., 61, italics added.

31. de Man, *Allegories of Reading*, 292.

32. Barthes, "The Third Meaning," 60.

33. Ibid., 64.

34. Jacques Lacan, "The Function of Language in Psychoanalysis," in *The Language of the Self*, trans. Anthony Wilden (New York: Delta, 1975), 11.

35. Roland Barthes, "Change the Object Itself," in *Image–Music–Text*, 167.

Representation, Appropriation, and Power

This essay juxtaposes two widely divergent approaches to the problem of representation—a problem that has been posed with renewed urgency by the art of the last decade, but misrepresented by its criticism. For what has been celebrated (and, less frequently, denounced) as a *return to* representation after the long night of modernist abstraction is in many instances a *critique of* representation, an attempt to use representation against itself to challenge its authority, its claim to possess some truth or epistemological value. Criticism, however, has subsumed this impulse under the dubious banner of a revival of figurative modes of expression; for a theoretical discussion of the issues raised by contemporary art, we must therefore look elsewhere—to the group of Continental critics known as the poststructuralists, whose work has also been identified as a critique of representation.

The poststructuralist critique of representation could not contrast more sharply with both traditional and revisionist art-historical treatments of the same problem. In the following pages, I will discuss these two approaches as exemplifying the difference between a discipline (art history) which believes representation to be a disinterested and therefore politically neutral activity, and a body of criticism (poststructuralism) which demonstrates that it is an inextricable part of social processes of domination and control. No attempt is made to mediate or reconcile these two positions; rather, I hope to demonstrate their incompatibility. Thus, my working hypothesis throughout is that the poststructuralist critique could not possibly be absorbed by art history without a significant reduction in its polemical force, or without a total transformation of art history itself.

ART HISTORIANS AND POSTSTRUCTURALISTS

Devotion to truth and precision of scientific method arose from the passion of scholars, their reciprocal hatred, their fanatical and unending discussions and their spirit of competition—the personal conflicts that slowly forged the weapons of reason.

— MICHEL FOUCAULT, "Nietzsche, Genealogy, History"

My subject will be a specific network of images and texts, paintings and the commentaries that frame them, that articulates the link between representation and power in our culture, as well as the problem this link poses for art-historical inquiry. This network is not my own device, but emerged in the course of a panel ostensibly devoted to "The Applicability of Literary Critical Methodology to the Analysis of Painting" held at last December's [December 1981] convention of the Modern Language Association (a professional organization of literary scholars and teachers roughly equivalent to the College Art Association). Although this event provides the pretext for my remarks, I will not limit myself to it.

Two of the commentaries that I will consider are not by art historians, but by critics who explicitly reject the division of intellectual labor into discrete disciplines: Michel Foucault's famous analysis of *Las Meninas* in the opening chapter of *Les mots et les choses* (English translation: *The Order of Things*), and Louis Marin's complementary analysis of the *Arcadian Shepherds* in his article "Towards a Theory of Reading in the Visual Arts."[1] These commentaries are linked not only by the contemporaneity of the paintings they discuss—Velázquez painted *Las Meninas* in 1656; although Poussin produced two versions of the *Arcadian Shepherds*, the one that concerns us is dated by Anthony Blunt "after 1655"—but also by method and intent. Both Foucault and Marin interpret these works as "representations of [Classical, i.e., 17th-century] representation," and this they do in order to demonstrate not their uniqueness, but their conformity with the anonymous, impersonal rules which regulated the Classical system of representation.

Foucault and Marin were not present at the MLA; their arguments were, however, represented there by two art historians, Svetlana Alpers and Michael Fried, who assessed their value for art-historical studies. While both Alpers and Fried address their work primarily to a literary audience—their recent essays have appeared in such journals as *Critical Inquiry* and *New Literary History*—and while neither objects, at least in principle, to the transfer of textual analysis to the visual arts, both spoke of the dangers involved in this displacement, citing Foucault on Veláz-

quez and Marin on Poussin as examples. Alpers criticized Foucault for neglecting the specific *pictorial* traditions out of which, in her view, *Las Meninas* was composed, while Fried rejected as "ahistorical" and "reductive" Marin's use of a linguistic distinction to define the structure of history painting. Despite the fact that neither Alpers nor Fried professes any particular affection for their own discipline—both prefaced their remarks by stating their alienation from art history—their negative judgments on Foucault and Marin, ultimately pronounced in the name of art-historical "truth," confirm Freud's remarks, in his 1925 paper on "Negation," on the psychological origins of intellectual judgment:

> To deny something in one's judgment is the same thing as to say: "That is something that I would rather repress." A negative judgment is the intellectual substitute for repression; the "No" in which it is expressed is the hallmark of repression, a certificate of origin, as it were, like "Made in Germany."[2]

The work of Foucault and Marin is indeed something that art history (which was, after all, made in Germany) would rather repress. For although Alpers's analysis of *Las Meninas* might seem, as we shall see, to support rather than refute Foucault's reading of the painting, and while Fried's discussion of the role of the viewer in late 18th- and early 19th-century French painting turns on the same dialectic of affirmation and negation as Marin's treatment of the same problem in the 17th century, Foucault and Marin's mutual concern with the *conventionality* of works of art, their tendency always to *conform* to certain institutional specifications, stands in direct conflict with Alpers and Fried's (and the majority of their colleagues') interest in the *individuality,* the *singularity* of both works and periods of art. Thus, Foucault's and Marin's arguments ultimately discredit Alpers's assessment of the originality of Velázquez's achievement and Fried's claim for the historical specificity of his own argument.

The question before us, then, is not, as Alpers proposed, whether Foucault has served *Las Meninas* well (her answer was that "he has served the painting well, but not truly") but whether Alpers and Fried have served Foucault and Marin well. And the answer is that they have not; in fact, Foucault and Marin were *mis*represented on this occasion in at least two significant ways.

Although their work has been absorbed into the American academy primarily as "literary criticism" and ghettoized in departments of English and Comp Lit, neither Foucault nor Marin attends primarily to the literary text; like their colleagues Jacques Derrida and Roland Barthes,

both have written (Marin extensively) on the artifacts of visual culture. Their methods, moreover, are hybrid, combining as they do philosophical, literary, scientific and historical modes of analysis. To present their work on a panel devoted to the applicability of *literary* criticism to painting without acknowledging its "multidisciplinary" character was to distort its basic polemical thrust. For poststructuralist criticism is an adversarial criticism, conceived in opposition to a dominant cultural order that isolates knowledge into various branches, each endowed with its own object of study and methodological instruments.[3] (Thus, Foucault lectures in the "history and systems of thought," while Marin teaches the multidisciplinary field of semiotics.)

Moreover, neither Alpers nor Fried acknowledged the most important—and most radical—aspect of Foucault's and Marin's work on representation, and that is their attempt, in Marin's words, "to explore representational systems as apparatuses of power." Both work to expose the particular interests which all representations serve, their affiliations with classes, offices, institutions. For example, in "Fantasia of the Library" Foucault discusses Manet's art as "museum painting"—painting as "a manifestation of the existence of museums and the particular reality and interdependence that paintings acquire in museums."[4] And in his most recent book, *Le portrait du roi,* Marin treats the artistic productions of the court of Louis XIV, from its architecture through its entertainments, as manifestations of the absolute, unlimited power of the King.

To investigate representational systems as apparatuses of power is not to study their appropriation by those in power for political or propagandistic purposes—despite the fact that the histories of art and architecture are composed primarily of such monuments to authority. Nor is it to decipher the ideological messages encoded therein; Foucault and Marin must be distinguished from those ideological critics—Marxist or otherwise—who would interpret a work's implicit content. Foucault and Marin do not interpret works of art, if to interpret them is to assign them a meaning. They are interested less in what works of art *say*, and more in what they *do*; theirs is a performative view of cultural production. Thus, Foucault and Marin investigate representation not simply as a manifestation or expression of power, but as an integral part of social processes of differentiation, exclusion, incorporation, and rule. Both work to expose the ways in which domination and subjugation are *inscribed within* the representational systems of the West. Representation, then, is not—nor can it be—neutral; it is an act—indeed, the founding act—of power in our culture.

The second half of this essay will be devoted to the poststructuralist critique of representation and its relevance for contemporary artistic production. For the moment, however, I want to consider the implications of art history's resistance to poststructuralism. Art historians might be expected to embrace Foucault and Marin, who have contributed immeasurably to our understanding of the ways in which artistic production participates in larger social and historical processes. In recent years there has been growing art-historical interest not only in the problem of visual representation per se, but also in the contextual or circumstantial analysis of works of art, in such topics as Medici iconography or royal patronage, where art is explicitly linked with power. Why, then, have Foucault and Marin been ignored? Why is their work considered to be "dense," "difficult," "irrelevant"? Could it possibly be because art history—conceived, in Panofsky's phrase, as a humanistic discipline—is itself implicated in the poststructuralist critique?

Although all attempts to characterize intellectual movements are condemned from the outset to a distressing superficiality, a few words on the impulse that motivates poststructuralist criticism may help to elucidate the great divide that separates it from art history. Poststructuralism emerged in a social and political climate—post-1968 France—of growing disaffection with the terms and conditions of humanist discourse. For the humanist notion of "universal Man" is fashioned in the image of Western European man and his civilization. All other races and cultures are marginalized, and within the West all difference, nonconformity, divergence from the norm is either confined or expelled. The current political and economic crisis of the West—the emergence of Third World nations, the women's movement, increasing restrictions in socioeconomic life, general ecological catastrophe . . . —has begun to expose the exclusionary character of humanist discourse; the poststructuralist critics work to articulate its basic presuppositions, and to disarticulate them as well, to expose their internal contradictions and their complicity with a dominant social and cultural order.

Thus, all of the poststructuralists have examined to varying degrees their own implication in an academic system that submits and thereby confines the intellectual to a discipline. If they refuse to remain decorously within the boundaries of a single area of competence, this is because they view the "humanities" themselves as products of a systematic activity of restriction and exclusion engineered to control the production of knowledge in our society. Despite their claim to disinterestedness, the humanities actually work to legitimize and perpetuate the hegemony of Western European culture: the history of art, for example, is the history

of Western European art, from its origins in the ancient world through its culmination on this continent. This is not, as we shall see, the only way art history collaborates with power; it does, however, signal the necessity for a thorough reevaluation of the humanistic principles upon which art history is based.

ART HISTORY AS A HUMANISTIC DISCIPLINE

The humanities . . . are not faced with the task of arresting what might otherwise slip away, but of enlivening what might otherwise remain dead.

— ERWIN PANOFSKY, "Art History as a Humanistic Discipline"

Art history is a highly contentious discipline, characterized by internecine debate, competition, and personal conflict; the vehemence with which art historians argue among themselves is surpassed only by the enthusiasm with which they band together in order to defend their own proprietary rights. Thus, despite differences in their work (which center mainly on the issue of history), Alpers and Fried presented the MLA with a united front. The air of mutual congratulation that pervaded the panel was not, however, primarily a matter of scholarly decorum, but a function of their common purpose on this occasion: to shore up the boundaries of art history against a poststructuralist invasion.

This reaction is characteristic of the art-historical reception of the writings on art not only of the poststructuralists, but of all nonspecialists. To cite but one example: At the beginning of her review [*Art in America,* March–April 1979] of Meyer Schapiro's selected papers on *Modern Art,* Linda Nochlin adduced, as proof of both Schapiro's and art history's preeminence, his debate with German existential philosopher Martin Heidegger over an 1886 or '87 van Gogh painting (usually referred to as *Old Shoes*). The painting depicts two well-worn, perhaps discarded boots, their laces undone, their soles gaping. In "The Origin of the Work of Art" (1935–36)—which stands, along with Kant's *Critique of Judgment* and Hegel's *Lectures on Esthetics,* as one of the three great meditations on art in the history of modern philosophy—Heidegger identified those boots as a "pair of peasant women's shoes," claiming rather sentimentally that "from the dark opening of the worn insides the toilsome tread of the worker stares forth."[5] In a rejoinder to Heidegger, published in 1968, Schapiro dismissed this interpretation as "fanciful," claiming that the painting does not, in fact, represent a pair of peasant

woman's shoes at all, but the artist's own shoes, and must therefore be interpeted as a (displaced or metonymic) self-portrait. (Schapiro's text, "On the Still Life as Personal Object," is thus a restatement of the theory of still life as self-portraiture developed in his writings on Cézanne.)[6]

In her review, Nochlin presents Schapiro's litigious text not only as evidence of his uncommon intellectual prowess—for what other art historian would have challenged the greatest philosopher of our century?— but also as a victory of art history over philosophy. Dismissing what she considers to be "metaphysical cant," she writes, "In attempting to endow art with lofty metaphysical *power*, Heidegger has lost touch with what makes art, rather than the objects it *represents*, important" (italics added). Schapiro's great service to his field, then, is to have reclaimed art for the art historian by wresting it from the hands of the philosopher.

There is irony here, however, for Nochlin presumes that Schapiro had the last word in this debate, ignoring the fact that the Heidegger-Schapiro case had been reopened two years earlier by another poststructuralist critic, Jacques Derrida, in a lecture delivered at Columbia and published the subsequent year in his book of essays on painting.[7] In that text—titled "RESTITUTIONS / de la vérité en pointure," roughly, "Restitutions of the truth of pa(o)inting"—Derrida does not defend Heidegger against Schapiro's attack; nor does he adjudicate between their conflicting claims. Rather, he demonstrates that there is, in fact, no contest. For Heidegger and Schapiro are in perfect agreement; confronted with the painting, both ask themselves the same question: "Whose shoes are these?" "To whom do they refer?" "Whom do they *represent*?" Both presume that, if they are to interpret the painting, they must first attribute the boots to the specific human subject to whom they may be said to belong. Thus, both interpretations rest upon an initial substitution: of the person for the thing, the animate for the inanimate, the organic for the inorganic. This substitution is not, however, preliminary to the interpretation of the painting—it *is* the interpretation of the painting. For once the identity of the owner of the shoes has been established, everything else falls effortlessly into place.

In this way, both Heidegger and Schapiro have achieved the humanistic goal defined for art history by Panofsky: both have indeed *enlivened* what might otherwise have remained dead, inert, senseless—despite (or rather because of) the fact that it is precisely this inertia, this senselessness, that the painting appears to depict. Both proceed according to the principles not only of humanism, but of humanist historicism, which wants not merely to reconstruct the past, but to reanimate it—and, in its most extreme instance, to *relive* it.[8] By treating the work of art as inert

until the historian breathes life—sense—into it, both Heidegger and Schapiro exemplify what Derrida identifies as the fundamentally compensatory relation of art history to its objects, its tendency always to respond to what is believed to be a basic deficiency or lack within the work, which must therefore be supplemented by interpretation.

What is more, in both cases this restitution—of the "truth" of the painting—is accomplished according to an identical process of *attribution* (of the shoes to their owner). An attribute is always a property. In painting and sculpture, attributes are (usually inanimate) objects which belong to a specific figure and enable us to establish its identity; hence the role of the attribute in iconographic analysis (Panofsky: "If the knife that enables us to identify St. Bartholomew is not a knife but a corkscrew, the figure is not St. Bartholomew"). But formal or stylistic analysis is also concerned with attribution: not only is it addressed to what are believed to be the intrinsic *properties* of works of art; connoisseurship treats the work of art itself as an attribute that allows us to identify the artist (or, less frequently, the historical period) to which the work belongs. At its inception, art history was conceived as a science of attribution whose function it was to rescue late medieval and Renaissance works of art by restoring them to their authors. Although most works of art have by now been so restored, Schapiro's response to Heidegger indicates that debates over attribution—whether of paintings to their authors or the objects they depict to their putative owners, but in both cases to a specific human subject—remain central to art-historical speculation.

Elsewhere, Schapiro formulates the principles upon which his attribution of the shoes to van Gogh, and his entire theory of still life as self-portraiture, are based; his vocabulary alerts us to what is at stake here (I have italicized the relevant phrases):

> Still life . . . consists of objects that . . . whether artificial or natural, are *subordinate to man* as objects of *use, manipulation and enjoyment*; these objects are smaller than ourselves, within arm's reach, and *owe their presence and place to a human action or purpose.* They convey *man's sense of his power over things* in making or utilizing them.[9]

In this passage, representation communicates with power via the medium of possession (use, enjoyment). Thus, we can identify the motives of art history, at least insofar as it is practiced as a humanistic discipline: a desire for *property*, which conveys man's sense of his "power over things"; a desire for *propriety*, a standard of decorum based upon respect for property relations; a desire for the *proper name*, which designates the specific person who is invariably identified as the subject of the work of

art; finally, a desire for *appropriation*. For the Heidegger-Schapiro debate is basically a contest over the *proprietorship* of the image. As Derrida observes, in attributing the boots to the peasant woman or the artist, Heidegger and Schapiro have actually claimed them for themselves, via their own identifications with the peasant and the cosmopolitan:

> To say "This (this painting or these boots) refers to X" is to say "This refers to myself" via the detour of "This refers to *a* self." Not only "This is someone's property," but also "This is *my* property." For among the many identifications at work here, we cannot overlook Heidegger's identification with the peasant and Schapiro's with the city-dweller, the former's with the enracinated native, the latter's with the uprooted emigré.[10]

REPRESENTATION

All art is "image making" and all image making is the creation of substitutes.

— E. H. GOMBRICH, "Meditations on a Hobby Horse"

What sanctions both Heidegger's and Schapiro's appropriation of the painting is a view of representation as substitution: the image is treated as a stand-in or replacement for someone who would not otherwise appear. Art historians have always tended to define representation in this way, despite Alpers's assertion that they lack an operative concept of representation and are therefore incapable of dealing with works like *Las Meninas*—works, that is, which she believes to be "self-conscious and rich in those representational concerns to which literary studies have been more attuned." She attributes this deficiency—which she proposes to supplement—to art history's iconological project as formulated by Panofsky in the introduction to his *Studies in Iconology*, specifically, to his distinction between subject matter or meaning on the one hand and form on the other:

> When an acquaintance greets me on the street by removing his hat, what I see from a formal point of view is nothing but a change of certain details within a configuration forming part of the general pattern of color, lines and volumes which constitutes my world of vision. . . . However, my realization that the lifting of the hat stands for a greeting belongs to an altogether different realm of interpretation.[11]

Alpers balks when Panofsky transfers the results of this encounter to painting: "What Panofsky chooses to ignore is that the man is not present but represented in the picture." Yet if in this passage Panofsky

fails to adddress the problem of representation, we cannot therefore conclude that he lacks a theory of representation. As his essay "Perspective as Symbolic Form" makes abundantly clear, Panofsky defines representation as a symbolic activity, as opposed to the replication of visual experience (representation as imitation or illusion).

Alpers attributes this second view to Gombrich, claiming that his famous phrase "Making comes before matching" indicates that he views representation as illusion, and therefore primarily as a matter of imitative skill. Yet the citation at the beginning of this chapter indicates that he too views representation as a symbolic activity, the creation of substitutes (this is in fact what "Making comes before matching" means). In "Meditations on a Hobby Horse," Gombrich opposes his own view of representation to what he identifies as the "traditional view": representation as imitation. Illusion, according to Gombrich, is only secondary, something that may be added or superadded to a representation, but which is in no way essential to it.

It could be demonstrated that art history has always defined representation in relation to these two activities—substitution or imitation—and that they correspond perfectly with the German *Vorstellung*—representation, in the sense of a symbolic activity—and *Darstellung*—presentation, in the sense of a theatrical presentation. (Thus, the distinction may be primarily linguistic.) The first, or symbolic mode is the mode of substitution; the image is conceived as a replacement, a stand-in, and therefore as compensating for an *absence*. The second, or theatrical mode is the mode of repetition; the image is defined as the replica of a visual experience, and the artist works to promote the illusion of the tangible, physical *presence* of the objects he represents. Thus, art historians have always located representation in terms of the poles of absence and presence which, as Derrida has shown, constitute the fundamental conceptual opposition upon which Western metaphysics is based.[12] What is needed, then, is not a concept of representation (for we already have two), but a critique.

As Gombrich testifies, these two modes of representation are far from evenly matched; art historians have tended always to introduce the concept of imitation only to dismiss it as inessential, supplementary, even *erroneous*. Thus, Wölfflin prefaces his discussion of "The Most General Representational Forms" with the remark: "It is a mistake for art history to work with the clumsy notion of the imitation of nature, as though it were merely a homogeneous process of increasing perfection."[13] The illusionistic image is even suspected of fraud, of attempting to pass for something it is not (direct visual experience); motivated by a Platonic

distrust, art historians have tended to suspend or bracket the referent; they work to distinguish images from the objects they represent by restricting themselves to what is specific, *proper* to representation itself. (Thus, Schapiro: "I find nothing in Heidegger's fanciful description of the shoes represented by van Gogh that could not have been imagined by looking at a real pair of peasants' shoes.")

So accustomed have we become to this formulation of the problem of representation—through works of art that call attention to their own material properties, and through an art history that teaches us to view them as more or less harmonious or dissonant combinations of lines and colors—that we may have difficulty in appreciating what Foucault and Marin identify as the absolutely fundamental condition of representation, at least as it was conceived in the 17th century, and that is its *transparency* (which is not the same thing as illusionism). In the Classical system of representation as formulated by the Port-Royal logicians, the sign is entirely ordered by and dependent upon what it signifies: "It is characteristic," Foucault writes, "that the first example of a sign given by the *Logique de Port-Royal* is not the word, nor the cry, nor the symbol, but the spatial and graphic representation—the drawing as map or picture. *This is because the picture has no other content in fact than what it represents.*" [14]

To claim that representation is transparent to its objects is not to define it as mimetic or illusionistic—maps, for example, do not simulate visual experience. Rather, it means that every element of the work of art is *significant,* that is, it refers to something that exists independently of its representation. Thus, "transparency" designates a perfect equivalence between reality and its representation; signifier and signified mirror one another, the one is merely a reduplication of the other. Yet such transparency can be achieved only through a strategy of concealment: for example, the legendary transparency of the picture plane prescribed in Alberti's *Della Pittura* was attained only by effacing the image's material support. Thus, Marin writes of a specific pictorial tradition, running from the Renaissance at least through the 17th century and embodied in the institution of single-point perspective (perspective is, literally, seeing through, *per-specere,* trans-parency): "The material elements of the representation—and precisely the traces left by the painter's work, by his transformative activity in the painting—have to be erased or concealed by what the painting represents, by its 'objective reality.'" Thus, when Foucault and Marin attend to the problem of visual representation, they work to articulate—to render visible—those implicit, invisible strategies and tactics whereby representation achieves its putative trans-

parency; neither is interested in what representation reveals, but in what it *conceals.*

THE PLACE OF THE VIEWER

A text is made of multiple writings, drawn from many cultures and entering into mutual relations of dialogue, parody, contestation, but there is one place where this multiplicity is focused and that place is the reader, not, as was hitherto said, the author.

— ROLAND BARTHES, "The Death of the Author"

Panofsky's man on the street in fact alerts us to what Classical representation would conceal, thereby achieving its essential transparency: the fact that paintings are messages addressed to a viewer with the intention of influencing his beliefs or modifying his behavior in one way or another. They have what linguists call a pole of emission and a pole of reception; these two poles constitute a painting's "representational apparatus." Although this communicational model of pictorial practice is far from unproblematic (in part because it appears to resurrect the discredited category of intentionality), it sensitizes us to the fact that the viewer's relation to a work of art is prescribed, assigned in advance by the representational system.

Because works of art tend, as often as not, to efface these two poles in favor of the message they relay, art-historical inquiry has generally neglected them; Alpers and Fried, however, are to be counted among a handful of art historians who have recently begun to attend, not to problems of style or iconography, but to the position of the viewer in front of the work of art, thus moving into the territory known, in literary studies, as reception esthetics.

There is, however, at least one art-historical precedent for this attention to the role of the viewer, and that is the work of Leo Steinberg. Steinberg's sensitivity to the viewer has informed all of his work. In "The Philosophical Brothel," in which he traces the evolution of Picasso's *Demoiselles d'Avignon,* Steinberg's treatment of the viewer's relationship to the painting rests upon what is ultimately a linguistic metaphor: the painting's mode of address. Early sketches show a young man entering the brothel stage right; in the final painting, Steinberg argues, the role of this figure, who appears to command the scene, has been transferred to the viewer. Thus, the decisive moment in the creation of the *Demoiselles,* the point at which its *mise en scène* fell into place, is

a shift from a narrative or a third-person mode of address to a second-person mode in which the painting confronts—indeed, *propositions*—the spectator.

"No other painting," Steinberg writes, "(*Las Meninas* excepted) addresses the spectator with comparable intensity."[15] And when we turn to Alpers's discussion of *Las Meninas,* we find that it relies upon the same linguistic metaphor, even though she has set out to demonstrate, *contra* Foucault, that *Las Meninas* was fabricated out of specific *pictorial* traditions. In her view, *Las Meninas* embraces two modes of visual representation, "each of which constitutes the relationship between the viewer and the picturing of the world differently." Alpers's initial characterization of these two modes proceeds according to long-standing art-historical polarities. The first mode is Southern, exemplified by the conventions of Albertian perspective: "The artist presumes himself to stand with the viewer *before* the pictured world"—that is, both outside and prior to it. The second mode is Northern, descriptive; the world offers images of itself (as in a mirror or camera obscura) "without the intervention of a human maker," and is thus "conceived as existing prior to the artist-viewer."

When Alpers reiterates the difference between these two modes in a single sentence, however, the linguistic metaphor rises to the surface: "The artist in front of the first kind of picture claims that 'I see the world,' whereas the second shows rather that 'it is seen.'" Alpers's distinction corresponds perfectly to Émile Benveniste's distinction, in his *Principles of General Linguistics,* between discursive and historical (or narrative) statements (*discours/histoire*). Benveniste divides language into two "enunciative systems." The first, discourse, is characterized by the use of the first- and second-person pronouns and adverbial forms such as "here," "there," "now," and "then" which refer to the spatial and temporal situation in which statements take place. Discursive statements thus presuppose a speaker and a listener, as well as "the former's intention to influence the latter in some way or another."[16]

Historical (or narrative) statements, on the other hand, are characterized by the *suppression* of all reference to both speaker and listener, as well as to the spatial and temporal situation of utterance.

> In order for there to be narrative [Benveniste writes], it is necessary and sufficient that the author remain faithful to his enterprise as historian and banish all that is foreign to the narration of events (discourse, personal reflections, comparisons). . . . Events are set down as they occurred, as they gradually appear on the horizon of the story. Nobody is speaking here. *Events seem to narrate themselves.*

Although Alpers does not acknowledge this correspondence, she proceeds to read *Las Meninas* as the compounding—"in a dazzling but fundamentally unstable and unresolvable way"—of these two modes of representation-enunciation. Thus, she proposes that the viewer's relation to the depicted scene is profoundly paradoxical:

> The world seen that is prior to us is precisely what, by looking out (and here the artist is joined by the princess and part of her retinue), confirms or acknowledges us. But if *we* had not arrived to stand before this world to look at it, the priority of the world seen would not have been defined in the first place. Indeed, to come full circle, the world seen is before us because we (along with the King and Queen as noted in the distant mirror) are what commanded its presence.

This circularity, Alpers concludes, is what is so "extraordinary" about *Las Meninas.*

Is this where interpretation comes to rest? Does this circularity between viewer and viewed truly define the originality of Velázquez's achievement in this painting? Does it adequately account for the specificity of *Las Meninas*? What if it could be demonstrated that this combination of two antithetical modes of representation-enunciation is not peculiar to *Las Meninas,* or even to Velázquez, but exists in other 17th-century paintings as well? And what if it is not peculiar to painting, but is shared by literature? (In fact, Marin demonstrates that the rules of grammar and logic as formulated by the 17th century attributed this coexistence of two apparently incompatible modes to every statement.) What if, finally, the circularity that Alpers finds in *Las Meninas* ultimately defines what Foucault calls the Classical *episteme*—the horizon within which all knowledge was contained, the limit that circumscribed what it was possible to say, to depict, even to think in the 17th century? Then Velázquez's achievement could no longer be described as an *original* compounding of two distinct representational modes, but the unfolding, on the surface of his canvas, of the Classical system of representation itself—which is what Foucault has claimed for it all along.

REPRESENTATION AND PROPERTY

By calling the people his private property the king is merely declaring that the owner of private property is king.

— MARX, "A Contribution to the Critique of Hegel's Philosophy of Right"

In *Other Criteria,* Steinberg describes *Las Meninas* as an "inventory of the three possible roles assignable to a picture plane"—window, mirror, and

painted surface—which are "paraded in sequence" across the back wall of Velázquez's palace studio. These three elements—the first and last of which are reiterated in the implied window and reversed canvas that frame the central scene—represent the multiple roles played by the surface of *Las Meninas* itself: a window through which we perceive the scene *and* a mirror in which it is perceived (by the painter depicted within it). Steinberg reminds us, however, that "17th-century interiors often juxtapose a doorway or window view with a framed painting and, next to that, a mirror filled with a reflection."[17] His characterization of the painting as an "inventory" thus contradicts Alpers's assessment of Velázquez's "dazzling but fundamentally unstable and unresolvable" achievement. What Alpers identifies as specific to this painting Steinberg views as typical of 17th-century painting in general.

For Marin, the coexistence within a single work of art of the same two apparently incompatible modes—painting-as-window and painting-as-mirror—is not only typical, but the very foundation upon which the Classical system of representation was erected. Thus, he defines its "contradictory axioms":

> (1) The representational screen is a transparent window through which the spectator, Man, contemplates the scene represented on the canvas as if he saw the real scene represented in the world; (2) but at the same time, that screen—actually a surface and a material support—is also a reflecting device on which the real objects are pictured.

The first axiom, painting-as-window (equivalent to Benveniste's level of discourse), attributes the image to a specific human subject—the "eye/ I" who occupies the vantage point in the system of single-point perspective—who has substituted for things his representations of them and may therefore claim the representation as his, as one of the modes of *his* vision, *his* thought. However, in the second axiom, painting-as-mirror (equivalent to the level of history), this subjective viewer disappears, and the world therefore seems to represent itself without the intervention of an artist. The second axiom thus postulates perfect equivalence between reality and its representation, so that representations "can ontologically appear as the things they represent, ordered in a rational and universal discourse, the discourse of reality itself." It is through the suppression of all evidence of the representational apparatus, then, that the authoritative status of Classical representation, its claim to possess some truth or epistemological value, is secured.

(The role of the mirror in establishing the truth-value of pictorial representation is also discussed by Steinberg in a lecture on *Las Meninas*,

written in 1965 and delivered many times since but published only recently: "We discover that Velázquez' summary looking glass conflates two distinct things into one: what the king and queen see from their station and what we see from ours—the real thing and the painting of it—the mirror reveals as identical, as if to grant that the masterpiece on the canvas mirrors the truth beyond any mirror's capacity to surpass. In this sense, *Las Meninas* may be said to celebrate the truthfulness of the painter's art.")[18]

In order to explain how these contradictory axioms can coexist in a single painting, Marin synthesizes Benveniste's observation that historical statements are characterized by the *suppression* of all marks of emission and reception with Freud's hypothesis that all negation is actually (a disguised or displaced form of) affirmation. (When a patient says, "You ask who this person in the dream can have been. It was *not* my mother," Freud comments, "We emend this: 'So it *was* his mother.'")[19] Thus, Marin deduces what he calls the "negation-structure" of Classical representation:

> The canvas as a support and as a surface does not exist. For the first time in painting [Marin is discussing Brunelleschi's perspective constructions], Man encounters the real world. But the canvas as a support and as a surface exists to operate the duplication of reality: the canvas as such is *simultaneously posited and neutralized*, it has to be technically and ideologically assumed transparent. Invisible and at the same time a necessary condition of visibility, reflecting transparency theoretically defines the representational screen.

This simultaneous affirmation and negation of the representational apparatus not only secures the transparency of Classical representation; at the same time it defines the (ontological and epistemological) status of the subject of representation. For if, in the first axiom, the representation is attributed to a specific human subject who "appropriates things, reality as *his* things, *his* reality," the second axiom establishes that "such a subject is not located in space and time with all their determinations, but acts as a universal and abstract mind whose only function is to judge of things and affirm them." (In Classical political theory, of course, this function was attributed only to the King, the impartial, universal judge.)

In the Classical system of representation, then, the subject of representation is posited as absolutely *sovereign*. In other words, the person who represents the world is transformed, through the act of representation, from a subjective being enmeshed in space and time—by which he is, in a sense possessed—into a transcendent, objective Mind that ap-

propriates reality for itself and, by appropriating it, dominates it. Here is Marin's description of this operation:

> We may understand this process as one by which a subject inscribes himself as the center of the world and transforms himself into things by transforming things into *his* representations. Such a subject has the right to possess things legitimately because he has substituted for things his signs, which represent them adequately—that is, in such a way that reality is exactly equivalent to his discourse.

Representation is thus defined as appropriation and is thereby constituted as an apparatus of power. Marin's analysis stops here; his treatment of Classical representation can, however, be situated in terms of 17th-century social and economic life, in order to expose the essentially political function which representation served. We must not automatically assume that appropriation equals property, despite Locke's famous 1690 definition: "Whatsoever that he removes out of the State that Nature hath provided, and left it in, and joyned to it something of his own, and thereby makes it his *Property*."[20] Prior to Locke, however, the concepts of appropriation (labor) and property were mutually exclusive; property was acquired through inheritance, conquest, or legal division, but never through labor (which was associated not with wealth but with poverty).[21] Locke's idea that a man has a natural right to property created by his labor was thus a radical formulation, and it certainly did not correspond to the economic and political realities of the 17th century.

In the feudal mode of production, the worker had no legal right to the fruits of his own labor, which accrued to the owner of the land. Landed property was equivalent to political power; economics and politics were inextricably intertwined.[22] However, in the absolute monarchies that emerged from the feudal mode of production to dominate Europe from the 15th through the 18th centuries—and were thus coeval with the Classical system of representation—economic and political interests were, at least theoretically, distinct.[23] The principal feature of the Absolutist state was its revival of Roman law, which rigorously distinguished the economic rights determined by private property from the absolute authority vested in the state. Roman civil law (*jus*), which regulated the economic transactions among men, was based on the absolute and unconditional character of private property; Roman public law (*lex*), however, which governed the political relations between the state and its subjects, counterbalanced the juridically unconditional character of private property with the formally absolute nature of imperial sovereignty.

By reviving Roman law, the Absolutist states of early modern Europe reintroduced this separation of the economic and political spheres: power was consolidated in a central monarchy, whose sovereignty was absolute; at the same time, the property titles of the feudal aristocracy were strengthened. The same historical process that reduced the political power of the aristocracy thus compensated this loss by granting them unprecedented gains in ownership. This was the basic contradiction upon which the social structure of the Absolutist state was based—a contradiction that ultimately led to its demise. The absolute sovereignty of the King gave him the power to override medieval privileges and ignore traditional property rights; paradoxically, it was precisely those privileges and rights that had been strengthened with the ascendancy of Absolutism. As a result, the history of the Absolutist state is primarily the history of the conflicting claims of the monarchy and the aristocracy to political power.

In *Tristes Tropiques* Claude Lévi-Strauss proposes that works of art can be read as imaginary resolutions of real social contradictions;[24] the Classical system of representation is indeed constituted in such a way as to facilitate precisely such a resolution. Its two contradictory axioms reproduce the two antithetical poles—property/sovereignty—that define the social contradictions that traverse the Absolutist state. In Classical representation, this antinomy is resolved through the dialectic of affirmation and negation, through which the conflicting claims of property and sovereignty are made to coincide. For the axiom that defines representation as the property of a specific individual depends, for its legitimacy, on that which defines representation as the expression of abstract, universal truth. And there was no more universal truth, in the ideology of Absolutist rule, than the undisputed fact of the ruler's absolute, God-given supremacy.

It is hardly inconsequential that the feudal principles of territorial lordship and, with them, the political power vested in landed property, persisted most strongly throughout the age of Absolutism in Spain, where they ultimately contributed to the collapse of the Hapsburg dynasty.[25] And now, perhaps, we can begin to understand the implications of Foucault's placement of *Las Meninas* at the very beginning of his analysis of the Classical *episteme,* as well as his enigmatic assertion that Velázquez's painting represents the *absence* of the subject of representation—"of the person it resembles and the person in whose eyes it is only a resemblance." In *Las Meninas* these two "subjects" are made—invisibly—to coincide.

The painting, of course, is focused on a central point—defined by the

architecture of gestures and gazes that cuts across and subtends the perspective construction of space—that is clearly occupied by the person for whom this scene exists, who may claim this representation as *his*. (This person is also the model whose image Velázquez presumably traces on the canvas depicted within the painting.) This focal point of the painting, however, is not contained within the painting itself, but is external to it—as it must be, if Marin's observations on the position of the subject of Classical representation are correct. For if, through representation, the subject is transformed into an abstract, transcendent Mind "whose only function is to judge of things and affirm them," then such a subject can never appear within his own representation. (This absence of the subject from the scene of representation is acknowledged, Foucault claims, within the painting itself by the fact that only the reverse side of the canvas on which his portrait presumably appears is visible to the spectator of *Las Meninas*.)

And yet, following the hypothesis of the negation-structure of Classical representation, this elision of the subject of representation must also be its affirmation. For although the person for whom the representation exists is never to be found within the representation itself, he nevertheless recognizes himself therein, Foucault asserts, in a displaced way—in the form of "an image or reflection."[26] And indeed, in *Las Meninas* the figure who occupies the position of "first viewer"—and whose gaze is therefore prior to the painter's—is reflected within the painting itself by the mirror which disrupts the continuity of the back wall of Velázquez's palace studio. The mirror not only establishes the identity of the person whose representation this is; it also defines the point that he occupies as absolutely sovereign. For it is, as the title of one of Foucault's later sub-chapters indicates, "The Place of the King."

Although that point might also seem to be occupied by the painter, as he stood before *Las Meninas* to paint it, and by the viewer, as he contemplates the image, neither the artist nor the viewer may be said to have usurped the privilege and power that belong to the sovereign alone. For the painting represents not the painter's but the King's vision; Velázquez appears to have abdicated his own role as "author" of the image to that superior authority that sustains him and his art. Indeed, must we not identify Philip IV as the ultimate "author" of *Las Meninas*, just as Marin gives the *Arcadian Shepherds* not to Poussin, but to Cardinal Rospigliosi, who commissioned the painting and invented its program along with the phrase "Et in Arcadia ego"? (Rospigliosi's authorship is acknowledged, Marin argues, within the painting itself by the fact that the index finger

of the shepherd who tries to decipher the inscription on the tomb points to the letter "r" in the word "Arcadia," which is also the central letter of the inscription and which is located at the exact geometrical center of the painting.)

Nor has the spectator of *Las Meninas* usurped the place of the King; for that we will have to wait until the end of the 18th century, when Absolutist rule will be dissolved and Man, as Foucault tells us in the most audacious hypothesis in *The Order of Things,* will make his first appearance on the stage of history. What we are given to contemplate in *Las Meninas* is delimited, circumscribed by the vision of the King; we see no more and no less than what He sees. (This is what I take Foucault to mean when he states that *Las Meninas* depicts the *limits* of Classical representation.) Indeed, the painting works as a trap for the gaze of the viewer, who is summoned by the gazes of the painter and the princess, only to be subjected, through them, to the gaze of the King.

MOURNING MODERNITY

The testing of reality, having shown that the loved object no longer exists, requires forthwith that all the libido shall be withdrawn from its attachments to this object. Against this demand a struggle of course arises—it may be universally observed that man never willingly abandons a libido-position, not even when a substitute is already beckoning to him.

— FREUD, "Mourning and Melancholia"

Marin's discussion of the negation-structure of Classical representation was introduced, at the MLA, not by Alpers, but by Michael Fried, whose recent work has also been devoted to painting-viewer relations—but in radically different historical circumstances. In his book *Absorption and Theatricality* Fried investigates the role of the viewer in the late 18th century, that is, at precisely the moment when the transparency of Classical representation and, with it, its claims to truth, were eclipsed. As Jean Clay observes in his recent book on *Romanticism,* at the end of the 18th century the "transparency [of the picture plane] began to opacify, the [representational] screen to consolidate, [Dürer's] veil to tighten its mesh."[27] As Foucault writes, "The threshold between Classicism and modernity . . . had been definitively crossed when words ceased to intersect with representations and to provide a spontaneous grid for the knowledge of things."[28]

Yet Fried's treatment of the problem of the viewer at the threshold of modernity is remarkably similar to Marin's discussion of the same problem in the 17th century:

> The recognition that paintings are made to be beheld [Fried writes] and therefore presuppose the existence of a beholder led to the demand for the actualization of his presence. . . . At the same time . . . it was only by negating the beholder's presence that this could be achieved: only by establishing the fiction of his absence or nonexistence could his placement before and enthrallment by the painting be secured.[29]

Fried argues, however, that it was *only* "around the end of the 18th century" and *only* in France that "the existence of the beholder, which is to say the primordial convention that paintings are made to be beheld, emerged as problematic for painting as never before." It is not surprising, then, that he should indict Marin's hypothesis as "ahistorical," claiming that his application of Benveniste's structuralist distinction history/discourse is indicative of a search for some "transhistorical operator" that would define the "essence" of history painting. (Here, Fried merely reiterates the by now familiar charge that structuralism is ahistorical; however, the above analysis of the social structure of the Absolutist state demonstrates the historical character of Marin's analysis.)

Fried questions Marin's assumption that, whenever a figure or group of figures in a painting looks out at the viewer as if to acknowledge his presence before the canvas (as in *Las Meninas*), it is the representational apparatus that is being acknowledged. Even this acknowledgment, Fried argues, is historically determined, citing as evidence the fact that, in the contemporary critical reception of Greuze's 1777 *Le Fils ingrat*, the presence of a small boy who appears to gaze out of the canvas at the spectator was not perceived as disruptive of the painting's narrative continuity. But when Marin observes that, in Poussin's *Arcadian Shepherds*, no one appears to address the spectator directly—"except for the existence of the painting and the fact that we are looking at it, nothing in the iconic message marks its emission and reception; that is to say, no figure is looking at us as viewers, nobody addresses us as a representative of the sender of the message"—Fried objects that Marin overlooks what Fried views as "the primordial condition that paintings are made to be beheld."

But how does this "primordial condition" differ from the "transhistorical operators" which Fried categorically rejects? Fried's response would undoubtedly be that even this convention is "primordial" only insofar as it was conceived as such in the late 18th century. (Walter

Benjamin's remarks in "The Work of Art in the Age of Mechanical Reproduction" on the cult-value of primitive works of art, which were not intended primarily for exhibition, would support this point.) But how can a convention be both primordial and historical at the same time, and why is Fried's treatment of 18th-century representational conventions more historical than Marin's discussion of those same conventions as they were conceived by the 17th century?

Fried's skepticism concerning the existence of all such constants may be traced to his critical writings of the late '60s, specifically to the footnotes to "Art and Objecthood," an often-cited attack on minimal sculpture. In the footnotes to that article, Fried emends Clement Greenberg's assertion that "the irreducible essence of pictorial art consists in but two constitutive conventions or norms: flatness and the delimitation of flatness." Admitting that, "in its broad outline this is undoubtedly correct," Fried continues:

> . . . flatness and the delimitation of flatness ought not to be thought of as the "irreducible essence of pictorial art" but rather as something like the *minimal conditions for something's being seen as a painting*; . . . the crucial question is not what these minimal and, so to speak, timeless conditions are, but what, at a given moment, capable of compelling conviction, of succeeding as painting. This is not to say that painting *has no* essence; it *is* to claim that that essence—i.e., that which compels conviction—is largely determined by, and therefore changes continually in response to, the vital work of the recent past. The essence of painting is not something irreducible.[30]

Fried's demand for a radical historicism would appear, at least initially, to coincide with the Nietzschean perception—which has been central to Foucault's work ever since 1970—that what lies behind things "is not a timeless or essential secret, but the secret that things have no essence or that their essence was fabricated in a piecemeal fashion from alien forms."[31] But whereas both Nietzsche and Foucault expose essences as "inventions of the ruling classes," that is, as instruments of power, Fried neutralizes them when he claims that they change only in "relation to the work of the vital past." Although all three writers appear to proceed from the same hypothesis, then, Fried's attempt to preserve the category of essence by historicizing it is the antipode of Foucault's effort to destroy it.

Indeed, Fried's recent historical project is a recuperative one, concerned as it is with tracing the genealogy of his critical position in the '60s—a position developed to support the work of painters like Frank Stella and Morris Louis (and sculptors like Anthony Caro) and to re-

pudiate as theatrical the work of the minimal sculptors, which Fried viewed as representing a falling away from—indeed, the *loss* of—modernist ideals of purity and presentness. Alienated from subsequent developments in art, Fried has retreated into history; and one of the principal features of his recent work is an attempt to reclaim Diderot—who also condemned as theatrical much of the art of his time—for modernity.

In *The Order of Things*, however, Foucault convincingly situates Diderot squarely within the Classical order, citing as evidence his project for an Encyclopedia of all knowledge. Thus, Diderot's demand, in his critical and theoretical writings on art, for the simultaneous affirmation and negation of the viewer's presence before the work of art stands as perhaps the last great statement of the Classical theory of representation. Coming as it does at the twilight of the Classical order, that demand appears as a conservative attempt to make beholding, in Fried's own words, "once again a mode of access to conviction and truth."

Fried's own position at the twilight of modernity is equivalent to Diderot's at the end of the Classical order; thus, it is not surprising that Diderot's conservatism should be something that Fried would rather repress. For as his own work proceeds—Fried has now moved on from Diderot and David to Courbet—more and more it comes to resemble the work of mourning as described by Freud:

> The task is carried through bit by bit, under great expense of time and cathectic energy, while all the time the existence of the lost object is continued in the mind. Each single one of the memories and hopes which bound the libido to the object is brought up and hyper-cathected, and the detachment of the libido from it is accomplished.[32]

POSTSCRIPT: POSTMODERNISM

What Fried's work mourns is, of course, the death of modernism. Postmodernism—like poststructuralism—is a critique of representation, especially as it was conceived by modernism. "Modernism's formulation of the problem of representation," Fredric Jameson writes, "[was] borrowed from a religious terminology which defines representation as 'figuration,' a dialectic of the letter and the spirit, a 'picture language' (*Vorstellung*) that embodies, expresses and transmits otherwise inexpressible truths." Postmodernism, on the other hand, is characterized by its "resolution to use representation against itself to destroy the binding or absolute status of any representation." Thus, Jameson distinguishes between modernist and postmodernist works precisely according to "their rela-

tion to what is called the 'truth-content' of art, its claim to possess some truth or epistemological value." [33]

Jameson is distinguishing the (modernist) films of Syberberg from the (postmodernist) films of Godard. In the visual arts, the postmodernist critique of representation proceeds by a similar attempt to undermine the referential status of visual imagery and, with it, its claim to represent reality as it really is, whether this be the surface appearance of things (realism) or some ideal order lying behind or beyond appearance (abstraction). Postmodernist artists demonstrate that this "reality," whether concrete or abstract, is a fiction, produced and sustained only by its cultural representation. [34]

Much of the best current work deals with images, transmitted through the media, that exploit the documentary status of photographic or cinematic modes of representation. Photography and film, based as they are on single-point perspective, are *transparent* mediums; their derivation from the Classical system of representation is obvious, yet remains to be investigated critically. Artists who deal with such images work to expose them as instruments of power. Not only do they investigate the ideological messages encoded therein, but, more importantly, the strategies and tactics whereby such images secure their authoritative status in our culture. For if such images are to be effective tools of cultural persuasion, then their material and ideological supports must be erased so that, in them, reality itself appears to speak. Through appropriation, manipulation, and parody, these artists work to render visible the invisible mechanisms whereby these images secure their putative transparency— a transparency that stems, as in Classical representation, from the apparent absence of an author.

Thus when Fried—and Alpers—attempt to repudiate the work of writers like Marin and Foucault, they testify to art history's distance from contemporary artistic practice as well. Isolated not only from the most significant body of criticism of the present, but also from its art, art history has denied itself any connection to the vital present—which, as Walter Benjamin understood, is absolutely prerequisite for all historical investigation. Lacking that connection, the art historian lapses into antiquarianism—which may, in the end, be the fate of art history in the postmodern age.

NOTES

1. Louis Marin, "Toward a Theory of Reading in the Visual Arts: Poussin's *The Arcadian Shepherds,*" in *The Reader in the Text,* ed. Suleiman and Crosman

(Princeton: Princeton University Press, 1980), 293–324. All further citations from Marin are from this source.

2. Sigmund Freud, "Negation," trans. Joan Riviere, in *General Psychological Theory* (New York: Collier, 1963), 214.

3. The most illuminating statement of the political implications of both Derrida's and Foucault's criticism is Edward Said, "The Problem of Textuality: Two Exemplary Positions," *Critical Inquiry* 4 (Summer 1978), repr. in *Aesthetics Today* ed. Philipson and Gudel (New York: NAL, 1980), 89.

4. In Michel Foucault, *Language, Counter-Memory, Practice,* ed. Donald F. Bouchard (Ithaca: Cornell University Press, 1977), 92.

5. Martin Heidegger, "The Origin of the Work of Art," in *Poetry, Language, Thought,* trans. A. Hofstadter (New York: Harper & Row, 1971), 33–34.

6. Meyer Schapiro, "The Still Life as Personal Object—A Note on Heidegger and van Gogh," in *The Reach of Mind: Essays in Memory of Kurt Goldstein* ed. M. L. Simmel (New York: Springer, 1968), 206–08.

7. Jacques Derrida, *La vérité en peinture* (Paris: Flammarion, 1978), 291–436.

8. Thus Walter Benjamin, in his "Theses on the Philosophy of History," characterizes the method with which historical materialism has broken: "To historians who wish to relive an era, Fustel de Coulanges recommends that they blot out everything they know about the later course of history." *Illuminations,* trans. Harry Zohn (New York: Schocken, 1969), 256.

9. Meyer Schapiro, "The Apples of Cézanne," in *Modern Art: Selected Papers* (New York: Braziller, 1978), 19.

10. Derrida, *La vérité en peinture,* 297.

11. Erwin Panofsky, *Studies in Iconology* (New York: Harper & Row, 1962), 3–4.

12. Derrida not only exposes this opposition; he calls for its dissolution. See *Of Grammatology,* trans. G. C. Spivak (Baltimore: Johns Hopkins University Press, 1976), passim.

13. Heinrich Wölfflin, *Principles of Art History,* repr. Spencer, ed., *Readings in Art History* (New York: Scribners, 1969), vol. II, 157.

14. Michel Foucault, *The Order of Things* (New York: Pantheon, 1971), 64.

15. Leo Steinberg, "The Philosophical Brothel," *Artnews* (September 1972), 20.

16. Émile Benveniste, *Problèmes de linguistique générale* (Paris: Gallimard, 1966), 242.

17. Leo Steinberg, "Other Criteria," in *Other Criteria* (New York: Oxford University Press, 1972), 73–74.

18. Leo Steinberg, "Velázquez' *Las Meninas,*" *October* 19 (Winter 1982), 52.

19. Freud, "Negation," 213.

20. John Locke, *Two Treatises of Government* (1689) (New York: NAL, 1963), 329.

21. See Hannah Arendt, *The Human Condition* (Chicago: University of Chicago, 1958), 109 ff.

22. See Karl Marx, "Economic and Philosophical Manuscripts" (1844), in *Early Writings,* trans. Livingstone and Benton (New York: Vintage, 1975), 279–400.

23. This and the following paragraph are based on Perry Anderson, *Lineages of the Absolutist State* (London: NLB, 1974).

24. Claude Lévi-Strauss, *Tristes Tropiques,* trans. John Russell (New York: Atheneum, 1971), 176–80. Recently, Fredric Jameson has proposed applying Lévi-Strauss's schema to cultural production in general; see *The Political Unconscious* (Ithaca: Cornell University Press, 1981), 77 ff.

25. Anderson, *Lineages of the Absolutist State,* 60–84.

26. Foucault, *The Order of Things,* 308. The full citation reads as follows: "In Classical thought, the personage for whom the representation exists, and who represents himself within it, recognizing himself therein as an image or reflection, he who ties together all the interlacing threads of the 'representation in the form of a picture or table'—he is never to be found in that table himself."

27. Jean Clay, *Romanticism,* trans. Owens and Wheeler (New York: Vendome, 1981), 25.

28. Foucault, *The Order of Things,* 304.

29. Michael Fried, *Absorption and Theatricality* (Berkeley: University of California Press, 1980), 103.

30. Michael Fried, "Art and Objecthood," *Artforum* (1967), repr. in Philipson and Gudel, eds., *Aesthetics Today,* 235.

31. Michel Foucault, "Nietzsche, Genealogy, History," in *Language, Counter-Memory, Practice,* 142.

32. Sigmund Freud, "Mourning and Melancholia," in *General Psychological Theory,* 166.

33. Fredric Jameson, "In the Destructive Element Immerse," *October* 17 (Summer 1981).

34. On reality as an effect of signification, see Jean Baudrillard, *For a Critique of the Political Economy of the Sign,* trans. Rosen (St. Louis: Telos, 1981).

Sherrie Levine at A&M Artworks

Sherrie Levine is perhaps best known for a series of works, exhibited last spring [1982] at Metro Pictures, in which she rephotographed Walker Evans's FSA photographs.[1] In representing these canonical images of the rural poor—the expropriated—Levine was calling attention to the original act of appropriation whereby Evans first took these photographs, as if to illustrate Walter Benjamin's observation, in "The Author as Producer," on the economic function of photography: "[Photography] has succeeded in making even abject poverty, by recording it in a fashionably perfected manner, into an object of enjoyment," i.e., a commodity.

This series, and others like it—Levine has executed similar projects after Edward Weston, Andreas Feininger, and Eliot Porter—is responsible for her reputation primarily as an appropriator of images. Yet this characterization of Levine's activity—upon which have been based both claims for its importance as well as its dismissal as simply another Duchampian critique of the creative impulse—is insufficient, neglecting as it does both the variety of her esthetic strategies and the persistence of her thematic concerns.

For Levine has also staged a *Shoe Sale* at the Mercer Street Store ('77); exhibited stereotypical images, culled from the mass media, of maternity (The Kitchen, '78) and women artists (*Real Life* magazine); invited us to the studio of the late painter Dimitri Merinoff ('81); and written a brief but important text on David Salle (*Flash Art*, Summer '81). Most recently, she mounted a one-night exhibition of "Six Pictures after Franz Marc," high-quality reproductions of Marc's expressionist canvases, which Le-

vine purchased, framed behind glass, and exhibited for two hours one Sunday evening in May—an exhibition as a performance, with the artist herself in the role of independent curator.

In all her work Levine has assumed the functions of the dealer, the curator, the critic—everything but the creative artist. She has done this not merely to speak of the diminished possibilities for originality in an image-saturated culture, but more importantly in an attempt to counteract the division of artistic labor in a society that restricts the artist to the manufacture of luxury goods destined for the real agents of art-world appropriation—the dealer, the collector, the museum.

Sentimental images of animals—horses, deer, sheep, a sleeping cat—in their "natural" habitats, the "Six Pictures" are also consistent with the thematic issues addressed in all of Levine's previous work. Her purloined images have invariably been emblematic, allegorical; Levine does not represent women, the poor, or landscapes, but Woman, Poverty, Nature. She is not, however, primarily interested in these subjects per se, but in images of them. This is the primary motive behind her strategy of appropriation: she does not photograph women or landscapes, but pictures of them, for we can approach such subjects, Levine believes, only through their cultural representation.

What is more, these are subjects that exist outside of a dominant cultural order, which casts them as the "Other." All of Levine's images have been images of this Other; she consistently focuses on the mechanisms whereby our own animal instincts, our bestiality, are externalized, projected onto another—the opposite sex (she cites Paul Schrader's film *Cat People*), another social class, or nature in general. Externalized in an alien and alienating image, our drives come to appear to us as universal and *natural* forces which must be controlled or repressed, either directly or symbolically, through both ritualized and nonritualized forms of representation.

It is not surprising, then, that the expressionist impulse in art, based as it is on precisely this externalization of instinct, its projection onto the Other, should now come under Levine's scrutiny. Apropos of the "Six

Sherrie Levine, After Andreas Feininger, *1979. Courtesy Sherrie Levine.*

Pictures after Franz Marc," Levine cites feminist critic Susan Griffin: "Another strain of Romanticism—which we can see expressed in the conflicted and apocalyptic vision of Franz Marc—sought to know the power of nature and of eros, [but] experienced a hatred and fear of these forces. Rather than acknowledge eros as a part of its own being, this cast of mind divided itself from nature and then experienced a fear of the power of nature as nature returned to its consciousness in the body of women, of the 'Jew,' or 'darkness'" (*Pornography and Silence: Culture's Revenge against Nature*).

Levine's current work thus has a topical thrust—the "Six Pictures" are currently on view in the "Young Americans" exhibition at Chicago Museum of Contemporary Art; at Documenta she is exhibiting a similar series after Egon Schiele. In such contexts, Levine's images must be read as commentaries on the recent resurgence of the expressionist impulse. Yet the importance of Levine's critique of expressionism is that it is located within a much broader investigation of cultural representations of alterity, and the psychological, social and economic functions which such representations serve.

NOTE

1. See Carter Ratcliff, "Art and Resentment," *Art in America* (Summer 1982), 9–13. Page 11 shows Sherrie Levine's *After Walker Evans*.

Allan McCollum:
Repetition and Difference

*Each art has its own imbricated techniques of repetition, the critical
and revolutionary potential of which must reach the highest possi-
ble degree, to lead us from the dreary repetitions of habit to the
profound repetitions of memory, and ultimately to the [symbolic]
repetitions of death, through which we make sport of our own
mortality.*

— GILLES DELEUZE, *Répétition et différence*

Since 1975, when he stopped painting the large, repetitive decorative
abstractions, often on unstretched canvas, for which he first achieved
recognition in his native California, Allan McCollum has been manu-
facturing generic paintings: small, anonymous, more or less identical
objects, always exhibited in series and composed entirely of frame, mat,
and, where the image is supposed to appear, a blank. The artist de-
scribes these works as decoys: "False pictures, pseudo-artifacts which
beckon me into the desire to look at a picture, but which are complete
in doing that, and that alone." In them, painting is reduced *beyond* its
essentials to utter conventionality, banality. It is ironic, then, that as
recently as 1979 McCollum's work could still be cited as proof of the con-
tinuing viability of modernist abstraction[1]—as if, as Jean Baudrillard has
written, "Only the forgery can still satisfy our thirst for authenticity."

Minimalist in their monochromism, their investigation of framing, and
their repetitiveness, the generic paintings employ only the *vocabulary* of
minimalism; for what McCollum has devised is, in fact, an effective, all-
purpose strategy of esthetic infiltration—reminiscent in this respect of
Daniel Buren's deployment of striped fabric—with which to expose the
contradictions of cultural production in a market economy: the inescap-
able fact that, in exchange, all works of art are reduced to equivalence.
Clusters of the generic paintings have been exhibited in group shows,
where they have served as mirrors reflecting the interchangeability—the
in-difference—of the other works on display. More recently, for his first

solo exhibition in New York (mounted last March [1983] at Marian Goodman), McCollum doubled and then redoubled the stakes: 551 cast "plaster surrogates" swarmed across the gallery's walls in a continuous, undulating band, while in a second room photographs taken directly from television depicted (found) McCollums "on location"—pictures in the world re-presented as generic paintings.

Each of the surrogates was derived from the same model (frame, mat, and, where the image is supposed to appear, a blank). The only differences admitted were entirely marginal: insubstantial variations in size, proportion, and the color of the frame (mostly within a narrow range of golds and browns). While the specific combination of these three variables seemed to constitute each surrogate as singular, the potentially endless repetition of essentially identical objects prevented us from mistaking difference for uniqueness. For although it was possible to view each work as a mirror reflecting all the others, at the same time it was impossible to forget that each was merely a reflection of all the others.

Neither the wit nor the sheer visual beauty of the installation can be discounted; but these, too, seemed to function as decoys, as lures—as if to compensate for the muteness of each individual component. For while repetition inaugurated an indefinite play of substitutions, classifications, reversals, and repetitions, this textual game seemed to suspend any reference outside the series itself, as well as any subjective relation between artist and viewer. Instead, the surrogates functioned as an opaque screen interposed between the two, rendering them mutually absent one to the other—an absence described, perhaps, by the blank at the center of each work.

Still, taken as a whole, McCollum's installation did have an unmistakable external referent: the marketplace. Viewing it was less like gallery-going and more like window-shopping—or, rather, gallery-going *as* shopping. For what McCollum's work ultimately reflects is the recent infiltration into cultural production of what political economists identify as the "serial mode of production." Serialized production is both the definitive mode of late-capitalist consumer society and, since Warhol at least, the dominant model for art—and not only visual art, as Jacques Attali's diagnosis, in his book *Bruits,* of the situation of contemporary music confirms:

> No organized society can exist without structuring a place within itself for differences. No exchange economy develops without reducing such differences to the form of mass production or the serial. . . . Music lives [this contradiction] in deafening fashion: an instrument of differentiation, it has become the very locus of repetition. It indifferentiates itself in com-

modities and masks itself in the star system. Music can therefore allow us to hear the essentials of the contradictions in developed societies: *an anxious search for lost differences within a logic from which difference itself has been excluded.*[2]

This contradiction between difference and repetition is intrinsic to the serial mode of production itself—a mode which proceeds from, but is not identical with, the mass production of commodities. For while mass production and the social logic of homogenization which it entails work to eliminate difference (standardization), serial production reintroduces a limited gamut of differences into the mass-produced object. As Baudrillard observes in *Le système des objets* (1968), no object appears on the market today in a single type, but with a range of strictly marginal differences—of color, accessory, detail—which create the illusion of choice. Consequently, what we consume is the object not in its materiality, but in its difference—the object as sign. Thus, difference itself becomes an object of consumption, and the agenda of serial production becomes apparent: to carefully engineer and control the production of difference in our society.

If music allows us to hear these contradictions, visual art allows us to *see* them. Few works of art exist today as single, isolated examples; rather, the majority appear in series, and their significance resides primarily in the position they occupy within the series to which they belong.[3] To cite only the most obvious example: it makes no sense to exhibit one Cindy Sherman photograph by itself (although her work is often presented this way). To do so is to render it meaningless, for the significance of Sherman's work resides in the artist's permutations of identity from one photo to the next. Thus, Sherman has borrowed from the media not only a stock of feminine stereotypes, but also its serialized format.

In fact, serial production does not recognize the fine art/mass culture distinction (and is partially responsible for its dissolution). So that when McCollum exhibits his own series of black-and-white photographs of in-

Allan McCollum, Plaster Surrogates, *1982–83. Installation at the Marian Goodman Gallery, New York City, 1983.*

teriors, themselves taken from TV series, he moves us out of the gallery and into mass culture, demonstrating the pervasiveness of serial production. In McCollum's photographs of everyday life as represented in the mass media, framed pictures in the background become illegible—these are, after all, pictures of pictures of pictures—and are thereby transformed into "McCollums"—frame, mat, and, where the image is supposed to appear, a blank. Collectively captioned "Paintings on location—incidental to the action," these photographs reinsert McCollum's work back into the culture at large, where its greatest subversive potential resides.

If McCollum represents the advent of a repetitive culture—both within the art gallery and without—a culture in which difference is "artificially re-created by means of the repetition of quasi-identical objects" (Attali), still, we cannot immediately assimilate him to that tradition of melancholic artists, from Duchamp to Sherrie Levine, who insist upon the diminished possibilities for creativity in an image-saturated world (or so it has been claimed).[4] *For the automatic, mechanical repetition that characterizes consumption is only one—the most superficial—type of repetition. Art invokes other, more profound types—those of memory and ultimately (following Freud's formulation of a compulsion to repeat) of death.* The significance of McCollum's work resides in its superimposition of all three types, a superimposition which restores to repetition its critical—even revolutionary—power. For, as Deleuze writes at the conclusion of *Répétition et différence*:

> Repetition—even in its most mechanical, quotidian, habitual, stereotypical forms—has a place within art . . . For the only esthetic problem is how to insert art into everyday life. The more our daily life appears standardized, stereotyped, submitted to the accelerated reproduction of consumer goods, the more art must become part of life and rescue from it that small difference which operates between levels of repetition, making habitual consumption reverberate with destruction and death; linking cruelty to inanity; discovering, beneath consumption, the chattering of the schizophrenic; and reproducing esthetically, beneath the most ignoble destructions of war (which are still processes of consumption), the illusions and mystifications which are the real essence of this civilization—so that, in the end, Difference can express itself . . . even if it's only in the form of a contradiction here or there, thereby liberating the forces needed to destroy *this* world.

NOTES

1. Joseph Masheck, "Iconicity," *Artforum* (January 1979), 30–41.

2. Jacques Attali, "Introduction to *Bruits*," *Social Text* 7 (Spring/Summer 1983), 7, italics added.

3. A more detailed account of the serial mode of production in art would have to distinguish between contemporary artists' use of the series and the role that it played in both impressionism (Monet's "Rouen Cathedrals," for example) and modernism (Mondrian's serial production, for example). These questions are too complex to be tackled here; however, I would argue that while, in impressionism, the series works to claim the absolute uniqueness of each single moment of perception, and while, in modernism, it represents an evolutionary or developmental process, in contemporary art it is used to deny both uniqueness and development. Obviously, serial production in art must be linked to the stages of development of capitalism.

4. In a recent text, I dispute this interpretation of the Duchamp-Levine tradition. See "The Discourse of Others: Feminists and Postmodernism," in *The Anti-Aesthetic: Essays on Postmodern Culture,* ed. Hal Foster (Seattle: Bay Press, 1983).

From Work to Frame, or, Is There Life After "The Death of the Author"?

Towards the end of his career, Robert Smithson—who, in an attempt to regain control over his own production had removed his practice from the urban centers to the abandoned slag heaps and strip mines of an "infernal" postindustrial landscape—expressed new or renewed interest in the value-producing mechanisms of the art world: "Paintings are bought and sold," he told an interviewer in 1972. "The artist sits in his solitude, knocks out his paintings, assembles them, then waits for someone to confer the value, some external source. *The artist isn't in control of his value*. And that's the way it operates." As if predicting the fallout from the following year's auction of the Robert Scull collection—which would prompt some angry words from Rauschenberg about the "profiteering of dealers and collectors" (his *Double Feature*, for which Scull had paid $2,500, was auctioned for $90,000)—Smithson continued: "Whatever a painting goes for at Parke Bernet is really somebody else's decision, not the artist's decision, so there's a division, on the broad social realm, the value is separated from the artist, *the artist is estranged from his own production*." Having thus contradicted a deeply entrenched, distinctly modern view of artistic labor as nonalienated labor, Smithson predicted that artists would become increasingly involved in an analysis of the forces and relations of artistic production: "This is the great issue, I think it will be the growing issue, of the seventies: the investigation of the apparatus the artist is threaded through."[1]

The investigation the artist is threaded through indeed turned out—in the practices of Marcel Broodthaers, Daniel Buren, Michael Asher,

Hans Haacke, and Louise Lawler, as well as writings by such artists as Martha Rosler, Mary Kelly, and Allan Sekula (among others)—to be the main preoccupation of art in the '70s.[2] My purpose in citing Smithson's remark is not, however, to confirm his prescience or precedence; in fact, he came to this conclusion rather late, certainly *after* Broodthaers and Buren, and possibly *through* contact with their works. Rather, Smithson's remark interests me because it directly links the investigation of the apparatus the artist is threaded through to the widespread crisis of artistic authorship that swept the cultural institutions of the West in the mid-1960s—a crisis which took its name from the title of Roland Barthes's famous 1967 postmortem "The Death of the Author." If, as Barthes argued, the author could not—or could no longer—claim to be the unique source of the meaning and/or value of the work of art, then who—or what—could make such a claim? It is my contention that, despite its diversity, the art of the last twenty years, the art frequently referred to as "postmodernist," can perhaps best be understood as a response or series of responses to this question—even when artists simply attempt to reclaim the privileges that have traditionally accrued to the author in our society.[3]

Much of the art produced during the last two decades has been concerned simply to register the disappearance of the figure of the author. In this regard, one might cite the practices of Giulio Paolini and Gerhard Richter, both of which *stage* this event, but in significantly different ways. In Paolini the author figures as a kind of magician who performs a disappearing act (and *not* the alchemical *tours de force* of other *arte povera* artist-magicians); this is the significance of the formally dressed, top-hatted character who (dis-) appears in recent drawings and installations. As often as not, this figure is partially concealed: for Paolini, the work of art functions primarily as a screen or mask for its producer. (In *Hi-Fi* [1965], broad gestural brushstrokes—the modernist sign for the artist's "presence"—cover not only the canvas, but also the cutout figure of the painter standing before it, who is thereby *camouflaged*. And in *Delfo* [also 1965], a life-size photographic self-portrait, the artist is masked by sunglasses and further concealed behind the horizontal and vertical bars of a stretcher.) For a series of 1968 "Self-Portraits" Paolini appropriated self-portraits by Poussin and the Douanier Rousseau, suggesting that authorship is an assumed identity, achieved only through a complex series of historical identifications: "The point," Paolini maintained, "was to subtract my own identity and to assume instead an elective, historical and hypothetical one."[4] And at the 1970 "Biennale della giovane

pittura" in Bologna, Paolini exhibited an untitled 1917 Picabia collage, thereby appropriating not another artist's (self-)image, but an entire work.

If Paolini registers the disappearance of the author in individual projects, Richter does so at the level of his *practice*. Viewed individually, Richter's works remain as internally consistent and compositionally resolved as any produced under an authorizing signature; it is, rather, as he moves from photographically derived "realism" (landscape, portraiture, or still life) to abstraction (monochromatic, systemic, or gestural) and back again that Richter effectively refuses the principles of conceptual coherence and stylistic uniformity according to which we have been taught to recognize the "presence" of an author in his work. As Michel Foucault wrote in a 1969 essay, "What Is an Author?," one of the functions of the figure of the author is to "neutralize the contradictions that are found in a series of texts. Governing this function is a belief that there must be—at a particular level of an author's thought, of his conscious or unconscious desire—a point where contradictions are resolved, where the incompatible elements can be shown to relate to one another and to cohere around a fundamental or originating contradiction."[5] Criticism has been demonstrably uncomfortable with Richter's shiftiness and has therefore attempted to locate precisely such an originary contradiction governing his production—characteristically, the tension between painting and photography; however, this argument reveals less about the artist's desire, and more about the critic's desire for a coherent subject backing up—authorizing—works of art.[6]

In this respect, Richter's practice can be compared with that of Cindy Sherman, who "implicitly attack[s] auteurism by equating the known artifice of the actress in front of the camera with the supposed authenticity of the director behind it."[7] Until recently, Sherman appeared in all of her own photographs, but always as a different character; the shifts of identity that constitute the sense of her work are legible, however, only at the level of the series. To exhibit one Cindy Sherman photograph makes no sense, although her work is often exhibited in this way. If Sherman's practice is reminiscent of Richter's, Sherrie Levine's "appropriations" from the late '70s and early '80s—in which she rephotographed images by such photographers as Edward Weston and Walker Evans, or exhibited fine-art reproductions of paintings by Franz Marc, say, or Ernst Ludwig Kirchner—recall Paolini's appropriation of Picabia. Indeed, Levine's *Self-Portrait, after Egon Schiele,* produced for documenta 7 (1982), seems directly related to Paolini's "self-portraits." However, as the gender-shift in Levine's self-portrait demonstrates, to

reduce her questioning of the ownership of the image to Paolini's investigation of authorial identity (or Sherman's investigation of authorial identity to Richter's stylistic heterogeneity) is to ignore sexual difference. As Barthes observed, the privileges reserved for the author in our society are distinctly masculine prerogatives; the relation of an artist to his work is that of a father to his children.[8] To produce an illegitimate work, one which lacks the inscription of the Father (the Law), can be a distinctly *feminist* gesture; and it is not surprising that Sherman's and Levine's works lack the melancholy with which Richter and especially Paolini register the disappearance of the figure of the author.

> *It is obviously insufficient to repeat empty slogans: the author has disappeared; God and man died a common death. Rather, we should reexamine the empty space left by the author's disappearance; we should attentively examine, along its gaps and fault lines, its new demarcations, and the reapportionment of this void; we should await the fluid functions released by this disappearance.*
>
> — MICHEL FOUCAULT, "What Is an Author?"

Although the author is a distinctly modern figure, his death is not a postmodern "event." Barthes himself traced it to Mallarmé—to which we might add Duchamp's courting of chance, or the surrealists' flirtation with collaborative production techniques. Moreover, both of the candidates Barthes nominated to occupy the empty space left by the author's disappearance are recognizably modernist. Barthes's first proposal was that it is the reader or viewer who is responsible for the meaning of the work ("A text's unity," he wrote, "lies not in its origin but in its destination"); his second, that it is language itself, that is, the codes and conventions of literary or artistic production, that produces the work ("It is language which speaks, not the author; to write is, through a prerequisite impersonality . . . to reach that point where only language acts, 'performs,' and not 'me'").[9] A great deal of modernist practice did ignore or repress the role of the viewers in constituting a work; and modernist artists frequently celebrated the utter conventionality of the work of art as (a sign of) its absolute originality.[10] Although much recent art and criticism has investigated the production of viewers by and for works of art, and while a recognition of the conventionality of works of art, their regularity or conformity with institutional specifications, is also a characteristic of cultural production today, nevertheless, neither of Barthes's proposals is sufficient cause to posit a definitive break with modernist practice. Quite the reverse; as Foucault observed, "The themes destined

to replace the privileged position accorded the author have merely served to arrest the possibility of genuine change."[11]

Rather, postmodernism approaches the empty space left by the author's disappearance from a different perspective, one which brings to light a number of questions that modernism, with its exclusive focus on the work of art and its "creator," either ignored or repressed: Where do exchanges between readers and viewers take place? Who is free to define, manipulate and, ultimately, to benefit from the codes and conventions of cultural production? These questions shift attention away from the work and its producer and onto its *frame* —the first, by focusing on the *location* in which the work of art is encountered; the second, by insisting on the *social* nature of artistic production and reception. Sometimes the postmodernist work insists upon the impossibility of framing, of ever rigorously distinguishing a text from its con-text (this argument is made repeatedly in Jacques Derrida's writings on visual art);[12] at others, it is *all* frame (Allan McCollum's plaster painting "surrogates"). More often than not, however, the "frame" is treated as that network of institutional practices (Foucault would have called them "discourses") that define, circumscribe and contain both artistic production and reception.

Marcel Broodthaers's "Musée d'Art Moderne—Département des Aigles"—an imaginary museum the artist founded in 1968, and which would preoccupy him until 1972—is one of the earliest instances of the postmodern displacement from work to frame. For the inaugural exhibition, the rooms of Broodthaers's house in Brussels were filled with packing crates (the kind customarily used to transport works of art) upon which the words "picture," "with care," "top," and "bottom" had been stenciled. (The works of art themselves were represented by postcard reproductions of paintings by David, Delacroix, Ingres, Courbet, etc.) During the opening and closing "ceremonies," a van belonging to an art shipper was parked outside in the street; the opening also included a discussion of the social responsibilities of the artist. As a "real" museum curator (Michael Compton of the Tate) observed, Broodthaers thus presented "the shell of an exhibition, without the normal substance."[13] This remark reminds us of the empty egg and mussel shells— the latter, an ironic reference to the artist's Belgian origins—used in so many of his works. Broodthaers's preoccupation with the shell, and not the kernel—the container and not the contained—not only overturns a longstanding philosophical prejudice that meaning and value are intrinsic properties of objects; it also stands as an acknowledgment of the role of the container in determining the shape of what it contains.

It is customary to attribute recognition of the importance of the frame in constituting the work of art to Duchamp (the readymade requires its institutional setting in order to be perceived as a work of art), and to regard the investigation of the apparatus the artist is threaded through which took place in the 1970s as a revival of the productivist line elaborated in the '20s and '30s, specifically, of the demand (to paraphrase Walter Benjamin) that artists refuse to supply the existing productive apparatus without attempting to change it. I am arguing, however, that "the death of the author" constitutes a historical watershed between the avant-gardes of the '10s and '20s and the institutional critiques of the '70s, and that to regard the latter as a revival or renewal of the former can only lead to misapprehensions about contemporary practice. Broodthaers's shift from the role of artist to that of director of a (fictitious) museum is a case in point. In a 1972 manifestation of the "Musée d'Art Moderne—Département des Aigles" some 300 images of eagles from different historical periods were exhibited, each with a label declaring "This is not a work of art"; Broodthaers thereby acknowledged Duchamp's readymade strategy, but *interrupted* it with a Magrittian declaration of nonidentity. And in an interview published in the catalogue of a 1973 retrospective in Brussels, he observed that the questioning of art and its means of circulation can merely "justify the continuity and the expansion of [artistic] production," adding, "There remains art as production, as production."[14]

This enigmatic remark can perhaps be illuminated by looking at Broodthaers's final projects, in which vanguard practice becomes the *subject* of another, second-level practice. In these, Broodthaers addressed the military metaphor that sustained avant-garde practice—what he referred to as "the conquest of space." His final book—a miniature (4 by 2.5 cms) atlas published in 1975 and titled *The Conquest of Space: Atlas for the use of artists and military men*—explicitly linked military and artistic maneuvers, suggesting that artistic production is ultimately contained within the boundaries of the nation-state (French art, German art, etc.).

Marcel Broodthaers, "Musée d'Art Moderne—Département des Aigles, Section d'Art Moderne," Dokumenta V, Kassel, Germany 1972. Photograph © Maria Gilissen.

(As early as 1967, Broodthaers had addressed the figure of the artist-soldier with his *Femur d'Homme belge,* a human thigh bone painted the colors of the Belgian flag; speaking about this work, Broodthaers told an interviewer, "Nationality and anatomy were reunited. The soldier is not far off.")[15] Broodthaers's final installation, *Décor, a conquest,* a parodistic reconstruction of the Battle of Waterloo (which was fought by two imperial powers, England and France, on Belgian soil), traced the historical emergence of the avant-garde to the Napoleonic era, with its ideology of global conquest and domination. Here, Broodthaers questioned the avant-garde's claim to oppose bourgeois society and its values; in these works avant-garde culture stands revealed as the official culture of Imperialism.

More recently, Barbara Kruger has addressed the vanguard figure of the artist-soldier, but from a distinctly feminist perspective. In *Great Balls of Fire!* an "insert" published earlier this year in the Swiss magazine *Parkett,* she reproduced some of the more egregiously militaristic—and celebratorily phallocentric—passages from the manifestoes of the avant-garde, its declarations of war on bourgeois society. Thus, Kruger focused attention on its individualistic, heroic, and, above all, *masculine* model of artistic subjectivity. (Predictably, Marinetti comes off worse: "We will glorify war—the only true hygiene of the world—militarism, patriotism, the last projects were addressed to the military destructive gesture of anarchist, the beautiful Ideas which kill, and the scorn of women.")[16] Kruger's project reads in conjunction with her recent billboard (seen throughout the United Kingdom, as well as in California, Chicago, and Las Vegas), which declares "We Don't Need Another Hero," thereby linking escalating nationalism and militarism in the "real" world (the global popularity of the film *Rambo*; the North American public's reception of Oliver North as a "patriot") with the continuing search for artist-soldier-heroes in the "art world."

> Art whatever it may be is exclusively political. What is called for
> is the analysis of formal and cultural limits *(and not one* or
> the other) within which art exists and struggles. These limits are
> many and of different intensities. Although the prevailing ideology
> and the associated artists try in every way to camouflage them, and
> although it is too early—the conditions are not met—to blow them
> up, the time has come to unveil them.
>
> — DANIEL BUREN, "Cultural Limits," 1970

The historical avant-gardes were explosive, expansive, transgressive; every boundary was a frontier to be crossed, a barrier to be shattered,

an interdiction to be broken. Hence, their demand for the destruction of the frame: as Peter Bürger argues in his 1973 essay *Theory of the Avant-Garde*—in which he too advocates a displacement of critical attention away from individual works of art and onto their institutional frames—the historical avant-gardes called for the dissolution of art as an institution (meaning its constitution as a separate sphere of activity, its autonomy) and the reintegration of artistic into social practice.[17] By the end of the 1960s, however, it had become apparent that this demand had, at best, been premature, and that, at worst, avant-garde practice had all too easily been contained.

The cultural politics of the late '60s was a politics of cultural containment. "Containment" was also the key term in U.S. policy in Southeast Asia, and this use of the term could not have been far from Smithson's mind when he wrote the following explanation for his withdrawal from documenta 5 (1972): "Cultural confinement takes place when a curator imposes his own limits on an art exhibition, rather than asking an artist to set his limits . . . Some artists imagine they've got a hold on this apparatus, which in fact has got a hold of them. As a result, they end up supporting a cultural prison that is out of their control . . . Museums, like asylums and jails, have wards and cells—in other words, neutral rooms called "galleries." . . . Works of art seen in such spaces seem to be going through a kind of esthetic convalescence."[18] In removing his practice to the postindustrial landscape, Smithson was, of course, attempting to circumvent the frame; but he also confronted the problem of cultural confinement in his "Non-Sites," which set up a dialectical relationship between the gallery and a place outside it. Insofar as they are merely containers—metal bins filled with rocks or sand from specific sites—the "Non-Sites" also function as mirrors which reflect their own containment.

Daniel Buren approached the problem of cultural confinement somewhat differently, situating some of his works partially within and partially beyond the frame. *Within and Beyond the Frame,* was, in fact, the title of a 1973 installation at the John Weber Gallery in New York; a series of striped banners strung down the middle of the gallery extended out the window and across West Broadway. Similarly, the "missing parts" of a 1975 installation at the Museum of Modern Art in New York—the (imaginary) sections of Buren's work "concealed" by a staircase—were posted on billboards in SoHo, thereby reminding viewers that these two parts of the city were already connected by the art economy. In these projects, Buren turned the tables: instead of being contained by the museum, his work contained the museum.[19] Buren's "transgressions" of

the frame were engineered to call attention, not to themselves, but to the frame; as such they lacked the destructive impulse—and impulsiveness—of the modernist avant-garde. As he wrote in his 1970 essay "Critical Limits," "All the pseudo-revolutionary myth, and what it continues to influence, was/is possible only because one's attention has been fixed only on the object shown, its meaning, without looking at or discussing even once the place where it is shown."[20]

For Buren, "the Museum/Gallery for *lack of being taken into consideration* is the framework, the habit . . . the inescapable 'support' on which art history is painted" (38). Just as the canvas conceals its stretcher, and the image its support (as early as 1966, Broodthaers made a similar observation: "Even in a transparent painting the color still hides the canvas and the moulding hides the frame"),[21] so, too, for Buren, the *function* of the work of art—any work of art—is to conceal the multiple frames within which it is contained: "This is what the dominant ideology wants," he wrote, "that what is contained should provide, very subtly, a screen for the container" (38). Hence Buren's decision to paste his own deliberately anonymous or impersonal work—"vertically striped sheets of paper, the bands of which are 8.7 cms wide"—directly onto the walls of the museum or gallery, thereby literalizing the function of the work.

Buren's positioning of his work in relation to the institutional frame constitutes a critique of attempts to regain artistic freedom by working outside it—as if works placed outside the walls of a gallery or museum are not subject to external constraints. "A clear eye will recognize what is meant by freedom in art," he wrote, "but an eye which is a little less educated will see better what it is all about when it has adopted the following idea: that the location (outside or inside) where a work is seen is its frame/its boundary" (28–29). In this regard, Buren's critique of Smithson's exoticism is illuminating. A work of art, Buren contends, can be "shown outside the usual places of exhibition," including "the walls of the city, of a subway, a highway, any urban place or any place where some kind of social life exists" (indeed, in the mid-'60s, Buren placed his own work in such situations). However, this list of possible sites for works of art "excludes the oceans, the deserts, the Himalayas, the Great Salt Lake, virgin forests, and other exotic places—*all invitations for artistic safaris*" (50–51). For Buren, the "return to nature" is an escapist maneuver, an attempt not to confront, but merely to circumvent, the institutional frame: "As soon as frames, limits, are perceived as such, in art, one rushes for ways to bypass them. In order to do this, one takes off for the country, maybe even for the desert, to set up one's easel" (48).

For Buren, the "unveiling" of the institutional frame can take place

only within the frame, and not from some imaginary vantage point outside it. (As Jacques Derrida has written of his own critical practice, which also attends to the invisible frames/borders/limits of the philosophical or literary text: "The movements of deconstruction do not destroy structures from the outside. They are not possible and effective, nor can they take accurate aim, except by inhabiting those structures.")[22] Nevertheless, the deconstructive artist does not occupy the position traditionally reserved for the artist within that structure. As Buren writes, "He carries on his activity within a particular milieu, known as the artistic milieu, but he does so not as an artist, but as an individual." This distinction is crucial, Buren contends, "because particularly at this time [1967], the artist is hailed as art's greatest glory; it is time for him to step down from this role he has been cast in or too willingly played, so that the 'work' itself may become visible, no longer blurred by the myth of the 'creator,' a man 'above the run of the mill'" (25).

The deconstructive work must therefore be neutral, impersonal, anonymous (these terms are Buren's). An anonymous work is not simply one whose author's identity is unknown; rather, it is one that cannot be appropriated. "The producer of an anonymous work must take full responsibility for it," Buren contends, "but his relation to the work is totally different from the artist's to his work of art. Firstly, *he is no longer the owner of the work in the old sense*" (25). Here, Buren contradicts the legal definition of the author as proprietor. As soon as an artist signs a work, thereby claiming it as *his*, it becomes private property, a commodity which the artist is legally entitled to exchange. By contrast, the anonymous work is not subject to the effects of appropriation entailed by the signature: "It is not *his* [the artist's] work, but *a* work . . . This work being considered as common property, there can be no question of claiming the authorship thereof, possessively, in the sense that there are authentic paintings by Courbet and valueless forgeries" (19).

Similarly, Hans Haacke is interested, not in the properties of the work of art, but in the work of art as property. In two different projects from

Daniel Buren, Within and Beyond the Frame, *1973.*
Courtesy John Weber Gallery, New York City.

the early '70s (*Manet-PROJEKT '74* and *Seurat's "Les Poseuses" [small version], 1888–1975*) he traced the provenance of a 19th-century painting, focusing on "the social and economic position of the persons who have owned the painting over the years and the prices paid for it."[23] To this day Haacke continues to draw parallels between cultural and economic or political influence. (*Der Pralinenmeister*, 1981, focuses on the business practices of German art "patron" Peter Ludwig; *Taking Stock*, 1983–84, deals with the Thatcher connection of British collectors Charles and Doris Saatchi). However, the focus of his practice has gradually shifted away from the private appropriation of works of art: "If such collectors," Haacke writes, "seem to be acting primarily in their own self-interest and to be building pyramids to themselves when they attempt to impose their will on 'chosen' institutions, their moves are in fact less troublesome in the long run than the disconcerting arrival on the scene of corporate funding for the arts—even though the latter appears at first to be more innocuous."[24]

Since 1975 Haacke has been primarily concerned with exposing cracks in the anonymous, impersonal facade of corporate funding (Mobil, Chase, Allied Chemical, British Leyland, Philips, American Cyanamid, Alcan Oerlikon-Bührle—not to mention Tiffany and Cartier). *Metro-Mobilitan* (1985), for example, is a mock-up of the entabulature of New York's Metropolitan Museum, complete with inscription: "Many public relations opportunities are available through the sponsorship of programs, special exhibitions and services. These can often provide a creative and cost-effective answer to a specific marketing objective, particularly where international, governmental or consumer relations may be a fundamental concern.—The Metropolitan Museum of Art."[25] Directly beneath this inscription hangs a banner advertising the exhibition "Ancient Treasures of Nigeria" and its corporate sponsor, Mobil, flanked by two others on which are inscribed quotations from the company's statements defending its sales to the government of South Africa: "Mobil's management in New York believes that its South African subsidiaries' sale to the police and military are but a small part of its total sales . . ." and "Total denial of supplies to the police and military forces of a host country is hardly consistent with an image of responsible citizenship in that country." These banners hang in front of, and only partially conceal, a photograph which indicates what the benevolent facade of cultural patronage is intended to conceal: a funeral procession for black victims shot by the South African police at Crossroads, near Cape Town, on March 16, 1985.

Michael Asher also deals literally with the museum's facade. In 1979

he removed some of the exterior aluminum cladding from the Museum of Contemporary Art in Chicago, exhibiting it inside the gallery as (minimal) sculpture. The same year he replaced a bronze statue of George Washington from the entrance of the Art Institute of Chicago to the museum's 18th-century rooms. (Of the latter project, Asher wrote: "My use of the sculpture was not an authorial usage, but one intended to disengage it from its former appropriation.")[26] In both projects, the public function of (elements of) the museum's public facade (at the MCA, the "symbolic expression of the museum's expansion and future growth" (198); at the Art Institute, the "conveying [of] a sense of national heritage in historical and aesthetic terms" (208) was undermined. Writing of his project at the MCA, Asher observed: "I attempted to literally deconstruct the elements of the facade, thereby changing their meaning by negating both their architectural and sculptural readings, which the building had originally attempted to fuse. I contextualized the sculpture to display the architecture and the architecture to display the sculpture" (198).

Asher's literary deconstructive practice proceeds through *displacement*: elements are either moved or removed from their "original" contexts so that their contradictions can be examined.[27] Asher works only with the spatial and temporal givens of a situation, rarely adding anything to them, often subtracting something from them; he refers to this procedure as "material withdrawal"—"marking by disclosure, rather than by constructing figure-ground relationships" [89]. Writing about a 1973 exhibition in Milan, in which the walls of the gallery were sandblasted, removing several accumulated layers of white paint to expose the brown plaster underneath, he commented: "At the Toselli Gallery, I used a procedural approach, *attempting to materially withdraw an author's sign and responsibility.* Usually an artist's sign, as an addition to a given architectural space and a discrete, visually identifiable element, guides and restricts viewer awareness and shifts it from the problems inherent in the gallery space and the work to an arbitrarily formalized insert" (92; italics added). And in 1974 at the Claire Copley Gallery in Los Angeles,

Gerhard Richter, Shot Down, *1988. Courtesy Marian Goodman Gallery, New York City.*

Asher removed the wall separating the exhibition space from the office, thereby exposing to public scrutiny the dealer's activities. "The function of the work at the Claire Copley Gallery was didactic," Asher writes, "to represent materially the visible aspects of [the] process of abstraction" (96). (By "abstraction" Asher refers to the process through which a work's use value becomes exchange value.) For Asher, this process of commodification is not accidental; it is, rather, a crucial part of the reception of a work of art as such. Asher: "The only way for a work to be fully received is through its initial abstraction for exchange value" (100).

In preparation for a 1977 exhibition at the Stedelijk van Abbemuseum in Eindhoven, Asher had the translucent glass ceiling panels removed from half of the museum's galleries; the exhibition consisted of the replacement of these panels by the museum's work crew. Simultaneously, the other half of the museum contained an exhibition of works from the permanent collection selected by the museum's director. Thus, activity which is usually completed before an exhibition opens to the public was exposed to public view; the processual aspect of Asher's installation could not have contrasted more sharply with the static quality of the more traditional installation that accompanied it. However, the most "radical" aspect of this project was its acknowledgment that the artist is only one of a number of functions necessary for the production of a work of art: "By clearly distinguishing and specifically presenting the different participants (work crew, curator, artist) that make an exhibition possible at such an institution, I wanted to show how these necessary but separate functions are equally essential for the constitution of a work" (178). In emphasizing these "separate but equal" functions, Asher was acknowledging the *collective* nature of artistic production.

To argue that artistic production is collective production is not to encourage artists to collaborate with other artists; rather, it is to *defetishize* the work of art.[28] As Haacke has written: "I believe the use of the term 'industry' for the entire range of activities of those who are employed or working on a freelance basis in the art field has a salutary effect. With one stroke that term cuts through the romantic clouds that envelop the often misleading and mythical notions widely held about the production, distribution, and consumption of art. Artists, as much as galleries, museums, and journalists (not excluding art historians), hesitate to discuss the industrial aspect of their activities. An unequivocal acknowledgment might endanger the cherished romantic ideas with which most art world participants enter the field, and which still sustain them emotionally today."[29]

This statement of the collective or "industrial" nature of artistic pro-

duction is especially interesting in light of Haacke's emphasis on the relationship between capital and the art world. The recent penetration of international investment capital into the art world has resulted in an unprecedented expansion of the art apparatus. As the apparatus expands, so do the number and variety of activities necessary to the production, exhibition, and reception of works of art—art handlers, preparators, artists' representatives, publicists, consultants, accountants, administrators, etc. This multiplication and diversification of "intermediate functions"[30]—intermediate, because they exist in the gap between, or the nonsimultaneity of, production and reception—further alienates artists from their own production; as these functions multiply they increase both the spatial and temporal distance between artist and their "publics." At the same time, however, the expansion of the apparatus continually generates new positions from which artists can produce critical work.

At least this is what is suggested by the practice of Louise Lawler, who has occupied practically every position within the apparatus except that customarily reserved for the "artist." Thus, instead of contributing information about her work to the catalogue of a 1979 group exhibition at Artists Space in New York (in which she exhibited a painting of a race horse borrowed from Aqueduct), Lawler designed a logo for the gallery which appeared on the catalogue's cover, thereby presenting, rather than being presented by, the institution.[31] (This reversal of presentational positions is reminiscent of Buren's reversal of the relationship of container and contained.) At the entrance to her first one-person show in New York, Lawler presented an "Arrangement of Pictures" by gallery artists; in the back room she exhibited a series of photographs documenting the activities of other picture "arrangers" (museum curators, corporate art consultants, collectors). In Lawler's photographs of domestic interiors, works of art appear as one luxury good among others; in her photographs of corporate headquarters, they are, as often as not, simply pieces of office equipment. Thus, Lawler produced work

Michael Asher, "George Washington in the French Decorative Arts Galleries," Art Institute of Chicago, 1979. Photograph © Rusty Culp 1979.

from the position of an installation photographer, just as, for the New Museum's 1984 anthology of critical writings *Art After Modernism: Rethinking Representation,* she worked as photo-editor. However, Lawler's contribution does not simply illustrate the text; rather, it reads as a critical commentary upon it.

> *As soon as the legitimation crisis of the institutions that contain the discourse of visual culture seemed to be overcome—not by a resolution of their increasingly apparent contradictions and conflicts of interest, of course, but by a rigid sociopolitical reconstitution of traditional hierarchies and the aesthetic myths that adorn them /— —/ the radical practice of artists of Asher's generation could be marginalized to the extent that the work was made to appear historical before it had even properly entered the culture.*
>
> — BENJAMIN BUCHLOH
> Michael Asher: *Writings 1973–1983 on Works 1969–1979*

In 1982 Jenny Holzer commented that, by the late '70s, the investigation of the apparatus the artist is threaded through seemed to be finished: "As far as the systematic exploration of context is concerned, at that time [ca. 1977] that point had been made"[32] and indeed, the developments I have outlined above will undoubtedly appear to many readers as "ancient history." If I insist on these developments, it is for two reasons. First, I want to counter attempts like Holzer's to contain the investigation of the forces and relations of artistic production within a particular historical time-frame. More importantly, I want to suggest that the postmodern displacement from work to frame lays the groundwork for a materialist cultural practice—one which, to borrow Lucio Colletti's definition of materialist political practice, "subverts and subordinates to itself the conditions from which it stems."[33] For a recognition of the *de facto* social nature of artistic activity is essential if we ourselves are to employ, rather than simply being employed by, the apparatus we all— "lookers, buyers, dealers, makers"[34]—are threaded through.

NOTES

1. Bruce Kurtz, ed., "Conversation with Robert Smithson on April 22nd 1972," in *The Writings of Robert Smithson,* ed. Nancy Holt (New York: New York University Press, 1979), 200; italics added. That artistic labor is nonalienated labor is not only a tenet of bourgeois art theory; there is also a leftist version of this argument, based on (misreadings of) Marx's famous comparison of the

architect and the bee in *Capital,* volume I. See Janet Wolff, *The Social Production of Art* (London, 1981), 14–15.

2. See Martha Rosler, "Lookers, Buyers, Dealers, and Makers: Thoughts on Audience" and Mary Kelly, "Re-Viewing Modernist Criticism," both reprinted in *Art After Modernism: Rethinking Representation,* ed. Brian Wallis (New York, The New Museum of Contemporary Art, 1984), as well as Allan Sekula, "The Traffic in Photographs," *Art Journal* 41, no. 1 (Spring 1981), 15–25.

3. I discuss the reclaiming of authorial privilege in "Honor, Power, and the Love of Women," *Art in America* (January 1983).

4. Quoted in Germano Celant, *Giulio Paolini* (New York, 1972), 74; translation modified.

5. Michel Foucault, "What is an Author?" in *Language, Counter-Memory, Practice,* ed. D. F. Bouchard (Ithaca: Cornell University Press, 1977), 128.

6. See, for example, Stephen Ellis, "The Elusive Gerhard Richter," *Art in America* (November 1986). On the critical production of an artistic subject for works of art, see Griselda Pollock, "Artists, Mythologies and Media—Genius, Madness and Art History," *Screen* 21, no. 3 (Summer 1977), 57–96.

7. Douglas Crimp, "Appropriating Appropriation," in *Theories of Contemporary Art,* ed. Richard Hertz (Englewood Cliffs: Prentice-Hall, 1985), 162.

8. "The author is reputed to be the father and owner of his work: literary science therefore teaches *respect* for the manuscript and the author's declared intentions, while society asserts the legality of the relation of author to work (the 'droit d'auteur' or 'copyright,' in fact of recent date since it was only really legalized at the time of the French Revolution). As for the Text, it reads without the inscription of the Father. . . . Hence no vital 'respect' is due to the Text . . . it can be read without the guarantee of its father, the restitution of the inter-text paradoxically abolishing any legacy." Roland Barthes, "From Work to Text," in *Image–Music–Text,* ed. Stephen Heath (New York: Hill and Wang, 1977), 160–61. It is for this reason that I have left all pronominal references to the artist in the masculine gender; the author is indeed a "he."

9. Roland Barthes, "The Death of the Author," in *Image–Music–Text,* 143, 148.

10. For the modernist demand that works of art deny the presence of a "beholder," see Michael Fried, *Absorption and Theatricality: Painting and Beholder in the Age of Diderot* (Berkeley: University of California Press, 1980); for the treatment of conventionality as originality, see Rosalind Krauss, *The Originality of the Avant-Garde and Other Modernist Myths* (Cambridge, Mass.: MIT Press, 1984).

11. Foucault, "What Is an Author?," 118.

12. See "Parergon" and "Restitutions de la vérité en peinture" in *La vérité en peinture* (Paris: Flammarion, 1978); for a broader account of the impossibility of distinguishing text from context, see Derrida's "Signature, Event, Context," in *Marges de la philosophie* (Paris, 1972).

13. Michael Compton, "Marcel Broodthaers," in *Marcel Broodthaers,* exhibition catalogue (London: The Tate Gallery, 1980), 18.

14. "Dix milles francs de récompense," *Catalogue—Catalogue* (Brussels, 1973), n.p.

15. "Dix milles francs de récompense."

16. *Parkett* 11 (1986).

17. Peter Bürger, *Theory of the Avant-Garde*, trans. M. Shaw (Minneapolis: University of Minnesota Press, 1984).

18. Robert Smithson, "Cultural Confinement," in *The Writings of Robert Smithson*, 132. Smithson's description of the museum is reminiscent of Foucault's contemporaneous analyses of various institutions of confinement in the West—the asylum (in *Madness and Civilization*), the hospital (in *Birth of the Clinic*), the prison (in *Discipline and Punish*).

19. Jacques Derrida refers to this effect—when the whole becomes a part of its parts—as "invagination."

20. Daniel Buren, "Critical Limits," in *Five Texts* (New York, 1973), 38. All further Buren references are to this collection, and will henceforth be cited by page in my text.

21. Cited in Benjamin Buchloh, "Michael Asher and the Conclusion of Modernist Sculpture," in *Performance: Text(e)s & Documents*, ed. Chantal Pontbriand (Montreal, 1981), 64.

22. Jacques Derrida, *Of Grammatology*, trans. G. C. Spivak (Baltimore: Johns Hopkins University Press, 1976), 24. Jack Burnham has made a similar point about Hans Haacke's work: "He sees the museum and gallery context as an absolutely necessary element for the meaning and functioning of his works; . . . The walls of the museum or gallery are as much a part of his work as the items displayed on them. These works also need the 'impregnation' of the gallery to set them in opposition to other contemporary art." *Framing and Being Framed* (Halifax: The Press of the Nova Scotia College of Art and Design, 1977), 137.

23. Hans Haacke, "*Manet-PROJEKT '74*," in *Hans Haacke: Unfinished Business* (New York: The New Museum of Contemporary Art, 1986), 118. Haacke's proposal to trace the provenance of a Manet still life in the collection of the Wallraf-Richartz Museum in Cologne led to an unanticipated collaboration with Buren. When the proposal was rejected by the museum—"A museum knows nothing about economic power," the director wrote. "It does indeed, however, know something about spiritual power" (130)—Buren attempted to incorporate a facsimile of Haacke's work into his own project for the exhibition. However, the administration, in a sinister parody of Buren's pasting his work directly onto museum walls, ordered double layers of white paper to be pasted over the offending sections of the Buren-Haacke "collaboration." Although it was suppressed, Haacke's work was not without effect; in fact, it forced the museum to expose its own limits.

24. Hans Haacke, "Museums, Managers of Consciousness," in *Hans Haacke: Unfinished Business*, 68.

25. This quotation was taken from a leaflet published by the museum titled "The Business Behind Art Knows the Art of Good Business—Your Company and the Metropolitan Museum of Art."

26. Michael Asher, *Writings 1973–1983 on Works 1969–1979*, ed. Benjamin Buchloh (Halifax: The Press of the Nova Scotia College of Art and Design, 1983), 198. All further quotations from Asher are from this collection, and will henceforth be cited by page in my text.

27. "Displacement" is used here not in its Freudian sense (the transfer of psychic energy from one idea to another in the process of dream formation); rather, I refer to the use of the term in Derridean deconstruction, which "proceeds by way of displacement, first reversing the terms of a philosophical opposition, that is, reversing a hierarchy or structure of domination, and then displacing or dislodging the system." Mark Krupnick, "Introduction," *Displacement: Derrida and After* (Bloomington: Indiana University Press, 1983), 1.

28. I borrow the term "defetishize" from Lucio Colletti's description of Marx's project: "The task of political economy as a science consisted for Marx essentially—if we can accept a neologism—in the de-fetishization of the world of commodities, in the progressive comprehension that what represents itself as the 'value' of 'things' is in reality not a property of those things themselves, but reified human labour." *From Rousseau to Lenin* (New York, 1972), 89. I propose this somewhat awkward term in place of the more common "demystify," derived from Barthes. If the fetishism of the commodity consists in subordinating the private, concrete, and social aspects of human labor to its abstract aspect, the fetishism of the art-commodity proceeds by subordinating the social and abstract aspects of artistic labor to its private and concrete aspects. Thus, to insist on the collective (i.e., social) aspect of artistic labor is to reverse this tendency.

29. Haacke, "Museums, Managers of Consciousness," 60.

30. The term "intermediate functions" comes from Ernest Mandel, *Late Capitalism* (London: Verso, 1978). My account of the growth of the art apparatus is indebted to Mandel's analysis of the expansion of the services sector in chapter 12.

31. My reading of Lawler's practice is indebted to Andrea Fraser, "In and Out of Place," *Art in America*.

32. Quoted in Hal Foster, "Subversive Signs," in *Theories of Contemporary Art*, ed. Richard Hertz, 180.

33. Quoted in Diane Elson, "The Value Theory of Labour," in *Value: The Representation of Labour in Capitalism*, ed. D. Elson (London, 1979), 171.

34. This is the title of a crucial text on audience by Martha Rosler. See note 2.

PART II

Sexuality/Power

. . . if I have chosen to negotiate the treacherous course between postmodernism and feminism, it is in order to introduce the issue of sexual difference into the modernism/postmodernism debate—a debate which has until now been scandalously indifferent.

— THE DISCOURSE OF OTHERS: FEMINISTS AND POSTMODERNISM

Is gynephobia being defined as the "homosexual" component of masculine sexuality? Is the repression of a man's "horror of women" the repression of his homosexuality? But then how can the bisexuality of the drives precede the Oedipus complex?

— OUTLAWS: GAY MEN IN FEMINISM

What we must learn, then, is how to conceive difference without opposition.

— THE DISCOURSE OF OTHERS: FEMINISTS AND POSTMODERNISM

The stereotype inscribes the body into the register of discourse; in it the body is apprehended by language, taken into joint custody by politics and ideology.

— THE MEDUSA EFFECT, OR, THE SPECTACULAR RUSE

Honor, Power, and the
Love of Women

In 1911, just as the expressionist movement was gaining momentum in German-speaking countries, Freud speculated that the origin of the creative impulse lies in frustration, a sense that reality is impervious to desire:

> The artist is originally a man [and we will soon discover why, for Freud, the role of artist is invariably masculine] who turns away from reality because he cannot come to terms with the demand for the renunciation of instinctual satisfaction as it is first made, and who then in phantasy-life allows full play to his erotic and ambitious wishes. But he finds a way of return from this world of phantasy back to reality; with his special gifts he moulds his phantasies into a new kind of reality, and men [the spectator posited here is also masculine] concede them a justification as valuable reflections of actual life. Thus by a certain path he actually becomes the *hero, king, creator, favourite he desired to be,* without pursuing the circuitous course of creating real alterations in the outer world.[1]

When he assigns art a compensatory role, Freud appears merely to repeat the basic error of Western art theory (Hegel: "The necessity of the esthetically beautiful [derives from] the deficiencies of immediate reality").[2] Why must art always be defined as an *alternative* to reality? Sometimes art is a *recognition* of reality, a mode of apprehending and of representing it. And why do we tend to neglect the fact that works of art always exist as *part of* the material world? Thus, Freud's treatment of the artist could easily be indicted for complicity with philosophical esthetics. Such an indictment, however, would have to overlook what is truly original here: Freud—like the expressionists—situates art not in

relation to reality, but in relation to *desire*. Even more importantly, he locates it in relation not only to the artist's desire, but to the spectator's desire as well. The work of art is the token of an intersubjective relation between artist and spectator; the investigation of this relation is the task of a properly psychoanalytic esthetics.[3]

However, the desire that Freud attributes to the artist and the source of the pleasure he attributes to the spectator are by no means unproblematic. Both are motivated, he proposes, by a (masculine) desire to be a hero. The artist's hopes of royalty and of mastery were explicitly stated in 1911 ("hero, king, creator, favourite"). Six years later, when he reiterates this definition in the *Introductory Lectures on Psychoanalysis,* Freud will have more to say about the spectator's pleasure; in Lecture 23 he writes, "[The artist] makes it possible for other people once more to derive consolation and alleviation from their own sources of pleasure in their unconscious which have become inaccessible to them." That is, the spectator recognizes the desire of the artist represented in the work as his own (repressed) desire, and the lifting of repression is invariably accompanied by a sensation of pleasure. Esthetic pleasure, then, is essentially narcissistic: it arises from the viewer's identification of his own desire with the desire of the other (in this case, of the artist). (Elsewhere, Freud writes of the spectator of *Hamlet*: "The precondition of enjoyment is that the spectator should himself be a neurotic.")[4]

Since the desire to be a hero is shared by artist and spectator alike, it is tempting to regard it as innate and immutable—to posit a universal human desire for mastery. There is, however, an alternative to this essentialist reading; for it is Freud who has taught us (through Lacan) that desire is a *social* product, that it comes into the world because of our relations with others. What is the source of the artist's desire, then, if not the sense of frustration that Freud locates at the origin of the work of art, his sense of powerlessness to achieve in reality what he desires in his fantasy? His desire to be a hero, then—"to feel and to act and to arrange things according to his desires"[5]—arises only because he believes he *lacks* this power. (Lacan: Desire is lack.) And when this lack is represented within works of art, it will tend to be confirmed, that is, posited as (the) truth. Such works will also tend to reinforce the spectator's sense of his own impotence, *his* inability to create real alterations in the world.

We are all familiar with the popular diagnosis of Hitler as a frustrated artist (*verhinderter Künstler*): had he been able to sublimate in art his desire for power, the world might have been spared much anguish. Recently, this conceit has "inspired" a number of art works, most osten-

tatiously, Hans-Jürgen Syberberg's epic film *Our Hitler,* in which the führer is represented as history's greatest *filmmaker.*[6] (As I have argued elsewhere, Syberberg's work has much in common with that of the German "neoexpressionists.")[7] Such works estheticize, and thereby neutralize, the machinations of power; they also invert Freud's formula. For in the passage cited above, art is treated not as a sublimation of, but as a *realization* of desire; thus, the twenty-third lecture on psychoanalysis concludes: "[The artist] has thus achieved *through* his phantasy what previously he had achieved only *in* his phantasy—honour, power, and the love of women."

Sandro Chia's *The Idleness of Sisyphus* (1981) appears to confirm Freud's speculations on the artist. Not only does the painter's recourse to classical myth testify to his withdrawal from reality into a realm of subjective fantasy (the language of depth psychology is also the language of myth); what is more, Chia clearly identifies his own activity with that of a classical *hero*—Sisyphus, the Corinthian *king* condemned to eternal repetition. For it is not difficult to recognize in Chia's protagonist, as he struggles with a mass of inert, recalcitrant material, a displaced representation of the heroic male artist—a role Chia himself has rather pretentiously assumed, at least in interviews and public appearances.

Remember Sisyphus's crime and punishment: for (twice) rebelling against Death, he was sentenced eternally to push a giant boulder up the side of a mountain, only to have it roll back down again as he approached the summit, to the great amusement of the gods. Thus, if the Sisyphus myth can be said to represent Chia's own desire for royalty and for mastery, it also represents the sphere of perpetual frustration in which that desire is operative.

In Albert Camus's *The Myth of Sisyphus,* an extended philosophical argument against suicide composed in 1940 (that is, in the same year that France surrendered to Germany), Sisyphus is treated as the perfect embodiment of the modern (i.e., existentialist) hero, who confronts without flinching the absurdity of his existence. Yet Camus's recourse

Sandro Chia, The Idleness of Sisyphus, *1981. Collection, The Museum of Modern Art, New York City. Photograph © 1991 by The Museum of Modern Art.*

to classical myth works to transform his hero's inability to change the world from a historical into a metaphysical condition, the origins of which remain shrouded in mystery. In the same way, Chia's invocation of Sisyphus projects frustration as a permanent state. In both Camus and Chia, then, myth objectifies psychology, while psychology validates myth; both exist, however, in relation to an evacuated historical dimension.

This reading of Chia's painting is complicated, however, by the fact that his Sisyphus is a comic rather than tragic figure. Camus interpreted Sisyphus as an image of hope beyond hopelessness, of comfort and security in desolation. Such pathos is totally absent from Chia's treatment of the same myth; with his silly grin, business suit, and diminutive fedora, his Sisyphus combines the physiognomy of the clown with that of the petty bureaucrat. Thus, Chia does not defend his hero but ridicules his blind obedience; the artist sides not with the suffering of the victim, but with the laughter of the gods.

Chia appears to ridicule the artist-hero in the same breath that he proclaims his resurrection. Here, we encounter the fundamental ambivalence that sustains the current revival of large-scale figurative easel paintings, its perpetual oscillation between mutually incompatible attitudes or theories. Interpreted as irony, this ambivalence is sometimes summoned as evidence to support the thesis that painters like Chia are engaged in a genuinely critical activity; thus, *The Idleness of Sisyphus* has been interpreted as a "Dada cartoon designed to subvert the conventional mthic image."[8] Maybe I am taking Chia's painting too seriously, then; it is, after all, only a joke. Perhaps—*but at whose expense?* (Freud: Jokes are historically a contract of *mastery* at the expense of a third person.)[9]

In *The Idleness of Sisyphus* Chia debunks the (modernist) belief in progress in art—a belief which he and his colleagues emphatically repudiate. It must be stressed, however, that Chia is not critical, merely contemptuous of the ideology of progress; thus, he simply substitutes repetition (Sisyphus) for progress. If the social program of modernity can be defined, following Max Weber, as the progressive disenchantment of the world by instrumental reason, cultural modernism was also a demystification—a progressive laying bare of esthetic codes and conventions. In *The Idleness of Sisyphus,* however, Chia counters modernist *de*mystification with an antimodernist *re*mystification. Progress is exploded as (a) myth; Chia's painting is a joke, then, at the modernist painter's expense.

But because he identifies himself with Sisyphus, Chia seems to be indulging in *self*-mockery as well. Either way, *The Idleness of Sisyphus* tes-

tifies to the painter's ambivalence about his own activity, to a *lack* of conviction in painting—a lack Chia shares with most artists of his generation. (This is what links him with painting's supposed "deconstructors"—Salle, Lawson, et al.) And once we have acknowledged the prevalence of this attitude, how long can we continue to account for Chia and his colleagues' extraordinary prosperity—for these artists have indeed won "honour, power, wealth, fame . . ."—simply by positing some insatiable "hunger for pictures"?[10] Must we not speak instead of a more fundamental *contempt for painting*—a contempt which is shared by artists and audience alike?

The Idleness of Sisyphus alerts us, then, to what is at stake in the current revival of so-called expressionist painting and its widespread institutional and critical acceptance. (Chia's painting was immediately acquired by the Museum of Modern Art; this is not only a measure of his success, but also an indication that the institutions—and the critics—that support this kind of work must be named as its collaborators.) Artists like Chia construct their works as pastiches derived, more often than not, from the "heroic" period of modernism. Chia favors Boccioni's dynamic futurist line in particular, but he plunders a wide range of antimodernist sources as well—late Chagall, reactionary Italian painting of the '30s. The modern and the antimodern exist side by side in his work; as a result, they are reduced to absolute equivalence.

In Chia's work, then, quotation functions not as respectful *hommage*, but as an agent of mutilation. What Russian formalist critic Boris Tomashevsky wrote of the epigone seems applicable to the pasticheur as well:

> The epigones repeat a worn-out combination of processes and, as original and revolutionary as it once was, this combination becomes stereotypical and traditional. Thus the epigones kill, sometimes for a long time, the aptitude of their contemporaries to sense the esthetic force of the examples they imitate; they discredit their masters.[11]

Chia, Cucchi, Clemente, Mariani, Baselitz, Lüpertz, Middendorf, Fetting, Penck, Kiefer, Schnabel . . . —these and other artists are engaged *not* (as in frequently claimed by critics who find mirrored in this art their own frustration with the radical art of the present) in the recovery and reinvestment of tradition, but rather in declaring its bankruptcy—specifically, the bankruptcy of the modernist tradition. Everywhere we turn today the radical impulse that motivated modernism—its commitment to transgression—is treated as the object of parody and insult. What we are witnessing, then, is the wholesale liquidation of the entire modernist legacy.

Expressionism was an attack on convention (this is what characterizes it as a modernist movement), specifically, on those conventions which subject unconscious impulses to the laws of form and thereby rationalize them, transform them into images. (Here, convention plays a role roughly analogous to the censorship which the ego exercises over the unconscious.) Prior to expressionism, human passions might be represented by, but could have no immediate presence or reality within, works of art. The expressionists, however, abandoned the simulation of emotion in favor of its seismographic registration. They were determined to register unconscious affects—trauma, shock—without disguise through the medium of art; with Freud, they fully appreciated the *disruptive* potential of desire. Whatever we may think of this project today—whether we find its claims to spontaneity and immediacy hopelessly naive or whether we believe that the expressionists actually tapped a prelinguistic reserve of libidinal impulses—we should not overlook its radical ambition.[12]

In "neoexpressionism," however—but this is why this designation must be rejected—expressionism is reduced to convention, to a standard repertoire of abstract, strictly codified signs for expression. Everything is bracketed in quotation marks; as a result, what was (supposedly) spontaneous congeals into a signifier: "spontaneity," "immediacy." (Think of Schnabel's "violent" brushwork.) The pseudo-expressionists retreat to the pre-expressionist simulation of passion; they create illusions of spontaneity and immediacy, or rather expose the spontaneity and immediacy sought by the expressionists as illusions, as a construct of pre-existing forms.

In all discourse, quotation represents authority. Modernism—expressionism included—represents a challenge to authority, specifically to the authority vested in dominant cultural modes and conventions. Today, however, modernism has itself become a dominant cultural mode, as the quotation of modernist conventions in pseudo-expressionism testifies. Transgression has become the norm in a society that stages its own scandals (Abscam). Thus, the contemporary artist is trapped in a double bind: if the modernist imperative is obeyed, then the norm is simultaneously upheld; if the modernist imperative is rejected, it is simultaneously confirmed.

In other words, today the modernist imperative to transgression can be neither embraced nor rejected. Caught in this untenable situation, the pseudo-expressionists substitute an abstract revenge against modernism for its radical impulse. Modernist strategies are used against themselves; thus, the antiauthoritarian stance of the modernist artist is

attacked as authoritarian, and anyone who argues for the continuing necessity of antiauthoritarian critique thereby opens him or herself to charges of authoritarianism.[13]

What we are witnessing, then, is the emergence of a new—or renewed—authoritarianism masquerading as antiauthoritarian. Today, acquiescence to authority is proclaimed as a radical act (Donald Kuspit on David Salle).[14] The celebration of "traditional values"—the hallmark of authoritarian discourse—becomes the agenda of a supposedly politically motivated art (Syberberg, Anselm Kiefer, but also Gilbert & George). More often than not, however, the pseudo-expressionist artist claims to have withdrawn from any conscious political engagement, and this estheticist isolationism is celebrated as a return to the "essence" of art. (This is the basis for Achille Bonito Oliva's championing of the Italian "transavant-garde.")

Authoritarianism proclaimed as antiauthoritarian, antiauthoritarian critique stigmatized as authoritarian: this is one manifestation of what Jean Baudrillard diagnoses as a generalized cultural *implosion*.[15] Everything reverses into its opposite; opposites reveal mirrored identities. The imploded state of pseudo-expressionist art would seem, therefore, to *preclude* irony. For irony is essentially a *negative* trope calculated to expose false consciousness; the coexistence, in pseudo-expressionist work, of mutually incompatible attitudes suggests instead the *loss* of the capacity for negation, which Lacan locates at the origin of the schizophrenic breakdown.[16] Schizophrenic discourse is paralogical; it does not recognize the law of contradiction. Thus, the schizophrenic will be obliged *to say the opposite of what he means in order to mean the opposite of what he says.*[17]

Although most of the major symptoms of schizophrenia are to be found in pseudo-expressionist painting—hebephrenia, catatonia, ambivalence—I am not proposing that we diagnose contemporary artists, on the basis of their work, as schizophrenics. Nor would I proclaim schizophrenia, as some have, as a new emancipatory principle.[18] Still, my argument is more than descriptive; it seems to me that contemporary artists *simulate* schizophrenia as a mimetic defense against increasingly contradictory demands—on the one hand, to be as innovative and original as possible; on the other, to conform to established norms and conventions.

What we see reflected, then, in supposedly "revivalist" painting is the widespread antimodernist sentiment that everywhere appears to have gripped the contemporary imagination. This sentiment is hardly limited to art, but manifests itself at every level of intellectual, cultural, and political life at present. Antimodernism is primarily a disaf-

fection with the terms and conditions of *social* modernity, specifically, with the modernist belief in science and technology as the key to the liberation of humankind from necessity. Fears of ecological catastrophe, and of the increasing penetration of industrialization into previously exempt spheres of human activity, give rise to a blanket rejection of the ideology of progress. Responsibility for the crisis in social modernity is, however, often displaced onto its cultural program—especially the visual arts. Thus, the antiauthoritarian stance of the modernist artist—in particular, the expressionist valorization of human desire—is often blamed for the much-discussed "crisis of authority" in advanced industrial nations.[19]

Antimodernism is one manifestation of what Belgian political economist Ernest Mandel identifies as the "neo-fatalist" ideology specific to late capitalist society—a belief that science and technology have coalesced into an autonomous power of invincible force. In his book *Late Capitalism,* Mandel traces its effects in detail:

> To the captive individual, whose entire life is subordinated to the laws of the market—not only (as in the 19th century) in the sphere of production, but also in the spheres of consumption, recreation, culture, art, education and personal relations, it appears impossible to break out of the social prison. "Every-day experience" reinforces the neo-fatalist ideology of the immutable nature of the late capitalist social order. All that is left is the dream of escape—through sex and drugs, which are in their turn promptly industrialized.[20]

Sex, drugs, rock and roll—there is, as we know, another traditional means of escape (although this function has largely been assumed by the mass media): Art. And it is this route—blocked by the avant-garde's ambition to intervene, whether directly or indirectly, in the historical process—that pseudo-expressionist artists are attempting to force open once again. But in offering the spectator an escape from increasing economic and social pressures, they reinforce the neofatalist ideology of late capitalism. Theirs is an "official" art which provides an apology for the existing social order; collaboration with power replaces the oppositional stance of the modernist artist.

Have we not finally uncovered the source of the sense of frustration that Freud located at the origin of the work of art—namely, a belief in the opacity and omnipotence of the social process? It is not surprising, then, that the current "revival" of figurative modes of expression should be sustained everywhere by artists' desires to be heroes. The desire for mastery is nowhere more apparent than in that rapidly proliferating

genre of art works that can only be called the "artificial masterpiece."
Artificial, because genuine masterpiece status can accrue to a work of art
only after the fact; *masterpiece,* because such works, whether executed by
men or women, are motivated by a masculine desire for mastery, specifi-
cally, a desire to triumph over time.

When the historical conditions surrounding a work's production and
reception by the artist's contemporaries have been superceded, and yet
the work appears to continue to speak to us in the present *as if it had
been made in the present,* we elevate the work to the status of a classic.[21]
What this view of the work of art represses is the successive reappropri-
ation and reinterpretation of works of art by each successive generation.
A classic certainly did not appear to be a classic at the time of its first
appearance, and it is naive to assume that it meant the same thing to
the artist's contemporaries as it does to us. Nevertheless, the survival of
works of art gives rise to the illusion that timeless metaphysical truths
express themselves through them.

The artificial masterpiece inverts this situation: it speaks in the pres-
ent as if it had been made in the past. As such, it testifies primarily to
our impatience, our demand for instant gratification and, most impor-
tantly, the spectator's desire to see (his sense of) his own identity con-
firmed by the work of art. The extraordinary speed with which the
pseudo-Expressionists have risen to prominence indicates that their
work, rather than creating new expectations, merely conforms to exist-
ing ones; when "the fulfilled expectation becomes the norm of the prod-
uct," however, we have entered the territory of *kitsch.*[22]

Throughout the history of art, style has been one of the most effective
indices to the existence of a timeless truth in the work of art. Thus, Carlo
Maria Mariani resurrects 19th-century neoclassicism—a style which, in
its own time, was calculated to provide an ascendant bourgeoisie with
an idealized image of its own class aspirations and past struggles—an
image transposed, however, from the plane of history to that of myth.[23]
Mariani's neo-neoclassicism indicates that the academic project of sub-
limating history into form and universality—a project that was aban-
doned by the earliest modernists—has returned.

Although it may appear to occupy the opposite end of the stylistic
spectrum, A. R. Penck's cultivated neoprimitivist technique performs
exactly the same function. Penck's work derives directly from Ameri-
can painting of the 1940s—specifically, from the abstract expressionist's
early involvement with myth and primitive symbolism (early Gottlieb,
Pollock, etc.). These artists were interested in such emblematic imagery
primarily as a bearer of cultural information; Penck, however, uses it to

express a heroic affinity with the precultural—with the barbaric, the wild, the uncultivated. It also gives his work the appearance of having been around since the beginning of time.[24]

Artificial masterpieces are also manufactured today through the revival of outmoded artistic materials and production procedures, thereby denying the fundamental historicity of those materials and techniques.[25] Although the entire revival of easel painting must be evaluated in these terms, Francesco Clemente's resurrection of fresco is a particularly blatant denial of history, as are Jorg Immendorff's, Markus Lüpertz's, and, now, Chia's returns to monumental, cast-bronze sculpture. Other artists resuscitate discarded iconographic conventions: Louis Cane, for example, paints Annunciations. Here, Catholic subject matter indicates a desire for catholicity; but it also reads as a reference to Cane's recent "conversion" from modernist abstraction to antimodernist figuration.

Perhaps the most transparent strategy for simulating a masterpiece is that of antiquing the canvas itself. Thus, Gérard Garouste's neo-Baroque allegories—which, the artist insists, "stage the battle of the forces of order and disorder, of the rational and the irrational"—are dimly perceived through what appear to be layers of yellowed varnish. But Anselm Kiefer also "antiques" his canvases. Not only has he returned to landscape painting; he also attempts, through the implicit equation of the barren fields he depicts with the burnt and scarred surfaces of his own canvases, to impart to his paintings something of the desolation and exhaustion of the earth itself. (What is more, Kiefer attributes this desolation to mythical rather than historical forces. His "Waterloo" paintings bear a legend from Victor Hugo: "The earth still trembles/from the footsteps of giants.") Thus, Kiefer's art insists that it is only the faithful reflection of (its own) shattered depletion.

In the 1970s, as is well known, several writers—Richard Sennett and Christopher Lasch among them—diagnosed the collective Narcissism that appeared to have infected an entire society. It is tempting, on the basis of the phenomena discussed above, to describe our own decade as Sisyphean, referring, of course, to the widespread "compulsion to repeat" in which we appear to be deadlocked. It is, however, precisely this tendency to treat contemporary reality in mythological terms that is at issue here. When the critic diagnoses a collective neurosis, does he not also betray his own desire for (intellectual) mastery? In the eighth chapter of *Civilization and Its Discontents* Freud addressed the question of intellectual mastery, significantly, in the context of a discussion of the possibility of psychoanalyzing entire societies: "And as regards the thera-

peutic application of our knowledge," Freud writes, "what would be the use of the most correct analysis of social neurosis, since no one possesses authority to impose such a therapy on the group?"

Yet everywhere we turn today we encounter therapeutic programs for the amelioration of our collective "illness"—nowhere more blatantly than in the authoritarian call for a return to traditional values which, we are told, will resolve the crisis of authority in advanced industrial nations. Perhaps, then, it is to the issue of mastery—of power, authority, domination—that both art and criticism must turn if we are to emerge from our current impasse.

This text is a revised version of a speech delivered on September 22, 1982 to the Society for Contemporary Art, the Art Institute of Chicago. I would like to thank Courtney Donnell for inviting me to address that audience. I would also like to thank Barbara Kruger, without whose work and conversation parts of the above discussion would not have been possible.

NOTES

1. Sigmund Freud, "Formulations Regarding the Two Principles in Mental Functioning," in *General Psychological Theory* (New York: Collier, 1963), 26–27, my italics.

2. On art as supplement, see Jacques Derrida, "The *Parergon*," *October* 9 (Summer 1979), 3–41, as well as my afterword, "Detachment: from the *parergon*," 42–49.

3. Psychoanalytic discussions of the work of art's relation to its spectator occur mainly in film theory and criticism; see in particular the work of Christian Metz (*The Imaginary Signifier*) and Stephen Heath (*Questions of Cinema*).

4. Sigmund Freud, "Psychopathic Characters on the Stage," in *Standard Edition*, vol. 7, 308.

5. Ibid., 305. The entire passage reads as follows: "The spectator is a person who experiences too little, who feels that he is a 'poor wretch to whom nothing of importance can happen,' who has long been obliged to damp down, or rather displace, his ambition to stand in his own person at the hub of world affairs; he longs to feel and to act and to arrange things according to his desires—in short, to be a hero."

6. On *Our Hitler*, see Fredric Jameson, "In the Destructive Element Immerse," *October* 17 (Summer 1981), 99–118, and Thomas Elsaesser, "Myth as the Phantasmagoria of History . . . ," *New German Critique* 24–5 (Fall/Winter 1981–82), 108–54. I disagree with Elsaesser's defense of Syberberg's practice, but I am indebted to his insights on the modern functions of myth.

7. "Bayreuth '82," *Art in America* (September 1982), 135.

8. Michael Krugman, "Sandro Chia at Sperone Westwater Fischer," *Art in America* (October 1981), 144.

9. See Freud, *Jokes and Their Relation to the Unconscious*, trans. James Strachey (New York: Norton, 1960). This particular formulation of Freud's thesis is from Jane Weinstock, "She Who Laughs First Laughs Last," *Camera Obscura* 5 (1980), 107.

10. This is the title of Wolfgang Max Faust's recent book on contemporary German painting (*Hunger nach Bildern*).

11. Quoted in Hans Robert Jauss, *Toward an Aesthetic of Reception* (Minneapolis: University of Minnesota Press, 1982), 197.

12. See Theodor Adorno's discussion of Schoenberg's expressionism in *Philosophy of Modern Music* (New York, 1980), esp. 38–39.

13. This is the thrust of attacks launched recently by Peter Schjeldahl, who has increasingly been gravitating towards a neoconservative position, against myself and other writers—ironically, from the pages of the *Village Voice*, supposedly the last bastion of '60s-style radicalism.

14. "Salle, then, offers us an explicitly conformist art—an art in perfect harmony with its world. . . . Its attempt at maximalizing its resources is nothing but an acceptance of—submission to—the totality of its world." It is not that I disagree with Kuspit's description of Salle's enterprise; rather, I find no cause for celebration. "David Salle at Boone and Castelli," *Art in America* (Summer 1982), 142.

15. Jean Baudrillard, *L'Échange symbolique et la mort* (Paris, 1975), passim. For an English text, see Baudrillard's "The Beaubourg Effect," *October* 20 (Spring 1982).

16. See in particular Lacan's "On a question preliminary to any possible treatment of psychosis," in *Écrits: A Selection* (New York, 1977).

17. This formulation is Gregory Bateson's. See Anthony Wilden, *System and Structure* (London, 1972), 56–62.

18. Gilles Deleuze and Félix Guattari, for example. See their *Anti-Oedipus* (New York, 1977).

19. This is the argument of neoconservative Daniel Bell in *The Cultural Contradictions of Capitalism* (New York, 1976), esp. 85–119. For a rebuttal, see Jürgen Habermas, "Modernity versus Postmodernity," *New German Critique* 22 (Winter 1981), 3–14.

20. Ernest Mandel, *Late Capitalism* (London: Verso, 1978), 502. Mandel, of course, is indebted here to Lukács's *History and Class Consciousness*.

21. Jauss, *Toward an Aesthetic of Reception*, 28–32.

22. This definition is Wolfgang Iser's. Quoted in Jauss, ibid., 197.

23. Elsaesser, "Myth as the Phantasmagoria of History," 132–33.

24. Thus, Penck tends to project violence as part of some essential "human nature." But we can treat violence as innate only at the risk of overlooking its specific *social* determinants: its origins in frustration provoked by an opaque, omnipotent social process.

25. On the historicity of artistic materials and production techniques, see Benjamin Buchloh, "Michael Asher and the Conclusion of Modernist Sculpture," *Performance, Text(e)s & Documents,* ed. Chantal Pontbriand (Montreal, 1981), 55–65.

William Wegman's
Psychoanalytic Vaudeville

*Certain essential aspects of the world are accessible only
to laughter.*

— MIKHAIL BAKHTIN, *Rabelais and His World*

A retrospective is an occasion to chart the itinerary of a career, to articulate the ends towards which it is directed and the purposes by which it is shaped—in short, to assess an artist's achievement. To speak of William Wegman's achievement, however, as his current mid-career retrospective mounted by the Walker Art Center in Minneapolis encourages us to do, is to ignore the ways in which Wegman has effectively jettisoned the whole ideology of achievement. In our culture, achievements are invariably teleological and always comport some more or less explicit idea of mastery; whereas Wegman's work—if the plurality of his works can indeed be reduced to the singularity of an oeuvre—has been characterized from the very beginning by a deliberate refusal of mastery.[1]

Until recently, Wegman worked almost exclusively in video, drawing, and black-and-white photography; his works in these mediums are distinguished by their informality, artlessness, even vulnerability. Still, his refusal of mastery is not simply a matter of technique; rather it is often the explicit theme of his works, which speak of failure more often than success, of intention thwarted rather than realized, of falling short of rather than hitting the mark.[2] *Three Mistakes,* for example, an early black-and-white photograph (1971–72), depicts three puddles of milk next to three empty glasses, while a photo-diptych from the same period demonstrates the technique of *X-Ray Photography*: The first shot, captioned "How It's Done," explains the setup (Wegman attempting to photograph a female model through what appears to be a lead plate); the second, a photograph of the plate, is captioned "The Finished Product (Unsuccessful)."

156

In neither of these works does failure produce a melancholic sense of frustration or defeat, as it does in the work of so many of the younger artists whom Wegman clearly has influenced. Rather, if his work posits an essential powerlessness, it is one which can continually be traversed and enjoyed, and from which something can be carried away in the end. (Thus, from 1975 through '79 he executed a series of altered photographs, in which he capitalizes on his own mistakes, drawing directly onto overexposed or poorly developed prints, thereby salvaging what might otherwise have to be abandoned.)

This aspect of Wegman's activity is reminiscent of that of the late Roland Barthes; as Paul Smith writes in a recent essay on Barthes's last texts:

> Barthes was never a master, would never have wanted to be one. . . . In his project of decomposing the certainties and fixities of a kingly structure, our culture, Barthes acts almost as that most trifling value in the game, the pawn who makes relentless forays against the space of the king—classical, doxical, scientific, masculine space as that is in our inherited culture. And to the extent that this is a specifically disruptive gambit, it concerns us all.[3]

Barthes's weapon in this subversive activity was, of course, *écriture*, writing; Wegman's is laughter. He uses it to undermine all belief, to dislodge all certainty, to discredit all dogma.

> *The serious aspects of class culture are official and authoritarian; they are combined with violence, prohibitions, limitations and always contain an element of fear and intimidation. . . . Laughter, on the contrary, overcomes fear, for it knows no inhibitions, no limitations. Its idiom is never used by violence and authority.*
>
> — BAKHTIN

Wegman himself acknowledges the link between laughter and nonmastery in his work: "As soon as I got funny," he is quoted in the Walker catalogue, "I killed any majestic intentions in my work." Still, the Walker retrospective tends to minimize this aspect of his activity. Perhaps any retrospective would have done the same, but here this problem is compounded by the unjustifiable omission of Wegman's videotapes, in which his refusal of mastery is most explicit. Neither the 20-minute compilation tape titled—debatably—*The Best of Wegman,* nor Kim Levin's catalogue essay on Wegman's video are adequate substitutes for the tapes themselves, which often narrate the failure of his attempts to impose himself on, and at the expense of, his pet Weimaraner Man Ray.

What the Walker retrospective does include is a disproportionately large selection of the large-format (20-by-24-inch) color Polaroids that Wegman began making in 1979. The majority of these pictures are of Man Ray, either in distinctly human situations—*Ray and Mrs. Lubner in Bed Watching TV*, or wearing an Indian headdress, stranded in a canoe—or transformed into another breed, even species—wrapped in tinsel to become an *Airedale*, or photographed upside-down as *Ray Bat*. Abrams has recently published a collection of the Polaroids, titled *Man's Best Friend*. In the introduction, Lawrence Weider relates them to Wegman's videotapes—"In single photographs, Wegman and Man Ray manage to condense the extended conceits of the video performance into one elegantly composed and articulate image"—but he also observes a (highly significant) difference: "Unlike the grainy video image, the resulting glossy color prints have the presence and uniqueness of paintings."[4]

Elegant composition, presence, uniqueness—these are precisely the values that Wegman's earlier works repudiate. But it is not simply in their technical virtuosity that the Polaroids appear to reinstate the aura of mastery that Wegman once refused; in them, Man Ray is used in an entirely different manner. For while these "masterful" images deal with the domestication of the Other—our tendency to reduce its difference to a variation of identity—in them Man Ray behaves less, as in earlier works, as a foil that deflects Wegman's designs on him, and more like a passive and submissive model. (This development is pushed further in Wegman's recent parodies of fashion photographs, in which a woman is frequently substituted for the dog.)[5]

The Polaroids appear at the conclusion of the Walker retrospective; however, many are seen at its beginning as well, in a highly professional introductory slide show (accompanied by Wegman's voice-over commentary) about Man Ray, who died in March of 1982. Framed by—suspended between—these seductive images, the retrospective appears to be working at cross-purposes: on the ond hand, to commemorate Man Ray; on the other, to certify Wegman as a contemporary master.

This contradiction can be resolved, however, if Man Ray is regarded as substitute for his master; and, in a lengthy wall label, prominently displayed in the galleries and reprinted in the catalogue, this is exactly what curator Lisa Lyons proposes:

> Did Wegman regard Man Ray as an alter ego of sorts? Not exactly forthcoming on this point, he simply says that by using Ray he was able to diffuse the narcissism that is so often an element of conceptually oriented video and photography. That may be so, yet it is undeniable that Ray often appears as a surrogate for human presence in Wegman's work.

"It is undeniable . . . "—such certainty seems very un-Wegman-like. Wegman's statement is as follows: "There's always the risk in video of putting yourself on TV, being narcissistic. I think Man Ray diverted all that." So Lyons attributes to Wegman precisely what he himself denies—the narcissistic identification with an other, through which the ego is constituted as a (libidinal) object:

> The ego takes its place by taking the place of the other, by replacing that other within itself and by seeking to deprive it of its alterity. One of the most powerful forms this process can take is precisely the desire to rediscover the same, to repeat, to recognize, and thus to transform a movement of difference into one of identity.[6]

The narcissistic ego attempts to assimilate, to appropriate, to *master* the other, treating it as a mere extension of itself. But this is precisely what Wegman refuses to do—at least prior to 1979.

> *Laughter purifies from dogmatism, from the intolerant and the petrified; it liberates from fanaticism and pedantry, from fear and intimidation, from didacticism, naïveté and illusion, from the single meaning, the single level, from sentimentality. Laughter does not permit seriousness to atrophy and to be torn away from the one being, forever incomplete. It restores this ambivalent wholeness. Such is the function of laughter in the historical development of culture and literature.*
>
> — BAKHTIN

Wegman's refusal of mastery reveals his historical filiation with minimalism—minimalist performance in particular, with its assault on the exhibitionism of traditional performance modes. "The display of technical virtuosity," Yvonne Rainer wrote in 1966, "of the dancer's specialized body, no longer makes any sense." Significantly, Rainer rejected such display as introverted, self-congratulatory, *narcissistic*; in its place she advocated "a context wherein people are engaged in making a less spectacular demand on the body and in which skill is hard to locate."[7]

William Wegman, Dusted, 1982. Courtesy Holly Solomon Gallery, New York City.

In works of the early '70s, Wegman constructs just such a context. This was, of course, a time when many site-specific and ephemeral art works were being reinserted into the circuit of commercial distribution and exchange via photography, and many of Wegman's early photographs and videotapes *pose* as documentation—even though Wegman's performances were executed only for the camera. Sometimes he deals with the photographic packaging of the artistic personality: in the brief video sequence "Stomach Song," as well as in a pair of black-and-white photographs *Drinking Milk* (1971) he parodies the narcissistic conceits of "body art" and its substitution of the artist's body for the esthetic object (Acconci in particular comes to mind). In both works Wegman presents his own bare torso, cropped at shoulders and waist, as a face— nipples becomes eyes, and the navel a mouth, through which he either sings or drinks milk with a straw.

Although Wegman "comes out" of minimalism, many of his early works were conceived as parodies of specific minimalist practices and, more generally, of their austerity, reductiveness, humorlessness. A 1971 photograph of a sheet of masonite propped against a wall (reminiscent of Richard Serra's prop pieces from the late '60s) includes a pair of shoes protruding from underneath, as well as the caption "To Hide His Deformity He Wore Special Clothing." *Building a Box* (also 1971), nine photographs displayed as a grid, parodies process-oriented sculpture (Robert Morris's *Box with the Sound of Its Own Making* comes to mind), as well as the systemic and/or serial concerns of artists like Andre, Bochner, and LeWitt. (The last is also the target of several works involving Man Ray in serial poses: *Stormy Night, Ray-O-Vac, Permutations: Before/On/ After.*)

The structure of these works seems at least as significant as the practices they parody. For a parody is a dialogue; as Bakhtin observes, "In parody, two languages [the one being parodied, and the one that parodies] are crossed with each other, as well as two styles, two linguistic points of view and, in the final analysis, two speaking subjects."[8] Structured as a conversation, parody is dialogical; it narrates an artist's encounter with another work, another text, another subject.

If, in the works mentioned above, Wegman encounters other artistic practices, in a number of other works from the same period he engages with the spectator. A 1970 photograph of a stuffed parrot, for example, is improbably captioned *Crow*. This picture is not about the incommensurability of words and images; Wegman is not Magritte. Rather, he presents what initially appears to be a seamless, entirely plausible image of reality that turns out, on closer inspection, to be fundamentally du-

plicitous. For the shadow cast by the stuffed bird is not the shadow of a parrot at all, but of a crow. What we witness, in this work, is not the (narcissistic) reduction of difference to identity, but rather the emergence of difference out of apparent sameness.

In other works—*Madam I'm Adam,* which Wegman describes as a visual palindrome, and *Chairs* (both 1970)—what appear to be two identical photographs are exhibited side by side; they are not the same at all, however, but opposites—because one of the prints has been flopped. Wegman frequently employs such reversals and inversions (*Upside-Down Plywood,* 1972)—Bakhtin described parody as "the world inside-out"[9]— to *seduce* the viewer, to lead him astray, and thus to force him to recognize his (narcissistic) desire to perceive analogies, similarities, resemblances.

Insofar as the position of the spectator is inscribed, in these works, within the scenario they seek to tell, Wegman's art retains certain affinities with minimalism. A minimalist installation also denies the spectator any transcendental viewpoint outside the work, from which it can be viewed as a meaningful, self-contained object against which he can situate himself as an equally meaningful, self-contained subject. What distinguishes Wegman's work is his (re)introduction of narrative—the third person—into the intersubjective artist-viewer dyad. The appearance of this third term diverts both the artist's and the spectator's attempts reciprocally to constitute themselves as self-contained subjects, revealing instead their dependency upon an other they can never fully master or assimilate. And this third "person" was Man Ray.

> [Man Ray] *takes a lot of pressure off me. It's like having a third person in a conversation; one of you doesn't have to talk all of the time.*
>
> — WEGMAN

> *A joke is the most social of all the mental functions that aim at a yield of pleasure. It often calls for three persons and its completion requires the participation of someone else in the mental process it starts.*
>
> — SIGMUND FREUD
> *Jokes and Their Relation to the Unconscious*

In the Walker catalogue, Lisa Lyons writes that Wegman's art deals with such themes as "transference of identity" and "the realm of the irrational." Transference, irrationality—these are, of course, subjects investigated by psychoanalysis, and Wegman's involvement with them locates his works within a distinctly psychoanalytic (as opposed to psy-

chological) space. The videotapes, in fact, are a psychoanalytic vaude-ville played out within the classic scene of imaginary identification: al-though he faces the camera directly, Wegman never looks directly into it, but off to one side, at his own image in an off-screen monitor. Po-sitioned as both subject and object of the look, he reenacts the narcissistic fantasy of simultaneously occupying two positions, of being in two places at the same time.

The identification of the subject with his image is incomplete, how-ever (as Jacques Lacan demonstrates in his famous analysis of this same scenario in his commentaries on the mirror state), without the inter-vention of a third person, who grants this image to the subject: "In Lacan's mirror stage the infant is fixed, constrained in a representation which the infant believes to be the Other's, the mother's, image of [him or] her."[10] In Wegman's videotapes, this function falls to the spectator, whom the artist solicits as an accomplice in his narcissistic attempt to con-solidate himself as an autonomous, self-contained ego. (Significantly, the image Wegman contemplates in the off-screen monitor is identical to the spectator's image of him.)

Enter Man Ray, who, as Wegman remarks, "diverted all that."

Is it merely coincidental that the first photograph of Man Ray to ap-pear in the exhibition depicts a *Dog Dream*? (Man Ray sleeps on a sofa, while a stuffed alligator preys upon a stuffed squirrel.) Freud, of course, identified the dream as the "royal road" to the unconscious; but he also designated another mode of access, one that is somewhat less regal—the joke. Jokes, too, depend upon the intervention of a third person. If, as Freud argues in his celebrated study of *Jokes and Their Relation to the Un-conscious,* the distinguishing feature of a joke is the "explosive laughter" it produces; and, further, if we can never laugh at our own jokes (except, Freud adds, *par ricochet*), then the power to decide the fate of the joke resides not with the person who tells it, but with the person who listens.[11] Thus, Freud describes the joke as a scene with three protagonists: an exhibitionistically inclined first person, who tells the joke ("the motive force for the production of innocent jokes is not infrequently an ambi-tious urge to show one's cleverness, to display oneself—an instinct that may be equated with exhibitionism in the sexual field");[12] a second per-son, the object of the joke (who need not be a person at all, but an idea which is unacceptable to consciousness); and, finally, a voyeuristically inclined "third person," whose laughter completes the mental process initiated by the first.

This trio makes its first appearance in Freud's analysis of obscene

jokes, which, Freud contends, originate in a *failed* attempt at seduction. The joke begins as an obscene remark directed at a woman with the intention of arousing her sexually. Such remarks, however, frequently meet with the woman's resistance: "The ideal case of a resistance of this kind," Freud writes, "occurs if another man is present at the same time— a third person—, for in that case an immediate surrender by the woman is as good as out of the question."[13] The third person "soon acquires the greatest importance in the development of the smut" into a joke, however, for he gradually displaces the woman as its addressee. Thus, second and third persons change positions: the man becomes a second person, while the woman becomes the object of the joke. Thus, the positions of the two men are ultimately aligned with the grammatical positions assigned by the personal pronouns "I" and "you"; while the woman assumes the position of the nonperson, the "it," or, in Freudian terms, the "id."[14]

This scenario is continually reenacted in Wegman's videotapes, with Wegman as seducer, Man Ray as the other (the woman), and the spectator as "third person." Wegman frequently attempts to impose the human upon the not-human; sometimes he attempts to teach Man Ray to spell, or to smoke cigarettes, addressing him as "you." ("P-A-R-K was spelled correctly. *Wait* a minute. And you spelled O-U-T right.") Wegman is not, of course, attempting literally to seduce the animal, but he *is* encouraging his submission, acquiescence. And, as "*Wait* a minute" indicates, Wegman's attempts usually meet with (a greater or lesser degree of) resistance. In the mock television commercial "New and Used Car Salesman," for example, Wegman attempts to hold Man Ray on his lap— "Just as this dog trusts me, I would like you all out there to trust me and come down to our new and used car lot and buy some of our quality cars"—while Man Ray struggles to get free.

Here, it is not (as Kim Levin suggests) the "failure of words to live up to images" that is exposed, but rather the ultimate failure of the ego's narcissistic attempts to appropriate the other as one of the modes of its consciousness, of itself. As such, Man Ray comes to occupy the position of the "it"—"this dog"; in Wegman's work, then, he represents that measure of alterity that can never be fully assimilated or mastered.

But if Man Ray has assumed the position of the third person, then the spectator is simultaneously promoted to the position of the second person, and it is through the spectator's laughter that Wegman's failure is redeemed, even celebrated. And when we laugh at Man Ray's foiling of Wegman's designs, we are also acknowledging the possibility, in-

deed the necessity, of another, nonnarcissistic mode of relating to the Other—one based not on the denial of difference, but upon its recognition. Thus, inscribed within the *social* space in which both Bakhtin and Freud situate laughter, Wegman's refusal of mastery is ultimately political in its implications.

NOTES

1. For a similar discussion of the refusal of mastery, to which my own is indebted, see Paul Smith, "We Always Fail—Barthes' Last Writings," *SubStance* 36 (1982), 34–39.

2. In the early '70s John Baldessari, with whom Wegman has been closely associated, also executed a series of works which deliberately court esthetic error—works in which he attempted to photograph a bouncing ball so that it appeared in the middle of the frame, or four balls thrown into the air to form a straight line.

3. Smith, "We Always Fail," 34.

4. Lawrence Weider in William Wegman, *Man's Best Friend* (New York: Abrams, 1982), 9.

5. In the catalogue for the Walker retrospective, Lisa Lyons detects a shift in Wegman's career. Writing of Wegman's recent "Man Ray Portfolio," she observes, "Technically and stylistically, the portfolio prints may well mark the beginning of a new direction in Wegman's photography. Clearly, he has fallen under the medium's spell and, in fact, he acknowledges that he has recently become interested in the work of such masters of photography as Weston and Strand."

6. Samuel Weber, *The Legend of Freud* (Minneapolis: University of Minnesota Press, 1982), 94.

7. Yvonne Rainer, *Work 1961–73* (Halifax: The Press of the Nova Scotia College of Art and Design, 1974), 65–66.

8. Mikhail Bakhtin, *The Dialogic Imagination* (Austin: University of Texas Press, 1981), 76.

9. Bakhtin, *Rabelais and His World* (Cambridge, Mass.: MIT Press, 1968), 11.

10. Jane Gallop, *Feminism and Psychoanalysis* (Ithaca: Cornell University Press, 1982), 121.

11. Sigmund Freud, *Jokes and Their Relation to the Unconscious*, trans. James Strachey (New York: Norton, 1960), 100. Significantly, in his discussion of the psychology of the artist in the *Introductory Lectures on Psychoanalysis* (Lecture XXIII), Freud attributes the power to decide the success or failure of the work of art to the spectator; see my "Honor, Power, and the Love of Women," *Art in America* (January 1983), 7–8.

12. Freud, *Jokes and Their Relation to the Unconscious*, 143.

13. Ibid., 99.

14. "The common definition of the personal pronouns as containing the three terms *I, you,* and *it* abolishes the notion of 'person,' which belongs only to *I/you,* and disappears with *it.*" Émile Benveniste, *Problèmes de linguistique générale* (Paris: Gallimard, 1966). Benveniste's distinction seems highly relevant to Wegman's work, which constantly stages the struggle between the personal and the nonpersonal, the self and the Other, the ego and the id.

The Discourse of Others:
Feminists and Postmodernism

Postmodern knowledge [le savoir postmoderne] *is not simply an instrument of power. It refines our sensitivity to differences and increases our tolerance of incommensurability.*

— J. F. LYOTARD, *La condition postmoderne*

Decentered, allegorical, schizophrenic . . . —however we choose to diagnose its symptoms, postmodernism is usually treated, by its protagonists and antagonists alike, as a crisis of cultural authority, specifically of the authority vested in Western European culture and its institutions. That the hegemony of European civilization is drawing to a close is hardly a new perception; since the mid-1950s, at least, we have recognized the necessity of encountering different cultures by means other than the shock of domination and conquest. Among the relevant texts are Arnold Toynbee's discussion, in the eighth volume of his monumental *Study in History*, of the end of the modern age (an age that began, Toynbee contends, in the late 15th century when Europe began to exert its influence over vast land areas and populations not its own) and the beginning of a new, properly postmodern age characterized by the coexistence of different cultures. Claude Lévi-Strauss's critique of Western ethnocentrism could also be cited in this context, as well as Jacques Derrida's critique of this critique in *Of Grammatology*. But perhaps the most eloquent testimony to the end of Western sovereignty has been that of Paul Ricoeur, who wrote in 1962 that "the discovery of the plurality of cultures is never a harmless experience."

> When we discover that there are several cultures instead of just one and consequently at the time when we acknowledge the end of a sort of cultural monopoly, be it illusory or real, we are threatened with the destruction of our own discovery. Suddenly it becomes possible that there are just *others*, that we ourselves are an "other" among others. All meaning and every goal having disappeared, it becomes possible to wander through civilizations as

if through vestiges and ruins. The whole of mankind becomes an imaginary museum: where shall we go this weekend—visit the Angkor ruins or take a stroll in the Tivoli of Copenhagen? We can very easily imagine a time close at hand when any fairly well-to-do person will be able to leave his country indefinitely in order to taste his own national death in an interminable, aimless voyage.[1]

Lately, we have come to regard this condition as postmodern. Indeed, Ricoeur's account of the more dispiriting effects of our culture's recent loss of mastery anticipates both the melancholia and the eclecticism that pervade current cultural production—not to mention its much-touted pluralism. Pluralism, however, reduces us to being an other among others; it is not a recognition, but a reduction to difference to absolute indifference, equivalence, interchangeability (what Jean Baudrillard calls "implosion"). What is at stake, then, is not only the hegemony of Western culture, but also (our sense of) our identity as a culture. These two stakes, however, are so inextricably intertwined (as Foucault has taught us, the positing of an Other is a necessary moment in the consolidation, the incorporation of any cultural body) that it is possible to speculate that what has toppled our claims to sovereignty is actually the realization that our culture is neither as homogeneous nor as monolithic as we once believed it to be. In other words, the causes of modernity's demise—at least as Ricoeur describes its effects—lie as much within as without. Ricoeur, however, deals only with the difference without. What about the difference within?

In the modern period the authority of the work of art, its claim to represent some authentic vision of the world, did not reside in its uniqueness or singularity, as is often said; rather, that authority was based on the universality modern aesthetics attributed to the *forms* utilized for the representation of vision, over and above differences in content due to the production of works in concrete historical circumstances.[2] (For example, Kant's demand that the judgment of taste be universal—i.e., universally communicable—that it derive from "grounds deep-seated and shared alike by all men, underlying their agreement in estimating the forms under which objects are given to them.") Not only does the postmodernist work claim no such authority, it also actively seeks to undermine all such claims; hence, its generally deconstructive thrust. As recent analyses of the "enunciative apparatus" of visual representation—its poles of emission and reception—confirm, the representational systems of the West admit only one vision—that of the constitutive male subject—or, rather, they posit the subject of representation as absolutely centered, unitary, masculine.[3]

The postmodernist work attempts to upset the reassuring stability of that mastering position. This same project has, of course, been attributed by writers like Julia Kristeva and Roland Barthes to the *modernist* avant-garde, which through the introduction of heterogeneity, discontinuity, glossolalia, etc., supposedly put the subject of representation in crisis. But the avant-garde sought to transcend representation in favor of presence and immediacy; it proclaimed the autonomy of the signifier, its liberation from the "tyranny of the signified"; postmodernists instead expose the tyranny of the *signifier*, the violence of its law.[4] (Lacan spoke of the necessity of submitting to the "defiles" of the signifier; should we not ask rather who in our culture is defiled by the signifier?) Recently, Derrida has cautioned against a wholesale condemnation of representation, not only because such a condemnation may appear to advocate a rehabilitation of presence and immediacy and thereby serve the interests of the most reactionary political tendencies, but more importantly, perhaps, because that which exceeds, "transgresses the figure of all possible representation," may ultimately be none other than . . . the law. Which obliges us, Derrida concludes, "to thinking altogether *differently*."[5]

It is precisely at the legislative frontier between what can be represented and what cannot that the postmodernist operation is being staged—not in order to transcend representation, but in order to expose that system of power that authorizes certain representations while blocking, prohibiting, or invalidating others. Among those prohibited from Western representation, whose representations are denied all legitimacy, are women. Excluded from representation by its very structure, they return within it as a figure for—a representation of—the unrepresentable (Nature, Truth, the Sublime, etc.). This prohibition bears primarily on woman as the subject, and rarely as the object of representation, for there is certainly no shortage of images *of* women. Yet in being represented by, women have been rendered an absence within the dominant culture as Michèle Montrelay proposes when she asks "whether psychoanalysis was not articulated precisely in order to repress femininity (in the sense of producing its symbolic representation)."[6] In order to speak, to represent herself, a woman assumes a masculine position; perhaps this is why femininity is frequently associated with masquerade, with false representation, with simulation and seduction. Montrelay, in fact, identifies women as the "ruin of representation": not only have they nothing to lose; their exteriority to Western representation exposes its limits.

Here, we arrive at an apparent crossing of the feminist critique of

patriarchy and the postmodernist critique of representation; this essay is a provisional attempt to explore the implications of that intersection. My intention is not to posit identity between these two critiques; nor is it to place them in a relation of antagonism or opposition. Rather, if I have chosen to negotiate the treacherous course between postmodernism and feminism, it is in order to introduce the issue of sexual difference into the modernism/postmodernism debate—a debate which has until now been scandalously in-different.[7]

<center>"A REMARKABLE OVERSIGHT"[8]</center>

Several years ago I began the second of two essays devoted to an allegorical impulse in contemporary art—an impulse that I identified as postmodernist—with a discussion of Laurie Anderson's multimedia performance *Americans on the Move*.[9] Addressed to transportation as a metaphor for communication—the transfer of meaning from one place to another—*Americans on the Move* proceeded primarily as verbal commentary on visual images projected on a screen behind the performers. Near the beginning Anderson introduced the schematic image of a nude man and woman, the former's right arm raised in greeting, that had been emblazoned on the Pioneer spacecraft. Here is what she had to say about this picture; significantly, it was spoken by a distinctly male voice (Anderson's own processed through a harmonizer, which dropped it an octave—a kind of electronic vocal transvestism):

> In our country, we send pictures of our sign language into outer space. They are speaking our sign language in these pictures. Do you think they will think his hand is permanently attached that way? Or do you think they will read our signs? In our country, good-bye looks just like hello.

Here is my commentary on this passage:

> Two alternatives: either the extraterrestrial recipient of this message will assume that it is simply a picture, that is, an analogical likeness of the human figure, in which case he might logically conclude that male inhabitants of Earth walk around with their right arms permanently raised. Or he will somehow divine that this gesture is addressed to him and attempt to read it, in which case he will be stymied, since a single gesture signifies both greeting and farewell, and any reading of it must oscillate between these two extremes. The same gesture could also mean "Halt!" or represent the taking of an oath, but if Anderson's text does not consider these two alternatives that is because it is not concerned with ambiguity, with multiple meanings engendered by a single sign; rather, *two clearly defined*

but mutually incompatible readings are engaged in blind confrontation in such a way that it is impossible to choose between them.

This analysis strikes me as a case of gross critical negligence. For in my eagerness to rewrite Anderson's text in terms of the debate over determinate versus indeterminate meaning, I had overlooked something—something that is so obvious, so "natural" that it may at the time have seemed unworthy of comment. It does not seem that way to me today. For this is, of course, an image of sexual difference or, rather, of sexual differentiation according to the distribution of the phallus—as it is marked and then re-marked by the man's right arm, which appears less to have been raised than erected in greeting. I was, however, close to the "truth" of the image when I suggested that men on Earth might walk around with something permanently raised—close, perhaps, but no cigar. (Would my reading have been different—or less in-different— had I known then that, earlier in her career, Anderson had executed a work which consisted of photographs of men who had accosted her in the street?)[10] Like all representations of sexual difference that our culture produces, this is an image not simply of anatomical difference, but of the values assigned to it. Here, the phallus is a signifier (that is, it represents the subject for another signifier); it is, in fact, the privileged signifier, the signifier of privilege, of the power and prestige that accrue to the male in our society. As such, it designates the effects of signification in general. For in this (Lacanian) image, chosen to represent the inhabitants of Earth for the extraterrestrial Other, it is the man who speaks, who represents mankind. The woman is only represented; she is (as always) already spoken for.

If I return to this passage here, it is not simply to correct my own remarkable oversight, but more importantly to indicate a blind spot in our discussions of postmodernism in general: our failure to address the issue of sexual difference—not only in the objects we discuss, but in our own enunciation as well.[11] However restricted its field of inquiry may be, every discourse on postmodernism—at least insofar as it seeks to account for certain recent mutations within that field—aspires to the status of a general theory of contemporary culture. Among the most significant developments of the past decade—it may well turn out to have been *the* most significant—has been the emergence, in nearly every area of cultural activity, of a specifically feminist practice. A great deal of effort has been devoted to the recovery and revaluation of previously marginalized or underestimated work; everywhere this project has been accompanied by energetic new production. As one engaged in these ac-

tivities—Martha Rosler—observes, they have contributed significantly to debunking the privileged status modernism claimed for the work of art: "The interpretation of the meaning and social origin and rootedness of those [earlier] forms helped undermine the modernist tenet of the separateness of the aesthetic from the rest of human life, and an analysis of the oppressiveness of the seemingly unmotivated forms of high culture was companion to this work."[12]

Still, if one of the most salient aspects of our postmodern culture is the presence of an insistent feminist voice (and I use the terms *presence* and *voice* advisedly), theories of postmodernism have tended either to neglect or to repress that voice. The absence of discussions of sexual difference in writings about postmodernism, as well as the fact that few women have engaged in the modernism/postmodernism debate, suggest that postmodernism may be another masculine invention engineered to exclude women. I would like to propose, however, that women's insistence on difference and incommensurability may not only be compatible with, but also an instance of postmodern thought. Postmodern thought is no longer binary thought (as Lyotard observes when he writes, "Thinking by means of oppositions does not correspond to the liveliest modes of postmodern knowledge [*le savoir postmoderne*]").[13] The critique of binarism is sometimes dismissed as intellectual fashion; it is, however, an intellectual imperative, since the hierarchical opposition of marked and unmarked terms (the decisive/divisive presence/absence of the phallus) is the dominant form both of representing difference and justifying its subordination in our society. What we must learn, then, is how to conceive difference without opposition.

Although sympathetic male critics respect feminism (an old theme: respect for women)[14] and wish it well, they have in general declined the dialogue in which their female colleagues are trying to engage them. Sometimes feminists are accused of going too far, at others, not far enough.[15] The feminist voice is usually regarded as one among many, its insistence on difference as testimony to the pluralism of the times. Thus, feminism is rapidly assimilated to a whole string of liberation or self-determination movements. Here is one recent list, by a prominent male critic: "ethnic groups, neighborhood movements, feminism, various 'countercultural' or alternative life-style groups, rank-and-file labor dissidence, student movements, single-issue movements." Not only does this forced coalition treat feminism itself as monolithic, thereby suppressing its multiple internal differences (essentialist, culturalist, linguistic, Freudian, anti-Freudian . . .); it also posits a vast, undifferentiated category, "Difference," to which all marginalized or oppressed groups

can be assimilated, and for which women can then stand as an emblem, a *pars totalis* (another old theme: woman is incomplete not whole). But the specificity of the feminist critique of patriarchy is thereby denied, along with that of all other forms of opposition to sexual, racial, and class discrimination. (Rosler warns against using woman as "a token for all markers of difference," observing that "appreciation of the work of women whose subject is oppression exhausts consideration of all oppressions.")

Moreover, men appear unwilling to address the issues placed on the critical agenda by women unless those issues have first been neut-(e)ralized—although this, too, is a problem of assimilation: to the already known, the already written. In *The Political Unconscious,* to take but one example, Fredric Jameson calls for the "reaudition of the oppositional voices of black and ethnic cultures, women's or gay literature, 'naive' or marginalized folk art *and the like*" (thus, women's cultural production is anachronistically identified as folk art), but he immediately modifies this petition: "The affirmation of such non-hegemonic cultural voices remains ineffective," he argues, if they are not first *rewritten* in terms of their proper place in "the dialogical system of the social classes."[16] Certainly, the class determinants of sexuality—and of sexual oppression—are too often overlooked. But sexual inequality cannot be reduced to an instance of economic exploitation—the exchange of women among men—and explained in terms of class struggle alone; to invert Rosler's statement, exclusive attention to economic oppression can exhaust consideration of other forms of oppression.

To claim that the division of the sexes is irreducible to the division of labor is to risk polarizing feminism and Marxism; this danger is real, given the latter's fundamentally patriarchal bias. Marxism privileges the characteristically masculine activity of production as the *definitively human* activity (Marx: men "begin to distinguish themselves from animals as soon as they begin to produce their means of subsistence");[17] women, historically consigned to the spheres of nonproductive or reproductive labor, are thereby situated outside the society of male producers, in a state of nature. (As Lyotard has written, "The frontier passing between the sexes does not separate two parts of the same social entity.")[18] What is at issue, however, is not simply the oppressiveness of Marxist discourse, but its totalizing ambitions, its claim to account for every form of social experience. But this claim is characteristic of all theoretical discourse, which is one reason women frequently condemn it as phallocratic.[19] It is not always theory *per se* that women repudiate, nor simply, as Lyotard has suggested, the priority men have granted to it, its rigid

opposition to practical experience. Rather, what they challenge is the distance it maintains between itself and its objects—a distance which objectifies and masters.

Because of the tremendous effort of reconceptualization necessary to prevent a phallologic relapse in their own discourse, many feminist artists have, in fact, forged a new (or renewed) alliance with theory—most profitably, perhaps, with the writing of women influenced by Lacanian psychoanalysis (Luce Irigaray, Hélène Cixous, Montrelay . . .). Many of these artists have themselves made major theoretical contributions: filmmaker Laura Mulvey's 1975 essay on "Visual Pleasure and Narrative Cinema," for example, has generated a great deal of critical discussion on the masculinity of the cinematic gaze.[20] Whether influenced by psychoanalysis or not, feminist artists often regard critical or theoretical writing as an important arena of strategic intervention: Martha Rosler's critical texts on the documentary tradition in photography—among the best in the field—are a crucial part of her activity *as an artist*. Many modernist artists, of course, produced texts about their own production, but writing was almost always considered supplementary to their primary work as painters, sculptors, photographers, etc.,[21] whereas the kind of simultaneous activity on multiple fronts that characterizes many feminist practices is a postmodern phenomenon. And one of the things it challenges is modernism's rigid opposition of artistic practice and theory.

At the same time, postmodern feminist practice may question theory—and not only *aesthetic* theory. Consider Mary Kelly's *Post-Partum Document* (1973–79), a six-part, 165-piece art work (plus footnotes) that utilizes multiple representational modes (literary, scientific, psychoanalytic, linguistic, archeological and so forth) to chronicle the first six years of her son's life. Part archive, part exhibition, part case history, the *Post-Partum Document* is also a contribution to as well as a critique of Lacanian theory. Beginning as it does with a series of diagrams taken from *Écrits* (diagrams which Kelly presents as *pictures*), the work might be (mis)read as a straightforward application or illustration of psychoanalysis. It is, rather, a mother's interrogation of Lacan, an interrogation that ultimately reveals a remarkable oversight within the Lacanian narrative of the child's relation to the mother—the construction of the mother's fantasies vis-à-vis the child. Thus, the *Post-Partum Document* has proven to be a controversial work, for it appears to offer evidence of *female* fetishism (the various substitutes the mother invests in order to disavow separation from the child); Kelly thereby exposes a lack within the theory of fetishism, a perversion heretofore reserved for the male. Kelly's work is not antitheory; rather, as her use of multiple representational systems

testifies, it demonstrates that no one narrative can possibly account for all aspects of human experience. Or as the artist herself has said, "There's no single theoretical discourse which is going to offer an explanation for all forms of social relations or for every mode of political practice."[22]

A LA RECHERCHE DU RÉCIT PERDU

"No single theoretical discourse . . ."—this feminist position is also a postmodern condition. In fact, Lyotard diagnoses *the* postmodern condition as one in which the *grands récits* of modernity—the dialectic of Spirit, the emancipation of the worker, the accumulation of wealth, the classless society—have all lost credibility. Lyotard defines a discourse as modern when it appeals to one or another of these *grands récits* for its legitimacy; the advent of postmodernity, then, signals a crisis in narrative's legitimizing function, its ability to compel consensus. Narrative, he argues, is out of its element(s)—"the great dangers, the great journeys, the great goal." Instead, "it is dispersed into clouds of linguistic particles—narrative ones, but also denotative, prescriptive, descriptive, etc.—each with its own pragmatic valence. Today, each of us lives in the vicinity of many of these. We do not necessarily form stable linguistic communities, and the properties of those we do form are not necessarily communicable."[23]

Lyotard does not, however, mourn modernity's passing, even though his own activity as a philosopher is at stake. "For most people," he writes, "nostalgia for the lost narrative [*le récit perdu*] is a thing of the past."[24] "Most people" does not include Fredric Jameson, although he diagnoses the postmodern condition in similar terms (as a loss of narrative's social function) and distinguishes between modernist and postmodernist works according to their different relations to the "'truth-content' of art, its claim to possess some truth or epistemological value." His description of a crisis in modernist literature stands metonymically for the crisis in modernity itself:

> At its most vital, the experience of modernism was not one of a single historical movement or process, but of a "shock of discovery," a commitment and an adherence to its individual forms through a series of "religious conversions." One did not simply read D. H. Lawrence or Rilke, see Jean Renoir or Hitchcock, or listen to Stravinsky as distinct manifestations of what we now term modernism. Rather one read all the works of a particular writer, learned a style and a phenomenological world, to which one converted. . . . This meant, however, that the experience of one form of modernism was incompatible with another, so that one entered one world

only at the price of abandoning another. . . . The crisis of modernism came, then, when it suddenly became clear that "D. H. Lawrence" was not an absolute after all, not the final achieved figuration of the truth of the world, but only one art-language among others, only one shelf of works in a whole dizzying library.[25]

Although a reader of Foucault might locate this realization at the origin of modernism (Flaubert, Manet) rather than at its conclusion,[26] Jameson's account of the crisis of modernity strikes me as both persuasive and problematic—problematic because persuasive. Like Lyotard, he plunges us into a radical Nietzschean perspectivism: each oeuvre represents not simply a different view of the same world, but corresponds to an entirely different world. Unlike Lyotard, however, he does so only in order to extricate us from it. For Jameson, the loss of narrative is equivalent to the loss of our ability to locate ourselves historically; hence, his diagnosis of postmodernism as "schizophrenic," meaning that it is characterized by a collapsed sense of temporality.[27] Thus, in *The Political Unconscious* he urges the resurrection not simply of narrative—as a "socially symbolic act"—but specifically of what he identifies as the Marxist "master narrative"—the story of mankind's "collective struggle to wrest a realm of Freedom from a realm of Necessity."[28]

Master narrative—how else to translate Lyotard's *grand récit*? And in this translation we glimpse the terms of another analysis of modernity's demise, one that speaks not of the incompatibility of the various modern narratives, but instead of their fundamental solidarity. For what made the *grands récits* of modernity master narratives if not the fact that they were all narratives of mastery, of man seeking his telos in the conquest of nature? What function did these narratives play other than to legitimize Western man's self-appointed mission of transforming the entire planet in his own image? And what form did this mission take if not that of man's placing of his stamp on everything that exists—that is, the transformation of the world into a representation, with man as its subject? In this respect, however, the phrase *master narrative* seems tautologous, since all narrative, by virtue of "its power to master the dispiriting effects of the corrosive force of the temporal process,"[29] may be narrative of mastery.[30]

What is at stake, then, is not only the status of narrative, but of representation itself. For the modern age was not only the age of the master narrative, it was also the age of representation—at least this is what Martin Heidegger proposed in a 1938 lecture delivered in Freiburg im Breisgau, but not published until 1952 as "The Age of the World Picture" [*Die Zeit die Weltbildes*].[31] According to Heidegger, the transition to

modernity was not accomplished by the replacement of a medieval by a modern world picture, "but rather the fact that the world becomes a picture at all is what distinguishes the essence of the modern age." For modern man, everything that exists does so only in and through representation. To claim this is also to claim that the world exists only in and through a *subject* who believes that he is producing the world in producing its representation:

> The fundamental event of the modern age is the conquest of the world as picture. The world "picture" [*Bild*] now means the structured image [*Gebild*] that is the creature of man's producing which represents and sets before. In such producing, man contends for the position in which he can be that particular being who gives the measure and draws up the guidelines for everything that is.

Thus, with the "interweaving of these two events"—the transformation of the world into a picture and man into a subject—"there begins that way of being human which mans the realm of human capability given over to measuring and executing, for the purpose of gaining mastery of that which is as a whole." For what is representation if not a "laying hold and grasping" (appropriation), a "making-stand-over-against, an objectifying that goes forward and masters"?[32]

Thus, when in a recent interview Jameson calls for "the *reconquest* of certain forms of representation" (which he equates with narrative: "'Narrative,'" he argues, "is, I think, generally what people have in mind when they rehearse the usual post-structuralist 'critique of representation'"),[33] he is in fact calling for the rehabilitation of the entire social project of modernity itself. Since the Marxist master narrative is only one version among many of the modern narrative of mastery (for what is the "collective struggle to wrest a realm of Freedom from a realm of Necessity" if not mankind's progressive exploitation of the Earth?), Jameson's desire to resurrect (this) narrative is a modern desire, a desire *for* modernity. It is one symptom of our postmodern condition, which is experienced everywhere today as a tremendous loss of mastery and thereby gives rise to therapeutic programs, from both the left and the right, for recuperating that loss. Although Lyotard warns—correctly, I believe—against explaining transformations in modern/postmodern culture primarily as effects of social transformations (the hypothetical advent of a postindustrial society, for example),[34] it is clear that what has been lost is not primarily a cultural mastery, but an economic, technical, and political one. For what, if not the emergence of Third World nations, the "revolt of nature," and the women's movement—that

is, the voices of the conquered—has challenged the West's desire for ever-greater domination and control?

Symptoms of our recent loss of mastery are everywhere apparent in cultural activity today—nowhere more so than in the visual arts. The modernist project of joining forces with science and technology for the transformation of the environment after rational principles of function and utility (productivism, the Bauhaus) has long since been abandoned; what we witness in its place is a desperate, often hysterical attempt to recover some sense of mastery via the resurrection of heroic large-scale easel painting and monumental cast-bronze sculpture—mediums themselves identified with the cultural hegemony of Western Europe. Yet contemporary artists are able at best to *simulate* mastery, to manipulate its signs; since in the modern period mastery was invariably associated with human labor, aesthetic production has degenerated today into a massive deployment of the signs of artistic labor—violent, "impassioned" brushwork, for example. Such simulacra of mastery testify, however, only to its loss; in fact, contemporary artists seem engaged in a collective act of disavowal—and disavowal always pertains to a loss . . . of virility, masculinity, potency.[35]

This contingent of artists is accompanied by another which refuses the simulation of mastery in favor of melancholic contemplation of its loss. One such artist speaks of "the impossibility of passion in a culture that has institutionalized self-expression"; another, of "the aesthetic as something which is really about longing and loss rather than completion." A painter unearths the discarded genre of landscape painting only to borrow for his own canvases, through an implicit equation between their ravaged surfaces and the barren fields he depicts, something of the exhaustion of the earth itself (which is thereby glamorized); another dramatizes his anxieties through the most conventional figure men have conceived for the threat of castration—Woman . . . aloof, remote, unapproachable. Whether they disavow or advertise their own powerlessness, pose as heroes or as victims, these artists have, needless to say, been warmly received by a society unwilling to admit that it has been driven from its position of centrality; theirs is an "official" art which, like the culture that produced it, has yet to come to terms with its own impoverishment.

Postmodernist artists speak of impoverishment—but in a very different way. Sometimes the postmodernist work testifies to a deliberate *refusal* of mastery, for example, Martha Rosler's *The Bowery in two inadequate descriptive systems* (1974–75), in which photographs of Bowery storefronts alternate with clusters of typewritten words signifying in-

ebriety. Although her photographs are intentionally flat-footed, Rosler's refusal of mastery in this work is more than technical. On the one hand, she denies the caption/text its conventional function of supplying the image with something it lacks; instead, her juxtaposition of two representational systems, visual and verbal, is calculated (as the title suggests) to "undermine" rather than "underline" the truth value of each.[36] More importantly, Rosler has refused to photograph the inhabitants of Skid Row, to speak on their behalf, to illuminate them from a safe distance (photography as social work in the tradition of Jacob Riis). For "concerned" or what Rosler calls "victim" photography overlooks the constitutive role of its own activity, which is held to be merely representative (the "myth" of photographic transparency and objectivity). Despite his or her benevolence in representing those who have been denied access to the means of representation, the photographer inevitably functions as an agent of the system of power that silenced these people in the first place. Thus, they are twice victimized: first by society, and then by the photographer who presumes the right to speak on their behalf. In fact, in such photography it is the photographer rather than the "subject" who poses—as the subject's consciousness, indeed, as conscience itself. Although Rosler may not, in this work, have initiated a counter-discourse of drunkenness—which would consist of the drunks' own theories about their conditions of existence—she has nevertheless pointed negatively to the crucial issue of a politically motivated art practice today: "the indignity of speaking for others."[37]

Rosler's position poses a challenge to criticism as well, specifically, to the critic's substitution of his own discourse for the work of art. At this point in my text, then, my own voice must yield to the artist's; in the essay "in, around, and afterthoughts (on documentary photography)" which accompanies The Bowery . . . , Rosler writes:

> If impoverishment is a subject here, it is more certainly the impoverishment of representational strategies tottering about alone than that of a mode of surviving. The photographs are powerless to *deal with* the reality that is yet totally comprehended-in-advance by ideology, and they are as diversionary as the word formations—which at least are closer to being located within the culture of drunkenness rather than being framed on it from without.[38]

THE VISIBLE AND THE INVISIBLE

A work like The Bowery in Two Inadequate Descriptive Systems not only exposes the "myths" of photographic objectivity and transparency; it also

```
stewed

boiled

potted

corned

pickled

preserved

canned

fried to the hat
```

upsets the (modern) belief in vision as a privileged means of access to certainty and truth ("Seeing is believing"). Modern aesthetics claimed that vision was superior to the other senses because of its detachment from its objects: "Vision," Hegel tells us in his *Lectures on Aesthetics,* "finds itself in a purely theoretical relationship with objects, through the intermediary of light, that immaterial matter which truly leaves objects their freedom, lighting and illuminating them without consuming them."[39] Postmodernist artists do not deny this detachment, but neither do they celebrate it. Rather, they investigate the particular interests it serves. For vision is hardly disinterested; nor is it indifferent, as Luce Irigaray has observed: "Investment in the look is not privileged in women as in men. More than the other senses, the eye objectifies and masters. It sets at a distance, maintains the distance. In our culture, the predominance of the look over smell, taste, touch, hearing, has brought about an impoverishment of bodily relations. . . . The moment the look dominates, the body loses its materiality."[40] That is, it is transformed into an image.

That the priority our culture grants to vision is a sensory impoverishment is hardly a new perception; the feminist critique, however, links the privileging of vision with sexual privilege. Freud identified the transition from a matriarchal to a patriarchal society with the simultaneous devaluation of an olfactory sexuality and promotion of a more mediated, sublimated visual sexuality.[41] What is more, in the Freudian scenario it is by looking that the child discovers sexual difference, the presence or absence of the phallus according to which the child's sexual identity will be assumed. As Jane Gallop reminds us in her recent book *Feminism and Psychoanalysis: The Daughter's Seduction,* "Freud articulated the 'discovery of castration' around a sight: sight of a phallic presence in the boy, sight of a phallic absence in the girl, ultimately sight of a phallic absence in the mother. *Sexual difference takes its decisive significance from a sighting.*"[42] Is it not because the phallus is the most visible sign of sexual difference that it has become the "privileged signifier"? However, it is not only the discovery of difference, but also its denial that hinges upon

Martha Rosler, The Bowery in two inadequate descriptive systems, *1974–75.*

vision (although the reduction of difference to a common measure—
woman judged according to the man's standard and found lacking—is
already a denial). As Freud proposed in his 1926 paper "On Fetishism,"
the male child often takes the last visual impression prior to the "trau-
matic" sighting as a substitute for the mother's "missing" penis:

> Thus the foot or the shoe owes its attraction as a fetish, or part of it, to
> the circumstance that the inquisitive boy used to peer up at the women's
> legs towards her genitals. Velvet and fur reproduce—as has long been
> suspected—the sight of the pubic hair which ought to have revealed the
> longed-for penis; the underlinen so often adopted as a fetish reproduces
> the scene of undressing, the last moment in which the woman could still
> be regarded as phallic.[43]

What can be said about the visual arts in a patriarchal order that
privileges vision over the other senses? Can we not expect them to be a
domain of masculine privilege—as their histories indeed prove them to
be—a means, perhaps, of mastering through representation the "threat"
posed by the female? In recent years there has emerged a visual arts
practice informed by feminist theory and addressed, more or less ex-
plicitly, to the issue of representation and sexuality—both masculine and
feminine. Male artists have tended to investigate the social construction
of masculinity (Mike Glier, Eric Bogosian, the early work of Richard
Prince); women have begun the long-overdue process of deconstructing
femininity. Few have produced new, "positive" images of a revised femi-
ninity; to do so would simply supply and thereby prolong the life of the
existing representational apparatus. Some refuse to represent women at
all, believing that no representation of the female body in our culture
can be free from phallic prejudice. Most of these artists, however, work
with the existing repertory of cultural imagery—not because they either
lack originality or criticize it—but because their subject, feminine sexu-
ality, is always constituted in and as representation, a representation of
difference. It must be emphasized that these artists are not primarily
interested in what representations say about women; rather, they inves-
tigate what representation *does* to women (for example, the way it in-
variably positions them as objects of the male gaze). For, as Lacan wrote,
"Images and symbols *for* the woman cannot be isolated from images and
symbols *of* the woman. . . . It is representation, the representation of
feminine sexuality whether repressed or not, which conditions how it
comes into play."[44]

Critical discussions of this work have, however, assiduously avoided—
skirted—the issue of gender. Because of its generally deconstructive am-

bition, this practice is sometimes assimilated to the modernist tradition of demystification. (Thus, the critique of representation in this work is collapsed into ideological critique.) In an essay devoted (again) to allegorical procedures in contemporary art, Benjamin Buchloh discusses the work of six women artists—Dara Birnbaum, Jenny Holzer, Barbara Kruger, Louise Lawler, Sherrie Levine, Martha Rosler—claiming them for the model of "secondary mythification" elaborated in Roland Barthes's 1957 *Mythologies*. Buchloh does not acknowledge the fact that Barthes later repudiated this methodology—a repudiation that must be seen as part of his increasing refusal of mastery from *The Pleasure of the Text* on.[45] Nor does Buchloh grant any particular significance to the fact that all these artists are women; instead, he provides them with a distinctly male genealogy in the dada tradition of collage and montage. Thus, all six artists are said to manipulate the languages of popular culture—television, advertising, photography—in such a way that "their ideological functions and effects become *transparent*"; or again, in their work, "the minute and seemingly inextricable interaction of behavior and ideology" supposedly becomes an "*observable* pattern."[46]

But what does it mean to claim that these artists render the invisible visible, especially in a culture in which visibility is always on the side of the male, invisibility on the side of the female? And what is the critic really saying when he states that these artists reveal, expose, "unveil" (this last word is used throughout Buchloh's text) hidden ideological agendas in mass-cultural imagery? Consider, for the moment, Buchloh's discussion of the work of Dara Birnbaum, a video artist who re-edits footage taped directly from broadcast television. Of Birnbaum's *Technology/Transformation: Wonder Woman* (1978–79), based on the popular television series of the same name, Buchloh writes that it "unveils the puberty fantasy of Wonder Woman." Yet, like all of Birnbaum's work, this tape is dealing not simply with mass-cultural imagery, but with mass-cultural *images of women*. Are not the activities of unveiling, stripping, laying bare in relation to a female body unmistakably male prerogatives?[47] Moreover, the women Birnbaum re-presents are usually athletes

Dara Birnbaum, Wonder Woman, *1978, videotape. Courtesy Josh Baer Gallery, New York City.*

and performers absorbed in the display of their own physical perfection. They are without defect, without lack, and therefore with neither history nor desire. (Wonder Woman is the perfect embodiment of the phallic mother.) What we recognize in her work is the Freudian trope of the narcissistic woman, or the Lacanian "theme" of femininity as contained spectacle, which exists only as a representation of masculine desire.[48]

The deconstructive impulse that animates this work has also suggested affinities with poststructuralist textual strategies, and much of the critical writing about these artists—including my own—has tended simply to translate their work into French. Certainly, Foucault's discussion of the West's strategies of marginalization and exclusion, Derrida's charges of "phallocentrism," Deleuze and Guattari's "body without organs" would all seem to be congenial to a feminist perspective. (As Irigaray has observed, is not the "body without organs" the historical condition of woman?)[49] Still, the affinities between poststructuralist theories and postmodernist practice can blind a critic to the fact that, when women are concerned, similar techniques have very different meanings. Thus, when Sherrie Levine appropriates—literally takes—Walker Evans's photographs of the rural poor or, perhaps more pertinently, Edward Weston's photographs of his *son* Neil posed as a classical Greek torso, is she simply dramatizing the diminished possibilities for creativity in an image-saturated culture, as is often repeated? Or is her refusal of authorship not in fact a refusal of the role of creator as "father" of his work, of the paternal rights assigned to the author by law?[50] (This reading of Levine's strategies is supported by the fact that the images she appropriates are invariably images of the Other: women, nature, children, the poor, the insane. . . .)[51] Levine's disrespect for paternal authority suggests that her activity is less one of appropriation—a laying hold and grasping—and more one of expropriation: she expropriates the appropriators.

Sometimes Levine collaborates with Louise Lawler under the collective title "A Picture is No Substitute for Anything"—an unequivocal critique of representation as traditionally defined. (E. H. Gombrich: "All art is image-making, and all image-making is the creation of substitutes.") Does not their collaboration move us to ask what the picture is supposedly a substitute for, what it replaces, what absence it conceals? And when Lawler shows "A Movie without the Picture," as she did in 1979 in Los Angeles and again in 1983 in New York, is she simply soliciting the spectator as a collaborator in the production of the image? Or is she not also denying the viewer the kind of visual pleasure which

cinema customarily provides—a pleasure that has been linked with the masculine perversions voyeurism and scopophilia?[52] It seems fitting, then, that in Los Angeles she screened (or didn't screen) *The Misfits*— Marilyn Monroe's last completed film. So that what Lawler withdrew was not simply a picture, but the archetypal image of feminine desirability.

When Cindy Sherman, in her untitled black-and-white studies for film stills (made in the late '70s and early '80s), first costumed herself to resemble heroines of grade-B Hollywood films of the late '50s and early '60s and then photographed herself in situations suggesting some immanent danger lurking just beyond the frame, was she simply attacking the rhetoric of "auteurism by equating the known artifice of the actress in front of the camera with the supposed authenticity of the director behind it"?[53] Or was her play-acting not also an acting out of the psychoanalytic notion of femininity as masquerade, that is, as a representation of male desire? As Hélène Cixous has written, "One is always in representation, and when a woman is asked to take place in this representation, she is, of course, asked to represent man's desire."[54] Indeed, Sherman's photographs themselves function as mirror-masks that reflect back at the viewer his own desire (and the spectator posited by this work is invariably male)—specifically, the masculine desire to fix the woman in a stable and stabilizing identity. But this is precisely what Sherman's work denies: for while her photographs are always self-portraits, in them the artist never appears to be the same, indeed, not even the same model; while we can presume to recognize the same person, we are forced at the same time to recognize a trembling around the edges of that identity.[55] In a subsequent series of works, Sherman abandoned the film-still format for that of the magazine centerfold, opening herself to charges that she was an accomplice in her own objectification, reinforcing the image of the woman bound by the frame.[56] This may be true; but while Sherman may pose as a pin-up, she still cannot be pinned down.

Finally, when Barbara Kruger collages the words "Your gaze hits the side of my face" over an image culled from a '50s photo-annual of a

Louise Lawler, A Movie without the Picture, *1979, Aero Theater, Santa Monica, California. Courtesy Metro Pictures, New York City.*

female bust, is she simply "making an equation . . . between aesthetic re-flection and the alienation of the gaze: both reify"?[57] Or is she not speak-ing instead of the *masculinity* of the look, the ways in which it objecti-fies and masters? Or when the words "You invest in the divinity of the masterpiece" appear over a blown-up detail of the creation scene from the Sistine ceiling, is she simply parodying our reverence for works of art, or is this not a commentary on artistic production as a contract be-tween fathers and sons? The address of Kruger's work is always gender-specific; her point, however, is not that masculinity and femininity are fixed positions assigned in advance by the representational apparatus. Rather, Kruger uses a term with no fixed content, the linguistic shifter ("I/you"), in order to demonstrate that masculine and feminine them-selves are not stable identities, but subject to ex-change.

There is irony in the fact that all these practices, as well as the theo-retical work that sustains them, have emerged in a historical situation supposedly characterized by its complete indifference. In the visual arts we have witnessed the gradual dissolution of once fundamental distinc-tions—original/copy, authentic/inauthentic, function/ornament. Each term now seems to contain its opposite, and this indeterminacy brings with it an impossibility of choice or, rather, the absolute equivalence and hence interchangeability of choices. Or so it is said.[58] The existence of feminism, with its insistence on difference, forces us to reconsider. For in our country good-bye may look just like hello, but only from a masculine position. Women have learned—perhaps they have always known—how to recognize the difference.

NOTES

1. Paul Ricoeur, "Civilization and National Cultures," in *History and Truth*, trans. Chas. A. Kelbley (Evanston: Northwestern University Press, 1965), 278.

2. Hayden White, "Getting Out of History," *diacritics*, 12 (Fall 1982), 3. Nowhere does White acknowledge that it is precisely this universality that is in question today.

3. See, for example, Louis Marin, "Toward a Theory of Reading in the Visual Arts: Poussin's *The Arcadian Shepherds*," in *The Reader in the Text*, ed. S. Suleiman and I. Crosman (Princeton: Princeton University Press, 1980), 293–324. This essay reiterates the main points of the first section of Marin's *Détruire le peinture* (Paris: Galilée, 1977). See also Christian Metz's discussion of the enunciative apparatus of cinematic representation in his "History/Discourse: A Note on Two Voyeurisms," in *The Imaginary Signifier*, trans. Britton, Williams, Brewster, and Guzzetti (Bloomington: Indiana University Press, 1982). And for

a general survey of these analyses, see my "Representation, Appropriation, and Power," *Art in America* 70 (May 1982), 9–21.

4. Hence Kristeva's problematic identification of avant-garde practice as feminine—problematic because it appears to act in complicity with all those discourses which exclude women from the order of representation, associating them instead with the presymbolic (Nature, the Unconscious, the body, etc.).

5. Jacques Derrida, "Sending: On Representation," trans. P. and M. A. Caws, *Social Research* 49 (Summer 1982), 325, 326, italics added. (In this essay Derrida is discussing Heidegger's "The Age of the World Picture," a text to which I will return.) "Today there is a great deal of thought against representation," Derrida writes. "In a more or less articulated or rigorous way, this judgment is easily arrived at: representation is bad. . . . And yet, whatever the strength and the obscurity of this dominant current, the authority of representation constrains us, imposing itself on our thought through a whole dense, enigmatic, and heavily stratified history. It programs us and precedes us and warns us too severely for us to make a mere object of it, a representation, an object of representation confronting us, before us like a theme" (304). Thus, Derrida concludes that "the essence of representation is not a representation, it is not representable, *there is no representation of representation*" (314, italics added).

6. Michèle Montrelay, "Recherches sur la femininité," *Critique* 278 (July 1970); translated by Parveen Adams as "Inquiry into Femininity," *m/f* 1 (1978).

7. Many of the issues treated in the following pages—the critique of binary thought, for example, or the privileging of vision over the other senses—have had long careers in the history of philosophy. I am interested, however, in the ways in which feminist theory articulates them onto the issue of sexual privilege. Thus, issues frequently condemned as merely epistemological turn out to be political as well. (For an example of this kind of condemnation, see Andreas Huyssens, "Critical Theory and Modernity," *New German Critique* 26 [Spring/ Summer 1982], 3–11.) In fact, feminism demonstrates the impossibility of maintaining the split between the two.

8. "What is unquestionably involved here is a conceptual foregrounding of the sexuality of the woman, which brings to our attention a remarkable oversight." Jacques Lacan, "Guiding Remarks for a Congress on Feminine Sexuality," in *Feminine Sexuality*, ed. Juliet Mitchell and Jacqueline Rose (New York: Norton, 1982), 87.

Cindy Sherman, Untitled Film Still, *1980. Courtesy Metro Pictures, New York City.*

9. See my "The Allegorical Impulse: Toward a Theory of Postmodernism, Part 2," *October* 13 (Summer 1980), 59–80. *Americans on the Move* was first performed at The Kitchen Center for Video, Music, and Dance in New York City in April 1979; it has since been revised and incorporated into Anderson's two-evening work *United States, Parts I–IV*, first seen in its entirety in February 1983 at the Brooklyn Academy of Music.

10. This project was brought to my attention by Rosalyn Deutsche.

11. As Stephen Heath writes, "Any discourse which fails to take account of the problem of sexual difference in its own enunciation and address will be, within a patriarchal order, precisely indifferent, a reflection of male domination." "Difference," *Screen* 19 (Winter 1978–79), 53.

12. Martha Rosler, "Notes on Quotes," *Wedge* 2 (Fall 1982), 69.

13. Jean-François Lyotard, *La condition postmoderne* (Paris: Minuit, 1979), 29.

14. See Sarah Kofman, *Le respect des femmes* (Paris: Galilée, 1982). A partial English translation appears as "The Economy of Respect: Kant and Respect for Women," trans. N. Fisher, *Social Research* 49 (Summer 1982), 383–404.

15. Why is it always a question of *distance*? For example, Edward Said writes, "Nearly everyone producing literary or cultural studies makes no allowance for the truth that all intellectual or cultural work occurs somewhere, at some times, on some very precisely mapped-out and permissible terrain, which is ultimately contained by the State. Feminist critics have opened this question part of the way, but *they have not gone the whole distance*." "American 'Left' Literary Criticism," in *The World, the Text, and the Critic* (Cambridge, Mass.: Harvard University Press, 1983), 169, italics added.

16. Fredric Jameson, *The Political Unconscious* (Ithaca: Cornell University Press, 1981), 84.

17. Marx and Engels, *The German Ideology* (New York: International Publishers, 1970), 42. One of the things that feminism has exposed is Marxism's scandalous blindness to sexual inequality. Both Marx and Engels viewed patriarchy as part of a precapitalist mode of production, claiming that the transition from a feudal to a capitalist mode of production was a transition from male domination to domination by capital. Thus, in the *Communist Manifesto* they write, "The bourgeoisie, wherever it has got the upper hand, has put an end to all feudal, patriarchal . . . relations." The revisionist attempt (such as Jameson proposes in *The Political Unconscious*) to explain the persistence of patriarchy as a survival of a previous mode of production is an inadequate response to the challenge posed by feminism to Marxism. Marxism's difficulty with feminism is not part of an ideological bias inherited from outside; rather, it is a structural effect of its privileging of production as the definitively human activity. On these problems, see Isaac D. Balbus, *Marxism and Domination* (Princeton: Princeton University Press, 1982), especially chapter 2, "Marxist Theories of Patriarchy," and chapter 5, "Neo-Marxist Theories of Patriarchy." See also Stanley Aronowitz, *The Crisis in Historical Materialism* (Brooklyn: J. F. Bergin, 1981), especially chapter 4, "The Question of Class."

18. Jean-François Lyotard, "One of the Things at Stake in Women's Struggles," *SubStance* 20 (1978), 15.

19. Perhaps the most vociferous feminist antitheoretical statement is Marguerite Duras's: "The criterion on which men judge intelligence is still the capacity to theorize and in all the movements that one sees now, in whatever area it may be, cinema, theater, literature, the theoretical sphere is losing influence. It has been under attack for centuries. It ought to be crushed by now, it should lose itself in a reawakening of the senses, blind itself, and be still." In E. Marks and I. de Courtivron, eds., *New French Feminisms* (New York: Schocken, 1981), 111. The implicit connection here between the privilege men grant to theory and that which they grant to vision over the other senses recalls the etymology of *theoria*; see below. Perhaps it is more accurate to say that most feminists are ambivalent about theory. For example, in Sally Potter's film *Thriller* (1979)—which addresses the question "Who is responsible for Mimi's death?" in *La Bohème*—the heroine breaks out laughing while reading aloud from Kristeva's introduction to *Théorie d'ensemble*. As a result, Potter's film has been interpreted as an antitheoretical statement. What seems to be at issue, however, is the inadequacy of currently existing theoretical constructs to account for the specificity of a woman's experience. For as we are told, the heroine of the film is "searching for a theory that would explain her life and her death." On *Thriller,* see Jane Weinstock, "She Who Laughs First Laughs Last," *Camera Obscura* 5 (1980).

20. Published in *Screen* 16 (Autumn 1975).

21. See my "Earthwords," *October* 10 (Fall 1979), 120–32.

22. "No Essential Femininity: A Conversation between Mary Kelly and Paul Smith," *Parachute* 26 (Spring 1982), 33.

23. Lyotard, *La condition postmoderne,* 8.

24. Ibid., 68.

25. Jameson, "'In the Destructive Element Immerse': Hans-Jürgen Syberberg and Cultural Revolution," *October* 17 (Summer 1981), 113.

26. See, for example, "Fantasia of the Library," in *Language, Counter-Memory, Practice* (Ithaca: Cornell University Press, 1977), 87–109. See also Douglas Crimp, "On the Museum's Ruins," in *The Anti-Aesthetic: Essays on Postmodern Culture,* ed. Hal Foster (Seattle: Bay Press, 1983).

27. See Fredric Jameson, "Postmodernism and Consumer Society," in *The Anti-Aesthetic: Essays on Postmodern Culture,* ed. Hal Foster (Seattle: Bay Press, 1983).

28. Jameson, *The Political Unconscious,* 19.

29. White, "Getting Out of History," 3.

30. Thus, the antithesis to narrative may well be allegory, which Angus Fletcher identifies as the "epitome of counter-narrative." Condemned by modern aesthetics because it speaks of the inevitable reclamation of the works of man by nature, allegory is also the epitome of the antimodern, for it views history as an irreversible process of dissolution and decay. The melancholic, contemplative

gaze of the allegorist need not, however, be a sign of defeat; it may represent the superior wisdom of one who has relinquished all claims to mastery.

31. Translated by William Lovitt and published in *The Question Concerning Technology* (New York: Harper & Row, 1977), 115–54. I have, of course, oversimplified Heidegger's complex and, I believe, extremely important argument.

32. Ibid., 149, 150. Heidegger's definition of the modern age—as the age of representation for the purpose of mastery—coincides with Theodor Adorno and Max Horkheimer's treatment of modernity in their *Dialectic of Enlightenment* (written in exile in 1944, but without real impact until its republication in 1969). "What men want to learn from nature," Adorno and Horkheimer write, "is how to use it in order wholly to dominate it and other men." And the primary means of realizing this desire is (what Heidegger, at least, would recognize as) representation—the suppression of "the multitudinous affinities between existents" in favor of "the single relation between the subject who bestows meaning and the meaningless object." What seems even more significant, in the context of this essay, is that Adorno and Horkheimer repeatedly identify this operation as "patriarchal."

33. Fredric Jameson, "Interview," *diacritics* 12 (Fall 1982), 87.

34. Lyotard, *La condition postmoderne*, 63. Here, Lyotard argues that the *grands récits* of modernity contain the seeds of their own delegitimation.

35. For more on this group of painters, see my "Honor, Power, and the Love of Women," *Art in America*, 71 (January 1983), 7–13.

36. Martha Rosler interviewed by Martha Gever in *Afterimage* (October 1981), 15. *The Bowery in Two Inadequate Descriptive Systems* has been published in Rosler's book *3 Works* (Halifax: The Press of The Nova Scotia College of Art and Design, 1981).

37. "Intellectuals and Power: A Conversation between Michel Foucault and Gilles Deleuze," in *Language, Counter-Memory, Practice*, 209. Deleuze to Foucault: "In my opinion, you were the first—in your books and in the practical sphere— to teach us something absolutely fundamental: the indignity of speaking for others."

The idea of a counterdiscourse also derives from this conversation, specifically from Foucault's work with the "Groupe d'information de prisons." Thus, Foucault: "When the prisoners began to speak, they possessed an individual theory of prisons, the penal system, and justice. It is this form of discourse which ultimately matters, a discourse against power, the counter-discourse of prisoners and those we call delinquents—and not a theory *about* delinquency."

38. Martha Rosler, "in, around, and afterthoughts (on documentary photography)," in *3 Works*, 79.

39. Quoted in Heath, "Difference," 84.

40. Interview with Luce Irigaray in M.-F. Hans and G. Lapouge, eds., *Les femmes, la pornographie, l'erotisme* (Paris, 1978), 50.

41. *Civilization and Its Discontents*, trans. James Strachey (New York: Norton, 1962), 46–47.

42. Jane Gallop, *Feminism and Psychoanalysis: The Daughter's Seduction* (Ithaca: Cornell University Press, 1982), 27.

43. "On Fetishism," in *Sexuality and the Psychology of Love* (New York: Collier, 1963), 217.

44. Lacan, "Guiding Remarks," 90.

45. On Barthes's refusal of mastery, see Paul Smith, "We Always Fail—Barthes' Last Writings," *SubStance* 36 (1982), 34–39. Smith is one of the few male critics to have directly engaged the feminist critique of patriarchy without attempting to rewrite it.

46. Benjamin Buchloh, "Allegorical Procedures: Appropriation and Montage in Contemporary Art," *Artforum* 21 (September 1982), 43–56.

47. Lacan's suggestion that "the phallus can play its role only when veiled" suggests a different inflection of the term "unveil"—one that is not, however, Buchloh's.

48. On Birnbaum's work, see my "Phantasmagoria of the Media," *Art in America* 70 (May 1982), 98–100.

49. See Alice A. Jardine, "Theories of the Feminine: Kristeva," *enclitic* 4 (Fall 1980), 5–15.

50. "The author is reputed the father and owner of his work: literary science therefore teaches *respect* for the manuscript and the author's declared intentions, while society asserts the legality of the relation of author to work (the '*droit d'auteur*' or 'copyright,' in fact of recent date since it was only really legalized at the time of the French Revolution). As for the Text, it reads without the inscription of the Father." Roland Barthes, "From Work to Text," *Image–Music–Text*, trans. Stephen Heath (New York: Hill and Wang, 1977), 160–61.

51. Levine's first appropriations were images of maternity (women in their natural role) from ladies' magazines. She then took landscape photographs by Eliot Porter and Andreas Feininger, then Weston's portraits of Neil, then Walker Evans's FSA photographs. Her recent work is concerned with expressionist painting, but the involvement with images of alterity remains: she has exhibited reproductions of Franz Marc's pastoral depictions of animals, and Egon Schiele's self-portraits (madness). On the thematic consistency of Levine's "work," see my review, "Sherrie Levine at A&M Artworks," *Art in America* 70 (Summer 1982), 148.

52. See Metz, *The Imaginary Signifier.*

53. Douglas Crimp, "Appropriating Appropriation," in *Image Scavengers: Photography*, ed. Paula Marincola (Philadelphia: Institute of Contemporary Art, 1982), 34.

54. Hélène Cixous, "Entretien avec Françoise van Rossum-Guyon," quoted in Heath, "Difference," 96.

55. Sherman's shifting identity is reminiscent of the authorial strategies of Eugenie Lemoine-Luccioni as discussed by Jane Gallop; see *Feminism and Psychoanalysis,* 105: "Like children, the various productions of an author date from different moments, and cannot strictly be considered to have the same origin, the

same author. At least we must avoid the fiction that a person is the same, unchanging throughout time. Lemoine-Luccioni makes the difficulty patent by signing each text with a different name, all of which are 'hers.'"

56. See, for example, Martha Rosler's criticisms in "Notes on Quotes," 73: "Repeating the images of woman bound in the frame will, like Pop, soon be seen as a *confirmation* by the 'post-feminist' society."

57. Hal Foster, "Subversive Signs," *Art in America* 70 (November 1982), 88.

58. For a statement of this position in relation to contemporary artistic production, see Mario Perniola, "Time and Time Again," *Artforum* 21 (April 1983), 54–55. Perniola is indebted to Baudrillard; but are we not back with Ricoeur in 1962—that is, at precisely the point at which we started?

The Medusa Effect, or,
The Specular Ruse*

To speak is to make words common, to create commonplaces.
— EMMANUEL LÉVINAS, *Totality and Infinity*

Barbara Kruger propositions us with commonplaces, stereotypes. Juxtaposing figures and figures of speech—laconic texts superimposed on found images (Kruger does not compose these photographs herself)—she works to expose what Roland Barthes called "the rhetoric of the image": those tactics whereby photographs impose their messages upon us, hammer them home. It was Barthes who first proposed to replace the ideology of literary invention with an "ideolectology" whose operative concepts would be citation, reference, stereotype; and many artists today work within the regime of the stereotype, manipulating mass-cultural imagery so that hidden ideological agendas are supposedly exposed. But most of these artists treat the stereotype as something arbitrarily imposed upon the social field from without, and thus as something relatively easy to depose. Kruger, however, regards it as an integral part of social processes of incorporation, exclusion, domination, and rule—that is, as a weapon, an instrument of power.

Thus, in a recent work she interposes, between the viewer and a photograph of a woman in repose, a text which alludes to the stereotypical way society disposes of woman, positioning her outside "culture," in a state of nature/nurture. "We won't play nature to your culture," Kruger declares, thereby opposing what is itself already an opposition—nature/culture—and all that it presupposes: a binary logic that divides the social body into two unequal halves in order to subject one to the other ("Your assignment," Kruger writes in an earlier work, "is to divide and conquer") or, more precisely, the Other to the One (as she writes in a third work, "You destroy what you think is difference"). In refusing

191

this assignment, Kruger poses a threat; nevertheless, her work remains cool, composed. As she proposes elsewhere, "I am your reservoir of poses."

An inventory of Kruger's montage techniques—she juxtaposes, superimposes, interposes texts and images—and of the ends to which these techniques are put—she exposes, opposes, deposes stereotypes and clichés—indicates the importance of a "Rhetoric of Pose" to all her work. Most of the photographs Kruger reuses were originally staged—posed—and she crops, enlarges, and repositions them so that their theatricality is emphasized. She does not work with snapshots, in which the camera itself suspends animation, but with studio shots, in which it records an animation performed only to be suspended—a gesture, a pose. "What is a gesture?" Jacques Lacan asks in the ninth chapter (titled "What Is a Picture?") of *The Four Fundamental Concepts of Psychoanalysis.* "A threatening gesture, for example? It is not a blow that is interrupted. It is certainly something done in order to be arrested and suspended."[1]

Kruger's work, then, is concerned not with action, but with gesture or, more accurately, with the stereotype's transformation of action into gesture—"prowess into pose," as she puts it in a recent work. But "pose" appears in her work in other guises as well: for instance, in the *positionality* inscribed in language by the personal pronouns "I/we" and "you," which do not designate objects that exist independently of discourse, but manifest the subject positions of partners in a conversation. Following Émile Benveniste's distinction between "person" and "nonperson," only the first and second persons belong to the class of personal pronouns, which rigorously excludes the third person—the "nonperson," since it does not manifest a subject position but designates an objective existence. Personal pronouns have appeared in all of Kruger's works since 1980, and she uses them to incorporate the spectator—literally, because the deictic terms "I" and "you" refer directly to the bodies of speaker and addressee; through them, Kruger's pronouncements acquire body, weight, gravity.

So Kruger appears to address *me*, this body, at this particular point in space. But as soon as I identify myself as the addressee of the work, it seems to withdraw from me to speak impersonally, imperiously to the world at large. For Kruger's work operates according to a principle of double address; it oscillates perpetually between the personal and the impersonal. This oscillation is perhaps most apparent in those works which employ the first-person plural, which is not really a plural at all: as Benveniste observes, "we" does not signify a "multiplication of identical objects, but a *junction* between the 'I' and the 'not-I.'"[2] This "not-I"

can be either personal ("we" = "me" + "you") or impersonal ("we" = "me" + "them"). Kruger's "we," then, forces the viewer to shift uncomfortably between inclusion and exclusion; but it also allows her to welcome a female spectator into her work, since not only are her pronouns embodied, they are also engendered.

Consequently, the place of the viewer in Kruger's work is unstable, shifting. Personal pronouns are also known as "shifters," but not, as is widely believed, because they allow speaker and addressee to shift positions; on the contrary, shifters establish a strict rule of noncommutability—"you"—must never be "I."[3] Rather, they allow speakers to shift from code to message—from the abstract to the concrete, the collective to the individual or, again, the impersonal to the personal.[4] Hence their frequent appearance in the messages of the mass media, which tends, as Barthes observed, "to personalize all information, to make every utterance a direct challenge, not directed at the entire mass of readers, but at each reader in particular."[5] Kruger parodies this tendency in her work, exposing the contradictory construction of the viewing subject by the stereotype. As Norman Bryson writes in *Vision and Painting: The Logic of the Gaze*, "The stereotype addresses the viewer twice over, constructs him [sic] in two irreconcilable forms: as this potential donor of a vital quantum of solidarity, and as that featureless vector of political and economic energy (Worshipper, Citizen, Consumer, Producer)."[6] The stereotype, in fact, confers on the individual the dream of a double postulation: dream of identity/dream of otherness. Kruger: "You are not yourself."

Deixis is not, however, the only point of physical entry into Kruger's work, which is ultimately addressed to the struggle over the control and *positioning* of the body in political and ideological terms—a struggle in which the stereotype plays a decisive role. As Michel Foucault writes in *Discipline and Punish,* "The body . . . is directly involved in a political field; power relations have an immediate hold upon it; they invest it, mark it, train it, torture it, force it to carry out tasks, to perform ceremonies, to emit signs."[7] Many of the plates in Kruger's 1982 book *No Progress in Pleasure* bear witness to this state of affairs: in one, the monkeyshines of a group of formally dressed businessmen solicit the indictment "You construct intricate rituals which allow you to touch the skin of other men"—alluding not, I think, to repressed homosexuality, but rather to the fact that physical contact has itself become a social ceremony; in another, Kruger speaks of the state of pleasure in the society of the stereotype: "Your moments of joy have the precision of military strategy."

For Foucault, the political investment of the body is primarily an economic investment: "It is largely as a force of production that the body is invested with relations of power and domination; but, on the other hand, its constitution as labor power is possible only if it is caught up in a system of subjection." The stereotype is part of this "system of subjection": its function is to reproduce ideological subjects that can be smoothly inserted into existing institutions of government, economy, and, perhaps most crucially, sexual identity. (It is not surprising, then, that Kruger's work should deal so persistently with questions of gender.) Stereotypes treat the body as an object to be held in position, subservience, submission; they disavow agency, dismantle the body as a locus of action and reassemble it as a discontinuous series of gestures and poses—that is, as a semiotic field. The stereotype inscribes the body into the register of discourse; in it, the body is apprehended by language, taken into joint custody by politics and ideology.[8]

A form of symbolic violence exercized upon the body in order both to assign it to a place and to keep it in place, the stereotype works less through persuasion (the goal of traditional rhetoric: ideological adherence, consent) than through deterrence—what Jean Baudrillard calls "dissuasion." It promotes passivity, receptivity, inactivity—docile bodies. This effect is achieved primarily through intimidation: the stereotype poses a threat. Kruger's subject might well be defined as the rhetoric of intimidation: for example, the words "We will undo you" appear, in one work, over a photograph of a bandaged hand. Responding to charges that this work in particular is intimidating to viewers, Kruger stressed the fact that her work does not itself pose a threat, but signifies threat. Still, signs can be potent weapons, as Lacan observes in his description of the fight scenes staged by the Peking Opera:

> One fights as one has always fought since time immemorial, much more with gestures than with blows. . . . In these ballets, no two people ever touch one another, they move in different spaces in which are spread out whole series of gestures, which, in traditional combat, nevertheless have the value of weapons, in the sense that they may well be effective as instruments of intimidation.[9]

The stereotype, then, is an apotrope, a gesture executed with the express purpose of intimidating the enemy into submission. Today, even our most sophisticated technological means of physical destruction function primarily as apotropes—"nuclear threat." (Lacan: "Our most recent weapons might also be regarded as gestures. Let us hope they will remain as such!")[10] Thus, a photograph of a mushroom cloud finds its place in Kruger's lexicon of poses: "Your manias become science."

To be effective, stereotypes must circulate endlessly, relentlessly throughout society; as Foucault writes, "Posters, placards, signs, symbols must be distributed so that everyone may learn their significations."[11] And it is precisely at their point of circulation throughout society that Kruger intercepts stereotypes. It has become obligatory to cite her experience, more than a decade ago, as a graphic designer as the source for her current work. But Kruger exploits the instant legibility of graphic-design techniques only to expose it too as another weapon in the stereotype's arsenal. For that legibility is engineered to produce an immediate subjection, to imprint (stereo-*type*) the image directly on the viewer's imagination, to eliminate the need for decoding. Kruger's juxtapositions of images and texts produce the opposite effect: they impede circulation, postpone subjection, invite us to decode the message.

While the stereotype enjoys an unlimited social mobility—it must circulate freely if it is to perform its work—it must nevertheless remain fixed, in order to procure the generalized social immobility which is its dream. (As Foucault observes, the exercise of power aims at the effective immobilization of the social body.)[12] Immobility is a pervasive theme in Kruger's work: a female silhouette, literally pinned down, may appear with the injunction "We have received orders not to move"; or a patient may be held in place by a battery of dental appliances while the viewer is admonished, "You are a captive audience"; or the words "Your gaze hits the side of my face" may appear beside a female portrait head. In this last work, Kruger alludes specifically to the power attributed to vision to suspend movement and arrest life—the evil eye—identifying this power in terms of the classic polarities of vision in patriarchal culture: woman as the (passive) object of the active (i.e., masculine) gaze—a gaze which objectifies and masters. But can we be entirely certain that this woman is the victim of a *male* gaze? The response to this question will require a detour through classical myth and Freudian psychoanalysis, since what we have before us is a woman immobilized—turned to stone, in fact—by the power of the gaze . . . Medusa?

Barbara Kruger, Untitled *(You Are Not Yourself), 1983.*

Remember that it was *Medusa's* gaze that was endowed with the power of turning to stone all who came within its purview—with the power, that is, of creating figures, statues. Remember as well that Perseus contrived to steal this power for himself (and the appropriation of the gaze is the principal theme of the myth, beginning as it does with the theft of an eye),[13] to himself become a producer of figures. This he accomplished by means of a ruse: using his shield as a mirror, he reflected the deadly gaze back upon itself, whereupon Medusa was *immediately*—or so the narrative proposes—petrified. Turned against itself, Medusa's power turns out to be her vulnerability, and Perseus' vulnerability, his strength.

The myth's central episode is almost proto-photographic; it seems to describe that split-second in which vision bends back upon itself to produce its own imprint. Perseus inserts Medusa into a closed system, a relation of identity between seer and seen; the immediacy of this link makes the relationship of Medusa with her image indexical (and not simply iconic). Thus Medusa is transformed into an image, inserted into the order of designation; henceforth, she will serve primarily as the support for a long chain of discursive and figural events, beginning with Perseus' own account of his triumph over Medusa (recounted by Ovid), including the famous Roman mosaic depicting Perseus with Medusa's severed head (the prototype for countless depictions of the myth in the history of Western art), and extending into our own century with Ferenczi's, Freud's, and Hélène Cixous's psychoanalytic accounts of the myth. But what each of these authors—including myself—will systematically repeat and simultaneously deny is the ruse whereby Medusa is inserted into discourse in the first place—the violence whereby she becomes an object of depiction, narration, analysis. For Medusa herself will not depict, narrate, analyze; as Cixous says, Medusa never gets a chance to tell her side of the story.

Since Freud's well-known text "Das Medusenhaupt," the meaning of the myth has itself been petrified, immobilized. Focusing on Medusa's head as an apotrope—Athena, Freud reminds us, bore this emblem on her breastplate in order to repulse (in both senses) her enemies—he interprets it as a fetish, an emblem of castration, a displaced representation of female genitalia. Given the instantaneity invoked by the myth's central episode—Medusa sees herself and is immediately turned to stone—Freud might have related it not to the boy's, but instead to the girl's realization of her own "castration," at least as he imagines this scenario: "A little girl behaves differently [from a little boy]. She makes her judgment and her decision in a flash. She has seen it and knows that

she is without it and wants to have it."[14] Instead, Freud makes *his* judg-
ment and *his* decision in a flash; he has seen it and he knows "to de-
capitate = to castrate."[15] Thus, Hélène Cixous, in her manifesto "The
Laugh of the Medusa," attacks Freud's interpretation as a masculine pro-
jection: "You have only to look at the Medusa straight on to see her.
And she's not deadly. She's beautiful and she's laughing." But Cixous
also treats Medusa primarily as an apotrope: "Let the priests tremble,
we're going to show them our sexts!"[16] What both Freud and Cixous
overlook is the importance of the myth's central episode—the specular
ruse whereby Perseus was able to decapitate/"castrate" Medusa in the
first place.

Psychoanalysis can, however, tell us a great deal about the significance
of this episode, for there is more to the story of Perseus and Medusa
than meets the eye. Medusa's is clearly an imaginary capture, a capture
in the Imaginary. (Can it be that Perseus, like Kruger, had read Lacan?)
For in this act of seeing that is its own sight, this instantaneous identifi-
cation, what we recognize is the duality, the specularity, the symmetry
and immediacy that characterize Lacan's Imaginary order. "Lacan de-
fines the essence of the imaginary as a dual relationship, a reduplication
in the mirror, an immediate opposition between consciousness and its
other in which each term becomes its opposite and is lost in the play of
the reflection."[17] Moreover, he repeatedly refers to the subject's identifi-
cation with an image as its *capture*; it is with this capture that the ego
is constituted. (In Lacan, the ego is always an imaginary construct.) And
in the *Discours de Rome* he refers to the patient's imaginary constructions
of identity as *statues*.

Lacanian psychoanalysis also enables us to detect, in the myth's central
episode, a crucial elision; for this episode collapses what are, in fact, two
distinct moments: one in which Medusa sees herself, and another in
which she is petrified. These two moments must logically be distinct:
how can Perseus decapitate Medusa, if she is already turned to stone?
What Perseus' sword separates, then, is not only a head (or phallus) from
a body, but also, in narrative terms, an initial moment of seeing from a
terminal moment of arrest. In an important passage in *Four Fundamental
Concepts* devoted to the power of the evil eye to "arrest movement and,
literally, kill life," Lacan discusses precisely these two moments, refer-
ring to their "pseudo-identification" as (a) suture (a Lacanian concept
which specifies the subject's relation to the chain of its own discourse):

What I noticed there [Lacan has been discussing the Peking Opera fight
scenes] was the suture, the pseudo-identification that exists between what

I called the time of terminal arrest and the gesture and what, in another dialectic that I called the dialectic of identificatory haste, I put as the first time, namely, the moment of seeing. The two overlap, but they are certainly not identical, since one is initial and the other is terminal.[18]

The psychoanalytic concept of suture (derived from surgical terminology: to join the two lips of a wound) itself seems to have an apotropaic effect; I propose therefore to rename suture—at least insofar as Lacan uses the term to designate the "pseudo-identification" of an initial moment of seeing and a terminal moment of arrest—the "Medusa Effect": specular ruse, imaginary identification of seer and seen, immediacy, capture, *stereotype*. Lacan's discussion of the evil eye includes not only a description of the Medusa Effect, but also a prescription against it. Significantly, this prescription inverts the temporal order of the two moments which it elides (vision, Lacan argues, reverses the logical order of speech): *first,* a terminal moment of arrest; *then and only then,* an initial act of seeing:

> There, that by which the original temporality in which the relation to the other is situated as distinct is here, in the scopic dimension, that of the terminal moment. That which in the identificatory dialectic of the signifier and the spoken word will be projected forward as haste is here, on the contrary, the end, that which, at the outset of any new intelligence, will be called the moment of seeing.[19]

In placing the moment of arrest prior to the moment of seeing, Lacan is, of course, simply describing what happens when we look at a picture, any picture—first an arrested gesture (painting, photograph); then the act of viewing which completes the gesture. But he is simultaneously describing the mechanism of *pose*: to strike a pose is to present oneself to the gaze of the other as if one were already frozen, immobilized—that is, *already a picture.* For Lacan, then, pose has a strategic value: mimicking the immobility induced by the gaze, reflecting its power back on itself, pose forces it to surrender. Confronted with a pose, the gaze itself is immobilized, brought to a standstill (for the object does not move with the eye); a pose, then, is an apotrope. And to strike a pose is to pose a threat.

In Kruger's work, the strategic value Lacan attributes to pose is doubled and then redoubled. Doubled: To reiterate, a stereotype is an apotrope; posing as a mirror-image of social reality, its adequate, identical reflection, it is engineered to immediately immobilize the social body. Redoubled: Kruger reflects the stereotype back on itself, mimicking its techniques—its double address, its transformation of action into gesture, its instant legibility. How else to defeat an apotrope than with another apotrope?

Kruger's work, then, engages in neither social commentary nor ideological critique (the traditional activities of politically motivated artists: consciousness-raising). Her art has no moralistic or didactic ambition. Rather, she stages for the viewer the techniques whereby the stereotype produces subjection, interpellates him/her as subject. With one crucial difference: in Kruger's double inversion, the viewer is led ultimately to *reject* the work's address, this double postulation, this contradictory construction. There is a risk, of course, that this rejection will take the form of yet another gesture—a gesture of refusal. It can, however, be an active renunciation. Against the immobility of the pose, Kruger proposes the *mobilization* of the spectator.

NOTES

*This text is a revised version of an essay that appears in the catalogue of the exhibition "Barbara Kruger: 'We Won't Play Nature to Your Culture,'" mounted by the Institute of Contemporary Arts, London.

1. Jacques Lacan, *The Four Fundamental Concepts of Psychoanalysis,* trans. Alan Sheridan (New York: Norton, 1978), 116.

2. Émile Benveniste, *Problèmes de linguistique générale* (Paris: Gallimard, 1966), vol. I, 233.

3. This principle of noncommutability is central to Lévinas's thought. As Jean-François Lyotard observes, the "supposition that governs all of Lévinas's discourse as a sort of metaprescription for otherness could be expressed by this articulation: That /'You'/must never be /'I'/!" "The Insistence of Pragmatics," *Mississippi Review* (Winter/Spring 1983), 91.

4. Roman Jakobson, *Essais de linguistique générale* (Paris: Minuit, 1963), 178–80.

5. Roland Barthes, *The Fashion System,* trans. M. Ward and R. Howard (New York: Hill and Wang, 1983), 266.

6. Norman Bryson, *Vision and Painting: The Logic of the Gaze* (New Haven: Yale University Press, 1983), 155.

7. Michel Foucault, *Discipline and Punish,* trans. Alan Sheridan (New York: Pantheon, 1977), 25.

8. As Foucault observes, it is not primarily a question of making the body signify, but of making it into an object of signification: "One would be concerned with the 'body politic,' as a set of material elements and techniques that serve as weapons, relays, communication routes and supports for the power and knowledge relations that invest human bodies and subjugate them by turning them into objects of knowledge." *Discipline and Punish,* 28.

9. Lacan, *The Four Fundamental Concepts,* 116–17.

10. Ibid.

11. Foucault, *Discipline and Punish,* 111.

12. Foucault speaks of "the plague-stricken town, traversed throughout by

hierarchy, surveillance, observation, writing; the town immobilized by the functioning of an extensive power that bears in a distinct way over all individual bodies—this is the utopia of the perfectly governed city." *Discipline and Punish,* 198.

13. In Ovid, the story of Perseus' capture of Medusa begins: "He told them how there lay, beneath cold Atlas,/A place protected by the bulk of the mountain/Where dwelt twin sisters, daughters, both, of Phorcys./They had one eye between them, and they shared it,/Passing it from one sister to the other,/And he contrived to steal it, being so handed,/And slipped away." *Metamorphoses,* trans. R. Humphries, IV.771–78. Few of the myth's commentators even mention this remarkable episode; an exception is Louis Marin, who interprets it as an allegory of monocular perspective. *Détruire la peinture* (Paris: Galilée, 1977), 137–48.

14. Sigmund Freud, "Some Psychological Consequences of the Anatomical Distinction Between the Sexes," in *Sexuality and the Psychology of Love* (New York: Collier, 1963), 187.

15. Freud, "Medusa's Head," in ibid., 212.

16. Hélène Cixous, "The Laugh of the Medusa," trans. K. and P. Cohen, in *New French Feminisms,* ed. E. Marks and I. de Courtivron (New York: Schocken, 1981), 255. Cixous's subject is the feminine text; hence, "sexts."

17. Anika Lemaire, *Jacques Lacan* (London: Routledge Kegan Paul, 1977), 60.

18. Lacan, *The Four Fundamental Concepts,* 117.

19. Ibid., 114.

Posing

Whenever we are dealing with imitation, we should be very careful not to think too quickly of the other who is being imitated. To imitate is no doubt to reproduce an image. But at bottom, it is, for the subject, to be inserted in a function whose exercise grasps it.

— JACQUES LACAN, *The Four Fundamental Concepts of Psychoanalysis*

In the last few years, a certain calculated duplicity has increasingly come to be regarded as an indispensable deconstructive tool. Both contemporary art and contemporary theory are rich in parody, *trompe l'oeil,* dissimulation (and not simulation, as is often said)—that is, in strategies of mimetic rivalry. The mimic appropriates official discourse—the discourse of the Other—but in such a way that its authority, its power to function as a model, is cast into doubt. Perhaps because of our culture's long-standing identification of femininity with masquerade—as Barbara Kruger proposes in an often-quoted statement, "We loiter outside of trade and speech and are obliged to steal language. We are very good mimics. We replicate certain words and pictures and watch them stray from or coincide with your notions of fact and fiction"[1]—mimicry has been especially valuable as a feminist strategy. Thus, Gayatri Spivak recommends a procedure for the feminist literary critic—"To produce useful and scrupulously *fake* readings in place of the passively active fake orgasm"[2]—and Mary Ann Doane detects, in recent feminist film, "a frequent obsession with pose as position,"[3] an "obsession" she attributes to its generally deconstructive approach.

Insofar as the artists represented in the present exhibition ["Difference: On Representation and Sexuality," The New Museum of Contemporary Art, 1984–85] are also engaged in what Doane describes as the "uncoding, de-coding, deconstructing" of official images of the sexual body, their work exhibits a similar "obsession" (although it is precisely the fixation characteristic of obsession that is at issue here): Barbara Kruger addresses the transformation, in every photograph, of action into gesture

201

or, as she puts it in one work, "prowess into pose"; Silvia Kolbowski deploys fashion photographs in series in order to expose the rhetoric of the pose; Sherrie Levine treats authorship as a (paternalistic) pose; both Victor Burgin and Jeff Wall carefully control the *mise en scène* of their photographs, posing models after figures in nineteenth-century paintings (often of women). . . . Even Hans Haacke's project, which deals not with the properties of the work of art, but with the work of art as property (*possession?*), traces the provenance of Seurat's *Les Poseuses*. (Haacke's work has been included in the present exhibition presumably because its "object" belongs to a long tradition of images of the female nude— images destined for a male viewer, who supposedly accedes through the image to a position of imaginary control, possession. However, Haacke's emphasis on the transmission of the work of art from generation to generation—works of art are, of course, part of the *patrimony*, the legacy of the father—displaces, *dispossesses* the viewer, leading us to speculate, Who is really posing here? Is it the models, or their custodians?)

But if these artists all regard sexuality as a pose, it is not in the sense of position or posture, but of imposition, imposture; judging from the work exhibited here, neither the masculine nor the feminine position would appear to be a tenable position. *Imposition*: Sexuality comes not from within, but from without, imposed upon the child from the world of adults.[4] *Imposture*: Sexuality is a function that imitates another function that is inherently nonsexual (the psychoanalytic theory of *anaclisis* or "propping": "Sexual activity," Freud wrote, "attaches itself to [props itself upon] functions serving the purposes of self-preservation"—nourishment, self-defense, etc.).[5]

In recent critical writing, the question of the pose has been approached from two different perspectives, one social, the other psychosexual. The social approach tends to identify posing as a response to the surveillance of society by the agencies of the state. Homi Bhabha, writing of mimicry in colonial discourse (a strategy which he regards as an ironic compromise between "the synchronic *panoptical* vision of domination— the demand for identity, stasis—and the counter-pressure of the diachrony of history—change, difference") speaks of that "process by which the look of surveillance returns as the displacing gaze of the disciplined, where the observer becomes the observed."[6] And Dick Hebdige proposes an apotropaic politics of pose—"To strike a pose," he writes, "is to pose a threat"—based on the self-display of punk women who, posing, supposedly "transformed the fact of surveillance into the pleasure of being watched."[7] Although this approach, which regards the pose as a defensive maneuver against the increasing penetration of the public

into the private sphere, has much to recommend it, in this essay I want to approach the question of the pose from the perspective opened to us by psychoanalysis, which is concerned with precisely what the social approach tends to elide—namely, desire.

In Victor Burgin's *Zoo 78*, however, these two approaches are superimposed: in one of the sixteen images which compose this work, Burgin juxtaposes a photograph of a nude model posed after a scene he observed in a West Berlin peep show, with a passage from Michel Foucault's *Discipline and Punish*. The text describes an architectural arrangement, Jeremy Bentham's Panopticon—the prototype for modern prison architecture, as well as for the contemporary society of surveillance:

> The plan is circular: at the periphery, an annular building; at the center, a tower pierced with windows. The building consists of cells; each has two windows: one in the outer wall looks onto the lower, or rather is looked upon by the tower, for the windows of the tower are dark, and the occupants of the cells cannot know who watches, or if anyone watches.

In an interview, Burgin proposes a homology between the architecture of the Panopticon and that of the peep show, "where a naked girl dances on a small revolving stage with booths all around it which you can enter and, by putting a coin in a slot, get a peep at the girl." Understanding this homology, however, requires a psychoanalytic detour: "If we turn to psychoanalysis," Burgin suggests, "we find that Freud's discussion of voyeurism links it with sadism—the 'drive to master' is a component of scopophilia (sexually based pleasure in looking); this *look* is a mastering, sexually gratifying look, and the main object of this look in our society is the woman."[8] The implication being that both the peep show and the Panopticon are fueled by the same desire—specifically, a sadistic desire for mastery.

Foucault, however, explicitly rejected the notion that the Panopticon runs on any desire in particular; in fact, it is an apparatus engineered expressly to *neutralize* desire. "The desire which animates it," he wrote, "is entirely indifferent: the curiosity of the indiscreet, the malice of a

Victor Burgin, III Right, Zoo 78. *Courtesy John Weber Gallery, New York.*

child, the thirst for knowledge of the philosopher who wants to visit this museum of human nature, or the perversity of those who take pleasure in spying and punishing"—that is, Burgin's sadistic voyeurs. "The Panopticon," Foucault continues, "is a marvelous machine which, beginning with the most diverse desires, manufactures homogeneous effects of power."[9] What is more, if the Panopticon reduces desire to indifference, it also renders representation obsolete: "What I want to show," Foucault said in an interview, "is how power relations can materially penetrate the body in depth without depending even on the mediation of the subject's own representation."[10] In fact, the peep show is an inverted Panopticon: in the former, the voyeurs occupy the peripheral booths, the spectacle, the central stage; whereas in the latter, the (over)seer occupies the central tower, the prisoners the peripheral cells. All of which suggests that "the oppressive surveillance of woman in our society" may *not* be, as Burgin proposes, "the most visible, socially sanctioned form of the more covert surveillance of society-in-general by the agencies of the state."

I raise these objections here not in order to engage Burgin in an arcane theoretical debate (besides, Foucault's skepticism towards psychoanalysis, and psychoanalysts' hostility to Foucault, are well known). Rather, I want to point to a certain incommensurability which troubles every attempt to attribute a sexual motive to power (or a will-to-power to sexuality). Thus, my own psychoanalytic treatment of the pose should be read as fragmentary, incomplete, for it is only half of the story; it is, however, the half that Foucault would excise—that concerned with desire and representation.

> *That every subject poses in relation to the phallus has been understood. But that the phallus is the mother: it is said, but here we are all arrested by this "truth."*
>
> —JULIA KRISTEVA, *Polylogue*

Mary Kelly's *Post-Partum Document* may appear somewhat out of place in the present context, for it testifies to a *refusal* to pose. Thus, among the multiple representational modes employed in the *Document*—in addition to written texts, Kelly deploys charts, graphs, diagrams, drawings, imprints, plaster casts, found objects, even paintings (the dirty diaper liners in "Documentation I")[11]—there is one that is conspicuous in its absence. While it was composed primarily out of a mother's keepsakes (the objects to which she clings in order to disavow separation from her child), Kelly's "archaeology of everyday life" contains no photographs, no pictures of either mother or child, as if the family snapshot were not

our culture's principal form of memorabilia. Lest this absence be attributed to an iconoclastic motive—a feminist prohibition of representation—Kelly has related it instead to her refusal of narrative closure:

> [*Post-Partum Document*] is not a traditional narrative; a problem is continually posed but no resolution is reached. There is only a replay of moments of separation and loss, perhaps because desire has no end, resists normalisation, ignores biology, disperses the body.
>
> Perhaps this is also why it seemed crucial . . . to avoid the literal figuration of mother and child, to avoid any means of representation that risked recuperation as a slice of life.[12]

Still, the book in which this statement appears, and which documents the *Document,* opens with precisely such an image: a photograph of mother and son recording one of the conversations transcribed and annotated in "Documentation III." Perhaps Kelly chose this image as frontispiece for her book because it appears to illustrate the symbolic economy investigated in the *Document* itself, which is concerned primarily with the mother's investments (*Besetzungen,* literally, the occupation of territory; from *setzen,* to pose or posit; translated in the *Standard Edition* as *cathexis,* literally, holding fast, clinging) in the child. Kelly refers to Freud's speculation, in "The Dissolution of the Oedipus Complex," that the woman may postpone recognition of lack (castration) "in view of the promise of having the child. In having the child," she writes, "in a sense she has the phallus. So the loss of the child is the loss of that symbolic plenitude—more exactly, the ability to represent lack."[13] In the photograph in question, the child—upright in his mother's lap, entirely contained within the silhouette of her body—indeed appears to serve as maternal phallus. This reading might seem exorbitant, but it is remarked, within the image itself, by the phallic attribute the child holds in his left hand—a microphone connected to a cassette recorder, thereby linking possession of the phallic signifier with access to the symbolic order of speech, language ("the ability to represent lack").

Although we may never have seen Kelly or her son before, we never-

Mary Kelly, Post-Partum Document *(VI), 1979.*

theless recognize their pose, for it is identical to that of hundreds of thousands of cult images of mother and child—monuments to mother. Not just any mother, but the *phallic* mother of which both Freud and Lacan—and Kelly in the preface to the *Document*—speak, a mother whose attribute is wholeness, completeness, or, as this is valorized in the West, *virginity.* (Remember that, to risk a solecism, the name of the mother here is Mary.) The Virgin is a regressive figure: not only does it stage that split between knowledge and belief which is characteristic of fetishism; it also suspends—the Virgin does not believe in—the incest prohibition (in medieval tradition, the Virgin is both *mother and bride* of Christ). Thus, the Incarnation suspended the ancient Mosaic prohibition of representation—which Jean-Joseph Goux has convincingly linked with the prohibition of incest; historically, the Mosaic taboo was the proscription of the cult of female or maternal divinities, and the rites of (both symbolic and actual) incest it celebrated[14]—resulting in a proliferation of images of the Madonna and Child; but it also inaugurated an entire regime of representation based on the maternal body. As Julia Kristeva has written:

> It is significant that it should be the theme of maternity, of the woman's or the mother's body (Mona Lisa, the Virgin), that establishes the main pieces of the economy that will determine Western man's gaze for four centuries. Servant of the maternal phallus, the artist will deploy an art . . . of reproducing the body and space as objects to be seized and mastered, as existing within the compass of his eye and his hand. The eye and hand of a child, a minor. . . . Body-objects, passion for objects, canvas divided into form-objects, picture-object: the series is initiated for centuries of object-libido . . . which delights in an image and is capitalized upon in art-as-merchandise. Among the supports of this machine: an untouchable mother with her baby-object, as we see them in Leonardo, in Raphael.[15]

Or, centuries later, in the frontispiece to the *Post-Partum Document.*

What is most fascinating about this image, however, what holds our attention, arrests us—what Roland Barthes would have called its *punctum*—is the child's gaze, which seems to puncture the otherwise impenetrable surface of the image in order to fix us, its viewers, in place. What is this immobilizing gaze if not the figuration—the appropriation by the image as its own—of the gaze of the otherwise invisible photographer who framed and stilled this scene?[16] For there are not just two, but three subjects represented here; the identity of the third party is acknowledged outside the frame, in a caption that gives credit for considerably more than the image, since the name of the photographer is also the name of the father: Ray Barrie.

The Lacanian concept of the Name-of-the-Father refers to the legal attribution of paternity, the law whereby the son is made to refer to the father, to represent his presence (as in the photograph in question). Since such attributions can never be verified, but must be taken on faith, the Name-of-the-Father is both a juridical and a theological concept: "The attribution of paternity to the father," Lacan wrote, "can only be the effect of a pure signifier, of a recognition, not of a real father, but of what religion has taught us to refer to as the Name-of-the-Father." [17] Although Christianity suspended the Mosaic prohibition of representation, the interdiction of images of the Father remained in force; nevertheless, he returns as pure, disembodied gaze (fantasies of an all-seeing being) which subjects both mother and son—and, as relayed by the latter, the viewer as well—to His scrutiny.

Phallic Mother, Name-of-the-Father—can there be any doubt that here we are at Oedipus, at the crossroads at which the question of the child's sexual identity will be posed? Thus, the child's gaze seems to pose for the viewer a question similar to that which Lacan detects in the floating signifier—an anamorphic phallus-skull—in the foreground of Holbein's *Ambassadors*: Where is your phallus? (A question which, as we know from Freud's essay, "Medusa's Head," is capable of turning the subject to stone.) As Herman Rapaport writes in his Lacanian study of Lewis Carroll's photographs of little girls, "Such a question . . . refers on the register of the *Symbolique* to the annihilation of the subject, an annihilation that can be warded off only if the subject can convince himself that annihilation (castration, death) can be defeated by means of mastering events through overcoming time, that is, by image formation, immortalization in terms of photography (or Photo-Graphie: pictures but also narratives)." [18]

What is involved in this photograph, then—or, for that matter, in any photograph—is the figuration of a gaze which objectifies and masters, of course, but only by immobilizing its objects, turning them to stone.

> *The world of signs functions, and it has no type of signification whatsoever. . . . What gives its signification is the moment that we stop* [arrêtons] *the machine, the temporal interruptions we make. If these are faulty, we will witness the emergence of ambiguities that are sometimes difficult to resolve, but to which in the end we will always attribute a signification.*
>
> —JACQUES LACAN, *Le moi dans la théorie de Freud*

In *Gradiva* Victor Burgin re-presents Wilhelm Jensen's novella "Gradiva: A Pompeiian Fancy" (1903) as an allegory of photography. Jen-

sen's tale concerns an archaeologist (in Burgin's version, a generic "he") obsessed with an antique marble bas-relief of a young woman distinguished by her peculiar manner of walking: one foot rests squarely on the ground, while the other rises almost perpendicular to it. Gradiva, he names her, "the girl splendid in walking." In 1907, when he wrote "Delusion and Dream in Wilhelm Jensen's 'Gradiva,'" Freud had yet to elaborate his theory of the castration complex, and hence the ingenious theory of fetishism which proceeds from it; thus, he overlooked the fetishistic implications of the tale. Burgin, however, who has compared the photograph with the fetish—"The photograph, like the fetish, is the result of a look which has, instantaneously and forever, isolated, 'frozen,' a fragment of the spatio-temporal continuum"[19]—reads Jensen's tale in the light of Freud's subsequent work, foregrounding its fetishistic aspects.

Composed of seven photographs with accompanying narrative captions (photo-graphie), Gradiva is not simply a series of straightforward illustrations for Jensen's text; nor is it, as is sometimes said dismissively of Burgin's work, merely an "illustration" of (psychoanalytic) theory. For what is illustrated here is the process of—the desire for—illustration itself. To illustrate a text is in a sense to punctuate it, to arrest its development by the insertion of a gaze in the form of a figure or illustration—a gaze which brings the textural machine to a standstill. Thus, Burgin's work is itself punctuated by a series of three close-ups—figurations of the photographer's immobilizing gaze—which were themselves generated by interrupting the continuous flow of cinematic images. (Burgin took these photographs in a theater during the screening of a film.) These three gazes alternate with three images of Gradiva: first, as she appears in the bas-relief (a picture of a picture, of the frontispiece of the ninth volume of the Standard Edition, which includes "Delusion and Dream"); then, Burgin's photograph of a model posed as Gradiva among classical ruins; finally, Gradiva rediviva in the streets of contemporary Warsaw, reflected in what appears to be the mirrored facade of a building, next to an advertising poster of a couple locked in an embrace. This picture-within-a-picture might itself serve as an illustration for the seventh and final image—a "scene of writing," a passage Burgin copied out by hand and then photographed. Its source is neither "Gradiva" nor "Delusion and Dream," but Leopold Sacher-Masoch's Venus in Furs, and it deserves to be quoted here in full, for it alludes to the desire which activates the entire series or, rather, brings it to a standstill.

My gaze slid by chance towards the massive mirror hanging in front of us and I uttered a cry: in this golden frame our image appeared like a painting, and this painting was marvelously beautiful. It was so strange and so fantastic that a deep shiver seized me at the thought that its lines and its colours would soon dissolve like a cloud.

The specular image, then, is accompanied by anxiety—anxiety that it will "soon dissolve like a cloud." It is the nature of visions (apparitions) to dissolve before our very eyes without disclosing their secrets, just as dream-images are quickly forgotten upon awakening. Thus, when Jensen's protagonist, in a dream of the eruption of Vesuvius (the pivot of Freud's interpretation of the tale), sights Gradiva walking calmly through the rain of volcanic debris which fills the air, he is immediately seized by anxiety: "Because of a feeling that the living reality would quickly disappear from him again, he tried to impress it accurately on his mind."[20] Burgin illustrates this anxiety dream in his penultimate image, a close-up of a woman's face, eyelids closed, resembling nothing so much as a death mask; the caption reads: "In a dream of the destruction of Pompeii he believed he saw Gradiva, as if turning to marble." What is this scene of petrifaction if not the "fulfillment" of the protagonist's wish to halt Gradiva, to arrest her, pin her down?

This is not the place for an extended analysis of Jensen's tale (which Burgin's work nevertheless prompts). It should be noted, however, that the narrative is structured around a persistent opposition between mobility and immobility. Thus, Gradiva appears to represent, within the text itself, the mobility which recent criticism attributes to every text; as one commentator has written, "Gradiva is a pure force, a movement that carries in its wake, a motion that mobilizes, an emotion that makes everything into trance, into dance. The dance of signs: Gradiva crossing with singular indifference the stiff, cold frame of representation to engage Norbert to follow her."[21] And every time the protagonist succeeds at momentarily halting Gradiva, he is confronted with one of those ambiguities that are "sometimes difficult to resolve" of which Lacan speaks. Thus, the bas-relief gives rise to the question of sexual difference: He "could not say whether a woman's manner of walking was different from that of a man, and the question remained unanswered."[22] And upon encountering Gradiva (actually, his neighbor and childhood playmate Zoe Bertgang *posing* as Gradiva) among the ruins of Pompeii, an even more undecidable antinomy confronts him: "Gradiva, dead and alive at the same time. . . ."[23]

What we are dealing with, then, is an arrest which is also an *arrêt de*

mort, a phrase which has been very much on the mind of Jacques Derrida of late.[24] In French, *arrêt de mort* signifies both a death sentence and a stay of execution; the *arrêt* both condemns and grants reprieve, postpones the deciding of an antinomy. It is at precisely such points at which the laws of contradiction are suspended that fixated representations make their symptomatic appearances: "Suddenly images of power raise themselves up, erect themselves in the thoughts of the patients, and the metapsychological or economic reasons for this are clear: the subject does not want to lose his energy, to break into pieces, but to conserve himself in the monolithic *aporia* of an axis or crossing point that is endlessly forestalled in the undecidable suspension of an *arrêt de mort*." The fetishistic implications of this structure are clear: "If the poet as obsessive builds his monoliths at the crossroads, places his *arrête* on the *arrêt de mort*, it is not only to ward off death by an ambivalent forestalling, but to build a monument to mother, to worship the virgin and child." [25] Or the girl splendid in walking.

> *Looking at a photograph, I invariably include in my scrutiny the thought of that instant, however brief, in which a real thing happened to be motionless in front of the eye. I project the present photograph's immobility upon the past shot, and it is this arrest which constitutes the pose.*
>
> — ROLAND BARTHES, *Camera Lucida*

The photograph as record of a previous arrest: What do I do when I pose for a photograph? I freeze—hence, the masklike, often deathly expressions of so many photographic portraits. From a technical standpoint, this self-imposed immobility is entirely superfluous: thanks to rapid exposures and high-speed films, the camera itself is perfectly capable of suspending animation, arresting life—so-called "action" photography. (This has not always been the case; as Barthes reminds us, in the nineteenth century, "a device called the *appuie-tête* was invented, a kind of prosthesis invisible to the lens, which supported and maintained the body in its passage to immobility: this *appuie-tête* was the base of the statue I would become, the corset of my imaginary essence.")[26] Still, I freeze, as if anticipating the still I am about to become; mimicking its opacity, its still-ness; inscribing, across the surface of my body, photography's "mortification" of the flesh.

We customarily regard technology—image-technology in particular— as an instrument of rationalization, thereby overlooking its long-standing alliance with the irrational (and the unconscious). I believe that we can

detect, in our subjective response to the photographic encounter (at least as I have described it), a very ancient superstition: as if the camera were simply a device engineered to reproduce the effects of the evil eye. As Lacan writes in the ninth chapter, titled "What is a Picture?," of *The Four Fundamental Concepts of Psychoanalysis*:

> The evil eye is the *fascinum,* it is that which has the effect of arresting movement and, literally, of killing life. At the moment the subject stops, suspending his gesture, he is mortified. This anti-life, anti-movement function of the terminal point is the *fascinum,* and it is precisely one of the dimensions in which the power of the gaze is exercised directly.[27]

Lacan's theory of vision is a theory of scopic fascination (*fascinum* = witchcraft, sorcery), the power of images to arrest us, take us into custody. Thus, it undermines the idealist presuppositions upon which visual arts practice has been based for centuries, specifically, the tendency to identify the subject as the subject of perception/consciousness, as *master* of the visual field. For Lacan, the "subject" in the scopic field—that is, the visual field insofar as it is crosshatched by desire—occupies the position not of subject of the gaze, but of its object: "In the scopic field, the gaze is outside, I am looked at, that is to say, I am a picture. . . . The gaze is the instrument through which light is embodied and through which—if you will allow me to use a word, as I often do, in a fragmented form—I am *photo-graphed.*"[28]

Embodied in a "point of light, the point at which everything that looks at me is situated,"[29] the Lacanian gaze is *punctual*: it both punctuates (arrests, suspends) and punctures (pricks, wounds). If, posing for a photograph, I freeze, it is not in order to assist the photographer, but in some sense to resist him, to protect myself from his immobilizing gaze; as Lacan observes of the fight scenes staged by the Beijing Opera ballet, "They are always punctuated by a series of times of arrest in which the actors pause in a frozen attitude. What is that thrust, that time of arrest

Silvia Kolbowski, Model Pleasure VII, *1984. Photograph © Mary Bachmann.*

of the movement? It is simply the fascinatory effect, in that it is a question of dispossessing the evil eye of the gaze, in order to ward it off."[30]

Posing, then, is a form of mimicry; as Lacan observes of the phenomenon of mimetic rivalry in nature, "The being breaks up [se decompose], in an extraordinary way, between its being and its semblance, between itself and that paper tiger it shows to the other. . . . The being gives of himself, or receives from the other, something that is like a mask, a double, an envelope, a thrown-off skin, thrown off to cover the frame of a shield."[31] Thus, mimicry entails a certain splitting of the subject: the entire body detaches itself from itself, becomes a picture, a semblance. (Elsewhere, Lacan refers to it as a "separated" image: separate, from se parare, se parer, "to dress oneself, but also to defend oneself, to provide oneself with what one needs to be on one's guard," and, via se parere, s'engendrer, "to be engendered."[32] As we will observe momentarily, posing has everything to do with sexual difference.) This splitting of the subject is staged in Jeff Wall's Double Self-Portrait, for which the artist posed not once, but twice—double ex-posure—as if to illustrate the fundamental duplicity of every pose. Thus, the image itself is split along a central seam which seems to represent that bi-partition which the subject undergoes when it assumes an image. What is that seam if not the seam of castration, the unbridgeable divide which separates the sexes? As Lacan remarks, "It is in so far as all human desire is based on castration that the eye assumes its virulent function, and not simply its luring function as in nature."[33] And Wall's picture is (supposedly) split according to the sexual differential; but why, then, do I find it so difficult to determine which Wall is masculine, which feminine?

Watching Babette Mangolte's film Je: Le Camera/The Camera: Eye, in which models are filmed posing for their photographs, Mary Ann Doane observes, "The subjects, whether male or female, invariably appear to assume a mask of femininity in order to become photographable (filmable)"[34]—although it is the assumption of a mask, rather than the mask itself, that is customarily regarded as "feminine." Femininity is not a mask; rather, the mask is feminine (as Doane suggests when she appends, "as if femininity were synonymous with the pose"). We are by now familiar with that psychoanalytic notion—proposed by Joan Riviere, seconded by Lacan—that femininity be defined as masquerade, as a mask that conceals a nonidentity. Riviere regarded female masquerade as compensation for the (intellectual) woman's "theft" of masculinity: "Womanliness," she wrote, "could be assumed and worn as a mask, both to hide possession of masculinity and to avert the reprisals expected if she was found to possess it—much as a thief will turn out his pockets

and ask to be searched to prove that he has not the stolen goods."[35] (The *vaginal* nature of Riviere's image should be noted: the empty pocket as the sign of femininity.) Lacan, however, treats the masquerade as compensation, not for the possession of masculinity, but for its lack: "I would say that it is in order to be the phallus, that is to say, the signifier of the desire of the other, that the woman will reject an essential part of her femininity, notably all its attributes, through masquerade."[36]

As Gayatri Spivak has written, the definition of femininity as masquerade, as simulation and seduction, constitutes an "originary displacement" of the figure of the woman; thus, Spivak glosses Nietzsche's aphorism "The female is so artistic":

> Or: women impersonate themselves as having an orgasm even at the time of orgasm. Within the historical understanding of women as incapable of orgasm, Nietzsche is arguing that *impersonation* is woman's only sexual pleasure. At the time of the greatest self-possession-cum-ecstasy, the woman is self-possessed enough to organize a self-(re)presentation *without an actual presence (of sexual pleasure) to re-present.*[37]

The fake orgasm disrupts the philosophy of mimesis, of representation, which presupposes the presence of an original, a model which exists both prior to and outside of its re-presentation. (The logic of this disruption is detailed in Jacques Derrida's *La double séance*.) In her "Model Pleasure" series, Silvia Kolbowski also works to expose the myth of the "model," or the model as a myth. In her earlier work, Kolbowski dealt primarily with pose as position, literalizing, through the erratic placement of her photographs on the wall, the Lacanian postulate that sexual "identity" is primarily a matter of position in language (i.e., vis-à-vis the phallic "term"); her recent work, however, asks us to regard position itself as pose. Thanks to the serial disposition of these works— all-but-identical fashion poses mounted side-by-side—any image in the series can become the "model" for all the others; conversely, every image in the series is but an imitation of all the others. Thus, the "model" is dissolved by the series into a potentially endless repetition of identical

Judith Barry, Casual Shopper, *1980–81, videotape. Courtesy Judith Barry.*

gestures and poses. What is at issue, then, is its authority as "model," the supposed inimitability which, paradoxically, makes it imitable.

Lacan asks us to recognize that all human subjects are subject to castration—"The relation to the phallus," he wrote, "is set up regardless of the anatomical difference between the sexes"—although, in a discourse that privileges the phallus, only women have been diagnosed as such. Thus, he regards all human sexuality as masquerade: "The fact that femininity takes refuge in the mask . . . has the strange consequence that, in the human being, virile display itself appears as feminine."[38] Which might lead us to speculate whether it is not the man who envies woman's lack of phallus—as Spivak writes, "The virulence of Nietzsche's misogyny occludes an unacknowledged envy: a man cannot fake an orgasm. His pen must write or prove impotent"—since such a lack always presents itself as a phantom phallus. For Lacan, however, the theoretical importance of the masquerade—Spivak's "actively passive fake orgasm"—resides in the fact that it displaces the overworked active/passive opposition according to which masculinity and femininity are conventionally represented: "Carrying things as far as they will go," he proposes, "one might even say that the masculine and the feminine ideal are represented in the psyche by something other than this activity/passivity opposition. . . . Strictly speaking, they spring from . . . the term masquerade."[39]

Although Barthes describes the pose as an "active" transformation of the subject, to pose is, in fact, neither entirely active nor entirely passive; it corresponds, rather, to what in grammar is identified as the middle voice or diathesis (literally, dis + position: voice names the attitude/position of the subject to the action implied by the verb). Both the active and the passive voices indicate activity or passivity vis-à-vis an external object or agent; the middle voice, on the contrary, indicates the interiority of the subject to the action of which it is also the agent. Freud invokes the middle voice in his discussion, in "Instincts and their Vicissitudes," of the sado-masochistic drive: In addition to an active, externally directed stage, characterized by the desire to exercise violence or power over some other person as object—a stage which Freud terms "sadism," but which, as both Jean Laplanche and Leo Bersani have pointed out, is not sexual at all—and a masochistic stage, in which the active aim is changed into a passive aim, and the subject searches for another person as object of the drive (but subject of the action), Freud posits a third, intermediary stage, a "turning round of the drive upon the subject's self" (as in self-punishment, self-torture) without the attitude of passivity towards an external object/subject that characterizes mas-

ochism. (As Laplanche observes, it is only at this stage that the desire for mastery is transformed into sexual desire.)[40] "The active voice is changed," Freud writes, "not into the passive, but into the reflexive middle voice."[41]

Lacan's treatment of the drives in *The Four Fundamental Concepts* follows "Instincts and their Vicissitudes" *à la lettre*. However, in his discussion of the scopic drive, Lacan modifies Freud's formulation "*Sexualglied von eigener Person beschaut werden*"—a sexual organ being looked at by an extraneous person (but where is the subject in this formulation?): "In place of *werden* I put *machen*—what is involved in the drive is *making oneself seen (se faire voir)*. The activity of the drive is concentrated in this *making oneself (se faire)*."[42] In other words, the subject in the scopic field, insofar as it is the subject of desire, is neither seer nor seen; *it makes itself seen*. The subject poses as an object *in order to be a subject*.

Lacan's observation that the subject of the scopic drive is essentially a subject whose pose allows us to avoid both the reductive logic which assigns positionality in the scopic field according to gender—woman as object, man as subject of the "look"—as well as the banal moralism of such statements as "To photograph people is to violate them" (Susan Sontag), which ultimately rest upon a definition of the body as private property (a definition that is essential to the worker's being able to sell his labor power as a commodity). In her appropriated self-portraits, Sherrie Levine exposes precisely this presupposition: for what is offered to the gaze of the other is always a purloined image, a double or fake. (It is not accidental that Levine's self-portraits should be expressionist in origin, thereby exposing both the expressionist myth of authenticity, as well as the pervasive sense of inauthenticity which sustains the current expressionist "revival.") But Levine's work intersects with the question of the pose in another manner as well: as I have indicated elsewhere, until recently her work dealt consistently with images of the Other— women, children, Nature, the poor, the insane, etc. What Levine's work has consistently exposed is the desire for a domesticated other, an other which is almost the same, but not quite; her subject, then, has been the social production of an acceptable, purely marginal difference—a difference which is also a disavowal of real cultural, social, sexual division. However, as Derrida writes at the end of his interview "Positions,"

> If the alterity of the other is *posed*, that is *simply* posed, doesn't it amount to the same, in the form, for example, of the "constituted object," the "informed product" invested with meaning, etc. From this point of view I would even go so far as to say that the alterity of the other inscribes something in the relation which can in no way be posed.[43]

NOTES

1. Barbara Kruger, statement for *Documenta VII* catalogue, Kassel, 1982, 286.

2. Gayatri Chakravorty Spivak, "Displacement and the Discourse of Woman," in *Displacement: Derrida and After*, ed. Mark Krupnick (Bloomington: Indiana University Press, 1983), 186, italics added.

3. Mary Ann Doane, "Woman's Stake: Filming the Female Body," *October* 17 (Summer 1981), 25.

4. Jean Laplanche, *Life and Death in Psychoanalysis*, trans. Jeffrey Mehlman (Baltimore: Johns Hopkins University Press, 1976), 43 ff.

5. Sigmund Freud, *Three Essays on the Theory of Sexuality*, trans. James Strachey (London: Hogarth Press, 1962), 48. On "propping," see Laplanche, *Life and Death*, esp. 15–24.

6. Homi Bhabha, "Of Mimicry and Man: The Ambivalence of Colonial Discourse," *October* 28 (Spring 1984), 129.

7. Dick Hebdige, "Posing . . . Threats, Striking . . . Poses: Youth, Surveillance, and Display," *SubStance* 37/38 (1983), 86.

8. Victor Burgin, "Sex, Text, Politics," interview by Tony Godfrey, *Block*, no. 7 (1982), 15.

9. Michel Foucault, *Discipline and Punish*, trans. Alan Sheridan (New York: Pantheon, 1977), 202, translation modified.

10. Michel Foucault, "The History of Sexuality," interview by Lucette Finas, in *Power/Knowledge: Selected Interviews and other Writings, 1972–1977*, trans. and ed. Colin Gordon (New York: Pantheon Books, 1980), 186.

11. Lacan: "The authenticity of what emerges in painting is diminished in us human beings by the fact that we have to get our colors where they're to be found, that is to say, in the shit. . . . The creator will never participate in anything other than the creation of a small dirty deposit, a succession of small dirty deposits juxtaposed." *The Four Fundamental Concepts of Psychoanalysis*, trans. Alan Sheridan (New York: Norton, 1978), 117. What is Kelly's "Documentation I" if not "a succession of small dirty deposits juxtaposed?"

12. Mary Kelly, *Post-Partum Document* (London: Routledge & Kegan Paul, 1983), xvii.

13. Ibid., xvi.

14. Jean-Joseph Goux, "Moïse, Freud—la prescription iconoclaste," in *Les Iconoclastes* (Paris: Éditions du Seuil, 1978), 9–29.

15. Julia Kristeva, "Maternité selon Giovanni Bellini," in *Polylogue* (Paris: Éditions du Seuil, 1977), 417.

16. For a related reading of the gaze of the child, see Herman Rapaport, "Gazing in Wonderland: The Disarticulated Image," *enclitic* 6, no. 2 (Fall 1982), 57–77.

17. Jacques Lacan, "On the possible treatment of psychosis," in *Écrits: A Selection*, trans. Alan Sheridan (New York: Norton, 1977), 199.

18. Rapaport, "Gazing in Wonderland," 64.

19. Victor Burgin, "Photography, Phantasy, Function," in *Thinking Photography* (London: Macmillan, 1982), 190.

20. Wilhelm Jensen, "Gradiva: A Pompeiian Fancy," in Sigmund Freud, *Delusion and Dream and Other Essays* (Boston: Beacon, 1956), 154.

21. Sylvère Lotringer, "The Dance of Signs," *Semiotext(e)* 3, no. 1 (1978), 59.

22. Jensen, "Gradiva," 151.

23. Ibid., 194.

24. Jacques Derrida, "Living On: *Border Lines*," trans. James Hulbert in *Deconstruction and Criticism,* ed. Harold Bloom et al. (New York: The Seabury Press, 1979), 75–176.

25. Herman Rapaport, "Staging: Mont Blanc," in *Displacement,* 72.

26. Roland Barthes, *Camera Lucida: Reflections on Photography,* trans. Richard Howard (New York: Hill and Wang, 1981), 14.

27. Lacan, *The Four Fundamental Concepts,* 117.

28. Ibid., 106.

29. Ibid., 95.

30. Ibid., 117–18.

31. Ibid., 107.

32. Ibid., 214.

33. Ibid., 118.

34. Doane, "Woman's Stake," 24.

35. Joan Riviere, "Womanliness as a Masquerade," in *Psychoanalysis and Female Sexuality,* ed. Hendrik M. Ruitenbeek (New Haven: College and University Press, 1966), 213. Quoted in Mary Ann Doane, "Film and the Masquerade: Theorising the Female Spectator," *Screen* 23, nos. 3–4 (September–October 1982), 81.

36. Jacques Lacan, "The Meaning of the Phallus," in *Feminine Sexuality: Jacques Lacan and the école freudienne,* ed. Juliet Mitchell and Jacqueline Rose (New York: Norton, 1983), 84.

37. Spivak, "Displacement and the Discourse of Woman," 170.

38. Lacan, "The Meaning of the Phallus," 85.

39. Ibid., 193.

40. See Laplanche, *Life and Death,* 88 ff.

41. Ibid.

42. Lacan, *The Four Fundamental Concepts,* 195.

43. Jacques Derrida, *Positions* (Paris: Éditions du Seuil, 1972), 132.

Outlaws: Gay Men in Feminism

Criminals come in handy.

— MICHEL FOUCAULT, "Prison Talk"

If the treatment of male homosexuality as delinquency and disease is a product of the same legal and medical apparatus that "castrates" women (by regarding them as always already castrated)—and I will be arguing throughout this essay that it *is*—then the gay male intellectual has a fundamentally different stake in feminism than his heterosexual "counterpart." How can he articulate that difference without setting himself up as the "exemplary" male feminist? To do so would not only be to appeal to a marginal—and marginalizing—(homo)sexual identity, rather than to investigate the construction of that identity; it would also be to posit a Genet-ic link between feminist and gay politics, rather than confronting the obstacles which stand in the way of such an alliance. Writing about Derrida writing about Genet, Gayatri Spivak observes that, in rewriting Freud by suggesting that the male homosexual may not be caught up in castration anxiety, Derrida is also suggesting "that the 'feminization' of philosophizing for the male deconstructor might find its most adequate legend in male homosexuality defined as criminality, and that it cannot speak for the woman." For Spivak, this admission indicates the limits of deconstruction as a feminist practice; as she points out, in the end Derrida opts, not for homosexuality, but for fetishism: *Glas*, she writes, "is the classic case of fetishism, a uniquely shaped object (his bicolumnar book) that will allow the subject both to be and not to be a man—to have the phallus and yet accede to dissemination."[1] The gay male critic must also point out that, in Derrida's de-Oedipalized homosexuality, Genet remains outside the Law. Is this not, then, a *re*construction of the "legend" of the homosexual outlaw?

Nevertheless, Derrida's effort to rewrite the Freudian scripture on male homosexuality is welcome, for the myth of homosexual gynophobia remains perhaps the most powerful obstacle to a political alliance of feminists and gay men. The "function" of this myth, I believe, is to obscure the profound link between misogyny and homophobia in our culture—a link that is nowhere more apparent than in Freud's texts, in which the scapegoating of women often appears in conjunction with a scapegoating of homosexual men. It is tempting, on this basis alone, to presume a common interest uniting women and gay men; however, as Eve Kosofsky Sedgwick cautions in her extraordinary recent study of male bonding in nineteenth-century British fiction, *Between Men,* in which she argues convincingly that male homophobia is a distinctly *feminist* concern, "Profound and intuitable as the bonds between feminism and antihomophobia often are in our society, the two are not the same. As the alliance between them is not automatic or transhistorical, it will be most fruitful if it is analytic and unpresuming."[2] It is in the same analytic and unpresuming spirit—and in the hope of forging just such an alliance—that I offer the following response to the recent tendency, on the part of certain feminist writers, to characterize (our) society as a "homosexual monopoly" (this phrase is Luce Irigaray's). I must say at the outset that, while I believe this formulation itself to be patently homophobic, I do not consider any of the women whose work I will discuss to be homophobes. To do so would simply be to scapegoat feminism for the oppression of homosexual men. But I do believe that, in employing powerful theoretical models devised by a number of demonstrably homophobic male thinkers—primarily Freud and Lévi-Strauss—some feminists have inherited the ideological biases embedded in those models. Before proceeding, however, I will pause to comment on the deployment of a clearly identifiable homophobic tactic in the male-feminist debate: I refer to the recent pastime of Tootsie rolling.

> *The woman shall not wear that which pertaineth unto a man, neither shall a man put on a woman's garment; for all that do so are abomination unto the Lord thy God.*
>
> — DEUTERONOMY 22:5

"Homophobia directed by men against men is misogynistic," Sedgwick writes. "By 'misogynistic' I mean not only that it is oppressive of the so-called feminine in men, but that it is oppressive of women."[3] What about homophobia directed by women against men?

In response to an editorial request for an endorsement to appear

on the jacket of *The Anti-Aesthetic,* in which my essay "The Discourse of Others: Feminists and Postmodernism" first appeared, Linda Nochlin began by praising the book's "provocative and revitalizing critique of contemporary culture" (these words appear on the cover), but proceeded to criticize the paucity of texts by women in the collection, except those by Rosalind Krauss and "Craig playing a kind of 'Tootsie' role" (these words do not).[4] The association of transvestism and homosexuality is, of course, fully historical and contingent; however, in an ideological climate in which that association is presumed to be self-evident, to caricature a gay male feminist critic as a transvestite is tantamount to exposing his homosexuality. Perhaps Nochlin's characterization of the (gay) male feminist as a feminized man is to be read simply as an inversion of the Nietzschean characterization of the feminist as a masculine woman; even so, I would suggest—at the risk of confirming Freud's view of homosexuality as a paranoid structure—that it is as fully homophobic as Nietzsche's is misogynistic, for it deploys what has come to be recognized as a distinctly homophobic mechanism of social control.

Had Nochlin's letter remained an isolated incident, I might still be able to read it as I first did—as a comment on the fact that, in that essay, my homosexuality remains undisclosed. However, it turned out to be only a preview for the coming attraction, for Elaine Showalter's "Critical Cross-Dressing: Male Feminists and the Woman of the Year"—who turns out to be Dustin Hoffman in Sydney Pollock's film *Tootsie*—appeared in *Raritan* a few months later. (Because that essay appears in this volume [*Men in Feminism*], I will forego a summary.) In caricaturing Culler, Eagleton, and company as transvestites (a term which, in the homosexual subculture, is accurately perceived to be part of the clinical discourse on homosexuality, and therefore as hostile), Showalter is not, of course, questioning their masculinity. Quite the reverse: she is setting them up as straight men. But why is it presupposed that the male feminist is a heterosexual man? And why did Showalter not include a gay male feminist among the group?

Just as the blackmailing of homosexual men depends upon the public perception that they are straight, so too Showalter's—and Nochlin's—tactic relies for its effectiveness on the presumed heterosexuality of the critics whose work she discusses; this is what makes it a homophobic tactic. As Sedgwick demonstrates, homophobia is not primarily an instrument for oppressing a sexual minority; it is, rather, a powerful tool for regulating the entire spectrum of male relations. Homophobia is aimed not only at gay men, but also "at men who [are] not part of the distinctly homosexual subculture. Not only must homosexual men be

unable to ascertain whether they are to be the objects of 'random' homophobic violence, but no man must be able to ascertain that he is not (that his bonds are not) homosexual." The imputing of a homosexual motive to every male relationship is thus "an immensely potent tool . . . for the manipulation of every form of power that [is] refracted through the gender system—that is, in European society, of virtually every form of power."[5]

Showalter skirts the issue of homosexuality in her text when she discusses "parallels" between the 1980s and the 1880s and '90s—the period in which the "modern" form of homosexual persecution began in earnest (the Wilde trial). However, every item on the list of "popular entertainments" she produces as evidence for a "1980s fascination with cross-dressing"—*La Cage aux Folles, Torch Song Trilogy, The World According to Garp, Victor/Victoria, Cloud 9*—makes the connection between transvestism and homosexuality explicit. (*Garp* is the exception, but then it deals not with a transvestite, as Showalter implies, but with a transsexual.) This list testifies, then, less to a fascination with cross-dressing and more to an intensification of mass-media stereotyping of gay men as feminine. Showalter avoids this aspect of the sexual politics of the Reagan era by zeroing in on the one character, Michael Dorsey/Dorothy Michaels in *Tootsie,* whose transvestism is motivated *not* by sexuality, but by careerism. Nevertheless, she invokes "psychoanalytic theory" in order to present Dorothy/Michael as if (s)he were the classic transvestite. And once again we encounter the figure of Derrida clutching his bicolumnar book, only this time he is Dressed to Kill:

> In psychoanalytic theory [Showalter writes], the male transvestite is not a powerless man; according to psychiatrist Robert Stoller, in *Sex and Gender,* he is a "phallic woman," who can tell himself that "he is, or with practice will become, a better woman than a biological female if he chooses to do so." When it is safe or necessary, the transvestite "gets great pleasure in revealing that he is a male-woman. . . . The pleasure in tricking the unsuspecting into thinking he is a woman, and then revealing his maleness (e.g.,

Ethyl Eichelberger, Mrs. Wigg's Cabbage Patch. *Performance at P.S. 122, New York City, 1986. Photograph © Dona Ann McAdams.*

by suddenly dropping his voice) is not so much erotic as it is proof that there is such a thing as a woman with a penis."[6]

This is only the first passage I will cite in which "psychoanalytic theory" is deployed in order to polarize women and gay men by placing them in competition (for what? for straight men?). Besides, whose "theory" is being invoked here? Why does Showalter not inform her reader that Stoller regards homosexuality as a "gender disorder," or that he considers "feminine" boys who show signs of incipient homosexuality to be "in need of treatment"?[7] In aligning herself with the notoriously homophobic North American psychiatric establishment (Stoller is professor of psychiatry at the UCLA School of Medicine), Showalter uncritically perpetuates its biases. Thus, it is not surprising that her otherwise perceptive analysis of *Tootsie*'s antifeminism should include no mention of the film's homophobia—the source of much of its humor—or that the Julie Andrews character in Blake Edwards's *Victor/Victoria*, a female impersonating a female impersonator, should not be subjected to similar treatment.

But then Victoria poses as a (gay) man in order to get ahead in a man's (read: "homosexual-dominated") world: Edwards's film exploits the popular homophobic prejudice that show business (or fashion, or the art world) is controlled, not by Capital, but by a homosexual "mafia." Recently, a number of feminist writers have informed us that philosophy, fascism, even capitalism itself, are basically homoerotic formations. Philosophy: "Derrida comments repeatedly on the undisclosed homoeroticism of the official discourse of these phallogocentric philosophers [Hegel, Nietzsche, Freud, Marx]—a discourse supported by the relegation of public homosexuals like Jean Genet to criminality."[8] Fascism: "The Nazi community is made by homosexual brothers who exclude the woman and valorize the mother."[9] Capitalism: "Commodities . . . are the material alibi for the desire for relations among men."[10] In what follows, I will be concerned less with what these formulations have to say about philosophy, fascism, or Capital, and more with what they *do* to openly homosexual men. How do these theories distinguish between latent and patent homosexuality? How do they account for the persecution of homosexuals, especially in the fascist state and under Capital? Have these writers confused homosexuality with homophobia?

Proscriptions against sodomy have very "ancient roots." Decisions of individuals relating to homosexual conduct have been subject to state intervention throughout the history of Western Civiliza-

tion. Condemnation of those practices is firmly rooted in Judeao-Christian moral and ethical standards. . . . To hold that the act of homosexual sodomy is somehow protected as a fundamental right would be to cast aside millennia of moral teaching.

— CHIEF JUSTICE WARREN BURGER, *Bowers v. Hardwick,* 6/30/86

In the essays "Women on the Market" and "Commodities among Themselves," both reprinted in *This Sex Which Is Not One,* Luce Irigaray proposes that the other sex, the one which *is* one, is a fundamentally homosexual one. Irigaray extrapolates a "homosexual monopoly" from Lévi-Strauss's discussion of kinship structures as arrangements which facilitate the exchange of women among (groups of) men—exchanges in which women participate only as objects. "What the anthropologist calls the passage from nature to culture," she writes, "amounts to the institution of the reign of hom(m)o-sexuality. Not in an 'immediate' practice, but in its 'social' mediation." In characterizing what we customarily regard as male homosexuality as an "'immediate' practice," Irigaray implies that it is unmediated, that it does not pass through the circuits of desire and of representation that constitute (hetero)sexuality. That this is indeed her view of male homosexuality is demonstrated by her (first) theory of homosexual oppression: homosexuals are "ostracized," she maintains, because "*the 'incest' involved in homosexuality has to remain in the realm of pretense.*" Inverted commas notwithstanding, it is clear that Irigaray is not speaking figuratively, for she continues: "Consider the exemplary case of *father-son* relationships, which guarantee the transmission of patriarchal power and its laws, its discourse, its social structures. . . . [These relationships cannot] openly display the pederastic love in which they are grounded."[11] To reduce the social mechanisms which insure the transmission of property and the continuity of the dynasty to homosexual desire, and then further to reduce that desire to pederasty, is to align one's discourse with, rather than to explain, the official legal and medical discourse on male homosexuality. (In France, only consensual private homosexual acts *with minors* are subject to prosecution.)[12]

Irigaray recognizes that not all homosexual relationships are pederastic, and so she offers a second explanation of homosexual oppression: "The 'other' homosexual relations, masculine ones, are just as subversive, so they too are forbidden. *Because they openly interpret the law according to which society operates.*" (In this view, one supposes, the homosexual subculture would be the utopia of patriarchy.) Thus, homosexuality is forbidden because, on the one hand, it violates the law (the incest taboo)

that institutes the exchange of women and, on the other, because it is in perfect compliance with the law. Here, Irigaray believes she has uncovered a social contradiction: "Exchanges and relationships, always among men, would thus be both required and forbidden by law." [13] But I believe that what she has exposed is actually her own imprecise understanding of the terms of Lévi-Strauss's argument.

Closer feminist readers of Lévi-Strauss—Juliet Mitchell and Gayle Rubin, both of whom have responded to the exchange argument without positing a homosexual monopoly—emphasize the fact that, for Lévi-Strauss at least, the incest taboo is a prohibition against neither intergenerational nor homosexual liaisons. In her influential 1975 essay "The Traffic in Women: Notes on the 'Political Economy' of Sex," Rubin argues that the incest taboo in fact presupposes "a prior, less articulate taboo on homosexuality. A prohibition against some heterosexual unions assumes a taboo against non-heterosexual unions." Rubin characterizes this taboo, which institutes "compulsory heterosexuality," as a "taboo against the sameness of men and women":

> Men and women are, of course, different. But they are not as different as day and night, earth and sky, yin and yang, life and death. In fact, from the standpoint of nature, men and women are closer to each other than either is to anything else—for instance, mountains, kangaroos, or coconut palms. . . . Far from being an expression of natural differences, exclusive gender identity is the suppression of natural similarities. It requires repression: in men, of whatever is the local version of "feminine" traits; in women, of the local definition of "masculine" traits. [14]

Although one wonders whether Rubin would maintain this "repressive hypothesis" after her association with Foucault, nevertheless positing an ancient taboo against homosexuality allows her to connect the suppression of homosexuality with the oppression of women: "The suppression of the homosexual component of human sexuality," she writes, "and by corollary, the oppression of homosexuals, is . . . a product of the same system whose rules and relations oppress women." Rubin goes on to cite several instances of "institutionalized homosexuality" in non-Western cultures, but argues that in every case "the rules of gender division and obligatory heterosexuality are present even in their transformations." [15] That is, one is sometimes permitted to occupy either a masculine or a feminine position regardless of one's sex, *but never both*—which suggests that Rubin's is a taboo not against homosexuality, but against *bisexuality*.

Locating the prohibition of homosexuality prior to the institution of society (the incest taboo) can only lend support to the contemporary ten-

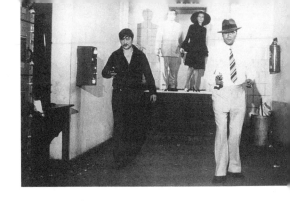

dency to regard the continuing criminalization of male homosexuality as a survival of ancient—even outmoded—prohibitions. In most cases—such as *Bowers v. Hardwick,* in which the U.S. Supreme Court upheld the constitutionality of the Georgia statute criminalizing consensual sodomy when performed by homosexual men, while admitting that the law would be unconstitutional if applied to heterosexual acts—"ancient" sanctions are invoked in order to justify laws criminalizing homosexual men, even when it is recognized that these laws may be obsolete. (Justice Powell, concurring with the decision of the Court: "The history of non-enforcement suggests the moribund character of laws criminalizing this type of private, consensual conduct. . . . But . . . I cannot say that conduct condemned for hundreds of years has now become a fundamental right.")[16] However, there is also a "progressive" version of this argument, which deplores the oppression of homosexuals while in the same breath celebrating liberal democracy: in this view, the persecution of homosexuals is "a salutary reminder of the barbarities into which blind prejudice against an unpopular minority can plunge an otherwise progressive society."[17]

Nothing could be further from the truth. The criminalization of male homosexuality is a relatively recent phenomenon (the Georgia statute recently upheld by the Supreme Court was ratified in *1968*).[18] "Ancient" prohibitions—which applied to all subjects alike—must be distinguished from the "modern" form of homosexual oppression—denial of civil rights, housing, Party membership (Pasolini), military or teaching careers . . . —which began only in the nineteenth century. The stigmatization of homosexuality "as a suspect classification"[19] presupposes the metamorphosis of *the* sodomite into *a* homosexual; as Foucault writes in the first volume of *The History of Sexuality*:

> As defined by the ancient civil or canonical codes, sodomy was a category of forbidden acts; their perpetrator was nothing more than the juridical subject of them. The nineteenth-century homosexual became a personage, a past, a case history, and a childhood. . . . Nothing that went into his total composition was unaffected by his sexuality. It was everywhere present in

Rainer Werner Fassbinder, The American Soldier, *1970, film.*

him: at the root of all his actions because it was their insidious and indefinitely active principle; written immodestly on his face and body because it was a secret that always gave itself away. It was consubstantial with him, less as a habitual sin than as a singular nature. . . . The sodomite had been a temporary aberration; the homosexual was now a species.[20]

What the nineteenth century witnessed, then, was the appearance of the homosexual delinquent—an individual constitutionally predisposed to commit proscribed or illicit sexual acts, and therefore in need of supervision, correction, incarceration. And while sanctions against sodomy are the justification for the criminalization of the homosexual, nevertheless, the two must not be collapsed. To locate the repression of homosexuality in times immemorial is to ignore history, for the "homosexual" has existed for only a century.

> *What, you would like to marry your sister! What is the matter with you anyway? Don't you want a brother-in-law? Don't you realize that if you marry another man's sister and another man marries your sister, you will have at least two brothers-in-law, while if you marry your own sister you will have none? With whom will you hunt, with whom will you garden, whom will you go to visit?*
>
> — MARGARET MEAD'S Arapesh "informants"

Juliet Mitchell's treatment of Lévi-Strauss's exchange argument in the chapter "Patriarchy, Kinship and Women as Exchange Objects" in *Psychoanalysis and Feminism* prompts speculation on the ways in which certain non-Western cultures have integrated, rather than repressed, "homosexual" impulses. For Mitchell, the differentiation of the sexes is not prior to the incest taboo (as Rubin argues), but accomplished through it. That taboo is not (*pace* Freud) a prohibition against intergenerational unions, but a taboo against the marriage of brother and sister; sexual differentiation, Mitchell observes, is instituted between these two through the prohibition of their incestuous coupling:

> The brother (maternal uncle) must give his sister away in marriage and not desire her incestuously; both he and his sister whom he gives away are as close as one can get to being each other. The distinction between them is minimal and the prohibition of their union (the incest taboo) establishes the smallest of differences which is necessary to inaugurate society.[21]

The most suggestive aspect of Mitchell's reading of Lévi-Strauss is her emphasis on the avunculate (a term that Rubin elides): "In order to establish the socio-cultural break with the biological given of two parents and their child," she writes, "a fourth term must intervene. This is where

the mother's brother comes in, and he comes in with the very inaugu-
ration of society, he is essential to it."[22] For the maternal uncle is the
agent of exchange; what he gives away is a sister and—reciprocity in
future generations aside—what he receives in return . . . a brother-in-
law—*two* brothers-in-law, according to the Arapesh theory of exponen-
tial return.[23]

Although the role of the maternal uncle varies from society to society,
it appears to be especially important in groups which practice institu-
tional or ritual forms of "homosexuality."[24] In New Guinea, for exam-
ple, where initiation into manhood often requires the ingestion of sperm
from adult males, the most important relationship is that between a
boy and his mentor—ideally; *his mother's brother*.[25] And while one sus-
pects Lévi-Strauss of suppressing evidence of homosexuality—his ad
hominem homophobic outburst about Fire Island in *Tristes Tropiques*
should be consulted[26]—his discussion in the same book of open homo-
sexual relationships between Nambikwara youths confirms my specula-
tion about the avunculate:

> Homosexual relationships are only allowed between adolescents who are
> "cross-cousins," that is, who would normally marry each other's sisters, so
> that the brother is acting as a temporary substitute for the girl. When the
> natives are asked about relationships of this kind, they invariably reply:
> "They are cousins (or brothers-in-law) making love." On reaching adult-
> hood, the brothers-in-law continue to express their feelings quite openly.
> It is not uncommon to see two or three men, who are both husbands and
> fathers, walking together in the evening with their arms affectionately
> around each other.[27]

As disarming as this passage may be, it also discloses the anthropolo-
gist's sexual politics, for he is able to regard a male lover only as a "tem-
porary substitute" for a woman. Homosexual relationships are simply a
"solution" to the shortage of marriageable women created in Nambik-
wara society because the chief has something that resembles a harem.
But then, for Lévi-Strauss the number of available women *always* seems

Stuart Marshall, Over Our Dead Bodies, *1991, film. Photograph © Sunil Gupta.*

insufficient: "Even if there were as many women as men," he claims, "these women would not all be equally desirable . . . the most desirable women must form a minority." (To which Irigaray retorts: "Are all men equally desirable?")[28] Thus, the "same" ideology that manifests itself in the misogynistic complaint that there are never enough women leads the anthropologist to the homophobic conclusion that homosexuality is only a last resort.

Nevertheless, Lévi-Strauss's exchange argument prompts speculation —which will be confirmed or refuted by further investigation of societies which institutionalize same-sex relationships—that the incest taboo may actually work to integrate homosexual impulses into the sexual economy, and that the "repression" of homosexuality may be less universal than Rubin supposes. Before we can grasp the implications of this possibility for feminism, we will have to follow up on anthropological leads which suggest that societies which institutionalize "homosexuality" are more egalitarian, less hierarchical, than societies which do not, and that male dominance over women is emphasized more strongly in the latter.[29] In this way, the "repression" of homosexuality may well be linked to the ascendancy of men over women. Perhaps the alternative to the legend of the homosexual outlaw will turn out to be the role of the homosexual in-law.[30]

> *It is not infrequently disappointment over a woman that drives a man to drink—which means, as a rule, that he resorts to the public house and to the company of men, who afford him the emotional satisfaction which he failed to get from his wife at home. If now these men become the objects of a strong libidinal cathexis in his unconscious . . .*
>
> — SIGMUND FREUD, "Psychoanalytic Notes upon an Autobiographical Account of a Case of Paranoia (Dementia Paranoides)"

In "Function and Field of Speech and Language in Psychoanalysis," Lacan links Lévi-Strauss's kinship structures with the unconscious: "Isn't it striking that Lévi-Strauss, in suggesting the implication of the structure of language with that part of the social laws which regulate marriage ties and kinship, is already conquering the very terrain in which Freud situates the unconscious?"[31] It is not surprising, then, that a number of feminist writers employing Freudian theory should have arrived at conclusions similar to Irigaray's. For example, in "The Purloined Punchline: Joke as Textual Paradigm," in which she formulates a Lacanian theory of narration, Jerry Aline Flieger suggests that the narrative contract itself may be fundamentally homoerotic. Flieger traces

Freud's version of the incest taboo (Oedipus) back to his analysis, in *Jokes and Their Relation to the Unconscious,* of the obscene joke—which Freud characterizes as a contract of mastery between two men at a woman's expense. When Flieger schematizes Freud's scenario, its homoerotic sub-plot rises to the surface: "PART I: BOY MEETS GIRL. . . . PART II: BOY LOSES GIRL. . . . PART III: JOKE CONQUERS ALL. . . . EPI-LOGUE: BOY GETS BOY?" (Flieger also provides a Lacanian update: "In Lacan's version of Freud's transparent master narrative, the closing line seems to read [comically] neither BOY GETS GIRL nor BOY GETS BOY but BOY *IS* GIRL.")[32]

It should be remembered, however, that the obscene joke origi-nates in a failed attempt at *heterosexual* seduction; in the Freudian sce-nario, homosexual gratification remains supplementary, compensatory. (Flieger: "The locker room joys of male bonding have replaced the original aim of seduction.")[33] For Freud, however, homosexuality is a solution not to the shortage, but rather to the inaccessibility of desir-able women: it is the woman's "resistance" that causes the erstwhile heterosexual seducer to turn instead to another man. (One is reminded of the famous passage on the inaccessibility of narcissistic women, who "have the greatest fascination for men [for Freud?] . . . since as a rule they are the most beautiful.")[34] Is it going too far to suggest that in the *Jokes* book, as well as in the passage from the Schreber case cited above, Freud uses male homosexuality as a threat against women in order to encourage them to be more responsive to men?

In any case, in both passages Freud appears to hold women responsi-ble for male homosexuality. This is a familiar psychoanalytic tactic: Why is it always the mother who is blamed for a son's homosexuality?[35] More-over, as I noted above, in Freud the scapegoating of women for male homosexuality frequently entails a scapegoating of homosexual men as well; here is one example, from *Das Medusenhaupt*: "Since the Greeks were in the main strongly homosexual, it was inevitable that we should find among them a representation of woman as a being who frightens and repels because she is castrated."[36] Since all men are supposedly

Derek Jarman, Caravaggio, *1986, film. Photograph © Mike Laye.*

frightened and repelled by the sight of female genitalia, why are the "homosexual" Greeks singled out here? Is gynephobia being defined as the "homosexual" component of masculine sexuality? Is the repression of a man's "horror of women" the repression of his homosexuality? But then how can the bisexuality of the drives precede the Oedipus complex?

This is not the place for an extended consideration of these questions, or of Freud's treatment of male homosexuality in general, which I reserve for another occasion. However, I do want to comment briefly on his argument, repeated over and over again, that the "social instincts"—camaraderie, esprit de corps, "the love of mankind in general"—are a manifestation of sublimated homosexual desire.[37] With this argument Freud himself comes close to positing a homosexual monopoly; but he also reveals what is at stake in the positing of such a monopoly.

In an interview published shortly before his death, Foucault speculated that the emergence of homosexuality as a distinct category is historically linked to the disappearance of male friendship:

> Homosexuality became a problem—that is, sex between men became a problem—in the 18th century. We see the rise of it as a problem with the police, with the justice system, and so on. I think the reason it appears as a problem, as a social issue, at this time is that friendship has disappeared. . . . The disappearance of friendship as a social institution, and the declaration of homosexuality as a social/political/medical problem, *are the same process.*[38]

Although Sedgwick rather summarily dismisses Foucault, claiming that he "suspends the category of 'explanation',"[39] her discussion of emergent homophobia in nineteenth-century England both confirms his speculation and allows us to sharpen it as an analytic tool. For homosexuality did not emerge as a problem because friendship had already disappeared; rather, as Foucault himself observed, intense male friendships were perceived as inimical to the smooth functioning of modern institutions—the army, bureaucracy, administration, universities, schools—which therefore attempted "to diminish, or minimize, the affectional relations."[40] And the primary weapon in this "progressive" campaign against male friendship was homophobia—the imputing of a homosexual motive to every male relationship; hence, the widespread tendency to regard such institutions of the military, the prison, and the boy's school as sites of rampant homosexual activity, rather than as machines for the reproduction, not of homosexuals, but of homophobes. As Sedgwick writes:

The fact that what goes on at football games, in fraternities, at the Bohemian Grove, and at climactic moments in war novels can look, with only a slight shift of optic, quite startlingly "homosexual," is not most importantly an expression of the psychic origin of these institutions in a repressed or sublimated homosexual genitality. Instead, it is the coming to visibility of the normally implicit terms of a coercive double bind. (It might be compared to the double bind surrounding rape that imprisons American women: to dress and behave "attractively," i.e., as prescribed, is always to be "asking for it.") For a man to be a man's man is separated only by an invisible, carefully blurred, always-already-crossed line from being "interested in men."[41]

Thus, Sedgwick deftly overturns received Freudian wisdom that repressed or sublimated homosexual desire lies at the origins of both the "social instincts" and of homophobia as well. Freud's theory of homophobia as repressed homosexuality has been celebrated by some gay writers for locating the "problem," not with homosexuality per se, but with homophobia.[42] However, this theory also makes it difficult—at times impossible—to distinguish homophobia from homosexuality; and I believe that the positing of a homosexual monopoly is predicated on precisely this confusion of terms. For it *would* make sense to speak of the undisclosed *homophobia* of the official discourse of philosophy, or to characterize the Nazi community as a *homophobic* brotherhood, and to investigate (as Sedgwick has) the way in which such homophobia affects women. Freud is not, of course, to be held responsible for the confusion of homosexuality and homophobia; his own confusion testifies to the historical limitations of his treatment of male homosexuality. But neither is Freudian theory to be invoked in support of theories of a homosexual monopoly, for it is a manifestation of the same homophobic mechanisms it purports to describe.

Homophobia, Sedgwick writes, "is by now endemic and perhaps ineradicable in our culture. The question of who is to be free to define, manipulate, and profit from the resultant double bind is no less a site of struggle today than in the eighteenth century, however."[43] That the

Marlon Riggs, Tongues Untied, *1989, video. Photograph courtesy Frameline.*

single most important contribution to the redefining of the terms of this struggle should have been made by a *feminist* writer is highly encouraging. By demonstrating that male homophobia is directed at both gay and straight men, and by demonstrating that it affects women as well (by requiring that what Sedgwick refers to as male "homosocial" desire be mediated by women), Sedgwick has effectively transformed the fear of homosexuality from an isolated political issue into a central concern of any left political coalition today. Nowhere is the importance of this issue for society at large more apparent than in the government's and the media's scapegoating of homosexual men for the AIDS pandemic—a homophobic tactic which is as threatening as the disease itself to the welfare of the entire population. Sedgwick's discussion of male homosocial desire departs from René Girard's discussion of rivalrous erotic triangles in *Desire, Deceit, and the Novel*; in conclusion, I would like to cite a passage from Girard's *The Scapegoat*—a passage which has chilling repercussions today, as proposals for the quarantine, internment, tattooing, even the extermination of homosexual men resound in our ears:

> Medieval communities were so afraid of the plague that the word alone was enough to frighten them. They avoided mentioning it as long as possible and even avoided taking the necessary precautions at the risk of aggravating the effects of the epidemic. So helpless were they that telling the truth did not mean facing the situation but rather giving in to its destructive consequences and relinquishing all semblance of normal life. The entire population shared in this type of blindness. Their desperate desire to deny the evidence contributed to their search for "scapegoats."[44]

NOTES

1. Gayatri Chakravorty Spivak, "Displacement and the Discourse of Women," in *Displacement: Derrida and After,* ed. Mark Krupnick (Bloomington: Indiana University Press, 1983), 177.

2. Eve Kosofsky Sedgwick, *Between Men: English Literature and Male Homosocial Desire* (New York: Columbia University Press, 1985), 20.

3. Ibid.

4. These words do appear in a letter addressed to the publisher of *The Anti-Aesthetic* (Seattle: Bay Press, 1983); they are reprinted here with the permission of Linda Nochlin. I agree with her that the absence of women writing about feminism is a serious problem with the collection; the original text of "The Discourse of Others" made a similar accusation, which was cut. My primary concern in this essay, however, is to differentiate the monolithic "men" in "men and feminism."

5. Sedgwick, *Between Men*, 87, 88–89.

6. Elaine Showalter, "Critical Cross-Dressing," in *Men in Feminism,* ed. Alice Jardine and Paul Smith (New York: Methuen, 1987), 116–32.

7. Robert Stoller, *Presentations of Gender* (New Haven: Yale University Press, 1983). See in particular Stoller's list of "gender disorders" beginning on 18.

8. Spivak, "Displacement and the Discourse of Women," 176.

9. Maria Antonietta Macciocchi, quoted in Sedgwick, *Between Men,* 220, n. 27. This frequently quoted homophobic formulation is especially surprising in light of Macciocchi's eloquent defense of Pasolini's feminism. See "Quatre Hérésies Cardinales pour Pasolini," in *Pasolini, seminare dirigé par Maria Antonietta Macciocchi* (Paris: Grasset, 1980), 127–58.

10. Luce Irigaray, "Women on the Market," in *This Sex Which Is Not One,* trans. Catherine Porter (Ithaca: Cornell University Press, 1985), 180.

11. Ibid., 171, and "Commodities among Themselves," 192–93.

12. See Jeffrey Weeks, preface to Guy Hocquenghem, *Homosexual Desire,* trans. Daniella Dangoor (London: Allison & Busby, 1978), 11.

13. Irigaray, "Commodities," 193.

14. In *Toward an Anthropology of Women,* ed. Rayna R. Reiter (New York and London: Monthly Review Press, 1975), 179–80.

15. Ibid., 180, 182.

16. Supreme Court of the United States, *Bowers v. Hardwick,* no. 85–140 (1986), n.p.

17. Bernard Knox, "Subversive Activities," *The New York Review of Books* XXXII, 20 (1985), 7.

18. Georgia statute 16–6–2 was actually rewritten in 1968 because it had been interpreted as inapplicable to heterosexual and lesbian sodomy. However, the legal history of homosexuality makes it impossible to regard ours as a "progressive" society: Under the Napoleonic code, homosexuality was not subject to legal sanctions in France until 1942; the Gaullist regime intensified legal sanctions in the 1960s. Although Britain repealed the death penalty for sodomy in 1861, it was only thereafter that the persecution of homosexual men began in earnest. In fact, the "liberalization" of laws criminalizing homosexuality has almost always been followed by an increase in prosecutions. See Weeks, preface to *Homosexual Desire,* 11, 25.

19. From *Bowers v. Hardwick.*

20. Michel Foucault, *The History of Sexuality* vol. 1, trans. Robert Hurley (New York: Pantheon, 1978), 43.

21. Juliet Mitchell, *Psychoanalysis and Feminism* (New York: Vintage, 1975), 375–76.

22. Ibid.

23. Cited by Lévi-Strauss in *The Elementary Structures of Kinship* (Boston: Beacon Press, 1969), 485.

24. Obviously, when we attribute "homosexuality" to non-Western cultures, we are exporting Western sexual ideology (as Foucault remarks, the term *homosexuality* itself dates to 1870), just as the tendency to regard the Greeks as "homo-

sexual" (and Plato and Sappho as gay ancestors), or Michelangelo as a "gay" art-ist, is anachronistic, at best. However, I retain these terms here as indications of the historical limits of a society that can regard homosexual behavior only as a manifestation of homosexual identity.

25. See *Ritualized Homosexuality in Melanesia*, ed. Gilbert H. Herdt (Berkeley: University of California Press, 1984).

26. Lévi-Strauss is in Porto Esperanca, Brazil, which he describes as "the weirdest spot one could hope to find on the face of the earth, with the possible exception of Fire Island in New York State." Here is the conclusion of his account of the strange rituals practiced by the inhabitants: "To complete the picture I must add that Cherry Grove is chiefly inhabited by male couples, at-tracted no doubt by the general pattern of inversion. Since nothing grows in the sand, apart from broad patches of poisonous ivy, provisions are collected once a day from the one and only shop, at the end of the landing-stage. In the tiny streets, on higher ground more stable than the dunes, the sterile couples can be seen returning to their chalets pushing prams (the only vehicles suitable for the narrow paths) containing little but the weekend bottles of milk that no baby will consume." *Tristes Tropiques*, trans. J. and D. Weightman (New York: Washington Square Press, 1977), 168–69. I should perhaps add that only once does Lévi-Strauss mention that his wife accompanied him on the travels chronicled in *Tristes Tropiques*.

27. Ibid., 354.

28. Irigaray, "Women on the Market," 171. Lévi-Strauss's remark appears in *Elementary Structures*, 38.

29. *Ritualized Homosexuality in Melanesia*.

30. Although Lévi-Strauss insists that the avunculate has disappeared in modern Western societies, some attention to male homosexual experience sug-gests that it has not disappeared *entirely*. As James Saslow writes at the conclusion of the acknowledgments in his recent book *Ganymede in the Renaissance: Homosex-uality in Art and Society* (New Haven and London: Yale University Press, 1986), "For those who, in Plato's words, are 'better equipped for offspring of the soul than for those of the body,' the birth of a nephew is perhaps the most immediate experience of the continuity of life and the value of working for future gener-ations" (xvi).

31. In *Écrits: A Selection*, trans. Alan Sheridan (London: Tavistock, 1977).

32. In *Lacan and Narration: The Psychoanalytic Difference in Narrative Theory*, ed. Robert Con Davis (Baltimore and London: Johns Hopkins University Press, 1983), 943–44, 960.

33. Ibid., 944.

34. See Sarah Kofman's excellent treatment of the problem women's "inac-cessibility" posed for Freud in *The Enigma of Woman: Woman in the Writings of Freud*, trans. Catherine Porter (Ithaca: Cornell University Press, 1985).

35. Consider the following, from *France-Dimanche* in 1962, purporting to tell "The Truth About Homosexuality": "A Swiss psychiatrist goes straight to the

point: according to him, in seventy percent of cases, it is the parents who are responsible for their children's homosexuality, and particularly the mother! . . . *Stress the mother's responsibility, however astounding it may seem. Too many mothers wish in their heart of hearts for their sons to be homosexual"* (italics original). Cited in Hocquenghem, *Homosexual Desire*, 69.

36. In *Sexuality and the Psychology of Love* (New York: Collier, 1963), 187.

37. Here is one statement of this theory, from the Schreber case: "After the stage of heterosexual object-choice has been reached, the homosexual tendencies are not, as might be supposed, done away with or brought to a stop; they are merely deflected from their sexual aim and applied to fresh uses. They now combine with portions of the ego-instincts and, as 'anaclitic' components, help to constitute the social instincts, thus contributing an erotic factor to friendship and comradeship, to *esprit de corps* and to the love of mankind in general. How large a contribution is in fact derived from erotic sources (though with the sexual aim inhibited) could scarcely be guessed from the normal social relations of mankind." "Psychoanalytic Notes upon an Autobiographical Account of a Case of Paranoia (Dementia Paranoides)," in *Three Case Histories* (New York: Collier, 1963), 164.

38. Bob Gallagher and Alexander Wilson, "Michel Foucault: An Interview," *Edinburgh Review* (1986), 58.

39. Sedgwick, *Between Men*, 87.

40. Gallagher and Wilson, "Michel Foucault," 58.

41. Sedgwick, *Between Men*, 89.

42. Hocquenghem, *Homosexual Desire*, 35.

43. Sedgwick, *Between Men*, 89–90.

44. René Girard, *The Scapegoat,* trans. Yvonne Freccero (Baltimore: Johns Hopkins University Press, 1986), 2–3.

PART III

Cultures

Perhaps it is in this project of learning how to represent our-selves—how to speak to, rather than for or about, others—that the possibility of a "global" culture resides.

— GLOBAL ISSUES

Instead of representing the Third World (as the site of difference or heterogeneity), we in the increasingly routinized metropolitan centers might ask the question of what (or who) cannot be assimilated by the global tendencies of capital and its culture.

— GLOBAL ISSUES

If culture is to be protected, is it not precisely from those whose business it is to protect culture.

— THE YEN FOR ART

Perhaps, then, it is to the issue of mastery—of power, authority, domination—that both art and criticism must turn if we are to emerge from our current impasse.

— HONOR, POWER, AND THE LOVE OF WOMEN

Transgression has become the norm in a society that stages its own scandals.

— HONOR, POWER, AND THE LOVE OF WOMEN

Politics of *Coppélia*

The point of intersection between dance and politics is often difficult to locate; some would deny its existence altogether. But it seems naïve to assume that ballets are a special class of artifacts made without reference to the broader issues of culture and society, and to conceive of the choreographer as an idiosyncratic genius cut off from the world. Rather, ballets should be open to the kinds of contextual analysis and criticism which have long been available to writing about literature and the visual arts. In his exemplary staging of *Coppélia* for the New York City Ballet, George Balanchine makes just this point. (*Coppélia* will be included in the NYCB winter season which begins later this month [November, 1976] at the New York State Theater.)

First produced in Paris in May 1870, *Coppélia* was the last ballet of the Second Empire; two months after its premiere, Napoleon III declared war on Prussia. Balanchine has restudied the ballet in terms of the social and political issues current in Paris on the eve of the Franco-Prussian War. Not surprisingly, the basis for his interpretation is musical; the passage that Leo Délibes composed for the Act III *divertissement* "Discord and War" is understood as a piece of propaganda, a parodic retort to Wagner and the Wagnerians. This reading makes sense. To an audience weary of repeated Prussian aggression on both military and musical fronts, the most resonant musical image of war would have been Wagnerian bombast. Whether Délibes actually intended such a parody is not at issue here. What matters is that Balanchine asks us to hear this music in this way.

The possible political implications of that *divertissement* have been

amplified on the stage of the State Theater: a fanfare heralds the appearance of a stream of spear-carrying music-hall Valkyries. Their jarring entry on the heels of a delicate allegorical celebration of the daily life cycle of the peasant immediately reminds us that *Coppélia* is lodged in a specific political context which, Balanchine seems to say, is inseparable from its meaning.

The central figure of Dr. Coppélius, the crazed inventor of automata who holds an entire village in thrall with his machinations, has also been rigorously rethought. Most productions since the original have presented Coppélius as either a harmless buffoon, or in a curious inversion of meanings, a figure for the alienated artist misunderstood by philistines. But Balanchine's Coppélius is clearly the emblem for the exhaustion of both physical and spiritual vitality that he must be if the plot of *Coppélia* is to make any sense whatsoever. In spite of his desire to impart life to his inanimate creations, Coppélius can never be a convincing Pygmalion: this is the source of his pathos. The irony is that he is the Inventor, not the Artist; his virtuosity remains technological.

Throughout history, the Inventor has enjoyed greatest power and prestige during periods dominated by mechanistic views of the world and of society. Automata have stood as emblems for that total rationalism which claims understanding of the internal operations of phenomena; more often than not, that understanding was the exclusive property of privileged classes. To the unenlightened, automata seemed to manifest magical properties, thus heightening the prestige of those who claimed to understand their inner workings. From the dynasties of the Pharaohs onward, the power of automata to mystify has been exploited by rulers to control the masses. The secrecy of Coppélius's machinations, the awe and terror they inspire in the inhabitants of the village, situate *Coppélia* squarely in the nexus of technology, philosophy, and politics.

Yet by the mid-19th century, the element of popular delight with automata diminished as the first undercurrents of the machine's threatening potential vis-à-vis man were felt. Vitalist arguments began to supplant mechanistic ones: the prestige of automata shrank correspondingly. *Coppélia* is a product of this historical moment. Here, the mechanistic worldview, personified by Coppélius, is confronted with and defeated by the superior intelligence and vitality of a single peasant girl, Swanilda. Restatement of the action reveals its simplicity: Swanilda discovers the ultimate vacuity of Coppélius's enterprise and plots to share her revelation with her fiancé, the *lumpen* Frantz. This prepares us for the celebration of the organic or vitalist worldview which is Act III.

Seen thus, the various episodes of *Coppélia*—particularly those which

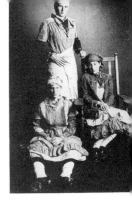

center around Frantz—assume a curious social importance. Coppélius exploits the erotic promise of the mechanical to manipulate Frantz, whose infatuation with Coppélius's lifeless creation, the wind-up Coppélia, is a clear image of the people held in thrall by bourgeois mystification. And when, in Act II, Coppélius attempts to draw life for his automaton from the drugged Frantz, the implications are potentially chilling: the master attempting to animate his constructs by sapping the strength of his victim.

But the political implications of *Coppélia* would remain just that— implications—were they not expressed through the dancing itself. The way in which styles of movement can convey political messages is an important subject which warrants serious critical investigation. Nonetheless, the role of Swanilda seems to reproduce in miniature the confrontation of philosophies at the center of the ballet. The plot requires that she impersonate the automaton in order to unmask it; the dancer must therefore successfully communicate two distinct styles of dancing, one imitative of the precise, stiff movements of the mechanical; the other, of the broad and uninterrupted flow of the natural. Through their juxtaposition, Swanilda demonstrates the infinite preferability of the living dancer over the seductive, yet ultimately threatening, automaton. As Swanilda, Patricia McBride seems totally aware of these distinctions; while she charms throughout, her witty impersonation of the automaton is not allowed to move us: that is reserved for the great nuptial pas de deux which climaxes the Act III celebration.

It may seem paradoxical that Balanchine, who has been credited with the invention of the formal, contentless ballet, should mount such a *Coppélia*. But Balanchine continually produces new work which eludes the previous categories and definitions used to describe him. His handling of *Coppélia* is expressive of a conviction that the ballet has far more intellectual density than is usually presumed; further, that that density exists precisely at the point where dance and society intersect. The relevant

The Split Britches Company in Split Britches, *1981.*
From left: *Lois Weaver, Peggy Shaw, Deb Margolin.*

information about *Coppélia*'s place in history might be available through historical reading; but here it has been embedded in performance, making it available to a wider audience, provided that audience is willing to think a little.

In this respect, NYCB's *Coppélia* could stand as a model for revivals of other classics. It is fascinating to speculate, for example, about the ways in which the Tchaikovsky-Petipa ballets, especially *The Sleeping Beauty*, reflect the dominant ideology of tsarist Russia, and how this information can be conveyed in performance. Such revivals will restore to the dance a long absent social and political resonance; Balanchine's *Coppélia* is a major step forward in that necessary process of rehabilitation.

Sects and Language

"Woman does not exist." "My sex is French." "There is no sexuality without parricide." These pronouncements—by Bernard-Henry Lévy, Philippe Sollers, and Armando Verdiglione respectively—are only a sample of the rhetorical rodomontade that was "Sex and Language," a three-day, three-ring conference staged last month in the unlikely setting of the Plaza Hotel's ornate second-floor ballrooms. Under the auspices of something called the International Freudian Movement, over 130 "intellectuals and artists" convened to consider such topics as "Psychoanalysis of the Sword," "Word of Woman and the Word of Man in Kibbutz," "Cancer, Sex and Language," "The Disappearance of the Body," and "Frigid Enjoyment." Pierre Daix interpreted the "Sexual Symbolism in Picasso's Figurative Language"; Achille Bonito Oliva introduced us yet again to the work of the painters of the Italian "Transavantgarde"; Alain Kirili exposed "The Wanton Truth of Sculpture." Trisha Brown, Carolee Schneemann, and Hannah Wilke performed; Iannis Xenakis and Lukas Foss played tapes of their music; William Burroughs, John Giorno, Kenward Elmslie, and Walter Abish read texts and poems. At night, films by Robert Altman, Anatole Daumont, and Alain Robbe-Grillet were screened.

This was the fifth such conference that the International Freudian Movement has sponsored, and it was reportedly the most elaborate. Since 1975, the Movement has been rehearsing in Milan, perfecting its version of the intellectual conference as theatrical event. The participation of artists and art critics, as well as a substantial art-world contingent in the audience, contributed to the conference's distinctly carnivalesque

profile. Yet in the end theater proved no substitute for ideas; as one observer remarked publicly at the conclusion, "Trop de confetti, peu de substance" (Too much confetti, too little substance).

The one clear theme to emerge from the sessions was that sex, understood as a biological function, is to be distinguished from sexuality, understood as a symbolic activity. Separated from procreation, sex becomes a form of sacrifice, of waste, an expenditure without return, a squandering of resources. This view is less dependent on Freud's hypothesis of the sexual origin of the neuroses than on Georges Bataille's notion of *la dépense*—discharge, prodigality, useless expenditure—derived from the American Indian potlatch ritual. While the distinction between sex and sexuality is both valid and important, here it was often presented in such rhetorically inflated propositions as "Sexuality is ungenital" and "Procreation is nothing but an hysterical fantasy." Such overstatements were neither challenged nor defended. As *New York Times* reporter Ed Rothstein observed during the ostensible debate with which the conference concluded, most of the talk focused on the conference itself, rather than its subject.

But in fact the conference *was* its own subject, and in this respect more questions were raised than answered. Why, for example, did more than half of the announced speakers fail to materialize? (The majority of the scheduled "heavies"—John Ashbery, Harold Bloom, John Searle, and Emmanuel Le Roi Ladurie among them—were conspicuous in their absence.) Why, given the Movement's "international" orientation, were there only a handful of French analysts, and endless Italians? Why were several important contributors to the study of the relation of sex and language—Julia Kristeva, Michel Foucault, and Leo Bersani, for example—never associated with the conference? Why, when an open exchange among practitioners of various disciplines was promised, were the contributions of artists, composers, and filmmakers treated as diverting interludes and never discussed formally by any of the participants? Why were round-table discussions of such topics as "The Terrorism against Sexuality" and "The Intellectual and Sex" conducted as a series of monologues, with debate or exchange among speakers discouraged, and questions from the floor proscribed until the conference's conclusion? And why, when questions were finally permitted, were they without exception left unanswered?

At the end of three grueling days of polemics, tirades, and much biblical exegesis, in French, Italian, Russian, and English, an audience of roughly 1,000 assembled in the Plaza's Baroque room for a promised "debate" on the congress; they appeared neither stimulated nor enlight-

ened, but suspicious and openly hostile. Released at last from silence, a mutinous crew hurled angry questions at an ad hoc panel, convened presumably to respond to the many rumors that by then were circulating—rumors concerning the conference's funding, its organizers' political affiliations, as well as their ulterior motives. "By what criteria," one troubled observer asked, "would you judge the success of the conference? If it's to perplex people, there are cheaper ways."

From the very beginning, the purpose of the conference had been obscure. What *was* clear was that its organizers were spending an enormous sum on it; estimates range from a conservative $140,000 to over a quarter of a million paid to the Plaza alone. What was the source of their funds, and what did they hope to receive in return? (The participation of the Banco de Roma, listed as an official sponsor, fueled rumors that the conference was a front for mysterious financial transactions.) Not only had the Movement rented one of New York's most costly venues, it also engaged the services of the high-powered P-R firm Ruder and Finn. A heavy advertising campaign began in February with an ad in the Sunday *New York Times* entertainment section, inviting the "general public" to rush their $40 subscription fees to Milan in the morning mail.

During a pre-conference press briefing, which concluded with the uncorking of endless bottles of Moët, a handful of intellectual celebrities, including Sollers and Robbe-Grillet, were trotted out to provide the hors d'oeuvres. They delivered enticing tidbits of their presentations to film crews, photographers, and correspondents from four continents. According to the *New York Times*, the Movement itself was covering the expenses of sixty European journalists. The conference was apparently being staged for the media; what the Movement laid out in *lire* it obviously hopes to recoup in publicity. But to what purpose will that publicity be used?

Stuart Schneiderman, a student of the prominent French analyst Jacques Lacan and the only practicing Lacanian analyst in the United States, was the lone participant publicly to raise the crucial question: "What do European intellectuals think they're doing when they come to America? What do they hope to achieve?" Schneiderman spoke on a panel devoted to "The Plague in New York," based on Freud's offhand remark to Jung as they arrived in New York in 1909: "They don't know that we're bringing them the plague" (referring presumably to his concept of the unconscious, which has indeed spread like an epidemic through the human sciences). We heard a great deal about the plague during the conference; it was, in fact, a leitmotif.

The main carriers were Lévy, Sollers, and Verdiglione, three imperious figures who dominated the conference. Any analysis of its purpose is inseparable from an analysis of their motives. We must therefore examine the doctor rather than the patient, the diagnosis rather than the disease, as Thomas Szasz proposed in his paper "Sexuality and Rhetoric"—a genuinely amusing yet barbed account of the passage of masturbation from pathogenic condition (in 19th- and 20th-century medicine in general, and Freud in particular) to therapeutic instrument (in contemporary therapy in general, and Masters and Johnson in particular).

Sollers and Verdiglione were the first to speak at the press conference, at the first morning's session, as well as at the final "debate"; they have, it seems, become inseparable. Lévy did not arrive until the conference's final day, but he was obviously its star attraction. At 33, he is the most prominent of that group of young French pop heroes who call themselves the *nouveaux philosophes,* and claim to be seeking an ethical alternative outside of politics. Having risen to public attention by playing to the media rather than passing through the customary academic channels, Lévy has maneuvered his way into *Lire* magazine's list of the ten "most influential" living French writers. His best-selling books advocate a wholesale rejection of politics and a return to monotheism as the only effective weapon against neofascism. This position is not peculiar to Lévy, and it is rapidly gaining ground throughout Europe.

For "Sex and Language" Lévy delivered a (literally) talmudic exegesis of the first chapter of Genesis, constructed according to his favorite rhetorical strategy—which is to claim that something "does not exist." Since, in Lévy's reading, Genesis tells us that *woman* does not exist, then "there can be no relation between the sexes" (which is also a Lacanian postulate), and "the only love that exists is love of the Father"—which sounds like a defense *of,* rather than *against,* fascism.

Sollers is not a new philosopher—or any kind of philosopher—but in recent years he appears to have aligned himself with the *nouveaux philosophes.* Principal editor of the influential journal *Tel Quel,* he is perhaps the most accurate barometer of European intellectual fashion. Having flirted with the French Communist party, then with Maoism, and then having publicly supported Giscard in the 1978 legislative elections, Sollers—who, until the recent turn of events, could be seen dining at the Elysée Palace—represents the gradual depoliticization of the French intelligentsia and their alliance with existing structures of power. As Sollers has lamented, "We lost a great deal of time raising problems about world revolution . . . and with interminable debates on socialism"—which he now defines as "unsuccessful capitalism."

Sollers has been affiliated with the International Freudian Movement from its inception, which brings us to the impresario himself, the 36-year-old psychoanalyst responsible for "Sex and Language"—Armando Verdiglione. Like Lévy and Sollers, Verdiglione is fascinated by power; since, in our society, power is institutional and not individual, in 1973 he founded the Movement, from which he is virtually indistinguishable. Armando Verdiglione *is* the International Freudian Movement.

Based in Milan, the Movement is curiously reminiscent of Sun Yung Moon's Unification church, with *seminarios*—yes, seminaries—in ten Italian towns. Like Moon, Verdiglione has set out to "unify" ideologically diverse groups about a central body of dogma—in this case, Freudian theory. He has attracted a surprisingly large number of young Italian followers, whom he instructs in the principles of psychoanalysis. Many of these "born-again" Freudians were highly visible during the New York conference, chairing panels, accosting journalists, wandering the hotel's hallways—which caused several members of the audience to refer to them as Verdiglione's "spies." The Verdiglionies were also selling the Movement's publications; in addition to several series of books, the Movement publishes a monthly "international journal of culture," *Spirali*—which resembles an intellectual *Readers' Digest*—and the more specialized journals *Vel* (psychoanalysis), *Clinica* (psychiatry), *Nominazione* (logic), and *Cause of Truth* (law)—all of which list Verdiglione as editor-in-chief. (Many of Verdiglione's employees are also currently his analysands; can psychoanalysis be used as an effective instrument of indoctrination?)

Until recently, the Movement had remained a primarily local, i.e. Italian, phenomenon. But now Verdiglione has embarked on a campaign to fulfill the international destiny promised by its title. The conquest of France has already begun. Earlier this year, *Spirali* began to appear in a French- as well as an Italian-language edition; Verdiglione has staged conferences at Paris's Beaubourg Center and appeared on French television to promote his book, *The Plague* (what else?), which appeared simultaneously in French and Italian. "Sex and Language"

Yvonne Rainer, Privilege, *1990, film.*

represents the opening of Verdiglione's American campaign. Later this year, *Spirali* is to appear in an American edition as well; plans have already been announced for a second New York conference, four years hence.

Claiming that "Western culture has misunderstood Freud," Verdiglione has cast himself in the role of principal defender of something he calls the "culture of Freud." In this, he is clearly out to displace Lacan as the world's preeminent psychoanalytic theoretician. (The time could not be more propitious, for last year Lacan dissolved his *École Freudienne de Paris* and has apparently ceased his theoretical activity; as the French put it, "Lacan se tait.")

Verdiglione, whose own writings betray an obsession with the Freudian theme of parricide, explicitly denies any debt to Lacan: in Verdiglionese, "Lacan never was and is not today a point of reference. . . . If I read him it happens along this experience I consider as a reading of Freud." Yet the topic of the New York conference would have been inconceivable without Lacan's emphasis on the linguistic aspects of Freud's thought; Lacan's most lucid and most often quoted formulation is that "the unconscious is structured like a language." Verdiglione has also subtly altered Lacan's plea for a "return to Freud," speaking instead of the "return *of* Freud," as if he were promising a full-scale resurrection.

Yet Verdiglione's various publishing ventures, as well as the conferences he stages more and more frequently, testify to broader ambitions: specifically, to manipulate the apparatus through which the intellectual is threaded in our society. In a paper on "The New York Rendezvous," which appeared in the May *Spirali,* he observes that "in Italy, the gap is growing deeper between politicians and cultured man," and that "the last forty years have been determinant in the European establishment of a distinction between power, privilege of the right, and culture, prerogative of the left." Verdiglione has set out to redress this imbalance; the first step is to dissociate himself from politics: "It therefore seems necessary for Europe to abandon the ideological-focused debates and polemics of the sixties, to emphasize the effectuality of a discourse Intellectual is the style [sic]."

Which may be translated: replace Marx with Freud, politics with psychoanalysis. Scorning Marcuse's attempt to synthesize the two, Verdiglione would erect psychoanalysis as *the* master discipline of cultural analysis. It is no longer the operative science of the unconscious, as in Freud, but of culture at large, and all aspects of human endeavor—

political, economic, social, esthetic—are to be reinterpreted as functions of the unconscious. Verdiglione claims to have relocated the Freudian unconscious "within culture." Some view this as his central theoretical contribution; yet both the unconscious and psychoanalysis have thereby lost their specificity.

This massive rejection of politics and retreat into the psyche is not specific to the Lévy-Sollers-Verdiglione triumvirate; they have, however, been banking on it as "the wave of the future." (It was indeed ironic, then, that the conference was held exactly one week before the recent Socialist victory in France; determined to maintain their distance from popular opinion, European intellectuals have steadily gravitated to the right as the electorate has moved to the left.) Conservatism manifests itself today throughout European intellectual life, nowhere more conspicuously than in the rhetoric which proclaims a supposed renaissance of artistic practice in Europe. Thus, it was entirely appropriate that the art critic Achille Bonito Oliva—the principal advocate of the Italian neo-expressionists Chia, Cucchi, Clemente, Paladino, and Nicola De Maria—should have participated in "Sex and Language," although he had little to say about either subject. In his texts on these painters, recently issued in a trilingual edition, *The Italian Trans-avantgarde*, Oliva praises them precisely for having abandoned what he considers to be the hopeless political engagement of '60s artists and for having rediscovered art's true essence, which he defines as "the continuous digging inside the substance of painting." (This is not the place for an extended analysis of the politics of current Italian—and German—art practice and theory, which I reserve for a subsequent article.)

One of the most disturbing corollaries of Verdiglione's position—and it provided the subtext of "Sex and Language"—is a belief that politics can be reduced to sexuality and explained in exclusively sexual terms. During the conference I learned that the Movement plans to hold a similar meeting in Warsaw in the near future; the recent crisis in Poland must delight Verdiglione, who will doubtless exploit it as signifying the

Isaac Julien, Looking for Langston, *1989, film. Photograph © Sunil Gupta.*

failure of Marxism. The subject of the Warsaw congress? Sexuality, of course. When I asked one member of the Movement whether focusing on sexuality wasn't sidestepping the economic questions that haunt Polish politics, he responded with astonishment: "But the question of politics *is* the question of sexuality." This is one of the Movement's articles of faith.

What links Verdiglione, Sollers, and Lévy, then, is their preoccupation with power, which manifests itself in their rejection of the Left and the centrist impulse that motivates their thought. Power is the central theme of Lévy's books; in *Barbarism with a Human Face* (1977; English translation 1979, Harper & Row; Italian translation, 1977, edited by Armando Verdiglione) he proposes the recentering of all philosophy about the question of power. Significantly, the only discipline that escapes Lévy's sweeping rejection of the last hundred years of Western thought is psychoanalysis; "Freudianism," he writes, "can be seen as a political recourse, a means of escaping from the appearances of 'leftist' thought." Thus, he rejects Marx and Engels's account of the economic basis of power, accounting for it instead by an appeal to Freud's topology of mental functions: Power, he claims, comes into being like the super-ego.

The question of power, especially in its relation to sexuality, is not, however, specific to these three men; it is also addressed by the recent writings of Michel Foucault. Foucault's analysis of power has nothing to do with Lévy's; whereas Lévy is fascinated by power, Foucault attempts to unmask it. In the first volume of his projected six-volume series on "The History of Sexuality," he focuses on sexuality as a specifically discursive apparatus, engendered and regulated by power; thus, the New York conference occupied territory already marked off by Foucault. How significant, then, that among the many names dropped during the sessions, Foucault's was never mentioned.

This neglect was not surprising, however, for by locating Freud *and* psychoanalysis in terms of a broader historical development, Foucault represents the adversary position. This is how he describes his thesis, in an interview about *The Will to Know:*

> In the nineteenth century, an absolutely fundamental phenomenon made its appearance: the inter-weaving, the intrication of two great technologies of power: one which fabricated sexuality and the other which segregated madness. . . . There came into being a vast technology of the psyche, which became a characteristic feature of the nineteenth and twentieth centuries; it at once turned sex into the reality hidden behind rational consciousness and the sense to be decoded from madness, their common content, and

hence that which made it possible to adopt the same modalities for dealing with both.

Thus, Foucault traces the genealogy of the concept of sexuality, specifically of its identification as the origin and end of all human activity. He does this in order to prepare the way for something else; in the same interview, he remarks, "[We] believe that we are 'liberating' ourselves when we 'decode' all pleasure in terms of sex shorn at last of disguise, whereas one should aim instead at a desexualization, at a general economy of pleasure not based on sexual norms."

Similar positions did, in fact, emerge during the conference, although they were never explicitly linked with Foucault. Thus, Philippe Némo, a Lacanian analyst associated with the *nouveaux philosophes* but clearly ideologically distinct from them, spoke, in his "Two Readings of the *Song of Songs*," of "le devoir de jouir"—roughly, the obligation to come. He called for a deconstruction of the "emprise du sexe"—the ascendancy of sex—and its tendency to displace other values. Stuart Schneiderman also touched on this question in his paper on "Love," remarking that "one of mankind's greatest accomplishments is to have turned sex into a problem," and identifying language as a *barrier* to instinctual fulfillment. But it was Thomas Szasz, ridiculing the new "disease" invented by Masters and Johnson, "masturbatory sexual inadequacy"—the inability to achieve orgasm by masturbation—who did the most damage to the proceedings. Sexual behavior is sexual behavior, he asserted, and to assign clinically therapeutic or culturally liberating values to it is "unworthy of the human intellect."

There were a number of other noteworthy presentations which stood outside the overall polemical tone of the conference: Alan Bass's elucidation of the printing metaphor in Freud's presentation of his theory of transference; Alain Cohen's revelation of the strategic importance of "The Secret" in Freud's texts; Robert Ricard's positing of "The Counter-Subject." (Since papers were presented simultaneously in three rooms,

Jenny Holzer, Spectacolor Board, *1982*, *Times Square, New York City.*
Photograph © Lisa Kahane, courtesy Barbara Gladstone Gallery.

it was impossible to hear them all; however, it was reported that Jean Ellenstein's "State and Sexuality" and Jean-Toussaint Desanti's "The Body of Ideal Objects" were also provocative and worthwhile.) However, these contributions tended to get lost in the shuffle.

The participation of these speakers raises the crucial question of collaboration. When I asked one participant why he and so many others had accepted Verdiglione's invitation, he responded, "We're perfectly willing to be exploited by him, as long as we can exploit him in return." Certainly the conference provided many speakers with an otherwise unavailable audience and unprecedented degree of public attention. (It also provided European participants with round-trip tickets to New York—no small enticement.) Yet their appearances, while they may not signify approval, nevertheless lent credibility to an otherwise suspicious operation—a credibility Verdiglione can only borrow, since his own writings possess none.

The question of complicity is especially crucial in the case of artists, whose works are frequently exploited for purposes diametrically opposed to those for which they were made. While painters, sculptors, and photographers may have difficulty in controlling the expropriation of their works, performance artists do not. Although Trisha Brown's solo *Accumulation plus Water Motor and Furthermore*—in which she performs three dances while reciting two texts—remains a tour de force, even when presented as a lunchtime *divertissement* at the Plaza, one wonders whether Brown is aware of the ultimate purpose of the event to which she lent prestige. Verdiglione knows that his conquest of America depends upon the participation of American artists and intellectuals, who do not, however, need Verdiglione.

The Critic as Realist

"To justify its existence," Baudelaire wrote in his *Salon of 1846*, "criticism should be partial, passionate, and political, that is to say, written from an exclusive point of view." Few 20th-century critics fulfill this imperative better than Georg Lukács, whose lengthy career (from the mid-teens through the 1960s) was devoted to an extended meditation on the esthetics of realism from a Marxist perspective. Yet it is precisely Lukács partisanship, his politically motivated advocacy of realism and rejection of modernism, that has made him one of the century's most problematic critical figures. Still, Lukács's contribution to the modernism-realism debate commands attention, especially in the context of a special issue on realism in the visual arts.

Born in Hungary, Lukács spent most of his life in exile, first in Vienna, then in Berlin and Moscow, returning to Budapest only after World War II. He was perpetually engaged in internecine esthetic debates, and his pronouncements on realism invariably betray their polemical origins. His writing became increasingly dogmatic and inflexible as the century progressed; his wholesale condemnation of modernist art and literature as "decadent" and his endorsement of a Popular Front esthetic suggest conformism to a Stalinist party line. Yet it is clear that Lukács had laid the theoretical foundations for these positions long before they became official Soviet policy—which raises the question of his influence in shaping the regressive Soviet esthetic doctrines of the 1930s, the decade during which the *Essays on Realism* were composed.

Perhaps more than any other 20th-century figure, Lukács poses the problem of the relation of the intellectual to power; it is not surprising,

then, that the most trenchant attacks on him should have come from his Marxist colleagues—from Ernst Bloch, in the course of what has become a famous debate on the proto-fascist tendencies of German expressionism; from Bertolt Brecht, who charged Lukács with an implicit "formalism"; and perhaps most devastating from Theodor Adorno, the most articulate Marxist defender of esthetic and intellectual autonomy: "Lukács' person is above suspicion. But the conceptual framework to which he sacrifices the intellect is so narrow as to smother everything that needs to draw free breath to live." (All three critiques have been collected in the volume *Aesthetics and Politics,* published in 1977 by New Left Books.) More recently, a number of younger Marxist critics have launched attacks, in the pages of *Telos* and *New German Critique,* on the bureaucratic tenor of Lukács's thought, his tendency to impose critical imperatives on artistic practice from above.

Even Lukács's staunchest supporters—Marxist and non-Marxist alike—have found it necessary to distance themselves from his more extreme positions. Thus, Susan Sontag is compelled to absolve Lukács of his "moral fervor," while Fredric Jameson proposes that we "set aside that part of Lukács' work which constitutes a set of recommendations to the artist." (For an excellent summary of Lukács's thought, which cannot be attempted here, see the chapter on Lukács in Jameson's *Marxism and Form.*) Yet I believe that the moralistic, prescriptive tone of much of Lukács's criticism can be overlooked only at the risk of deforming its basic working premises.

The recent publication in English of the *Essays on Realism* (originally collected in a 1970 German-language edition), concerned as they are primarily with artistic practice in the 1930s, permits a more accurate view of Lukács's conception of the role of criticism than the more properly historical analyses contained in his *Studies in European Realism* and *The Theory of the Novel* (both available in English translation from the Merlin Press). And it is on Lukács's view of criticism, and its implications for artistic practice, that I want to focus in this brief notice, at the risk of oversimplifying his complex and often contradictory account of realism itself, and the problems that it raises. For what the *Essays on Realism* demonstrate is that Lukács conceived criticism above all as a form of political *activism,* intervening in and directly shaping the development of art. Although this activism was largely a product of the polemical atmosphere—first in Germany, then in the Soviet Union—in which these essays were composed, it is also theoretically grounded in Marx and Engels's notion of *praxis*—the unity of thought and action, of theory and practice. Today we have come to suspect *any* form of critical intervention

into artistic practice (largely because of the prescriptive tone of late-formalist criticism in America), with the result that serious critical activity has largely withdrawn from engagement with the production of art into history or "pure" theory. Given the noninterventionist policy of contemporary art criticism, the time has come, I believe, to reiterate Baudelaire's plea for critical commitment.

Lukács's commitment is apparent from the very beginning of *Essays on Realism*, in his considerations of the proletarian novels of worker-writer Willi Bredel and the antifascist novels of Ernst Ottwalt. His criticism of the technical deficiencies of both writers—specifically, their use of a reportage technique akin to the introduction of documentary materials into avant-garde Soviet film and graphics—met with extreme hostility within the German Communist Party. This reaction led him explicitly to formulate his critical position: "Criticism in itself . . . has just as valid a place in the division of labour of our proletarian revolutionary movement as does creative writing with its special allotted tasks. . . . In no way can it rest content with simply following critically in the wake of our writers; it must rather seek—with the aid of our whole inheritance—to comprehend the necessary developmental tendencies of the epoch, *independently, if need be,* and struggle for their realization, *when necessary even against the present practice of the writers themselves*" (italics added). This proposition indeed suggests that criticism may sometimes find it necessary to proceed in advance of art; but before we condemn this view of the critic's role as prescriptive or "bureaucratic," we should remember that both Diderot's plea for a genuinely dramatic as opposed to theatrical painting and Baudelaire's exhortation to artists to depict "the heroism of contemporary life" were realized only subsequently, in the works of David and Manet. Criticism thus conceived prescribes remedies for what it diagnoses as the deficiencies of contemporary art.

Thus, Lukács recommended realism as a corrective to what he saw as the increasing hegemony of modernist theories of "pure" art. By denying the work of art any practical function, such theories work to neutralize art's effectiveness as a weapon of social change (Adorno's view of the critical stance of the pure work of art notwithstanding). Lukács's advocacy of realism hinges upon its potential instrumentality: it was not only criticism, but art itself that had to become partisan, passionate, and political to justify its existence. In the essay "Tendency and Partisanship" Lukács demands of the artist precisely what he demands elsewhere of the critic: that he apply the lessons of historical materialism to artistic practice. Thus, "realism" is defined—rigorously, philosophically—in opposition to idealism. In Lukács's characterization, the idealist is con-

cerned primarily, if not exclusively, with subjective perceptions of reality rather than the tangible existence of the object of perception—and thus, following Kant, with the forms rather than the contents of consciousness. The realist avoids such formalism by focusing on the objective social and historical forces that shape both external reality and our perceptions of it. Depicting contemporary reality in all its complexity, the realist exposes the contradictions that traverse late capitalist society—contradictions which also traverse and structure any representation of it. Lukács's realism is thus not a static mode or style of depiction; although he clings to an essentially mimetic view of the work of art, he understands realism primarily as a dynamic process that reveals what we accept as natural and thus inevitable to be in fact historically constituted, and thus subject to dissolution. Viewed in this way, realism itself cannot transform the world (as so many modernist utopian programs for art proposed to do); rather, depicting reality as it appears from a materialist perspective, realism prepares the way for its transformation.

If the function of art is viewed in this way, then its criticism inherits a specific obligation: to unmask the residues of idealist philosophy that persist in even the most politically conscious works of art. Thus, Lukács analyzes not the artist's intention—which may be above reproach—but the "unconscious" aspect of his works. (In this sense, texts like Roland Barthes's *Mythologies,* and even much recent "deconstructive" criticism find themselves unwitting heirs to the Lukácsian tradition of ideological analysis.) Yet Lukács's unconscious has nothing whatsoever to do with the Freudian unconscious, which he dismisses as "irrationalist." Rather, Lukács's unconscious is constituted by the reproduction of the dominant, middle-class ideology in individual consciousness, and thus in works of art.

Lukacs's attack on modernism proceeds as an unmasking of its idealist base, manifested in what he characterizes as its excessive subjectivism, agnosticism, formalism, and irrationalism. Yet this rejection of modernism can only be understood as part of a larger effort to demystify artistic practice itself: works of art are no longer to be viewed as the unique products of isolated "genius," but as products of specific social and historical forces. Indeed, Lukács's advocacy of a politically motivated art and criticism violates one of the fundamental principles of Western esthetic theory: the demand for "disinterestedness" which, from Kant onward, has been said to be prerequisite to esthetic experience. Refusing as he does the neutral, contemplative stance which tradition requires of the critic, Lukács stands in direct opposition to the idealist imperative that the work of art be "without purpose." This is what I take to be the

central thrust of his entire critical enterprise, and it has not, I believe, been sufficiently emphasized by any of his commentators. Lukács's project ultimately calls for the dismantling of the entire edifice of Western esthetics and the way it works to isolate, neutralize, and domesticate the work of art. (Most Marxist esthetic theories, of course, repudiate the notion of disinterestedness, but few seem as radical in their ultimate implications as Lukács's.)

I would like to make two brief remarks in conclusion on the relevance of Lukács's *Essays on Realism* to the present. The first concerns the criticism—and the practice—of realism today. Even while proclaiming realism as a viable, often political alternative to modernism, the contemporary appreciation of realist art remains largely enmeshed within theoretical presuppositions specific to modernism. Two examples, one specific, the other general, will suffice: in the catalogue of the recent exhibition at Paris's Centre Beaubourg of early 20th-century realist art (see p. 74), Jean Clair proposes that the sudden perception of the strangeness of the familiar analyzed in Freud's text on "The Uncanny" lies at the heart of (at least one brand of) realism; but can this "uncanniness" be distinguished from the "defamiliarization" techniques advocated by the Russian *formalist* critics, and practiced by their avant-garde artist-counterparts? Second, most contemporary writing on realism consists of *esthetic* appreciation, manifested in an emphasis on the artist's (subjective) "vision" at the expense of the objective reality he depicts. Such appreciation casts realism as a predominantly perceptual mode of art; on what basis, then, can we distinguish between a "perceptual" realism and a "perceptual" modernism? As more and more of the defining characteristics of modernism are imputed to realism—in order, no doubt, to prove its continuing validity, its "modernity"—how long can the distinction between realist and modernist art be maintained? Lukács's rigorous distinction between the two—even in the face of a realist practice that he recognized to be gradually yet inexorably collapsing into its opposite—stands as a necessary corrective to the formalist misapprehensions that unconsciously persist in discussions of contemporary realism.

My second observation concerns the renewed urgency, in the wake of modernism's demise, of Lukács's attempt to release art from its esthetic ghetto and to re-place it in terms that have always been considered to be foreign to it. In recent years we have witnessed a proliferation of art works that deliberately stand outside the compass of the esthetic. Duchamp, of course, is the great precedent, but I would also include Warhol and Rauschenberg, Smithson and (certain works of) Serra, Bal-

dessari and Ruscha, Dan Graham and Yvonne Rainer, as well as a large number of currently emerging younger artists, in this development. Criticism's typical response to the work of such artists has largely been to recuperate it for esthetic experience, viewing their innovations in the tradition of modernist formal experimentation. At the same time, we are also witness to a widespread attempt to resurrect esthetic experience in the form of a distinctly expressionist mode of painting, which represents only nostalgia for our rapidly receding modernist past. In light of these phenomena, Lukács's criticism, especially his attack on expressionism, should be read as a tonic—whether or not we agree with his estimation of realism as the truly progressive art movement of the 20th century.

"The Indignity of Speaking for Others": An Imaginary Interview

Q: In *The Absolute Bourgeois,* a study of the relationship of art and politics in mid-19th-century France, Marxist art historian T. J. Clark writes, "The problem for a revolutionary artist in the nineteenth century—perhaps it is still the problem—was how to use the conditions of artistic production without being defined by them. How to make an art-work that would not stay on an easel, in a studio, in the Salon for a month, and then on the wall of a sitting-room in the Faubourg Saint-Germain? How to invent a means of artistic distribution to bypass the art market or exhibition? How to destroy the normal public for art, and invent another? How to make art 'popular'? How to exploit one's privacy, and the insights it allowed, and yet escape from it?" Do you believe, as Clark suggests, that this is still the problem?

A: Clark's argument derives primarily from Walter Benjamin's 1937 essay "The Author as Producer," in which he advocates the transformation of the forms and instruments of artistic production itself: Artists must not supply the existing productive apparatus without attempting to change it. This productivist position—itself derived from Brecht—is hardly unique to Benjamin. In our century most "revolutionary" proposals for the transformation of art into an arena of social and political action—from the Russian productivist manifesto through the unlimited textual productivity celebrated by the French *Tel Quel* group—have identified art as a *productive activity,* invariably opposing it to a "traditional" view of art as *representation.* It could in fact be demonstrated, from another perspective, that the ideology of production is identical with the ideology

259

of modernism, as both an esthetic and a social phenomenon. Thus Clark, writing in 1973 about the advent of modernism—that is, in the wake of its demise—merely reiterates one of its fundamental premises.

Q: Then the productivist argument cannot be applied to a "postmodernist" art?

A: The Clark/Benjamin position has much to recommend it, especially today, when an artist can achieve easy success simply by accepting established modes of artistic production—easel painting, for example. Still, I would contend that the last group of artists to which the productivist argument applies emerged in the late 1960s, constituting what was known as the post-studio movement. In an attempt to counteract those forces which work to alienate artists from their production, post-studio artists either withdrew from the studio-gallery-museum power nexus, which administers the discourse of art in our society, or they attempted to subvert this nexus from within, addressing the invisible mechanisms which define art in our society. Yet by the mid-'70s the post-studio movement appeared to have lost much of its momentum: ephemeral and site-specific works had been effectively reinserted into the circuits of commercial distribution and exchange via photography; and artists who attempted to maneuver within institutional precincts seemed ultimately to confirm the (liberal-democratic myth of the) elasticity of those institutions—their ability to tolerate even their own most hostile opposition.

It was at this point that a new group of artists emerged, concerned with power less as it is vested in art-world institutions, and more as it is diffused throughout society. Significantly, at roughly the same time, Jean Baudrillard began publishing a series of extremely trenchant critiques of productivist ideology, arguing that power is no longer exercised exclusively or even primarily through control of the means of production, but through control of the means of representation—the code. What was needed, then, was a critique of representation—but one free from a productivist bias. And it was such a critique that this new group of artists set out to provide.

Q: Would you identify this shift from modernism to postmodernism with a broader shift from industrial to postindustrial society, from a society of production to one of information?

A: I do believe that we have witnessed a profound cultural shift in recent years. However, as Ernst Mandel observes, far from constituting a post-

industrial society, ours is the first society in which all sectors of the economy have been fully industrialized.

Q: And yet you would seem to reject a Marxist account of that shift in terms of the forces and relations of production. Why?

A: Because Marxism lacks an adequate theory of representation. (Louis Althusser's belated attempt to provide it with one tends to collapse representation into ideology.) This deficiency can be traced to the writings of Marx himself, specifically, to his implicit representational conception of his own discourse. For example, there is a celebrated passage in the *Eighteenth Brumaire* in which Marx describes the lack of class consciousness of the small-holding peasants in France (significantly, the same group that Courbet represented in the *Burial at Ornans,* which Clark discusses at length). This passage concludes with the famous remark, "They cannot represent themselves, they must be represented." Now this is exactly what Marx himself—not to mention Courbet—set out to do: his self-appointed task was to represent the interests of those whom he presumed to be incapable of representing themselves (just as he presumed that the State necessarily represents the interests of the ruling class). Here, Marx uncritically assumes the traditional role of politically motivated intellectual—or artist—in bourgeois society: he appropriates for himself the right to speak on behalf of others, setting himself up as their conscience—indeed, as consciousness itself. But in order to occupy this position, he must first deny them (self-) consciousness, the ability to represent themselves. In other words, Marx overlooks the constitutive role of his own discourse, which is held to be merely representing—and representative.

Q: What you are saying, then, is that to represent is to subjugate.

A: Precisely. There is a remarkable statement by Gilles Deleuze in a 1972 interview with Michel Foucault that encapsulates the political ramifica-

Renee Green, Sites of Genealogy *(detail:* Loophole of Retreat*), 1991.*
Courtesy Pat Hearn Gallery.

tions of the contemporary critique of representation: "In my opinion," Deleuze remarks, "you were the first . . . to teach us something absolutely fundamental: the indignity of speaking for others."

Q: Certainly the writings of Deleuze and Foucault—as well as those of Roland Barthes, Jacques Derrida, and others—have worked to problematize the activity of representation. But to what extent have their texts influenced contemporary artists?

A: Very little, I'm afraid. The issue of the politics of representation has been placed on the agenda of contemporary art, I would contend, by a specifically feminist consciousness. In recent years there has emerged a group of artists—most of them women, but not all, since the issues concern men as well as women—whose work is addressed to the question of representation and sexuality. (As Jacques Lacan remarks, "Images and symbols for the woman cannot be separated from images and symbols of the woman. . . . It is representation, . . . the representation of feminine sexuality, whether repressed or not, that determines how it comes into play.") These artists do not reduce all politics to sexuality; they do argue, however, that sexual inequality and domination cannot be explained exclusively in terms of economic exploitation—the exchange of women among men—but that it is primarily an effect of representation.

In our culture there is, of course, no lack of representations of women—or, for that matter, of other marginalized groups (blacks, homosexuals, children, criminals, the insane . . .). However, it is precisely in being represented by the dominant culture that these groups have been rendered absences within it. Thus, it is not the ideological content of representations of these Others that is at issue. Nor do contemporary artists oppose their own representations to existing ones; they do not subscribe to the phallacy of the positive image. (To do so would be to oppose some "true" representivity to a "false" one.) Rather, these artists challenge the activity of representation itself which, by denying them speech, consciousness, the ability to represent themselves, stands indicted as the primary agent of their domination.

The Problem with Puerilism

The history of modernism can be read (and recently it has been) as a series of unequal exchanges between the culture industry and the various urban subcultures which come into existence on the margins of, and resist assimilation into, controlled social life—exchanges mediated by the avant-garde.[1] The recent establishment of a culture-industry outpost in Manhattan's East Village—a neighborhood of multiple racial and ethnic, deviant and delinquent subcultures—is the latest episode in that history. An attempt magically to resolve a classic overproduction crisis (overproduction *by* artists, overproduction *of* artists), this sudden expansion of the market is also a textbook case in modern cultural economy; as such, it can be analyzed differently than it has been in the preceding pages. ["Slouching Toward Avenue D: Report from the East Village," by Walter Robinson and Carlo McCormick, *Art in America* (Summer 1984), 135–61.]

What has been constructed in the East Village is a simulacrum of the *social* formation from which the modernist avant-garde first emerged: I am referring, of course, to *la bohème*, the milieu in which exchange between high and low sectors of the cultural economy takes place. By the mid-19th century, the progressive marginalization of the artistic profession, and the erosion of artists' social and financial standing which this marginalization frequently entailed, had resulted in loose, shifting alliances between artists and other social groups—the ragpickers, streetwalkers and street entertainers, etc., who appear in the poetry of Baudelaire, the paintings of Courbet, Manet, Daumier, etc. From the very beginning, however, the avant-garde's relation to subcultural types was

ambivalent; hence, its celebrated irony—Baudelaire's recommendation that beggars wear gloves—which allowed contradictory attitudes to exist side by side.

Avant-garde irony was not, of course, reserved for the underclasses, but was often turned on the bourgeoisie as well; in either case, what it expresses is the avant-garde's intermediary position between the two. As Stuart Hall, who has written extensively on the politics of subcultural formations, observes, "The bohemian subculture of the *avant-garde* that has arisen from time to time in the modern city, is both distinct from its 'parent' culture (the urban culture of the middle class intelligentsia) and yet also a part of it (sharing with it a modernising outlook, standards of education, a privileged relation vis-à-vis productive labour, and so on)."[2] The fact that avant-garde artists had only partially withdrawn from the middle-class elite—which also constitutes the primary, if not the only, audience for avant-garde production—placed them in a contradictory position; but this position also equipped them for the economic function they would eventually be called upon to perform—that of broker between the culture industry and subcultures.

Subcultures demonstrate an extraordinary ability to improvise, out of the materials of consumer culture, ad hoc cultural forms which function as markers of both (group) identity and (cultural) difference. (Hall: Subcultures "adopt and adapt material objects—goods and possessions—and reorganize them into distinctive 'styles' which express the collectivity of their being-as-a-group.") Grounded in concrete social practices, these "styles" offer an alternative to the sterility of museum culture, and have periodically been appropriated as such by the avant-garde. Here is an (extremely condensed) description of this process:

> Improvised [subcultural] forms are usually first made saleable by the artisan-level entrepreneurs who spring up in and around any active subculture. Through their efforts, a wider circle of consumers gains access to an alluring subcultural pose, but in a more detached and shallow form as the elements of the original style are removed from the context of subtle ritual which had first informed them. At this point, it appears to the large fashion and entertainment concerns as a promising trend. Components of an already diluted stylistic complex are selected out, adapted to the demands of mass manufacture, and pushed to the last job-lot and bargain counter.[3]

Thus, thanks to the "pioneering" efforts of the avant-garde, difference first becomes an object of consumption.

Within the last few years in New York we have witnessed a series of isolated attempts to begin this process again: the reconsolidation of SoHo around established high-art traditions has propelled young, sometimes radical artists out to new marginal locations—the South Bronx, an abandoned massage parlor just south of Times Square—where they have regrouped with new subcultural recruits. The recent centralization of this tendency in the East Village provides it with both a geographic and, more importantly, an economic base, a network of artist-run commercial galleries established specifically for the marketing of subcultural productions (graffiti, cartooning, and other vernacular expressions) or puerile imitations of them. (The youth of the new avant- or, rather, "enfant-garde" indicates that Youth itself has become an important subcultural category.) The prevalence of subcultural models in contemporary "avant-garde" production—both the "new" British sculpture and the French *figuration libre,* to cite but two examples, are entirely dependent upon them—suggests that this is a global, rather than local, phenomenon; but it also documents the importance of subcultural appropriation in the maintenance of a global cultural economy.

If we regard the East Village art "scene" as an economic, rather than esthetic, development, we can account for the one characteristic of that "scene" which seems to contradict more conventional notions of avant-garde activity. I am referring to the surrender, by the East Village artist-entrepreneurs, to the means-end rationality of the marketplace: "Paintings are doorways to collector's [sic] homes," one East Village painter proclaims in a recent interview, no doubt hoping his candor will be mistaken for cynicism. Despite attempts to fabricate a genealogy for the artist-run galleries of the East Village in the alternative-space movement of the '70s, what has been constructed in the East Village is not an alternative to, but a miniature replica of, the contemporary art market—a kind of Junior Achievement for young culture-industrialists.

Even this aspect of the "scene" is familiar: it repeats Warhol's open acknowledgment of the marketability of an alluring avant-garde pose— a pose created, moreover, through affiliation with a variety of deviant and delinquent subcultural types. (Recently, an East Village artist staged a simulacrum of the Factory—itself a simulated Bohemia—thereby confirming Warhol's precedence.) Whether ironic or not, Warhol's acquiescence to the logic of the culture industry—his transformation of the studio into a Factory, his adoption of the techniques of serialized production, etc.—stands as a pivotal moment in the history of the avant-garde, the point at which its function in the mechanisms of cultural

economy first became visible. (Without Warhol, the above analysis of the avant-garde would not have been possible.) By destroying the avant-garde's pretense to autonomy, Warhol has left subsequent "avant-gardes" two alternatives: either they openly acknowledge their economic role—the alternative pursued by the East Village "avant-garde"—or they actively work to dislodge an entrenched, institutionalized avant-garde production model.

If Warhol exposed the implication of the avant-garde in cultural economy in general, the East Village demonstrates the implication of that economy in broader social and political processes. For this expansion of the market also participates in the ongoing "Manhattanization" of New York—the uprooting and displacement, by a coalition of city politicians (headed by the mayor) and real-estate speculators, of the city's subcultural populations, and their replacement with a young, upwardly mobile professional class. Artists are not, of course, responsible for "gentrification"; they are often its victims, as the closing of any number of East Village galleries, forced out of the area by rents they helped to inflate, will sooner or later demonstrate. Artists can, however, work within the community to call attention to, and mobilize resistance against, the political and economic interests which East Village art serves.

The East Village is not only a local phenomenon, but also a global symptom. Exhibitions of East Village art have been mounted as far afield as Amsterdam; its reception in the European and, now, the American art press has been ecstatic. An all too familiar reaction to the increasing homogenization, standardization, rigidification of contemporary social life, this reception is yet another manifestation of what Jacques Attali describes as our "anxious search for lost differences within a logic from which difference itself has been excluded."[4] Searching for lost difference has become the primary activity of the contemporary avant-garde. But as it seeks out and develops more and more resistant areas of social life for mass-cultural consumption, the avant-garde only intensifies the condition it attempts to alleviate. The appropriation of the forms whereby subcultures resist assimilation is part of, rather than an antidote to, the general leveling of real sexual, regional, and cultural differences and their replacement with the culture industry's artificial, mass-produced, generic signifiers for "Difference"—in the present instance, the empty diversity and puerilism of the East Village "avant-garde."

NOTES

1. See Thomas Crow, "Modernism and Mass Culture in the Visual Arts," in *Modernism and Modernity*, ed. Buchloh, Guilbaut, and Solkin (Halifax: The Press of the Nova Scotia College of Art and Design, 1983), 215–64. Although I would argue with Crow's tendency to treat the modernist avant-garde *as* a resistant subculture, the following treatment of culture-industry-subcultural relations is indebted to his.

2. Hall and Jefferson, eds., *Resistance through Rituals* (London: 1976), 13. Also cited in Crow, "Modernism and Mass Culture," 259.

3. Crow, "Modernism and Mass Culture," 252. For a more complex analysis of these mechanisms, Crow's entire section VIII (251–55) should be consulted.

4. Jacques Attali, "Introduction to *Bruits*," *Social Text* 7 (Spring/Summer 1983), 7.

Analysis Logical and Ideological

"Can it be argued," Rosalind Krauss asks at the beginning of her introduction to this collection of essays [*The Originality of the Avant-Garde and Other Modernist Myths*] written between 1976 and 1984 and published primarily in the journal *October,* "that the interest of critical writing lies almost entirely in its method? Can it be held that the content of any given evaluative statement—'this is good, important,' 'this is bad, trivial'—is not what serious criticism is, seriously, read for? But rather, that such criticism is understood through the forms of its arguments, through the way that its method, in the process of constituting the object of criticism, exposes to view those choices that precede and predetermine any act of judgment?" (p. 1). With this series of rhetorical questions, Krauss not only establishes the seriousness of her own critical practice; she also claims for herself a position on the front line of the critical avant-garde. For *The Originality of the Avant-Garde and Other Modernist Myths* is presented as a contribution to the ongoing project, initiated in the mid-1970s, of reconsidering not only the avant-garde (in this case, the "myths" that sustained modernist practice, the "myth" of originality in particular) but criticism as well, specifically, its complex social role as arbiter of taste and producer of (cultural) value. Thus, Krauss distances her present "demythologizing" criticism from formalism precisely according to the issue of value: referring to the normative criticism of Clement Greenberg (under whose aegis Krauss first entered the critical arena), she writes, "[Greenberg] would argue that the point of criticism has everything to do with value and almost nothing to do with method. Practically everything in *The Originality of the Avant-Garde . . .* stands in contradiction to this position" (p. 2).

However, Krauss's initial break with Greenberg was motivated less by methodological differences than by her disagreement with his (and Michael Fried's) assessment of the *value* of minimal (and, somewhat belatedly, pop) art. Informed by phenomenology (Merleau-Ponty in particular) and late Wittgenstein, Krauss's essays on minimalism, published in the late '6os and early '70s primarily in *Artforum,* were among the first to recognize and articulate the movement's theoretical value; they simultaneously established Krauss as an independent critical voice, as well as her reputation as a prominent member of the critical vanguard. Although there is little in the present collection to suggest that Krauss has reconsidered either minimalist production or her own position on it, *The Originality of the Avant-Garde* represents a further advance in her critical career, for these essays are informed by certain more or less recent developments in continental theory—namely, "structuralism, with its later poststructuralist modifications," as she writes in the introduction (p. 2)—which have explicitly repudiated the phenomenological argument on which her previous work rested. And it is on the basis of her embrace of the structuralist contention that cultural production is primarily a matter of codes and conventions, rather than of such discredited concepts as "intentionality," "originality," "subjectivity," etc., that Krauss claims not only membership in the critical avant-garde, but also to represent it: "Written during the decade from 1973 to 1983, these essays chart not only my own critical and intellectual development but that of a generation of American critics, although I must add, not for the most part critics concerned with the visual arts" (p. 2).

Although it could be argued that the "conventional attitude" (to borrow a phrase from Norman Bryson) endorsed by structuralism is in fact the ideology of late capitalist, consumer society—an argument that would account for the widespread conventionalism of contemporary art—nevertheless, my primary concern in this review is not to evaluate Krauss's claim to a vanguard position. Instead, I will argue that, in claiming such a position, Krauss overlooks the *ideological* function of the modernist "myths" she unmasks and, further, that her effort to detach criticism from evaluation constitutes a disavowal of the ideological process. Throughout, my remarks should be taken as applying principally to the critical vanguard Krauss claims to represent, as well as to the theoretical vanguardism of this particular collection of essays.

Reconsidering the avant-garde and reconsidering criticism's evaluative function are not unrelated projects; in fact, one entails the other. At least this is the argument of Peter Bürger's *Theory of the Avant-Garde*

(1974), arguably the most significant contribution to date to this double agenda. Criticism, Bürger maintains, must abandon the normative evaluation of art works (or movements) in favor of a "functional" analysis; thus, he advocates a displacement of critical attention from individual works of art to their institutional frame. Bürger regards this displacement as a historical consequence of (the failure of) the avant-garde: If the historical avant-garde movements of the '20s and '30s were unsuccessful in destroying the institutional status of art in bourgeois society and of reintegrating artistic into social practice, nevertheless they did destroy, Bürger contends, "the possibility of positing aesthetic norms as valid ones. This had consequences," he continues, "for scholarly dealings with works of art: the normative examination is replaced by a functional analysis, the object of whose investigation would be the social effect (function) of a work of art, which is the result of a coming together of stimuli inside the work and a sociologically definable public within an already existing institutional frame."

Although Krauss maintains that recent developments within criticism itself compel a reconsideration of the avant-garde and not, as Bürger proposes, the reverse, nevertheless she issues a Bürgeresque call to her colleagues to attend to the frame: in the essay "Sincerely Yours" she writes, "The notion of the painting as a function of the frame (and not the reverse) tends to shift our focus from being exclusively, singularly, riveted on the interior field. Our focus must begin to dilate, to spread" (p. 191). And in "Photography's Discursive Spaces" she offers an example of how this expanded critical focus indeed challenges (a particular) modernist myth: in this essay Krauss demonstrates that the flatness celebrated by formalism as a sign of painting's autonomy is actually a sign of its institutional dependency, the product of a historical development in which works of art "began to internalize the space of exhibition—the [gallery] wall—and to represent it." Thus, the "synonymy of landscape and wall" in Monet's *Nymphéas* is reinterpreted as "an advanced moment in a series of operations in which aesthetic discourse resolves itself around a representation of the very space that grounds it institutionally" (p. 133).

Krauss, however, deals with such conditions of exhibition only insofar as they are (presumably unconsciously) absorbed and represented by individual works of art. Despite her assertion, at the conclusion of the collection's title essay, of a functional correspondence between "a demythologizing criticism and a truly postmodernist art, both of them acting now to void the basic propositions of modernism" (p. 170), nowhere in her treatment of postmodernist production does she acknowledge the

work of those contemporary artists who have in fact engaged in a functional analysis of the institutional frame (Broodthaers, Buren, Asher, Haacke, Lawler, etc.). And while Bürger's argument can be (but is not always) interpreted as an exhortation to critics to abandon their institutionally sanctioned positions as arbiters of taste, and to examine instead the mechanisms which are productive of cultural value (beginning with criticism itself), nowhere in these essays does Krauss admit that criticism, including her own, might also be institutionally determined. In fact, two of the essays reprinted here—"Grids" and "This New Art: To Draw in Space" (on Gonzalez)—were originally commissioned by a commercial gallery (Pace); Krauss has also included her contribution to the Museum of Modern Art's scandalous hymn to the imperialist project, "'Primitivism' in 20th-Century Art."

Krauss's arguments are ultimately concerned less with institutions themselves than with well-placed scholars and critics within them. At least half the essays reprinted here proceed as debates with prominent practitioners of the discipline of art (and literary) history. Here is a (partial) list: William Rubin, John Richardson, Linda Nochlin, Robert Rosenblum, Pierre Daix ("In the Name of Picasso"); Rubin again ("The Photographic Conditions of Surrealism"); John Szarkowski and Peter Galassi ("Photography's Discursive Spaces"); E. A. Carmean, Jr. ("Reading Jackson Pollock, Abstractly"); Donald Kuspit, Suzi Gablik, Lucy Lippard ("LeWitt in Progress"); Morris Dickstein ("Poststructuralism and the Paraliterary")—not to mention a peculiarly bitter exchange with Albert Elsen over the posthumous casting of Rodin's *Gates of Hell*, "Sincerely Yours." To be sure, Krauss's debates with her colleagues are *not* concerned with the value of avant-garde works of art, which is in all cases presupposed: despite her desire to detach criticism from evaluation, she continues to speak of such things as the "extraordinary contribution of collage" (p. 34) and the "profound originality" of Giacometti's horizontal "gameboard" sculptures (p. 73), as well as to characterize Gonzalez's work from the '30s as "an almost unbroken chain of masterpieces" (p. 121). Rather, referring in her introduction to the "extremely polemical" tone of "Sincerely Yours," she attributes what she herself describes as her "often combative posture" primarily to methodological differences: "Perhaps," she writes, "it is the sweeping nature of the difference in our methodological bases—a difference that makes some of the questions raised by this work flatly incomprehensible to certain of my colleagues—that has encouraged that posture" (p. 5). Still, whether they are concerned with the value of works of art or with critical method,

such debates are academic: that is, they invariably take place within institutionally prescribed limits.

Not surprisingly, the lack of understanding Krauss invokes turns out to be mutual. If in her introduction she claims that the questions raised by her work may be "flatly incomprehensible" to certain of her colleagues, elsewhere she professes her inability to understand *them*: thus, "Photography's Discursive Spaces" concludes, "Everywhere at present there is an attempt to dismantle the photographic archive—the set of practices, institutions, and relationships to which nineteenth-century photography originally belonged—and to reassemble it within the categories previously constituted by art and its history. It is not hard to conceive of what the inducements for so doing are, but it is more difficult to understand the tolerance for the kind of incoherence it produces" (p. 150).

When she displaces analysis of the dismantling of the photographic archive from its (presumably economic) inducements to the "tolerance for the kind of incoherence it produces," Krauss signals the necessity for an *ideological* analysis of this phenomenon. Yet in claiming to be unable to understand that tolerance, she immediately withdraws the possibility of such analysis. (Remember that these are the essay's concluding words.) Which is what I find simultaneously stimulating and frustrating about these essays: Krauss repeatedly deploys her formidable intellectual arsenal in order to expose precisely those moments of incoherence or contradiction where ideology manifests itself. Yet because her arsenal lacks an articulated notion of ideology as larger than, and yet dependent upon, the concepts of individual consciousness and will, her essays tend to degenerate into (to borrow a phrase from Gayatri Spivak) "tirade[s] against the folly or knavery of practitioners of the discipline" of art history.

In this respect, *The Originality of the Avant-Garde* is reminiscent of the sixteenth number of *October*, a special issue edited by Krauss, titled "Art World Follies, 1981," and dedicated (according to an editorial preface) "to knaves and fools, with an emphasis on the latter." Claiming that "foolishness has become the medium through which almost every transaction in the art world is conducted," the editors attributed what was in fact a massive shift in the cultural economy to the mental deficiency or incompetence of individual subjects. Thus, the art-world institutions through which that shift was implemented were short-circuited, even though the editors identified a bypassing of institutions as one of the symptoms of the current outbreak of "foolishness": "The institutions that formerly generated the discourse through which modern art was

publicly interrogated, examined, and, if possible, understood—the museum, the university, the critical journal—...are now bypassed to make way for the process of consumption of quite another kind." What is a reader to do with this apparent endorsement of these institutions, or with the implausible suggestion that the entire art world (with the exception of a few enclaves, such as that occupied by *October*) had suddenly succumbed to an epidemic of "foolishness"? Had the editors attended to the ideological determinations of the phenomena they discussed, they might have avoided such untenable positions, and moved beyond denunciation (of foolishness) to critique (of ideology). (As Marx demonstrated in *The German Ideology*—which remains the model for all subsequent ideological analysis—critique does not denounce ideology as false but articulates the displaced or inverted truth it expresses.)

Stuart Hall has compiled a list of concepts which have done duty, in American social theory, for an absent concept of ideology—norms, "values," the "central value system"—to which Spivak has added a prepsychoanalytic concept of the unconscious "as a continuous and homogeneous part of the mind that is simply 'not conscious.'" *The Originality of the Avant-Garde and Other Modernist Myths* allows another term to be added to this list, for in these essays the empty place of ideology is occupied by the term "myth." Krauss's concept of myth is derived from Claude Lévi-Strauss's functional definition: "The purpose of myth," he wrote in "The Structural Study of Myth," "is to provide a logical model capable of overcoming a contradiction—an impossible achievement if, as it happens, the contradiction is a real one." However, in her paraphrase of Lévi-Strauss's definition, Krauss makes one inadvertent yet significant amendment. In the essay "Grids," written in 1978 and reprinted as the first essay in the collection (presumably because it both introduces the structuralist definition of myth as well as Krauss's method of unmasking it) she writes, "The function of the myth is to allow *both* views to be held in some kind of paralogical suspension" (p. 13). What Lévi-Strauss regarded as a *logical* model—no doubt because of his (ideologically overdetermined) attempt to disavow the difference between "primitive" and "scientific" thought—Krauss treats as *para-*, but not ideo-, logical, thereby reinstating the logic/myth opposition which Lévi-Strauss sought to dissolve.

Treating the cultural products of advanced industrial nations as some kind of high-tech *pensée sauvage* is an ideological gesture with determinable consequences; Krauss, however, unquestioningly deploys her modified structuralist model in order to expose the cultural contradiction the

modernist grid would "paper over." Positioning the grid at the inter-
section of "materialism" and "spiritualism"—"The grid's mythic power,"
Krauss writes, "is that it makes us able to think that we are dealing with
materialism (or sometimes science, or logic) while at the same time it pro-
vides us with a release into belief (or illusion, or fiction)" (p. 12)—she
argues that the grid "allows a contradiction between the values of science
and those of spiritualism to maintain themselves within the conscious-
ness of modernism, or rather its unconscious, as something repressed"
(p. 13). Here, the unconscious stands in for ideology; still, Krauss's use
of a psychoanalytic vocabulary suggests the essentially fetishistic charac-
ter of the operation she is describing. (Freud analyzed the fetish-object
as a compromise between fact and belief: I will return to the issue of
fetishism in my conclusion.)

Having discovered this operation in the collection's first essay, in the
essays that follow Krauss proceeds to uncover it everywhere within mod-
ernism. In a single sentence, she locates it in both Pollock and Mondrian:
"The great Pollocks, like the great Mondrians, operate through a struc-
ture of oppositions: line as opposed to color, contour as opposed to field,
matter as opposed to the incorporeal. The subject that then emerges
is the provisional unity of the identity of opposites" (p. 239). (Defining
Pollock's "subject" as "the operation of an abstract logic," she writes,
"There is nothing 'formalist' about this ambition"; but what is formal-
ism's subject if not the operation of an abstract logic?) She discovers it
in surrealism, specifically, in "the many antinomies that Breton speaks
of wanting surrealism to dissolve in the higher synthesis of a surreality"
(p. 94). She finds it in Georges Bataille's "anatomical geography," accord-
ing to which she maps Giacometti's ninety-degree rotation of the ver-
tical axis (which "emblematizes man's pretensions toward the elevated,
the spiritual, the ideal") onto the horizontal ("the mud of the real"
[p. 80]). She locates it in Gonzalez's writings: "The aesthetic battle lines
of the 1920s and '30s were drawn through the mimetic/abstract axis.
But further, these terms were understood as fronts for another set of
terms, namely matter and spirit. . . . Gonzalez was, intellectually, a crea-
ture of his time, and when setting out to verbalize his aesthetic invention,
he used the current terms of the debate" (p. 126). And so on. Thus, de-
spite Krauss's claim that these essays chart her critical and intellectual
development, her remarks, in "The Originality of the Avant-Garde," on
the *anti*-developmental nature of the grid would seem more to the point:
"When we examine the careers of those artists who have been most
committed to the grid, we could say that from the time they submit

themselves to this structure, their work virtually ceases to develop and becomes involved, instead, in repetition" (p. 160).

One problem with Krauss's treatment of "modernist myth" is its lack of historical specificity: as Heidegger wrote in "The Origin of the Work of Art," the matter/spirit opposition has provided the "conceptual schema" according to which the work of art has been defined ever since classical antiquity. Another problem is Krauss's refusal to recognize the fully ideological character of the operation she describes. When Kant positioned the esthetic midway between the practical and the theoretical branches of philosophy, defining esthetic judgment as the intermediary between judgments of fact and value judgments, he effectively assigned art the ideological task of proposing that the contradictory values or interests that traverse bourgeois society can achieve, if not a genuine (re)conciliation, at least some form of coexistence or compromise. (Hence, the premium placed on "harmony," "proportion," "unity" in neoclassical esthetics, as well as on "dissonance," "disproportion," "fragmentation" in romanticism.) As Franco Moretti proposes in *Signs Taken for Wonders* (1983), Kant's purpose was "to heal the laceration resulting from the 'disillusionment' created by the natural sciences, from which the separation between judgments of fact and value judgments stemmed." To be sure, Krauss also attributes the "rift between the sacred and the secular" to "science" (p. 12); but her only discussion of this rift in social as opposed to esthetic terms consists of a brief citation of the popular 1950s Broadway vulgarization of the Scopes trial, *Inherit the Wind.* Moreover, by characterizing this split as "a contradiction between the values of science and those of spiritualism," she ignores the ideology of the value-free nature of scientific inquiry. For what Kant's definition in fact presupposes is a society in which (as Moretti writes) "existence is split between a sphere where cultural values are everything and a sphere where they have no legitimacy at all," and a cultural system that regards permanent "conflict as a given fact of existence in society." The historical specificity of Moretti's argument allows him to understand what might otherwise remain flatly incomprehensible: "While capitalist society," he writes, "is unthinkable without the scientific and technical progress reflected in the separation of intellect and morality, it is equally unthinkable without the incessant attempt to annul the separation and remedy it, an attempt to which the extraordinary and apparently inexplicable proliferation of aesthetic activities that distinguishes capitalism bears witness."

Which obliges us to reconsider our prejudice that modernism and bourgeois society were at odds; however, this is one "modernist myth" that Krauss seems determined *not* to unmask, even though at times she comes close to recognizing what this "myth" actually entails. For example, in her contribution to the "'Primitivism'" catalogue, "No More Play," she articulates the subtext of Giacometti's *Spoon Woman*: "By taking the metaphor and inverting it, so that 'a spoon is like a woman' becomes 'a woman is like a spoon,' Giacometti was able to intensify the idea, and to universalize it by generalizing the forms of the sometimes naturalistic African carvings toward a more prismatic abstraction. In forcing on the Dan model the image of the woman *who is almost nothing but womb*, Giacometti assimilated the formal elegance of the African object to the more brutish conception of stone-age fertility Venuses." At this point, readers might well expect some evaluation of the "myth" of the biological woman that underpins Giacometti's "formal" maneuver; here is what immediately follows in Krauss's text: "With this celebration of the *primal function of woman* as seen through a primitivized formal logic, Giacometti had assumed the most vanguard of positions. He found himself in concert with the aggressive anti-Western stance of the visual avant-garde" (pp. 48–49, italics added).

Krauss has undoubtedly articulated something absolutely fundamental about the avant-garde: its misogyny—the price, perhaps, at which a vanguard position was purchased. At moments like these, when ideology surfaces in the modernist text, criticism is confronted with the urgent need not simply of demystifying, but of *reevaluating* the avant-garde; as Roland Barthes wrote in 1971, reviewing his own demythologizing criticism of the 1950s, "If the alienation of society still demands the demystification of languages (and notably the language of myths), the direction this combat must take is not, is no longer, that of critical decipherment but that of *evaluation*" (Barthes's italics). Moreover, the notion that the avant-garde's was an "aggressive anti-Western stance"—a received idea recycled in Krauss's text—has been refuted in much recent work on First-Third World relations (I will cite only Gayatri Spivak's statement, "The precondition for the avant-garde is the disavowal of the scandal named 'Imperialism'").

A critical view of ideology might also have led Krauss to question her own intolerance for incoherence, as well as her exclusive attachment to logical (rather than rhetorical) analysis. Although she recognizes that "structuralism, . . . in allowing one to think the relationships between heterogeneous integers, permitted release from notions of stylistic coherence or formal consistency" (p. 5), and while she rejects art-historical

attempts to bestow a spurious unity on the careers of Atget or Giaco-
metti, nevertheless her procedure throughout these essays is to produce
coherence out of incoherence, unity out of diversity. In "The Photo-
graphic Conditions of Surrealism," for example, she sets out to demon-
strate "what unites *all* surrealist production" (p. 115). After a brief in-
troductory invocation of Wölfflinian comparative method ("fashioned
to net the illusive historical beast called style" [p. 91]), she proceeds to
William Rubin's prior attempt to produce an "*intrinsic* definition of sur-
realist painting"—a definition Rubin claims to be the "first such defini-
tion ever produced." As if to dramatize the thesis of the collection's title
essay (that the avant-garde's claim to absolute originality was predicated
upon a ground of repetition and recurrence), Krauss first demonstrates
that Rubin's definition merely repeats André Breton's 1925 definition
of surrealist painting as organized around two poles—"automatism and
dream"—and then proceeds to disqualify this as a definition: "If one
wishes to produce a synthesis between A and B," she writes, "it is not
enough simply to say, 'A plus B.' A synthesis is rather different from a
list" (p. 92). She then diagnoses Breton's (and therefore Rubin's) failure
as a "failure to *think* the formal heterogeneity of Miró and Magritte into
something like stylistic unity. . . . Attempting to define surrealism, Bre-
ton produces instead a series of contradictions which . . . strike one as
being irreducible" (p. 93).

What is at issue here is *not*, as might have been expected from a critic
influenced by poststructuralism, Breton's (or Rubin's) desire for unity,
coherence, noncontradiction, but rather his (their) failure to produce
such unity—a failure Krauss attributes to an allegiance to traditional
art-historical notions of style. "Issues of surrealist heterogeneity," she
proposes, "will be resolved around the semiological functions of pho-
tography rather than the formal properties operating the traditional
art-historical classifications of style. What is at stake, then, is the reloca-
tion of photography from its eccentric position relative to surrealism to
one that is absolutely central—definitive, one might say" (p. 101). One
wonders what Derrida, whose concept of "spacing" Krauss employs in
this text, would have to say about the invocation of his project of *de-
centering* Western metaphysics in support of an art-historical project of
recentering, or about Krauss's footnote reference to his *Of Grammatology*
as a "seminal text" (p. 91). After all, it is thanks to Derrida that we have
understood the phallic metaphor which sustains all reference to the
"seminal"; hence his project of "feminizing philosophy"—*dissemination*.

Krauss has, it is true, anticipated objections: "Now, it may be ob-
jected," she writes, "that in turning to photography for a principle of

unification, one is simply replacing one set of problems with another. For the same visual heterogeneity reigns within the domain of surrealist photography as within its painting and sculpture" (p. 101). However, this heterogeneity poses no real problem, for it too turns out to be a myth; Krauss proceeds to demonstrate—via Derrida—the "incredible coherence of European photography of this period—not, as is sometimes suggested, its diffraction into different sects" (p. 118). Thus Krauss constructs a monolithic surrealism which disavows or represses all difference within the movement, all "diffraction into sects," in the name of some higher conceptual unity. In this respect, "The Photographic Conditions of Surrealism" is emblematic of *The Originality of the Avant-Garde* as a whole, for in discovering the same "abstract logic" at work everywhere within modernism, Krauss has effectively produced a monolithic modernism which denies all difference, heterogeneity, contradiction (especially Bürger's crucial distinction between "modernism" and "avant-garde," terms which Krauss uses interchangeably).

Perhaps this is simply a rhetorical maneuver: Krauss constructs an undifferentiated modernism in order to juxtapose to it a heterogeneous, disseminated, decentered postmodernism. However, when she turns to postmodernist practice, her initial move is to exorcize the supposed diversity of contemporary production. In "Notes on the Index" she unifies postmodernist art according to the signifying conditions of a single medium, photography (as in "The Photographic Conditions of Surrealism"); however, in "Sculpture in the Expanded Field," she contradicts this assertion of photography's centrality by denying the relevance of medium and invoking *logic* in its stead: "What appears as eclectic from one point of view can be seen as rigorously logical from another. For, within the situation of postmodernism, practice is not defined in relation to a given medium—sculpture—but rather in relation to the *logical operations* on a set of cultural terms, for which any medium—photography, books, lines on walls, mirrors, or sculpture itself—might be used" (p. 288, italics added).

Although it runs throughout these essays, the privilege Krauss grants to logic reaches its apogee in this text, in which she begins by detailing "the logic of the monument," proceeds to map the entire field of postmodernist sculpture according to a *mathematical* model, and concludes with an assertion of the "possibility of looking at historical process from the point of view of logical structure" (p. 290). But insofar as logic proceeds formally, presenting its rules without reference to the time, place, or circumstances of their use, is it not the mode of analysis most *inimical* to understanding historical process?

If there *has* been a recent shift in critical method, it can perhaps best be characterized as a displacement from logical to rhetorical analysis, from a criticism concerned primarily or exclusively with the abstract truth or falsehood of statements, to one which deals with their use in specific social circumstances. (Thus, a shift from logic to rhetoric coincides with a shift from work to frame.) Unlike logic, rhetoric "is not a matter of pure form, but has to do with the relation of language to the world (to life) through the relation of linguistic expressions to the specific circumstances in which their use makes sense" (Newton Garver). And insofar as rhetoric also specifies the proper use of contradictory expressions (such as metaphors) it is also the site of the *ideological*.

As Moretti observes, the purpose of rhetoric is *not* "to ascertain an intersubjective truth, but to enlist support for a particular system of *values*." Rhetoric, in fact, has a primarily *evaluative* function; Moretti describes it as "an unrivalled mechanism for welding into an indivisible whole description and evaluation, 'judgments of fact' and 'judgments of value.'" So that, while logic may remain an indispensable tool for recognizing contradictory statements or propositions, it cannot explain their evaluative, i.e., ideological, function. As Foucault wrote in *The Archaeology of Knowledge* (a text Krauss cites at length on several occasions): "By correcting itself, by rectifying its errors, by clarifying its formulations, discourse does not necessarily undo its relations with ideology. The role of ideology does not diminish as rigour increases and error is dissipated."

Along with Barthes and Derrida, Foucault is probably the most frequently cited authority in *The Originality of the Avant-Garde*; ironically, all three stand in opposition to a philosophical tradition which regards language as primarily logical in character and maintains that logic rather than rhetoric furnishes the ultimate criterion of meaning (Husserl, Frege, Whitehead, Russell, early Wittgenstein). Because Krauss remains committed to this tradition (see, for example, her discussion of the proper name in "In The Name of Picasso" [pp. 26–28], which relies on Frege and Russell, rather than on, say, Derrida's chapter "The Battle of Proper Names" in *Of Grammatology* or feminist critiques of the patronymic, both of which emphasize the *social* function of the proper name as guarantor of the continuity of the dynasty and the transmission of property) her work does not participate in the fundamental displacement enacted in poststructuralist criticism. Although both Derrida and Foucault have expressed reservations about a traditional concept of ideology—the former because it appears to accept the matter/spirit dichotomy; the latter because it overlooks the direct, unmediated effects of

power upon the bodies of its subjects—nevertheless their displacement of criticism from logic to rhetoric seems compatible with ideological critique. For neither Derrida nor Foucault are concerned primarily with ascertaining the truth, but rather with investigating, in Foucault's words, "the political and economic interests [truth] serves."

Krauss's commitment to logical analysis repeatedly brings her up short when confronted with the ideological. For example, in her treatment of collage she writes, "It is often said that the genius of collage, its modernist genius, is that it heightens—not diminishes—the viewer's experience of the ground, the picture surface, the material support of the image; as never before, the ground—we are told—forces itself on our perception. But in collage, in fact, the ground is literally masked and riven. It enters our experience not as an object of perception, but as an object of discourse, of *re*presentation" (p. 38). Perhaps. But then why is it "often said" that collage heightens the viewer's perceptual experience of the ground? In what kind of circumstances can so blatant a contradiction of what Krauss regards as the facts be widely accepted as truth? To what can we attribute this split between perception and representation? Between fact and belief?

Krauss's treatment of collage appears in "In the Name of Picasso," written for the "Art World Follies" issue of *October* and against the "flood of critical and scholarly essays on Picasso" stimulated by the Museum of Modern Art's 1980 retrospective, almost all of them dedicated to what Krauss describes as an "art history of the proper name"—"an art history turned militantly away from all that is transpersonal in history—style, social and economic context, archive, structure" (p. 25). (The absence of ideology from this list of "transpersonal" historical agencies is itself revealing.) That Picasso should be subjected to an autobiographical approach, Krauss finds "highly objectionable"; but that it should be applied, by Robert Rosenblum, to collage, she finds "grotesque" (p. 39). For collage, she contends, "raises the investigation of the impersonal workings of pictorial form, begun in analytical cubism, onto another level: the *impersonal* operations of language" as they are described in Ferdinand de Saussure's *Course in General Linguistics,* the principal source of 20th-century structural analysis. Briefly, Krauss analyzes collage in terms of de Saussure's differential hypothesis, his contention that meaning is not the result of a correlation between a sign and a thing, but rather the product of a systematic play of differences among signs themselves. According to Krauss, the "subject" of collage is not so much the studio props—the pipes, winebottles, musical instruments, etc.—that

furnish its "subject matter," but rather the differential pictorial code (line/color, closure/openness, planarity/recession, etc.) according to which these objects are represented. "Thus if the elements of cubist collage do establish sets of predicates," Krauss argues, "these are not limited to the properties of objects. They extend to the differential calculus at the very heart of the formal code of painting. What is systematized in collage is not so much the forms of a set of studio paraphernalia, but the very system of form" (p. 37).

However, de Saussure's differential hypothesis has itself been subjected to some rather serious critical scrutiny—not the least of which has come from Derrida, who has exposed de Saussure's allegiance to a logical view of language (in *Speech and Phenomena,* Derrida demonstrates how the famous distinction signifier/signified satisfies and upholds the purely logical criterion that the sign be of an entirely different order than what it signifies). But the differential hypothesis has also been analyzed in *social* terms by Jean Baudrillard, who regards it as "the fundamental articulation of the ideological process" in bourgeois society, which systematically strips both objects and subjects of their materiality and their history by submitting them to a differential logic so that their *value* can be determined. (What lies outside the code is without value.) Baudrillard argues that a differential logic is central to the process of consumption: "What is consumed," he wrote in his 1968 book *La société du consommation,* "is the object not in its materiality, but in its difference [from other functionally identical objects]—i.e., *the object as sign.*" Thus, he reinterprets Marx's famous notion of commodity fetishism as a fetishism of signs: "If fetishism exists," Baudrillard explains in his 1970 essay "Fetishism and Ideology," "it is not a fetishism of substances and (supposedly ideological) values which the fetish object would incarnate for the alienated subject. Behind this reinterpretation . . . lies a *fetishism of the signifier.* The subject is caught up in the factitious, differential, coded, systematized aspect of the object. It is not the passion for substances that speaks in fetishism . . . but the *passion for the code* which, controlling both objects and subjects and subordinating both to itself, delivers them up to abstract manipulation. This is the fundamental articulation of the ideological process: not in the projection of alienated consciousness into superstructures, but in the extension, to every level [of society], of a structural code."

Lacking a working notion of ideology, the critic will tend to celebrate the most ideologically overdetermined events as extraordinary esthetic achievements. Hence, Krauss on collage: "The extraordinary contribution of collage is that it is the first instance within the pictorial arts of

anything like a systematic exploration of the conditions of representability entailed by the sign" (p. 34). However, if her analysis of collage as a "representation of representation" (p. 37) is viewed through the lens of Baudrillard's critique of de Saussure, then it is difficult to avoid the conclusion that what collage in fact represents is the moment at which the logic of consumption definitively entered the work of art. Thus, we could no longer maintain, as Krauss does, the hypothesis of "a rift between collage as a system and modernism proper" (p. 38). Rather, collage would participate fully in modernism's fetishism of the code, its fascination with the differential, the systematic, the artificial, the factitious (as Baudrillard reminds us, "fetish" derives from the Latin root *facticius*). If Krauss overlooks the fetishistic implications of collage, it is perhaps because she believes that, as she writes elsewhere, "the signifier cannot be reified" (p. 161); but this statement itself constitutes a disavowal of the ideological process, at least as it is analyzed by Baudrillard.

What Krauss ultimately signals is the urgent necessity for a *reevaluation*, on ideological grounds, not only of collage, but of modernism in general—both those "myths" unmasked in *The Originality of the Avant-Garde* and those that are not, especially the myth of a vanguard position. Until this process of reevaluation has taken place, it will be difficult to maintain with any conviction (as Krauss does throughout these essays) that modernism has entered a state of crisis. For until modernist myth has been not only deciphered, but evaluated, its hegemony will remain unchallenged. As Roland Barthes wrote in 1971, "There is no putting into crisis without evaluation."

Bibliographical Note: Spivak's remarks on ideology are taken from her essay "The Politics of Interpretations," reprinted in *The Politics of Interpretation*, edited by W. J. T. Mitchell and Wayne Booth (Chicago: University of Chicago Press, 1984). My text is informed by Spivak's, which discusses in detail the lack of a notion of ideology in contemporary criticism in general, especially that claiming to deal with the politics of textuality. An English translation of Bürger's *Theory of the Avant-Garde* has been published by the University of Minnesota Press (1984); see also Benjamin Buchloh's review [*Art in America,* January 1985], in which similar issues are discussed. Garver's discussion of logic and rhetoric, as well as Derrida's position on them, can be found in the preface to the English edition of Derrida's *Speech and Phenomena* (Evanston: Northwestern University Press, 1973). Baudrillard's crucial essay "Fetishism and Ideology" is included in the collection *Towards a Critique of the Political Economy of the Sign* (St. Louis: Telos, 1981). Barthes's remarks on criticism and evalua-

tion are taken from "Change the Object Itself" and "Writers, Intellectu-als, Teachers," both reprinted in Stephen Heath's anthology *Image–Music–Text* (New York: Hill and Wang, 1979). Spivak's provocative remark on the avant-garde's disavowal of "Imperialism" was made in lectures on "The Production of Colonial Discourse" delivered during the summer of 1983 at the University of Illinois, Champaign/Urbana.

Improper Names

Lothar Baumgarten is perhaps best known as the man who inscribed the names of the Indian populations of South America—*Namba, Bororo, Xavante, Toba, Arekuna* . . . —around the base of a semi-circular skylight at Documenta 7 in 1982. As early as 1971, however, when he was still a student of Joseph Beuys at the Düsseldorf Academy, Baumgarten could be found inscribing South American Indian names—*Tapirapé, Yuracaré, Xikrin, Cayapo, Mbaya-Caduveo* . . . —on photographs of what looks like tropical rainforest (but which turns out to be *Grünkohl*, a variety of broccoli), or the names of animals indigenous to South America—*anaconda, tapir, tukan, pekari, caiman* . . . —on a photograph of himself dressed as a shaman (recalling Beuys's own shamanistic pretensions). From 1973 to '77 Baumgarten was preoccupied with the production of a film based on a Tuyi myth, *The Origin of the Night,* which opens with a sequence of 52 names of tropical plants and animals—*carob, agouti, moskito, coati, mango* . . . —which slowly materialize one by one until they fill the screen, only to be replaced by a second set of names—*iguana, imbauba, tatu, pirol, marimonda* . . . —which then disappear one by one. In 1973, in collaboration with Michael Oppitz, a German anthropologist and ethnographic filmmaker, Baumgarten filled a chest with eagle feathers on which he had painted the names of North American Indian nations—*Tlingit, Heida, Tsimshian, Athabascan, Chippewa* . . . ; both an homage to Marcel Broodthaers and a (structuralist) critique of his 1972 exhibition "The Eagle from the Oligocene Epoch to the Present," this project was also exhibited at Documenta 7, along with Baumgarten's 1982 book *Die Namen der Bäume,* in which a list of the names of South

American trees—*pekoare-baum, weschuco, geigenbaum, liquidambarbäume, cabime, cacaobaum* . . . —branches into a textual and photographic account of Baumgarten's 18-month sojourn in a Yanomami village in the Upper Orinoco Basin in southwest Venezuela (1978–80). For his 1983 exhibition "Land of the Spotted Eagle," Baumgarten again invoked North American Indian names—*Haskapi, Sitka, Bella Coola, Cowlitz, Cree* . . . — this time inscribing them directly on the walls of the Museum Abteiberg in Mönchengladbach; for the German pavilion at the 1984 Venice Biennale he produced a marble floor inlaid with the names of the principal rivers of the Amazon Basin—*Amazonas, Tapajos, Xingu, Vaupes, Orinoco, Tocantins, Purus*; in 1985, on walls decorated with decaying frescoes of domesticated animals in the nursery of the Castello di Rivoli in Turin, he inscribed the names of South American animals—*pekari, zapallo, jabuti, manita, danta* . . . And in November of this year, in conjunction with an exhibition at l'ARC, Baumgarten will occupy Paris's Metro stations, replacing their Napoleonic designations with the names of the native populations of France's colonial empire.

What this abbreviated resumé of Baumgarten's career is intended to reveal—in addition to the persistence of his interest in the Americas and their autochthonous populations—is the frequency of his recourse to (Indian) names, which might be said to constitute the primary medium of his work. Although Baumgarten's practice is irreducibly plural—he mounts installations, publishes books, writes texts, exhibits photographs, produces films, travels—names are the one element common to all his activities, and I emphasize them here because I believe they are essential to understanding the nature of his proposal to us. For all of Baumgarten's work is concerned with what Jacques Derrida calls the *anthropological war*—"the essential confrontation that opens communication between peoples and cultures, even when that communication is not practiced under the banner of colonial or missionary oppression"—a war that begins with "the battle of proper names."[1]

In *The Conquest of America* Tzvetan Todorov characterizes the initial encounter of Europe and the new world as a type of semiotic warfare—a violent confrontation between two radically heterogeneous symbolic systems.[2] Baumgarten's project for the 1984 Venice Biennale, in which he "superimposed the topographical structure of the Amazon Basin upon the lagoon of Venice," was inspired by an early episode in this linguistic war: In 1499 Amerigo Vespucci, sighting the northern coast of the continent which will eventually bear *his* name, sees houses on stilts that appear to float on water or to hang suspended from trees. He is reminded

of Venice and immediately names the place *Venezuela*—little Venice—
thereby obliterating its Indian name and instituting in its place a *proper*
(i.e., Spanish) name. Thus "Venezuela" is inscribed within a system of
cultural associations and values—mercantilism, cosmopolitanism, Chris-
tianity—that is entirely foreign to it, and henceforth its name will testify
to, but also cover over the traces of, the violence implicit in this—or
any—historical act of denomination. By superimposing the geography
of the Amazon Basin onto that of Venice, Baumgarten was, of course,
commemorating this act; but he was also reversing its priorities. More
importantly, because in his work these two "systems" remained trans-
parent one to the other, he was also proposing an alternative, nonviolent
model of cultural confrontation in which one culture can occupy the
space of another without obliterating it.

The battle of proper names begins, however, with Christopher Co-
lumbus—a veritable nominophiliac. (As Todorov reminds us, Columbus
changed his own name to "Colón"—colonizer—so that it might corre-
spond more closely to his own activity, which he conceived as the spread-
ing of Christianity.) Arriving in the new world, Columbus is plunged
headlong into a baptismal frenzy; here is part of Bartolomeo de las
Casas's account of his activities on January 11, 1493:

> He sailed four leagues to the East, reaching a cape which he called *Bel
> Prado*. From there, to the southwest rises the mountain which he called
> *Monte de Plata*, which he said was eight leagues away. At eighteen leagues
> to the East, a quarter southeast of the *Bel Prado,* is found the cape which
> he called *del Angel.* . . . Four leagues to the East one quarter Southeast,
> there is a point in which the Admiral called *del Hierro.* Four leagues
> farther, in the same direction, is another point which he named *Punta Seca,*
> then six leagues farther is the cape which he called *Redondo.*

In naming these places, Columbus is, of course, claiming them for
Spain; as Todorov writes, "[de]nomination is equivalent to taking pos-
session." But he is also obliterating their Indian names, and his letters
indicate that he is perfectly aware of this fact. (For example, in February
1493 he writes to Santangel: "To the first [island] I came upon, I gave
the name of *San Salvador,* in homage to His Heavenly Majesty who has
wondrously given all this. The Indians call this island Guanahani.")
Todorov interprets Columbus's disregard for these names as a symptom
of a broader lack of interest in communicating with the Indians; his
obsession with proper names indicates that his primary interest in the
new world is in its landscape, and not in its inhabitants:

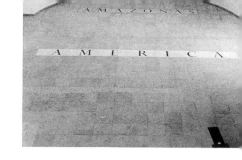

Proper names form a very particular sector of the vocabulary: devoid of meaning, they serve only for denotation, but not directly for human communication; they are addressed to nature (to the referent), not to men; they are, in the fashion of indices, direct associations between aural sequences of sounds and segments of the world. The share of human communication that occupies Columbus's attention is therefore that sector of language which serves, at least in its initial phase, only to designate nature.

However, to regard proper names as direct associations between sequences of sound and segments of the world—to claim that they do not pass through a system of simultaneously linguistic and social differences—is also to disavow the violence implicit in any act of denomination.[3] The names Columbus gives to places in the new world—Beautiful Meadow, Silver Mountain, Arrowhead Point, Desert Point, Round Cape—betray a desire for motivated signs, a conviction that names must reflect the places they designate—and not simply the site, but its *appearance*. His is a visualist conception of language in which "words are, and are only, the images of things." And the New World is simply a series of sites/sights to be named.

Not only the new world, but also its inhabitants, were subjected to this visual reductionism. When the "Indians"—another of Columbus's misnomers—figure in his writings at all, it is primarily as exotic sights; the only encounters with them he narrates are with their bodies as seen/scene (or perhaps *ob*scene: Columbus never fails to comment on their nudity). Thus he could write of the necessity of teaching the Indians "to speak"; suspecting a slip of the pen, Columbus's translators have amended this: "to learn our language." However, it is clear that this is not what Columbus, who was fluent in several languages, meant; he was unable to recognize the Indians as sign producers. It is not simply that Columbus was *uninterested* in communicating with the Indians, as Todorov suggests. How could he possibly have communicated with them when, by regarding them primarily as sights, he had already rendered them mute?

Lothar Baumgarten, America, *1983–84, German Pavilion, Venice Biennale.*
Courtesy Marian Goodman Gallery, New York City.

When Baumgarten deploys Indian names he is, of course, restoring the memory of something that has been effaced or obliterated. But he is also challenging a continuing European tendency to treat both the South American landscape and its inhabitants primarily as exotic sights; for Baumgarten does not employ names to conjure up a vision, but rather to provide an alternative to the ethnographic project of "visualizing" the Other. Thus his work can be aligned with that of contemporary anthropologists like Johannes Fabian, who has produced a trenchant critique of the implicit visualism of ethnographic practice. *Visualism* is Fabian's term for "a cultural, ideological bias towards vision as the 'noblest sense' and toward geometry qua graphic-spatial conceptualization as the most 'exact' way of communicating knowledge." For anthropology, rooted as it is in direct observation of the Other (field work), "the ability to 'visualize' a culture [is] almost . . . synonymous with understanding it."[4]

Fabian is one of a number of (mostly younger) anthropologists and literary critics who have recently begun critically to reexamine the rhetorical strategies of ethnographic discourse; most of their critiques focus on the effacement of the anthropologist qua observer from the ethnographic text, the suppression of all traces of the encounter in which contact with the Other takes place.[5] ("Personal" accounts, such as Lévi-Strauss's *Tristes Tropiques* or Malinowski's *A Diary in the Strict Sense of the Term,* remain peripheral to the anthropological canon.) However, while it is important to acknowledge the position of the anthropologist-observer, it is also essential to challenge the constitution of the anthropologist as an observer in the first place, and the Other as observed. Once these positions are in place, the Other is effectively reduced, not simply to an object, but to an icon.

The effacement of the anthropologist from ethnographic texts can be traced to the enormous corpus of colonial travel literature produced in the 18th and 19th centuries, out of which the discipline of anthropology developed. As Mary Louise Pratt remarks in an important recent article, that literature "textually produces the Other without an explicit grounding in an observing self or in a particular encounter in which contact with the Other takes place."[6] These accounts are *not* composed of narratives of heroic exploits, dangerous encounters, and close escapes, but instead of lengthy, often extremely boring presentations of landscape. The effect of such writing is to minimize all human presence, including that of the travelers themselves. "In the main," Pratt writes, "what is narrated proves to be a descriptive sequence of sights/sites, with the travelers present chiefly as a kind of collective moving eye which registers

these sights." Thus, landscape is depopulated verbally, and "indigenous peoples are relocated in separate manners-and-customs chapters as if in textual homelands or reservations, where they are pulled out of time to be preserved, contained, studied, admired, detested, pitied, mourned."

Significantly, this "discursive division of labor"—landscape description on one hand, manners-and-customs chapters on the other—reflects the academic hierarchy of the genres of painting as it was codified in the 18th century, specifically, the hierarchical distinction between landscape and genre. As is well known, this hierarchy was not fixed, but gradually shifted: as the 18th century passed into the 19th, landscape was elevated in importance, and genre was correspondingly demoted. Although all such developments in the history of art are overdetermined, Pratt's reading of the travel literature of the period suggests that the history of European esthetics will have to be rewritten in terms of what was going on simultaneously at the colonial frontier—that shifts in European taste not only influenced, but were also influenced by, the dictates of colonial expansionism.

For it is clear that this division of esthetic labor served a distinct economic and political purpose. Even a cursory survey of the vast corpus of images which artists contributed to the European project of "visualizing" South America (such as those included in Hugh Honour's 1977 exhibition "The European Vision of America")[7] reveals a predominance of panoramic landscape views. As Pratt writes, "Panoramic views are an important commonplace in European esthetics. . . . In the context of exploration . . . such views acquire and serve to familiarize meanings they may not have on the domestic front. They suggest, for example, the fantasy of dominance that is commonly built into this stance: the eye 'commands' what falls within its gaze; the mountains 'show themselves' or 'present themselves'; the country 'opens up' before the European newcomer, as does the unclothed indigenous bodyscape."[8] This fantasy of dominance is inextricably bound up with projects of colonization. For while manners-and-customs chapters tend to locate natives in an unspecified timeless past, and to regard anything they do as evidence of an unchanging custom or ritual, landscape descriptions inhabit the future—they are *prospects*: "In scanning prospects in the spatial sense—as landscape panoramas—the eye knows itself to be looking at prospects in the temporal sense—as possibilities for the future, resources to be developed, landscapes to be peopled or repeopled by Europeans."

Prior to his return in 1980 from his 18-month sojourn with the Yanomami, Baumgarten's South America was primarily an *imaginary* South

America based exclusively on texts, myths, images, and languages collected by generations of explorers, travelers, ethnographers, and artists. In this, his work develops out of—and extends—a specifically German tradition: The two most renowned German works about the Orient, Goethe's *Westöstlicher Diwan* and Schlegel's *Über der Sprache und Weisheit der Indier,* were based, respectively, on a trip down the Rhine and on hours of research in Paris libraries.[9] Karl May—who claimed that his immensely popular *Winnetou* books, which narrate the adventures of a German ("Old Shatterhand") among the Indians of North America, were autobiographical—never left his own country.[10] Similarly, Baumgarten's film *The Origin of the Night* was shot entirely in the forests of the Rhine; a film about the jungle by someone who had never been to the jungle, it tends to reflect the ideological limitations of its sources. Thus, in it the jungle is depopulated—although Baumgarten does use a mobile hand-held camera to represent a passage through the landscape.

Since 1980, however, Baumgarten's work has been based primarily on the archive of myths, photographs, sound recordings, films, and drawings he assembled while living among the Yanomami. The problematic of his activity has shifted to devising presentational contexts for this material that will undermine its inherent exoticism and its ethnographic interest. For example, he has not mounted exhibitions of his photographs of the Yanomami; he has, however, published them in several of his books and catalogues, often in juxtaposition with images of "savages" from the 16th and 17th centuries, or ethnographic photographs from the 20th. Baumgarten insists that his photographs of the Yanomami differ from ethnographic portraits because, in them, his position as a participant-observer is openly acknowledged: "You can see how I was with him." However, given the fact that the effacement of the observer, and the claim to objectivity which this effacement supports, are not specific to ethnographic discourse, but are also *built into* the photographic apparatus itself, it is difficult to accept this claim—however honorable Baumgarten's intentions may be. For every photograph of the Other is a visual reduction of the Other—both a distancing and a muting.

In Baumgarten's defense, it can be argued that, were we to declare a moratorium on photographs of the Other, they would remain, not simply the muted, but also the *invisible* victims of Western ethnocentrism; thus, the discussion of the problematic nature of these photographs can productively be linked with feminist debates over images of women within a phallocentric order.[11] Moreover, Baumgarten provides his photographs with narrative captions designed to counteract the

ethnographic tendency to deny both subjectivity and historicity to the Other, to treat natives as generic (male) specimens. Subjectivity: "Vashishimi and Hekuna, her blind grandmother, taste the strawberrylike fruit of the kataoto tree, whose sweetness they love so much"; historicity: "The visitors from Tayari stand in the high grass of the Orinoco bank at El Plantanal waiting to be taken across with a canoe. They have come to make peace with their arch-enemies of Mahekodo. Their mutual assaults have gone on for seven years."[12] Although the Yanomami may now be treated as historical subjects, nevertheless they remain (exotic) sights and, perhaps more importantly, the addressee of these photographs remains a *viewer,* hence, an observer removed in both space and time from any potential encounter with them. In other words, Baumgarten's photographs of the Yanomami do not challenge the constitution, in both the esthetic and the imperialist arenas, of the European subject as an "eye."

My criticism might seem misplaced—after all, I am arguing with photography, and not with Baumgarten's use of it—were it not for the fact that other of his works since 1980 do in fact challenge the entrenched visualist bias of both artistic and ethnographic practice. For example, in his first exhibition in North America Baumgarten explicitly referred to the interest which transforms the landscape into a prospect, and the viewer into a prospector: In May 1985 at Marian Goodman in New York Baumgarten presented a series of black-and-white photographs taken in 1978 in La Gran Sabana, a vast grassland in southeast Venezuela. The supposed site of the legendary El Dorado sought by generations of European adventurers, La Gran Sabana is once again witnessing a gold rush—a development to which Baumgarten alluded by inscribing, directly on the walls of the gallery between panoramic landscape views, the names of the minerals found in the region and, inverted above these, the names of the species endangered by the extraction of these minerals, thereby linking the representation of landscape, the commercial exploitation of its resources, and its destruction.

Last winter Baumgarten returned to La Gran Sabana, traveling on foot for 13 weeks in the company of two Arekuna guides, traversing the savannas, scaling the mountains, descending into the mines, in preparation for a major exhibition in Caracas last summer. Although most of his work since 1980 has been concerned specifically with Venezuela and its autochthonous populations (although by now the ideological implications of this distinction should be apparent), this was the first time he had exhibited work there; in addressing the Europe-identified Vene-

zuelan oligarchy—which constitutes the sole support system for the country's museums and artists—he was addressing those who stand to benefit most directly from the exploitation of the resources of La Gran Sabana, hence from the destruction of the landscape and its indigenous populations. In these circumstances he aligned himself more militantly than previously with the Indians. In his catalogue essay, he enumerates in painful detail the effects on the Indians of the clearing of the forests, the pollution of the rivers, the extermination of the wildlife:

> Today all [the Indians] know about Simón Bolivar, who liberated them from the Spanish crown. But who will liberate them from the new industrial *conquistadores* with their newly discovered but sham "concern" for the Indians? Silent, the canyons are filling up with cans, because today Pepsi-Cola and Polar [a Venezuelan distillery] have become their *padres*. For the last 50 years the Church has been indoctrinating them in the new faith; but now the traffic in souls has been displaced, and [corporations] hold the reins.

Such militance was not without its price. Oswaldo Trejo, director of the Museo de Bellas Artes, refused to publish Baumgarten's catalogue essay without substantial cuts (including the passage translated here), on grounds that "such complaints are best registered through the channels of social communication" (from which Trejo apparently excludes museums). When Baumgarten refused to make the deletions, the museum published, instead of a catalogue, a four-page "didactic guide" to the exhibition which explicitly disavows any political agenda: "Baumgarten's work," it reads, "is not political."[13] The museum was also "unable" to realize two parts of what was originally conceived as a four-part exhibition: in addition to a complex, ambitious installation in the Museo de Bellas Artes, Baumgarten proposed to inscribe, on the walls of the courtyard of the adjoining Galeria de Arte Nacional, the names of the minerals and animals of La Gran Sabana and, on the facade of a building which stands across Plaza Morelos from the Galeria, the names of Venezuela's indigenous populations, printed in reverse (as political slogans printed on walls frequently are in Venezuela), and deployed roughly according to their geographical situation in the country, thereby constituting a schematic map of the country. (Since the names for the latter project had already been fabricated by a commercial signmaker, Baumgarten eventually set them up in the adjoining Parque de Caobos and photographed them.

In a small greenhouse in the Jardín Botanico, Baumgarten did manage to realize a third project composed almost entirely of proper names.

Above the entrance to the greenhouse he inscribed "Venezuela" in large Gothic letters; inside he installed six toucans for the duration of the exhibition. Suspended from each of the perches fabricated for the toucans was a small green plaque bearing the name of one of "Los Buscadores de El Dorado"—European explorers (Lope de Aguirre, Vespucci), soldiers (the German mercenary Hans Staden), prospectors (Alexander von Humboldt, a mining inspector by profession, who traveled in South America from 1799 to 1804), anthropologists (Theo Koch-Grünberg, Pierre Clastres), and artists (Ferdinand Bellermann, whose panoramic views of the Venezuelan landscape, painted in the mid-19th century, now hang in the living rooms of many of Caracas's oligarchs). Their collective project can be described as the discovery, conquest, colonization, exploitation, indoctrination, study, and representation—in short, the *invention*—of "Venezuela" by and for the European imagination. In invoking these names, Baumgarten was, of course, tracing the genealogy of his own activity in the country; but he was also tracing the history of its exploitation by Europe—a history that is embedded in a constellation of proper names. (In a gesture reminiscent of Broodthaers, Baumgarten also placed, on a music stand inside the greenhouse, a score of the Venezuelan national anthem, but the toucans ate it.)

Taken individually, any one of these projects may have seemed dispensable; however, they were conceived as an ensemble and, had all three been realized, they would have inscribed onto the geography of Caracas a second, imaginative geography of proper names specifying a particular itinerary through the city. Michel de Certeau has argued that, for the inhabitants of a city, place names constitute "a strange toponymy that is detached from actual places and flies high over the city like a foggy geography of 'meanings' held in suspension, directing the physical perambulations down below. . . . [They] provide traffic patterns: they are stars directing itineraries."[14] Discontinuous, fragmentary, emphasizing certain places and consigning others to oblivion, these itineraries are the opposite of the visual totalizations provided by maps or panoramic landscape views; as such they stand as obstacles to rational, panoptical organization of space for purposes of administration and surveillance. Instead, they make the city *habitable.*

By describing such an itinerary, Baumgarten's four-part exhibition in Caracas would have reproduced, on an urban scale, the strategy of his installation in sala 2 of the Museo de Bellas Artes—an imaginary reconstruction of the geography of La Gran Sabana, specifically of the spec-

tacular cloud-shrouded mesas (*tëpitón*) which rise abruptly out of the savanna, sometimes to heights of a kilometer or more. Wind-eroded, carved by waterfalls (Salto del Angel, at 979 meters the world's highest, plunges from the top of Auyan-tëpi), the *tëpitón* are among the oldest geological formations on the face of the earth. In Caracas Baumgarten filled the gallery with enormous packing crates—the kind used to transport art—each of which stood for one of the *tëpitón*. Deployed roughly according to their geographical orientation, the crates-*tëpitón* provided a kind of three-dimensional map of the region. Nevertheless, the installation specified a physical, rather than a visual appropriation of the landscape; hence, the visitor was denied the kind of geometrical or geographical overview a map provides. Unlike at Venice, where Baumgarten's schematic representation of the Amazon Basin could be viewed from a catwalk encircling the exhibition space, in Caracas there was no way visitors could remove themselves from the installation in order to survey it in its entirety, and thereby constitute themselves as viewers. Rather, they were implicated within the installation itself, and as they moved through the labyrinth of crates-*tëpitón*, their itineraries created dimensions, vectors, and directions in this otherwise static space; in other words, they *mobilized* it.

A number of "events" deployed strategically throughout the installation alluded to the ongoing exploitation of the resources of La Gran Sabana: On the sides of each crate-*tëpitón,* color photographs taken last winter, many in the mines, were mounted behind wire mesh which interfered with their visibility. Posters for *la lucha contra malaria* (the government's anti-malaria campaign) and the stenciled letters "DDT" also appeared on the sides of the crates. Yellow mosquito-repelling lightbulbs, and the blue bulbs simulating the phosphorescence of the damp jungle floor provided dim illumination. On top of some of the crates, or on the floor beside them were "still lifes" composed of mining equipment (pans, pickaxes, etc.) and banana leaves. Indian artifacts suspended from the sides of several of the crates—including several *guayares* (baskets worn like backpacks) outfitted for an expedition—alluded to the inhabitants of the region, as did the names of the Indians—*Arekuna, Kamarakoto, Pemón*—stenciled on the sides of the crates along with the names of species threatened with extinction. Baumgarten inscribed the names of the trees on the gallery walls, which he covered with *urucu* (an orange pigment used by Indians to paint their bodies). Finally, across the top of each crate, Baumgarten stenciled the Pemón name of one of the *tëpitón—Roroima, Muroshipang, Apaurai, Sororopan, Auyan . . .* These names seemed to detach themselves from the crates and to float above the exhibition in what

was indeed a "strange toponymy" that oriented—gave sense and direction to—movement down below.

When published, the catalogue will include Spanish texts by Miguel Ortiz Briceño, an Arekuna living in the Comunidad de San José de *Twau-ken* in La Gran Sabana, which relate the Indian legends about the origins of the names of the *tëpitón*. The function of these names, and the legends associated with them, is to invest an otherwise alien landscape with both historical and mythic significance. Like the forests they inhabit, and the birds which figure so prominently in them, these legends are endangered by the commercial development of the region. Having related the significance of the names of some 66 *tëpitón* (which, he admits, has in many cases been forgotten), our Arekuna interlocutor reminds us that the linguistic war continues to this day:

> Many names of the mountains, as well as of the animals, rivers and places, have been mutilated or translated into Spanish, because many people find them easier to pronounce [that way]; thus, for example, the plural of *Tëpi* is *Tëpitón,* and not "tepuyes," as is often said. Similarly, the plural of *wit* (mountain) is *witon,* and not "witones."

> Because people are negligent, or do not want to make the extra effort to pronounce Pemón words correctly, the names of most places have been changed. . . . Thus, for example, "Kavanayen-tëpi," when in reality the proper name is *Kavanarúyen-tëpi* . . . and *Chirikëyen-tëpi* (mountain of the stars), and not "Chirikayen-tëpi."

> The Pemón language condemns this abuse, with which etymological law is needlessly, uselessly broken, depriving the language of harmony and corrupting its pleasing sonority.

In commissioning and publishing these texts, Baumgarten is, of course, rescuing the legends they relate from oblivion. But he is also offering an alternative (poetic, mythic) experience of the landscape as invested with significance—one which contradicts the experience of landscape only as a prospect to be developed. There is a danger, of course, that in presenting this material—the knowledge *of* the Indians— he is simply providing the raw material out of which ethnographers, folklorists, and specialists in Indian dialects will produce still more knowledge *about* the Indians. The role which ethnography plays in the extermination of the cultures it studies is well documented. ("The Bororos of Brazil sink slowly into their collective death, and Lévi-Strauss takes his seat in the French Academy.")[15] Still, these texts—and the installation of which they are an integral component—indicate the limits of the

European project of visualizing the Other. It is time to stop looking, and listen to what the Indians may have to say.

NOTES

1. Jacques Derrida, "The Battle of Proper Names," in *Of Grammatology*, trans. G. C. Spivak (Baltimore: Johns Hopkins University Press, 1976), 107.

2. Tzvetan Todorov, *The Conquest of America*, trans. Richard Howard (New York: Harper & Row, 1984).

3. Todorov repeats the error—and here he has a long philosophical tradition behind him—of treating the proper name as a unique appellation reserved for a unique being or thing. As Derrida has written, this is pure fantasy. The function of the proper name is to inscribe the person (or the place) it designates into a system of differences, thereby obliterating uniqueness by making identity a function of position within a system. "To name, to give names that it will on occasion be forbidden to pronounce, such is the originary violence of language which consists in inscribing within a difference, in classifying, in suspending the vocative absolute" (*Of Grammatology*, 112).

4. Johannes Fabian, *Time and the Other: How Anthropology Makes Its Object* (New York: Columbia University Press, 1983), 106.

5. See, for example, James Clifford and George E. Marcus, eds., *Writing Culture: The Poetics and Politics of Ethnography* (Berkeley and Los Angeles: University of California Press, 1986).

6. Mary Louise Pratt, "Scratches on the Face of the Country; or, What Mr. Barrow Saw in the Land of the Bushmen," *Critical Inquiry* (Autumn 1985), 121.

7. Hugh Honour, *The European Vision of America* (Cleveland: The Cleveland Museum of Art, 1975).

8. Pratt, "Scratches on the Face of the Country," 124. The treatment of the landscape as feminine, and of the *female* body as a landscape, is a fundamental narrative strategy. For an analysis, see Teresa di Lauretis, "Desire in Narrative," in *Alice Doesn't* (Bloomington: Indiana University Press, 1984), 103–57. A good example of the visual representation of the female body as landscape is the recent series of Calvin Klein television commercials in which the camera pans over a reclining woman as if over a mountain range. Although I have not yet been able to pursue the implications of this observation, the *Indian* body was (and is) also represented, as often as not, as landscape.

9. See Edward Said, *Orientalism* (New York: Pantheon, 1978), 19. Said distinguishes German from British and French Orientalism on this basis.

10. Hans-Jürgen Syberberg's 1974 film *Karl May* is an interesting treatment of the home-grown character of German exoticism; see also Thomas Elsaesser, "Myth as the Phantasmagoria of History: Syberberg's *Our Hitler*," *New German Critique* 24–25 (Fall/Winter 1981–82), 123–30.

11. For a summary and discussion of the feminist debate, see Mary Ann

Doane, "Film and the Masquerade: Theorising the Female Spectator," *Screen* 23 (September–October 1982), 74–87.

12. The captions appear in *Señores Naturales,* the catalogue for Baumgarten's installation at the 1984 Venice Biennale, 40. The relevant images appear on pages 25 and 34–35.

13. Baumgarten plans to publish the catalogue in conjunction with an exhibition in Europe next year.

14. Michel de Certeau, *The Practice of Everyday Life* (Berkeley and Los Angeles: University of California Press, 1984), 104. De Certeau's discussion of spatial "practices that are foreign to the 'geometrical' or 'geographical' space of visual, panoptic or theoretical constructions" is practically a description of Baumgarten's strategies.

15. Ibid., 25.

Interview with Craig Owens

Anders Stephanson

AN EXPLANATORY NOTE

I did this interview together with Gregorio Magnani in February 1987 for a book project of ours that was to introduce the American debate on postmodernism in Italy . . . Craig Owens was supposed to correct the transcript but never managed to do it. After his death I realized that, even unfinished, it contained much of value. What follows here, then, is the "second" version of our conversation, the version beyond mere transcription . . . as I have edited it a bit. . . . We [*Social Text*] publish it as a tribute to someone who was associated with our journal . . . , someone whose voice is already deeply missed. New York, November 1990.

Anders Stephanson: There is some question as to when exactly the category of postmodernism becomes important in the art world, and in what sense. When Jameson turns it into a social category in the beginning of the 1980s, it obviously lost some, if not all, of its general oppositional value as a description of certain cultural practices of the 1970s.

Craig Owens: The notion that Fred Jameson appropriates a single postmodernist discourse—and that therefore the discourse of postmodernism as opposition is no longer tenable—is a little bit monolithic and totalizing. There were still possibilities and sites where it was going on: the discourse was not that homogenized.

For me the term and the discussion became important around 1975, before Lyotard. He meant nothing at this point, and I hadn't even heard

of him. It was specifically a reaction to the hegemony of formalist theory, which had claimed or appropriated the term modernism. Modernism meant what Clement Greenberg had said it meant. The definition therefore excluded things like Duchamp, dada, surrealism; things that were not part of high modernism. So one became aware at a certain moment that practices of the late 1960s and the '70s no longer could be discussed within that high-modernist paradigm; and if they were, it was only to see them as somehow degenerate, perverse, corrupt, as representing the loss of purity, the loss of purpose, the loss of high culture.

Obviously a lot of these practices went back to such moments as Duchamp and the readymades in 1913 or 1915, back to dada and surrealism. These links were very clear; but in order to theorize them, to deal with contemporary production without evaluating it in terms of the categories and criteria of high modernism as elaborated by Greenberg and Michael Fried, it seemed necessary to elaborate a counterdiscourse. The term postmodernism was picked up in part from architecture, but only as a term, not as a discourse. Much of architectural postmodernism was fundamentally antimodernist, an antimodern movement, anti-Mies, again a specific reaction within a local discipline, a specific site. The only people I knew who were talking about this in the visual arts in the early to mid-'70s—which was then confirmed when I went to Europe at the end of the '70s—were people associated with *October*. A lot of it had to do with Rosalind Krauss and her attempt to dissociate herself from Fried.

AS: Yet Krauss was also influenced by Jameson as a result of that Irvine theory seminar of his that she participated in.

CO: No, it was largely the other way around. She had already written two early texts on the subject, for example the 1974 text on the index, at the end of which there is a discussion of postmodernism. But what Krauss did get from Jameson was the argument about historicism and the use of the semiotic square, the stuff she used in "Sculpture in the Expanded Field," which was an attempt to systematize, to find some kind of nice logical model from which one could generate and circumscribe the possibilities of postmodernism. It's a text which actually misses completely Fred's usage because it ends with the possibility of looking at historical process from the point of view of *logical* structure, finding a mathematical and purely logical method for dealing with the mapping of certain postmodern practices. Therefore it has nothing

whatsoever to do with historical explanation, with "emergence" and the causes of emergence.

But by then the discourse was coming into place. The term was already in use but among a very specific circle of people, who were using it to consolidate their own withdrawal from mainstream dominant art discourse and practice. It was also at this moment in the mid- to late-'70s that the market starts its recovery which will then continue through the '80s. There was a new interest in and proliferation of art writing, which deliberately did not set itself the task of coming up to the level of "seriousness" set by Greenberg and Fried. What then came to be seen as the postmodern was that proliferation of discourses on the outside. These were not activities that were trying to theorize postmodernism or the question of postmodernism, but to function *as* postmodernism. Roughly at the same time, some of us began to articulate this within art practice, as one way of detaching oneself from the art that was being pushed by the galleries, the art that was being written about in the art journals. So there was a strong sense that this articulation removed one from the dominant centers of the art world and art market. Whether it was a good old modernist withdrawal is another matter. At a certain moment theorists like Fred Jameson could then enter and look at this field of practices—which did seem fragmented, which did seem heterogeneous and dispersed—and theorize it, sitting in one place and talking about heterogeneity and relating that to the social.

AS: This is still an internal art matter. Lyotard has not yet entered?

CO: The first time I heard of his argument was in 1980 in Montreal. There was much talk there about Hegel and communication, and Habermas, about whom I knew little then. Initially what was informing the debate anyway was Frankfurt School stuff, and Walter Benjamin. The discourse in the art world was identified with *the photographic.*

AS: Not hyperrealism?

CO: No because that was seen to be the continuation of a reactionary tendency during the modernist period. I mean the notion of the photographic as opposed to photography per se, theorization of the photographic in terms of its multiple copies: no reflection of originality in the original, timed with the "death of the author," the mechanization of image production. What wasn't discussed, which would have been interesting, was the notion of technological modes of image production

and how it moves away from individual to collective creation. The first half of Benjamin's text "Art in the Age of Mechanical Reproduction" was the key text. So far as I myself was concerned, that was my time as a Derridean. It seemed that poststructuralist theory offered a very good critical language for dealing with contemporary art practices. I also began to ask what these two ways of reacting to contemporary art practices were actually reactions to. This is then something picked up and developed by Jameson: critical discourse as a symptom of something larger, the postmodern.

AS: Hal Foster said that this was a nonquestion. As a historian I must disagree.

CO: I disagree with that too. It is historical not in the sense of "when" so much as "by whom," what position, where the discourse emerges. The crucial questions, if any, that remain about this are: who speaks about this and where and for what purpose?

AS: We are now somewhere around 1980 and you're coming out of your Derridean period. Postmodernism is then connected up with the outside of the art world. There is Habermas's intervention which subsumes poststructuralism under the whole idea of the postmodern. There is Jameson's emerging argument. There is a transition into social theory. This is when it loses some of its oppositional aura as a designation for art practices directed against something specific within the art world.

CO: It is also, a little later perhaps, appropriated as a marketing term. And simultaneously with this presumably rather serious critical discussion within art discourse, there is an apparent breakup of the homogeneity of the art world. That was not what we initially tried to theorize, but it was what was then taken to be postmodern and was subsequently taken up by the journalistic art press. So was the phrase "the postmodern condition"—taken up by people who had never read Lyotard or Jameson—to represent how modernism was seen as a restrictive discourse, as a normative discourse, which specified a single line, a single historical development that could practically then be predicted.

AS: Was that the moment of neoexpressionism?

CO: Not quite yet. There is a difference too between this and what's going on in Europe in the early '70s which we don't hear about in any serious way until 1981. There was a tremendous black-out on informa-

tion from Europe, stemming from the dominance of the American art market and the export market. This was a real issue in European production at the time. There was no equal exchange: we were sending a lot over there, but very little from there was shown here. It was somehow regarded here as derivative from issues that had already been addressed or were being addressed in contemporary American art. It wasn't seen in terms of its cultural specificity or even as a reaction to a certain kind of hegemony of American art. David Salle's work, for example, could therefore be viewed as different, as having a relation with certain photographic practices. I saw the first Schnabel painting when Castelli Green Street was about to open. This is the local version of something—not even called neoexpressionism at that point—until there is some awareness of the European phenomenon with which it then seems to be aligned.

Gregorio Magnani: The neoexpressionist phenomenon was an American one anyway: it happened here before it happened there.

CO: It had to have *validation* here. That changed a lot, the appearance of European art in New York, challenging the dominance of a certain kind of critical discourse. It didn't lead to the questioning of U.S. imperialism in the arts or anything like that. But the sudden recognition of a European Other and the fact that there were these cultural practices going on that our press didn't report on, all of this changed the scene. *Artforum* suddenly published a lot on European art because it had European advertisers, and dealers were concerned to establish and validate this work. There are more buyers here, more collectors. There was some necessity, it seems to me, to come to terms with, or to negotiate with, to admit the existence of, to acknowledge, this European production. Throughout the 1970s, we hadn't had the slightest idea. Very few people here knew who Richter and Polke were. Which is one of the things that allowed David Salle to rip off Sigmar Polke blind, and to present this work as his in this country. And then when the Polke paintings started being shown, suddenly one recognized one's ignorance of what had gone on, apart that is from a glancing knowledge, for example, of *arte povera*. The last artist people knew about was *Manzoni*. And no one paid much attention to Manzoni either.

There was an incredible resistance such that if we knew American art, if we theorized American art, and if we therefore exported American theory, we thought we were dealing with contemporary art. This need to admit European production, and also on some level to begin to deal

with European theoretical production, became important in my experience around 1979–80. It did not influence people at *October* at all but I left it in 1980 and moved into the art arena by working at *Art in America,* where one was much more exposed to this. I went to Europe and looked at European art for the first time in five years, *European* art this time, not *American* art *in* Europe (Richard Serra's sculptures and so forth).

But what now interests me in thinking about that moment historically is what that admission was about. How Europe and North America somehow establish a certain unequal exchange, based at least on a recognition on this side of the Atlantic of European producers. How that is a way that Northern countries do not have to admit other practices and other activities.

GM: Why at that precise moment?

CO: This had something to do with broader cultural and political issues. Not only a high cultural sphere here being threatened from below by all kinds of activities that early in the '70s just said: "we don't want to have anything to do with it, we're going to constitute other activities outside of institutionalized art." There were the feminist activities in the art world, setting up things like the Women's Building in Los Angeles, and various feminist collectives: various challenges to how the supposed tolerance and inclusiveness of the art world was in fact including powerful white men from a certain middle class. That was what constituted cultural production.

There was an opening to something, but an opening to something that was ultimately the same, the same institutional network, the same economic market network. We already have transatlantic trade in the visual arts so we just shift the balance of trade a little bit. It does not bring in Latin American art for instance.

AS: But there is no issue at stake here of the same intensity as was the case say in 1950 when the exportation of American art was something quite special and had very clear political functions. There is nothing inherently difficult about making the art market here the postmodern capital of the world. Perhaps one would then be importing Latin American art at some point if that suddenly happens to become the thing to do.

CO: Well, the problem is the nature of that world. Because it is categorized as and looks like colonial art. Luis Camnitzer has a very interesting notion of neoexpressionism, which is of course one of the

First World structures that starts to manufacture colonial art: everything that is traditionally identified with colonial art—pastiche, derivativeness, work based on reproductions from art magazines (I mean, how many artists are now painting from reproductions in art magazines? Sherrie Levine just paints reproductions from art books). This was all associated with the status and the position of colonial producer. Luis Camnitzer, a Uruguayan artist, then asked the interesting question: what happens now on the periphery where they have always looked to New York, Paris, Dusseldorf, wherever, for their art to imitate, when they see that what is being presented to them as postmodern art is something they can recognize as that which they have been doing all along, except that it has been known as colonial art. He thinks that what is happening in Latin America is that it is leading to a valorization of previously discredited local expressionist traditions, both in Venezuela and Argentina in the '50s, positions that were also linked to politics. But those things were not being valued because they did not correspond to what was being done in the Western centers. We are producing our own colonial art so that we don't have to import it, our own image of the global economy. These things enter our political economy, our consciousness, as signs. It is about keeping the export centers of production here. We need these markets, not simply the production but also the ideological market.

AS: There must also be something internal that causes the events around 1980: a certain exhaustion of form or approach. What was in fact being produced in the metropolis? What was the reaction against?

CO: I have trouble with the notion of exhaustion because it assumes that things just run out and die of old age, as opposed to seeing that there is some active attempt to displace certain entrenched cultural practices. There was already something in place at that moment. Obviously something had happened that could not be accounted for, and this was the proliferation of activities in the mid-'70s. None of these activities could actually claim the sort of dominance and centrality that modernist cultural productions—what Greenberg and Fried called modernism—could claim in the '50s and '60s. There was no single practice that seemed to have that.

AS: In twenty-five words or less, what precisely were these activities?

CO: Prior to 1977, first of all the proliferation of film, video, and performance. Installation work. The nonobject. The dematerialization of art.

It seemed possible then to go back and theorize that earlier moment—
what conceptual art had to do with was a certain art economy based on
the circulation of works of art as signs or whatever. I am not saying that
these activities did not have a certain coherence: they were not just a
proliferation of random things about which you would hear said that
anything could be considered art (this is McLuhan speaking at the end
of the '60s: anything is art). You also get certain institutional theories
developing out of the art of that moment, such as "how can we possibly
call this art." There is coherence to these things: 1968–72, which is when
Lucy Lippard thinks the dematerialization of art took place.

We are talking about a period—this is what the theorization seemed
to be about in the mid-'50s—when the hegemony of primarily painting
and secondarily sculpture, understood as the fabrication of discrete ob-
jects, portable objects, and along with those, theories of meaning—speci-
ficity about painting, etc., "define the philosophic notion of the category
painting" and so on. This was precisely what we were opposing. And
this is an attempt to deal with all these cultural activities which were
predicated on hybridizations, performance as a mode which incorpo-
rated inclusiveness rather than exclusiveness. The argument about pho-
tography came out claiming that photography constituted the repressed
aspect of modernism, that we were involved in the return of the re-
pressed and liberating it. Serious artistic intention then was recognized
through the production of easel painting or welded steel sculpture.

My problem with people like Jameson coming along and just talk-
ing about Warhol and Rauschenberg is therefore that there is a re-
striction to that corpus of work. Jameson initially wrote about Whitney
art.

GM: High criticism seemed by then to interest less and less people.

CO: But the initial attempt was to maintain the seriousness rather than
to bring that seriousness into question. There was agreement with some-
one like Fried that the only opposite of that seriousness is a kind of
frivolity or lightweight. Which is one reason there was such an attempt
to prop up this theorization of modernism with European models.

*GM: There was a break not only in the dominance of American art but also in
art theory.*

CO: There may have been an attempt in theory in the late '70s to con-
tinue what had gone on in art practices in the early '70s, for example, the
inclusiveness of Yvonne Rainer, incorporating texts into her works, and

various other sites of culture, this work that did try to reach out and also to establish some kind of collaborative activities. But already by the end of the '70s, there was less of this, less heterogeneity, less mixing of voices, and it may well be that this was relocated into a kind of theoretical practice, in order to keep it going. Because I think there are exchanges that go back and forth in this way. These critical and productive efforts are not synchronous. It is precisely at that moment, when the attempt to open up diminishes, that criticism begins to do so. The problem is that you either impute it back into the art, thereby imputing it into an art that doesn't exist, or there isn't any actually existing postmodern production but a *call* for something different. A recognition that we were getting the same old stuff, a desire expressed for something different. Desperate reaching around for practices to pull into this, often recognizing a little bit later that you were really mistaken. We are now into this interesting phenomenon in the late 1980s where people are taking back what they said in the early '80s.

AS: Speaking of theory, with the advent of Althusserian Marxism in the late '60s in Europe, one gets a discourse that cuts across a whole variety of disciplines, intra and extra-academic.

CO: In the art world, it occurs more so in England. There are more theoretically informed practices there. The *Screen* magazine version of Althusserian theory, for example. There is a certain narcissism involved when criticism picks up on those practices that are constituted in its own image; but it is also with a sense of solidarity with them which were clearly not the kind of practices that the art marketing system wanted.

AS: Why not?

CO: There is a traditional view, held both left and right, that art, the visual arts specifically, represents something that is outside of theory, outside intellectual speculation.

AS: How can that be with Greenberg's theorizations in the background?

CO: Greenberg developed a theory that painting is about vision, vision alone. You could then produce the theory of opticality. The visual must then eliminate any extraneous materials, anything that belonged to any other discipline. The critic can therefore come in and produce a quasi-philosophical, or quasi-Kantian theory of painting, on top of that. There

is also a division of labor between artist and critic here which was very rigidly enforced and is now, today, again rigidly enforced. This is something that Jameson belongs to. You treat the work of art as a symptom, you place the artist in the position of the unconscious reflex and the critic in the position of the diagnostician. This is a strict division of labor. Attempts by myself and Martha Rosler around 1983 to engage Jameson and to say "Yes, these practices are indeed symptoms that need to be diagnosed but that there are also these other cultural practices that are informed by an Althusserian theory, by other forms of theory, where artists are actually engaged in cultural diagnosis themselves, and asking questions about what a politically motivated or leftist critical practice is in relation to these." But the response is silence because these things don't fit, you can't theorize them as symptoms in the same way.

Getting back to the earlier moment, the split between critic and artist, then, had been compromised, and we were writing not necessarily *about* these critical and oppositional practices but *alongside* them. There was an exchange there, and one's criticism was conducting the same work in a different arena and in a different way. I feel that way about, say, Barbara Kruger's work and my work. This is not a question of always writing about them, or always promoting them, but whether one chooses to ally oneself with oppositional practices or talk about mainstream cultural activities. And if you are going to talk about them, you have to talk about them in terms of their institutional support. If you are only talking about art that you've seen in the Whitney Museum of American Art, you are dealing with an extreme limitation.

AS: But isn't it true that oppositional artists themselves become marketable, say, after 1980?

CO: This is seriously overplayed. Hans Haacke does not sell much work, and he has not had a show in an American museum until now. Kruger's work is also interesting because it costs far more to produce in terms of photomechanical work, labs and so forth, than it costs to produce a painting, yet it sells for one-tenth of the latter's price. You can't sell a photograph for anything near a painting, even if there is only one of it.

AS: So the market is not in fact all-inclusive on that level.

CO: There is an internal hierarchy of producers within that market. And nor has the market been able to include everything. There has for in-

stance been a complete disappearance of video. It just isn't there, though supposedly it is marketable. For that we had to wait for the advent of the VCR. There are now people working independently through direct mail: Lyn Blumenthal is putting together seven or eight tapes that she wants to market through direct mail. It is called "What does she want?" It is feminist video from the '70s and '80s, and she has apparently been tremendously successful. She is setting up her own marketing network, selling them like the Book of the Month Club. In the '70s we had portopacs but no VCR, but there was gallery support for video, for example Castelli. This does not exist anymore. Video in the gallery context was not marketable, it was not absorbed by the market. At the moment, therefore, I find more students interested in video than in the past. It seems to sit outside the commodity sphere. Performance art was only marketable only insofar as the Brooklyn Academy has now tried to do it on a major scale. One synthesizes a collaborative avant-garde.

The reason for the disappearance of a lot of those activities like earthworks in the landscape is that they have to be supported by state art councils, and with the decrease in that sort of funding they are disappearing. Corporations aren't particularly interested. They subsist on the margin but haven't been very successful in becoming the object of discussion, or entering into these totalizing theories of modern culture. They have not made it into the dominant channel of information which is the mainstream art magazine, or are there only because of some sense of obligation. There is an incredible laziness on the part of critics and writers and magazines because criticism no longer sets the agenda for the discussion. If it ever did.

AS: Although Krauss points out that there is now a strong resurgence of theoretically induced art, art which takes theory as its originary force. That is in a way the critic setting the agenda.

CO: Yes, but there we have the critic and the artist at war; there is the same division of labor, and there is also some notion that these artists are somehow impinging on the critical function. Krauss has rarely acknowledged or written about works that come from a theoretical base, practically never. In fact she has often set Mary Kelly up publicly as its antagonist. Mary Kelly appeared in New York and Krauss said to her: "This would have been fine if you had only done it as a book." The idea that a certain kind of theoretical investigation belongs in a book in hardcover and not on the walls of galleries is again to reinforce this image. And Kelly actually made the book only to document something.

AS: There is an argument to make, however, that certain things are better presented in written form than on the wall.

CO: Yes, but that is not to say that works of art *cannot be* a theoretical investigation in the way that Kelly's work is an investigation of female fetishism. It is not just an *illustration* of theory, it is not just derived from theory. The critical function, in the absence of the critic trying to set the agenda, was being carried out by art. For a period in the later '70s and early '80s, it brought into the arena arguments, positions, speculations, that criticism had largely ignored. It is extraordinary to me how magazines work. If you sit at a magazine meeting and say "I want to write an article about X," the first question you get is "Is there an exhibition?" If somebody else hasn't decided to show it, the managers are very reluctant to take it upon themselves to say we will now push this work. If the Museum of Modern Art decides to exhibit it, then there is no problem. There is a certain abdication of the setting of the agenda to the museum, to the gallery, to the dealer.

AS: Yet the magazine also works as a reflection of the market, as a kind of barometer or stock market if you will.

CO: It does that too. But there is an unwillingness to place the authoritative voice, taste-making function, of the museum behind otherwise unauthorized, unestablished practices: it is a going out on the limb. We want to see that we are not the only ones so that we won't make a mistake. It's also because it is part of an apparatus which is not only a market apparatus. It is part of a consciousness industry. It is also about establishing what is contemporary art, what is going to count as contemporary art.

AS: But surely a magazine like Artforum *can pretty much write what it wants and sponsor whatever happens to strike its fancy.*

GM: Or negatively by not writing about it, as in the case of Art in America *deciding not to write about neo-geo.*

CO: Which is a way of establishing one's "independence" from the market. It has that role: we think for ourselves. It functions on the one hand so that the press can maintain a kind of equality with the market, with curators, museum directors, dealers and so forth, in determining taste, but it also means that the press isn't going to step out. The art magazines are full of talk of the market, the dominance of the market: there is a

notion that we are autonomous from that. What is going on is really a much more *concerted* activity.

AS: But there seems to me not to be any logic that would underpin all this.

CO: The system is running very smoothly right now. Each of these various constituents of it are really performing their role quite well, so far as the "health" of this machine is concerned. For the art press to take on a role of setting the agenda would be perceived by people in the field as stepping out of bounds, usurping other positions. We play our part in this institution and we will all benefit from that.

There *is* critical activity. It seems to me to challenge first of all the division of labor—artist/critic, theoretician/historian, and so on. It is interesting to see how this activity is represented within the art world. Alan Sekula, who is a photographer, who is a historian, who is a critic, is represented, and he used to publish occasionally in *Artforum* but only as a writer. His artistic practice has never been seen in any mainstream art magazine. His photographs are sometimes either published in certain left art journals, most of which come out of Canada, or in books which Nova Scotia Press publishes.

AS: His "value" as a photographer would warrant otherwise, in other words?

CO: I suppose that his work certainly does not come up to any standards that the art world has regarding a good or acceptable photograph. But this is also because Sekula's work, along with that of Fred Lonidier, is articulated specifically in relationship to labor movements. Lonidier exhibits projects in union halls. These figures who align themselves with communities and other forms of organized political activities are not considered really a part of the art world. Membership in the art world is an exclusive activity. If you choose to situate your practice elsewhere, then you're fine, you have your own friends, your own activity. People like Sekula, Martha Rosler, Lonidier, Carl Beveridge in Toronto, really do feel that it is necessary to participate outside as well as inside. It is necessary to be represented within art-historical discourse because when someone like Jameson comes along to write about contemporary art, what he is going to consult is what the art magazines write about, what the museums show, what certain people like Rosalind Krauss will tell him about it. So the problem of marginalized art practices is even greater when it comes to their discussion by those who have a certain critical take on the art world per se but then render these practices further invisible.

When the discussion and diagnosis of postmodernism is not situated in relation to the specific institution such as the museum, gallery, art-press, when those sorts of mediation, construction, administration are overlooked, it presupposes that we are just talking with "cultural production" as opposed to those who determine what is seen and what is not, what is discussed and what is not discussed. A radical critical practice presumably would work through whatever channels are available both within and without the specific institutions and align itself with the position that these other practices represent vis-à-vis them. And to criticize the art that is in fact promoted as the cultural production of the 1980s, of the period. To articulate to some extent why it is that people like Sekula and Rosler situate their work outside and at the price of invisibility and silence when it comes to critical discussion.

AS: I see the logic of your account but I still don't understand why magazines like Artforum *and* Art in America *wouldn't deal with Sekula and Rosler.*

CO: First of all, you can't get the discourse in. I tried to do it in both cases and the response is: "Our readership. . . ." There is this fantasy that there is a homogeneous art readership, which determines what goes in. This readership is not then equipped intellectually to read a certain kind of discourse. Second of all, it is not interested. If they buy *Art in America* they are not interested in oppositional activities, supposedly. When you try to break down this notion of a homogeneous readership, and talk about audiences, you're told that "we have to write something that goes across the board." This is the notion of the average reader to whom everything must absolutely be intelligible and of interest. It is also the fact that for *Art in America* to put itself behind these activities is already a statement. We published an interview with two Cuban artists, and some guy who publishes *Art Market* at once began talking about "the Marxists at *Art in America*." In fact, of course, there was never any Marxist cultural theory printed in that magazine. The reason here was that we published the words of two Cuban producers who didn't speak about the repression of artists in Cuba;.and that they had all these friends in Miami who could be quoted against this. There was a real internal fight at the magazine after that. *Artforum* is another matter. There you have a single editor determining what goes in and she is tremendously idiosyncratic. Her own interests and particular cultural perception at any given moment determines. It is not in that sense a good barometer of what is going on. *Art in America* tends to be a barometer.

AS: So why haven't there been more "oppositional" art publications? Anyone could set that up.

CO: There are a few, especially regional ones like *Art Papers,* which have tried to provide an alternative to the hegemony of the New York art world, which they have then tended to deny. The other answer to that is that you have two choices: you can decide to publish an oppositional art magazine, or you can try to enter a broader cultural discussion by situating your critical activity in relation to journals like *Social Text* or *New Left Review.* Artistic practices usually do not enter into the general discussion of culture. Jameson is an exception here for which he is absolutely to be congratulated, to some extent in fact an ally because he does take visual art seriously.

AS: Edward Said recently said that Jameson is a buccaneer, by which he meant that he is unafraid of dashing into foreign territory.

CO: Said also makes certain recommendations at the end of his text in *The Anti-Aesthetic*: we can use the visual faculty to restore historical memory or whatever. But how he actually would put that into practice is not clear. It is thrown down for other people to pick up, but it isn't anything that he is particularly interested in.

The other thing that I find peculiar is that while there is a tremendous art community interest in the work of theorists—every art class that studies contemporary cultural theory reads Jameson's article—that interest and desire to engage in discussion is refused on the other side. Those academic stars are not particularly concerned. Typically not a single one of the people on the theorist panel at the Yale Conference showed up for the panel on cultural practices. It happens over and over again: "This is the panel of the visual artists, this is the producers panel." This is also accompanied by—and has been so since the mid '70s—a sense that because there is not much serious discourse being produced in or out of the visual art community and because we are now overproducing Comp Lit Ph.D.s, here is now a field that can be *colonized.* So we get the phenomenon of people moving into this field. The problem is not that they haven't studied art history. So what? It is that they really haven't got much identification with, or many connections within, this particular community. People like Stephen Melville who said that the last intelligent art critic he had read was Michael Fried and that he, Melville, was therefore to continue to carry the torch and talk about whatever. When Melville published something in *October* very early on about Cindy

Sherman's "paintings" and we said, you just can't say her *paintings*, it's that simple, he replied: No, but you miss my theory, painting must go out of itself to recover itself.

AS: So what are the alignments on that score within the art world? It is pretty peculiar in a way that the people in art schools are reading the preeminent orthodox Marxist critic in the U.S.

CO: You are going to have to remember that this is not yet, nor will it ever be, the dominant discourse within the academy. This is still seen as an *alternative* mode of educating an artist. What I found extraordinary in England was the widespread notion that this work has become "hegemonic," that this theoretical image-text work is the dominant practice. It is not. In the same way the theoretical discourse is not in any way dominant within the art schools. But it seems very interesting that there are various people positioned throughout the academy that introduced this. And the reaction of the students is largely that twenty-five people out of thirty resist it because it confuses the traditional idea of "reaching down into oneself and producing." They perceive it as a threat to their continued happy existence as little cultural producers.

AS: What are these minority Jamesonians going to produce once they are out of art school?

CO: They are going to pick up and produce within the tradition of oppositional practices that currently exists. People like Haacke, Kruger, who also worked very hard to establish an exhibition system for this work, so there is some place to go. Unfortunately, a lot of times these things are held up as a model for emulation, and there isn't a critical relation to these practices. While Haacke's and Kruger's work comes out of a critical relationship vis-à-vis certain forms of image production and institutional arrangements, the work of the second or third generation is coming out like epigones, followers. It lacks the same kind of oppositional, critical, *antagonistic* edge that gives the previous work its real punch. This is what happens when work becomes institutionalized.

GM: In what sense is all this stuff actually oppositional?

CO: Haacke's work seems to me to operate oppositionally on a lot of different fronts, in a lot of different moments. Now it stands in opposition to the dominant patronage relationships; and historically the

shift in patronage relations is a very important issue to talk about. There is a tendency to say that there is no difference when you have in front of the museum "Mr. and Mrs. John D. Rockefeller" as opposed to "Mobil" or "IBM." But that shift from the old type patronage of specific families, patronage as an obligation of a certain kind of status, all this is very different from multinationals supporting works of art. Haacke is raising this issue. What effect does that shift have on production? And the fact that his work initially was excluded and that his work became effective by means of kamikaze strategies, where it was effective because it was censored or withdrawn. I don't think that the fact that it is now within the institutions makes it any less pointed. It does not challenge and it does not subvert. It is absurd to expect a single producer working from a single place to subvert. I think there is a persistence of that notion.

GM: From abroad, perhaps, it seems there are two American kinds of developments or trends.

CO: But they are not equally matched: they are not equally established. If you take a look at the large shows, the show that the Museum of Modern Art reopened with, you have a very strong statement. It is international painting and sculpture and it shows one Latin American artist. A contemporary survey of international art, and all that is shown is American and European men.

The number of producers who are turning out their neo-geo canvases is far in excess of the people working within the so-called oppositional mode. I think it's because there are a number of people within the press—or there were at least—interested in these other practices and making sure that they were somehow represented; but the perception from Europe or wherever, was that there was this incredibly widespread, market-supported, oppositional activity in this country. In fact, they had to do extra work to get shown. It was only very recently that they began to enter into the SoHo galleries. Although there was a place prepared for it from the early '70s in certain conceptual works, at Castelli and so forth. But Castelli is not now showing this work.

AS: It is of course true that for every Haacke and Kruger, artists in their '40s and '50s, there are ten neo-geos and "cute-commodity-fetishism" artists (Halley, Steinbach, Koons). Is the dominant tendency among "alternative" artists actually not very alternative or oppositional at all?

CO: It is very interesting and somewhat unsettling to see—because the generational question is central—how these artists in constituting themselves, have appropriated a certain figure of the artist who is someone who reads, who writes, who talks theory. The theory has lost any kind of critical edge. This theory is functioning closer to how Jameson sees theory as functioning—theory as part of this reflex—as opposed to these models they have. Peter Halley's model seems to me to be almost like Dan Graham's—artist/theoretician, artist/writer—yet Graham's writing was clearly *critical*. It wasn't used to support or prop up an art practice, it wasn't used to infuse totally blank and empty canvases with some kind of social reference. It wasn't being used to present oneself as an intellectual, which is how Peter Halley presents himself. That seems to be an emptying-out of the reasons that artists began to speak, began to write, to occupy multiple positions, and not to be merely artists. The whole thing has lost its criticality. It is not dissatisfied with anything, except, as in Halley, the most existential lament of "our society as a prison."

GM: True for Halley but there are also those like Peter Nagy who do not in fact play high-brow.

CO: But those practices which are oppositional are those formed out of the late '6os and early '70s, a very different political and cultural moment. The attempt to emulate or reconstitute such practices at this moment historically, rather than thinking how a radical, critical practice might be formed out of contemporary social relations, both artistic and social, seems to me to miss the boat. I wonder about how the tradition of th e readymade, Duchamp, can be appropriated by somebody like Koons or Steinbach, in relation specifically to the commodity. For it's important here that the show comes out of Conrans; it doesn't come out of the "junkyard of capitalism." It is not the discarded, it is not the obsolete, it is not this material which is being looked at rather melancholically by Duchamp. It is contemporary stuff: digital alarm clocks. There is an important difference there, and if one collapses that difference and says "Oh they're just found objects on display" without seeing how the object itself was found, then there is no commentary about the commodification of the lost object; it is not coming out of a critical dissatisfaction and attempt to understand a set of production relations. I wonder if Sherrie Levine and Peter Nagy are not just attempts to compromise or mediate between these two positions. Which seem to me to be relatively antagonistic.

The Yen for Art

On March 30, 1987—one day before the Reagan administration announced protectionist trade sanctions against Japan *and* Margaret Thatcher dispatched one of her trade ministers to Tokyo with the threat that she might soon take retaliatory action against Japanese banks and investment firms operating in the City of London—one of the seven paintings of sunflowers Vincent van Gogh produced in 1888 and '89— "to decorate a room in his house," as Tom Brokaw reminded us on the *NBC Nightly News*—was sold at auction in London to the Yasuda Fire and Marine Insurance Company of Tokyo for a record 24.75 million pounds sterling (or 38.9 million dollars, roughly the budget of a *Star Wars* or, perhaps more appropriately, *The Empire Strikes Back*).[1] A manifestation of Japan's need to find outlets for its phenomenal trade surplus—as a Yasuda spokesman put it to the *New York Times,* "We have sizeable assets"—this sale affords an excellent opportunity to analyze the recent penetration of international investment capital into the art market. Here, however, I will concentrate not on the sale itself, but on the response it provoked in the Western (art) press, which contributed its own brand of cultural protectionism to the week's activities.

In the April 13 issue of *Time* Robert Hughes—never one to pass up the opportunity to condemn the marriage of art and commerce, especially when the opportunity carries a hefty lecture fee (Hughes has been traveling around the country lecturing on "Art and Money" for $3,500 a shot)—denounced the *Sunflowers* sale as a monument to "the new vulgarity" of "a new entrepreneurial class that has fixated on 'masterpieces.'" *Masterpieces* appears in quotation marks because, in Hughes's

316

opinion, the painting's aesthetic value—what we might call its Hughes value—has been compromised by popular appeal: "Why such a price for *Sunflowers*?" he asks. "It is one of the largest Van Goghs, if not necessarily the best. Thanks to mass reproduction it is exceptionally popular and famous. Its clones have hung on so many suburban walls over the decades that it has become the *Mona Lisa* of the vegetable world." What is more, this particular version of the painting has not worn well. Here is Hughes's assessment of its "reduced condition": "The high chrome yellow paint that Van Gogh used was unstable, and it has darkened to ocher and brown, so that the whole chromatic key of the painting is gone; the paint surface has turned callused with time and has little of the vivacity or even the textural beauty one sees in other Van Goghs." In other words, as it has aged, the painting has become the *Mona Lisa* of the mineral world—although Hughes does not appear to appreciate the irony that the world's most expensive work of art should be a gold painting.

Hughes's dismissal of *Sunflowers* because of its popular appeal does not, however, prevent him from condemning its sale in the name of the public: "Private collectors," he writes, "are driving museums out of the market. . . . No museum in the world can compete with the private sector for paintings like *Sunflowers*." (One might well ask why they would want to, given the painting's "reduced condition.") In pitting museums against the private sector, Hughes not only ignores the recent alliance of museums and corporate capital (the Whitney Museum's cohabitation with both Phillip Morris and Equitable being only the most obvious example); he also presupposes that museums in fact function in the public interest. However, the new-found "populism" of such institutions as the Metropolitan Museum can be attributed only to corporate support, which has brought with it an emphasis on box-office receipts and on productivity—hence, the merchandising of everything from signature scarves to reproductions of fake Egyptian cats. Today, every museum worth its salt has a director of marketing. It is clear that, at least in the 1980s, museums regard "the public" as a mass of (potential) consumers.

At the conclusion of his diatribe Hughes once again identifies the traffic in paintings as public enemy number one: "The big auction," he writes, "as transformed by Sotheby's and Christie's, is now the natural home of all that is most demeaning to the public sense of art. *Sunflowers* was once alive, and now is dead—as dead as bullion. . . ." (Thus, to protect the work of art from private appropriation, Hughes *fetishizes* it, attributes living or animate properties to it.) However, the *Sunflowers* case

is complicated by the fact that, in its statement to the press about the acquisition, the Yasuda Fire and Marine Insurance Company also invoked the public. Upon arriving in Japan, the painting will immediately go on public exhibition (in the Sejii Togo Memorial Yasuda Kansai Museum on the 42nd floor of Yasuda's corporate headquarters in Tokyo) as a token of the company's "gratitude to the Japanese people." For it turns out that this acquisition was also a restoration: the painting was purchased to replace another version of *Sunflowers,* one that was on loan from a private Japanese collection to the Yokohama City Art Museum in 1945, when it was destroyed, as the *New York Times* put it, "by fire." (*Firestorm* is more like it.) That the *Times* did not name those responsible for the destruction of the painting is one indication of just how sensitive an issue Yasuda's acquisition of *Sunflowers* is, especially in light of current tensions between Japan and the West.

I cite this episode here to demonstrate how malleable the concept of the public can be. That both Hughes and Yasuda could invoke "the public," one in condemning the sale of the van Gogh, the other in publicizing its acquisition, indicates that "the public" is a discursive formation susceptible to appropriation by the most diverse—indeed, opposed—ideological interests; and that it has little to do with actually existing publics or constituencies.

Hughes's appraisal of the van Gogh suggests that it would have been at home in the "Damaged Goods" exhibition at the New Museum (summer 1986)—a celebration of the return to the object in contemporary art; alternately, a temple to the fetish commodity. Every Saturday afternoon one of the ten invited artists, Andrea Fraser posing as Jane Castleton, a docent, conducted a tour of the museum, beginning in its bookstore/gift shop: "The New Museum started its Docent Program because, well, ah, to tell you the truth, because all museums have one. It's just one of those things that makes a museum a museum. . . . But the New Museum has other things in common with other museums . . . it has a bookstore/gift shop." Walking to a wood panel in one corner of the bookstore/gift shop, Fraser/Castleton pulled it aside: "Over here, conveniently located in the bookstore/gift shop behind this panel is the control board for the Museum's security system. Of course all museums have security systems—owning and exhibiting art, like all valuable property, is a responsibility, and the Museum's first responsibility is to protect the culture it fosters."

In presenting her contributions to the exhibition in the form of a docent's tour, Fraser was situating her practice in the tradition of intellectual critique instituted in the 1970s. But she was also inverting the terms

of that critique, at least as they were defined by Peter Bürger in his *Theory of the Avant-Garde,* which calls for a "functional analysis" of works of art, an examination of their "social effect (function), which is the result of the coming together of stimuli emanating from within the work itself and a sociologically definable public within an already existing institutional frame."[2] Unlike Daniel Buren, who investigated the function of the work of art, Fraser focuses on the function of the institution frame itself—specifically, its avowed purpose of protecting cultural artifacts in the name of the public.

"This particular board," Fraser/Castleton continued, calling our attention to the corporate logo affixed to the control panel, "is an Imperial Product—fit to protect the property of emperors, fit to protect an empire, as it were. From this top box, the guards, with a key, can turn the entire system on and off. This panel here receives signals from the perimeter intrusion detection system—a versatile system that can be used on walls, windows, display cases, storage cases, ATMs, safes, vaults, and any other material that can be physically compromised. It can pick up the high-frequency shock waves that intruders broadcast as a result of their attempted forced entry, the shock waves produced by hammering, cutting, drilling, or the more archaic breaking." Note the sexual subtext here: phrases like "physically compromised" and "forced entry" connote rape, hence the body's vulnerability, hence the need for protection. "And finally," Fraser/Castleton informed us, "this last panel monitors the combination microwave/infrared detector which you probably didn't notice as you walked through the door, although I'm sure it noticed you!" Thus Fraser called attention to one of the subtle inversions of cultural protectionism: while the museum claims to protect works of art in the name of the public, it actually protects them *from* the public. (At the entrance to the exhibition proper, Fraser/Castleton reminded us that works of art must be protected from viewers: "I have to remind you that no one, not even a docent, may touch works of art on display. Touching works will dull the colors and deteriorate paintings because of oils from

Andrea Fraser, Museum Highlights: A Gallery Talk, *1989, Philadelphia Museum of Art. Photograph © Kelly and Massa.*

the skin, and will also wear away the surface of sculptured works. [Shades of *Sunflowers!*] We must remember that these works of art are real and original and can never be replaced.")

The central themes of Fraser's talk—the link between aesthetics and protection—emerged when she praised the artful installation of the security system: "The Museum's security system was designed by American Security Systems, a company that cares as much about aesthetics as it does about protection—that's their slogan." (In the printed version of the talk, available in the bookstore/gift shop, Fraser adds a footnote: "Really, I didn't make it up!") This link resurfaced when Fraser/Castleton singled out one of Allan McCollum's *Perfect Vehicles,* describing it as a "deer-shaped vessel from Chicama in northern Peru." Quoting from the *Metropolitan Museum Guide,* she continued: "During the 14th and 15th centuries, the Chimu kingdom ruled the north of Peru from its capital at Chan Chan. Its monarchs amassed great wealth and constructed enormous walled compounds from which to protect it. These compounds contained so many objects made of precious metals that during Spanish colonial times they were exploited as mines." And then, citing Noam Chomsky from the catalogue of the "Disinformation" exhibition at the Alternative Museum: "Current estimates suggest that there may have been about 80 million Native Americans in Latin America when Columbus 'discovered' the continent. By 1650, 95% of this population had been wiped out. The systematic extermination of Latin America's population continues today in Brazil, Paraguay, and Guatemala. . . . This vessel was given to the museum by Nelson A. Rockefeller. But, ah, as we discussed earlier in the talk, they care as much about protection as they do about aesthetics. . . ."

If culture is to be protected, is it not precisely from those whose business it is to protect culture? As Fraser points out, the protection of culture is a responsibility claimed by those most deeply implicated in the destruction of indigenous cultures and the social relations of reciprocity and obligation those cultures embody, so that the capitalist social relation—the wage relation—can be imposed. In other words, along with "soul-making," the protection of culture is an ideological alibi for the project of imperialism—an alibi in which we witness an inversion which, I propose, is the hallmark of protectionist discourse. For it is those who stand to benefit most from the destruction of culture who pose as its protectors.

Fraser/Castleton then directed attention to Louise Lawler's *Two Editions* on an adjacent wall: "Notice the two painted squares. Notice how

much larger the square on the left is than the square on the right. Well, the square on the left represents the amount the United States and European community spends on military research, while the square on the right represents the amount spent by the same countries on health research. It costs $590,000 a day to operate one aircraft carrier." If they saved up for 68 days, they could buy a van Gogh.

Which brings me back to Robert Hughes. Comparing the sale of *Sunflowers* with the auction the same week in Geneva of the Duchess of Windsor's jewelry, Hughes again assumes the role of critic-as-art-appraiser: "Most of the jewelry was florid stuff from the 40s and 50s of no stylistic distinction, with some good stones and a few imaginative settings. None of that mattered. Sotheby's had projected a total sale of $7.5 million; the two-day affair fetched $50 million." And then a parenthetical addition, which may well be an editorial interpolation: "(which, in accordance with the Duchess's will, went for the benefit of medical research at Paris's Pasteur Institute)." Then the unmistakable voice of Robert Hughes resumes: "The well-known bauble collector Elizabeth Taylor phoned in from Los Angeles to pick up a diamond clip for $565,000." (She might, of course, have contributed the sum to the operation of an aircraft carrier for a day.) The juxtaposition in the same paragraph of the Pasteur Institute and Elizabeth Taylor brings to mind private efforts to raise funds for research into the HIV virus in order to compensate for the public sector's scandalous refusal to appropriate adequate funding. Hughes does not mention the fact that the sale of the Duchess's jewels raised $50 million for AIDS research, which makes his verdict on this sale ironically applicable to himself: "One thinks of this event as ugly social comedy [which Hughes obviously does] at one's own risk."

This sudden invocation of "risk" in Hughes's cultural protectionist discourse reminds us that we the public are currently the target of massive publicity campaigns exhorting us to learn how to *protect* ourselves against HIV infection—when, of course, it is the person with the virus who needs to be protected from the public . . . and not only medically. As our president—an expert in protection—reminds us, celibacy is the best protection. Thus AIDS becomes a weapon in the right's campaign against nonreproductive sexual activity. As in the effort to reinstate prayer in the public schools, in the campaigns against abortion and pornography and "drug abuse," behavior once regarded as private is being redefined as public—as criminal. And this reinscription of the private as public is invariably enacted in the name of *protection*—in the anti-

pornography campaign, the protection of women; in the anti-drug campaign, the protection of children; in the anti-abortion campaign, the protection of *unborn* children.

Cultural protectionists like Hughes share the same agenda. When he fetishizes *Sunflowers* as a once-living thing, Hughes sounds like a foetus fetishist. When he observes that the price of a painting is nothing but an index of the collector's desire, adding "and nothing is more manipulable than desire, a fact as well known to auctioneers as to hookers," he not only scapegoats women for prostitution—the word Hughes is searching for here is *pimps*—he also presumes his reader's moral stance on commercial sex. When he speculates on why "the new entrepreneurial class" needs paintings, observing that "art confers an oily sheen of spiritual transcendence and cultural respectability," he adds, "This is why even a soft-porn merchant like Bob Guccione, publisher of *Penthouse* magazine, is now a 'major' collector." Guccione is the only collector Hughes mentions by name in the article. Not only does "oily sheen" read as an anti-Italian slur; here Hughes aligns the cultural protection movement with the anti-pornography movement.

As Barbara Ehrenreich observed on the recent "The Regulation of Fantasy: Sexuality and the Law" panel sponsored by the Dia Art Foundation (March 1987), the key term in the right's condemnation of our society is *permissiveness*. Now this permissiveness is not an index of immorality or degeneracy, as they would have us believe, but an essential factor in a disaccumulative economy, the extensive regime of postwar capitalism or consumer society—which must promote consumption, expenditure, self-indulgence, the gratification of every desire as our fundamental economic *obligations*. Thus the right, champion of free enterprise, is caught in a contradiction between its economic and its ethical agendas. Instead of recognizing the economic determinants of this contradiction, however, responsibility for the current crisis of capitalism is displaced, as Ehrenreich observed, onto the supposedly irresistible allure of "alternative life styles." But as often as not it is the cultural sphere that is held responsible for permissiveness—and not only film and television, which as instruments of capital are the primary media through which we are daily reminded of our obligation to consume, but also the anarchic, antagonistic, potentially liberating culture of the avant-garde.[3] This is, of course, the argument of Daniel Bell's *The Cultural Contradictions of Capitalism,* and it has lately been taken up by Hilton Kramer and Company at *The New Criterion.* Unlike Hughes, these ideologues advocate the transfer of cultural patronage from state-sponsored museums to precisely those private interests traditionally engaged in

the protection of culture—a strategy which complements perfectly the privatization of foreign policy by the Reagan administration. Nevertheless, the terms of the argument remain the same. And the question of who is to define, manipulate, and profit from "the public" is, I believe, the central issue of any discussion of the public function of art today.

NOTES

1. This text develops out of the Dia discussion in which I took part (2/10/87); it is not a record of the talk I presented that night.

2. Peter Bürger, *Theory of the Avant-Garde*, trans. Michael Shaw (Minneapolis: University of Minnesota Press, 1984), 87.

3. See Jürgen Habermas, "Modernity—An Incomplete Project," in *The Anti-Aesthetic: Essays on Postmodern Culture,* ed. Hal Foster (Seattle: Bay Press, 1983).

Global Issues

To think of the Third World as distant cultures, exploited but with rich intact heritages waiting to be recovered, interpreted, and curricularized in English translation helps the emergence of "the Third World" as a signifier that allows us to forget [the] "world-ing" [of what is today called "the Third World"], even as it expands the empire of the discipline.

— GAYATRI CHAKRAVORTY SPIVAK

In the context of a symposium on "globalism," it is important to distinguish the benevolent Third-Worldism of contemporary metropolitan culture—the sudden (but by no means unpredictable) interest, on the part of academics, curators, critics, and artists, in the cultural products (but not the economic or political situation) of the so-called Third World (more on this problematic signifier presently)—from the deconstructive and/or archeological work on imperialist formations being produced by such postcolonial intellectuals as Edward Said, Gayatri Spivak, and Homi Bhabha. (All of these critics have been influenced by European theory produced in the aftermath of decolonization—Foucault's linkage "power-knowledge," Derrida's critique of Western ethnocentrism, Lacan's formulation "Man's desire is the desire of the Other.") Today, the *confusion* of these two distinct (though not unrelated) enterprises presides over the emergence of a New Exoticism: the attempted recovery, beyond or behind the distortions of racist/imperialist representation, of an "authentic" Third World voice (the native, the tribal, etc.). In opposition to this tendency, these postcolonial intellectuals attend, not to the "native," but rather to the *European* subject of/in imperialism, specifically, the mechanisms through which Europe consolidated itself as a sovereign subject by positing its colonies as its "Others." Thus the displacing gaze of colonial surveillance is turned back on the colonizer in order to pose the question of the desire, *not* of the "Other" (Fanon's "What does the black man want?"), but rather of the colonizing, i.e. European subject.

Not surprisingly, postcolonial intellectuals are generally critical of First

World projects to recover an "authentic" native voice. On one hand, this search betrays a nostalgia for lost or obliterated origins; more importantly, in projecting the fantasy of a subject uncontaminated by contact with the West, it effectively disavows the historical *fact* of colonization. (It was, after all, the "social mission" of imperialism to give the native a voice, to transform the other into a programmed near-image of the European self.) The *political* consequences of the search for the "native" are clear: situated in some imaginary precolonial space, those on the other side of the international division of labor from us are once again denied access to modernity (postcoloniality). As Spivak points out, this tendency fits only too well with the increasing subalternization of the working class of the peripheries of microelectronic capitalism, its subtraction from participation in the ideology of consumerism (sometimes euphemistically referred to as a "higher standard of living").

The postcolonial critics of imperialism remind us that the business of imperialism is often conducted in the name of anti-imperialism, as the ongoing production of the Third World as a signifier (of difference, otherness) testifies. In order to construct the monolithic entity "the Third World," differences *within* that world must be reduced and, whenever possible, eliminated. The heterogeneity of the margins is thus sublated in the deceptively (a)symmetrical opposition of the First and Third Worlds—an opposition which is susceptible to seemingly endless transformations: North–South, development–underdevelopment, (in the sphere of culture) modernity–tradition. . . . It has been suggested, of course, that what unifies the Third World, makes it a "world," is its common experience of colonialism and imperialism—as if these forces operated in the same manner throughout history and in every geopolitical situation. But even this view should not prevent us from seeing the Third World for what it "is"—a thoroughly contradictory ideological construct unified only by its lack of unity. (This contradiction is all too easily appropriated as an allegory of postmodernism, another supposedly global phenomenon that nevertheless values differences, specificity, nontranslatability— at least in one of its variations.)

Fred Wilson, Primitivism: High and Low. *Installation view at Metro Pictures, New York City. Photograph © 1991 by Ellen Page Wilson.*

Instead of representing the Third World (as the site of difference or heterogeneity), we in the increasingly routinized metropolitan centers might ask the question of what (or who) cannot be assimilated by the global tendencies of capital and its culture. Spivak:

> Outside (though not entirely so) the circuit of the *international* division of labor, there are people whose consciousness we cannot grasp if we close off our benevolence by constructing a homogeneous Other referring only to our own place in the seat of the Same or the Self. Here are subsistence farmers, unorganized peasant labor, the tribals, and the communities of zero workers on the street or in the countryside. *To confront them is not to represent them but to learn to represent ourselves* [italics added].

Perhaps it is in this project of learning how to represent *ourselves*—how to speak *to,* rather than for or about, others—that the possibility of a "global" culture resides.

PART IV

Pedagogy

I've come to regard the production of aesthetic meaning and value as a collective enterprise . . . as the product of a group of . . . curators, art historians, caption writers, preparators, docents, lecturers, art historians, and even dealers and collectors . . . acting together (and not necessarily consciously in concert) to produce what we think of as being the meaning of the work of art, and the value of the work of art.

— BALDWIN LECTURE, OBERLIN COLLEGE

Art history is, of course, not the history of works of art; it's the history of slides of works of art.

— BALDWIN LECTURE, OBERLIN COLLEGE

We thus encounter once again the unavoidable necessity of participating in the very activity that is being denounced precisely in order to denounce it.

— THE ALLEGORICAL IMPULSE:
TOWARD A THEORY OF POSTMODERNISM, PART 2

[I would like to see] the revitalization of the art department in a way that no longer treats artistic activity as self-exploration and expression but regards art as a profession as important to our society as scientific or technological research. This involves not only the development of a series of courses in issues in contemporary culture but also attention to the studio program, bringing it more in line with the options available to art today . . .

It is necessary to develop a new curriculum for the teaching of the history of 20th-century art . . . To this end I propose a series of courses in the visual culture of the 20th century organized around a specific set of issues or topics—colonialism and orientalism and primitivism; the emergence of an ideology of the sign; sexual politics (Reich in Berlin with Berlin art).

EDITORS' NOTE

To Craig Owens, teaching was a necessary part of his project. He always questioned the arbitrary separations between and among theories and practices. When teaching, he focused on the academy's relationship to those theories and practices. A critic, editor, curator, and teacher, Owens refused to be confined by a simple definition.

We hope that the following selection of syllabi and bibliographies indicate the breadth of Owens's pedagogic commitment. We are reproducing them in their original form.

Postmodern Art 1971–1986

A survey of major developments in cultural theory and practice in Europe and North America after the "death of the author" (Barthes). Topics to be addressed include the critique of the avant-garde production model; postmodernism and postindustrial society; the role of cultural institutions; the "conventional attitude" (Norman Bryson); race, class, and gender; art in/and the public sphere. Although the course will eschew a "proper names" approach and concentrate instead on issues, artists to be considered include Marcel Broodthaers, Robert Smithson, Gerhard Richter, Sigmar Polke, Bernd and Hilla Becher, Gordon Matta-Clark, Lawrence Weiner, Joseph Kosuth, Robert Barry, Jannis Kounellis, Mario Merz, Giulio Paolini, Daniel Buren, Michael Asher, Dan Graham, Hans Haacke, Louise Lawler, Andrea Fraser, Alan McCollum, Cindy Sherman, Richard Prince, David Salle, Julian Schnabel, Anselm Kiefer, Barbara Kruger, Mary Kelly, Victor Burgin, Martha Rosler, Fred Lonadier, Allan Sekula, and Jenny Holzer.

USEFUL ANTHOLOGIES

Hal Foster, ed., *The Anti-Aesthetic: Essays on Postmodern Culture* (Seattle: Bay Press, 1983).

Richard Hertz, ed., *Theories of Contemporary Art* (Englewood Cliffs, N.J.: Prentice-Hall, 1985).

Brian Wallis, ed., *Art After Modernism: Rethinking Representation* (New York: The New Museum of Contemporary Art, 1984).

PERIODICALS

Artforum, Art in America, Arts Magazine, October (quarterly), *wedge* (New York), *Block* (England), *Parachute* (Canada), *Flash Art* (Italy), *LAICA Journal* (California), *Art & Text* (Australia), *Afterimage* (photography), *Screen* (film).

OUTLINE OF THE COURSE

I. Cultural Containment (Robert Smithson, Dan Graham, Richard Serra, Bernd and Hilla Becher, conceptual art).

Selections from *The Writings of Robert Smithson*, ed. Nancy Holt (New York: New York University Press, 1979): "A Tour of the Monuments of Passaic, New Jersey"; "A Museum of Language in the Vicinity of Art"; "Incidents of Mirror-Travel in the Yucatan"; "The Spiral Jetty"; "Cultural Confinement"; and "Conversation with Robert Smithson on April 22nd 1972."

Fredric Jameson, "Periodizing the 60s," in *The 60s Without Apology*, ed. Sohnya Sayres et al. (Minneapolis: University of Minnesota Press, 1984), 178–209.

* * *

II. The Death of the Author (Gerhard Richter, Sigmar Polke, Giulio Paolini, Sherrie Levine).

Roland Barthes, "The Death of the Author" and "From Work to Text," in *Image-Music-Text*, trans. Stephen Heath (New York: Hill and Wang, 1977).

Griselda Pollock, "Artists, Mythologies, and Media—Genius, Madness, and Art History," *Screen* 21, no. 3 (Fall 1980), 57–96.

Interview with Gerhard Richter by Rolf-Gunter Dienst, in *Gerhard Richter* (exhibition catalogue; Venice: Biennale, 1972).

Benjamin Buchloh, "Readymade, Photography, and Painting in the Painting of Gerhard Richter," in *Gerhard Richter: Abstract Paintings* (exhibition catalogue; London: Whitechapel Gallery, 1979).

Benjamin Buchloh, "Parody and Appropriation in Francis Picabia, Pop, and Polke," *Artforum* 20, no. 7 (March 1982), 28–34.

Rosalind Krauss, "The Originality of the Avant-Garde," in *The Originality of the Avant-Garde and Other Modernist Myths* (Cambridge, Mass.: MIT Press, 1984); reprinted in *Art After Modernism*, op. cit., 13–29.

Douglas Crimp, "Appropriating Appropriation," in *Image Scavengers* (exhibition catalogue; Philadelphia: Institute of Contemporary Art, 1983); reprinted in *Theories of Contemporary Art*, 157–62.

* * *

III. From Work to Frame (Marcel Broodthaers, Daniel Buren, Michael Asher, Hans Haacke, Louise Lawler, Jenny Holzer, Barbara Kruger).

Peter Bürger, *Theory of the Avant-Garde*, trans. Michael Shaw (Minneapolis: University of Minnesota Press, 1984), chapters 3 and 5.

Benjamin Buchloh, "Marcel Broodthaers: Allegories of the Avant-Garde," *Artforum* 18, no. 9 (May 1980), 52–59.

Daniel Buren, selections from *Five Texts* (Oxford: Museum of Modern Art, 1973): "Standpoints"; "Critical Limits"; "Function of the Museum."

Daniel Buren, "The Function of the Studio," *October* 10 (Fall 1979), 51–58.

Michael Asher, *Writings 1973–1983 on Works 1969–1979,* ed. Benjamin Buchloh (Halifax: The Press of the Nova Scotia College of Art and Design, 1983), 88–100, 164–82, 196–220.

Hans Haacke, "Museums, Managers of Consciousness," in *Hans Haacke: Unfinished Business*, ed. Brian Wallis (exhibition catalogue; New York: The New Museum of Contemporary Art, 1986), 60–72.

Rosalyn Deutsche, "Property Values: Hans Haacke, Real Estate, and the Museum," in *Hans Haacke: Unfinished Business*, op. cit., 20–37.

Andrea Fraser, "In and Out of Place" (on Louise Lawler), *Art in America* 73, no. 6 (June 1985), 122–29.

Benjamin Buchloh, "Allegorical Procedures: Appropriation and Montage in Contemporary Art," *Artforum* 21, no. 1 (September 1982), 43–56.

Hal Foster, "Subversive Signs," *Art in America* 70, no. 10 (November 1982); reprinted in *Theories of Contemporary Art*, 179–88.

Bruce Ferguson, "Wordsmith: A Conversation with Jenny Holzer," *Art in America* 74, no. 12 (December 1986), 108–15.

* * *

IV. The Birth of the Viewer (Robert Morris, Dan Graham, Peter Campus, Bruce Nauman, Jack Goldstein, Richard Prince).

Robert Morris, "Notes on Sculpture," in *Minimal Art*, ed. Gregory Battcock (New York: E. P. Dutton, 1968), 222–35.

Michael Fried, "Art and Objecthood," *Artforum* 5, no. 10 (June 1967); reprinted in *Minimal Art*, ed. Gregory Battcock (New York: E. P. Dutton, 1968), 116–47.

Dan Graham, "Essay on Video, Architecture, and Television," in *Video-Architecture-Television: Writings on Video and Video Works, 1970–1978*, ed. Benjamin Buchloh (Halifax: The Press of the Nova Scotia College of Art and Design, 1979).

Douglas Crimp, "Pictures," *October* 8 (Spring 1979); reprinted in *Art After Modernism*, op. cit., 175–87.

Kate Linker, "On Richard Prince's Photographs," *Arts Magazine* 57, no. 3 (November 1982), 120–22.

* * *

V. Representation and Sexuality (Cindy Sherman, Mary Kelly, Victor Burgin, Silvia Kolbowski, John Greyson).

Laura Mulvey, "Visual Pleasure and Narrative Cinema," *Screen* 16, no. 3 (Autumn 1975); reprinted in *Art After Modernism*, op. cit., 361–73.

Kate Linker, "Representation and Sexuality," *Parachute*, no. 32 (Fall 1983); reprinted in *Art After Modernism*, op. cit., 391–415.

Victor Burgin, "Photography, Phantasy, Function," in *Thinking Photography*, ed. Burgin (London: Macmillan, 1982), 177–216.

Tony Godfrey, "Sex, Text, Politics: An Interview with Victor Burgin," *Block*, no. 7 (1982), 2–26.

Mary Kelly, "No Essential Femininity," *Parachute*, no. 26 (Spring 1982), 31–35.

Michel Foucault, "The Eye of Power," in *Power/Knowledge: Selected Interviews and Other Writings, 1972–1977*, ed. Colin Gordon (New York: Pantheon, 1980), 146–65.

* * *

VI. The Conventional Attitude (David Salle, Julian Schnabel, Thomas Lawson, Allan McCollum, the "Simulationists").

Thomas Lawson, "Last Exit: Painting," *Artforum* 20, no. 2 (October 1981); reprinted in *Art After Modernism*, op. cit., 153–65.

The Holy Ghost Writers, "Condensation and Dish Placement," *Real Life Magazine* 9 (Winter 1982–83), 9–13.

Hal Foster, "Signs Taken for Wonders," *Art in America* 74, no. 6 (June 1986), 80–91, 139.

Peter Halley, "The Crisis in Geometry," *Arts Magazine* 58, no. 10 (Summer 1984), 111–15.

* * *

VII. History/Memory/Archaeology (Anselm Kiefer).

Benjamin Buchloh, "Figures of Authority, Ciphers of Regression: Notes on the Return of Representation in European Painting," *October* 16 (Spring 1981); reprinted in *Art After Modernism*, op. cit., 107–34.

* * *

VIII. Reinventing Documentary (Martha Rosler, Allan Sekula, Connie Hatch, Fred Lonidier).

Martha Rosler, "in, around, and afterthoughts (on documentary photography)," in *3 Works* (Halifax: The Press of the Nova Scotia College of Art and Design, 1981).

Martha Gever, "An Interview with Martha Rosler," *Afterimage* (October 1981), 10–17.

Allan Sekula, "Dismantling Modernism, Reinventing Documentary (Notes on the Politics of Representation)," in *Photography Against the Grain: Essays and Photo Works 1973–1983,* ed. Benjamin Buchloh (Halifax: The Press of the Nova Scotia College of Art and Design, 1984).

Abigail Solomon Godeau, "Photography After Art Photography," in *Art After Modernism*, op. cit., 75–85.

Fred Lonidier, "Working with Unions," in *Cultures in Contention*, ed. Douglas Kahn and Diane Neumaier (Seattle: Real Comet Press, 1985).

* * *

IX. Legacies of Imperialism (Lothar Baumgarten).

Gayatri Chakravorty Spivak, "Three Women's Texts and a Critique of Imperialism," *Critical Inquiry* 12, no. 1 (Autumn 1985), 243–61 (special issue, *"Race," Writing, and Difference*, ed. Henry Louis Gates).

Mary Louise Pratt, "Scratches on the Face of the Country; or, What Mr. Barrow Saw in the Land of the Bushmen," *Critical Inquiry*, op. cit, 119–43.

Bibliography:
Contemporary Art and Art Criticism

SOME USEFUL ANTHOLOGIES

Hal Foster, ed., *The Anti-Aesthetic: Essays on Postmodern Culture* (Seattle: Bay Press, 1983).

Richard Hertz, ed., *Theories of Contemporary Art* (Englewood Cliffs, N.J.: Prentice-Hall, 1985).

Brian Wallis, ed., *Art After Modernism: Rethinking Representation* (New York: The New Museum of Contemporary Art, 1984).

PERIODICALS

Artforum, Art in America, Arts Magazine, October (quarterly), *wedge* (New York), *Block* (England), *Parachute* (Canada), *Flash Art* (Italy), *Art & Text* (Australia), *Afterimage* (photography), *Screen* (film).

BACKGROUND READING

Fredric Jameson, "Periodizing the 60s," in *The 60s Without Apology*, ed. Sohnya Sayres et al. (Minneapolis: University of Minnesota Press, 1984), 178–209.

COURSE OUTLINE

I. Consuming Images

Stephen Koch, *Stargazer: Andy Warhol's World and His Films*, 2d ed. (New York: Boyars, 1985), 3–46, 114–38.

Roland Barthes, *Mythologies*, trans. Annette Lavers (London: Jonathan Cape, 1972).

Benjamin Buchloh, "Parody and Appropriation in Francis Picabia, Pop, and Polke," *Artforum* 20, no. 7 (March 1982), 28–34.

Interviews with Gerhard Richter, in *Gerhard Richter* (exhibition catalogue; Venice: Biennale, 1972).

Benjamin Buchloh, "Readymade, Photography, and Painting in the Painting of Gerhard Richter," in *Gerhard Richter: Abstract Paintings* (exhibition catalogue; London: Whitechapel Gallery, 1979).

II. The Death of the Author/The Birth of the Viewer

Roland Barthes, "The Death of the Author" and "From Work to Text," in *Image-Music-Text*, trans. Stephen Heath (New York: Hill and Wang, 1977).

Michael Fried, "Art and Objecthood," *Artforum* 5, no. 10 (June 1967); reprinted in *Minimal Art*, ed. Gregory Battcock (New York: E. P. Dutton, 1968), 116–47.

Robert Morris, "Notes on Sculpture," in *Minimal Art*, ed. Gregory Battcock (New York: E. P. Dutton, 1968), 222–35.

Rosalind Krauss, *Passages in Modern Sculpture* (New York: Viking, 1977).

Dan Graham, "Essay on Video, Architecture, and Television," in *Video-Architecture-Television: Writings on Video and Video Works, 1970–1978*, ed. Benjamin Buchloh (Halifax: The Press of the Nova Scotia College of Art and Design, 1979).

III. Cultural Containment

Selections from *The Writings of Robert Smithson*, ed. Nancy Holt (New York: New York University Press, 1979): "A Tour of the Monuments of Passaic, New Jersey"; "A Museum of Language in the Vicinity of Art"; "Incidents of Mirror-Travel in the Yucatan"; "The Spiral Jetty"; "Cultural Confinement"; and "Conversation with Robert Smithson on April 22nd 1972."

Peter Bürger, *Theory of the Avant-Garde*, trans. Michael Shaw (Minneapolis: University of Minnesota Press, 1984), chapters 3 and 5.

Daniel Buren, selections from *Five Texts* (Oxford: Museum of Modern Art, 1973): "Standpoints"; "Critical Limits"; "Function of the Museum."

Daniel Buren, "The Function of the Studio," *October* 10 (Fall 1979), 51–58.

Michael Asher, *Writings 1973–1983 on Works 1969–1979,* ed. Benjamin Buchloh (Halifax: The Press of the Nova Scotia College of Art and Design, 1983), 88–100, 164–82, 196–220.

Hans Haacke, "Museums, Managers of Consciousness," in *Hans Haacke: Unfinished Business,* ed. Brian Wallis (exhibition catalogue; New York: The New Museum of Contemporary Art, 1986), 60–72.

Rosalyn Deutsche, "Property Values: Hans Haacke, Real Estate, and the Museum," in *Hans Haacke: Unfinished Business,* op. cit., 20–37.

Andrea Fraser, "In and Out of Place" (on Louise Lawler), *Art in America* 73, no. 6 (June 1985), 122–29.

IV. The Spectacle

Walter Benjamin, "The Work of Art in the Age of Mechanical Reproduction," in *Illuminations,* trans. Harry Zohn (New York: Schocken Books, 1968), 217–51.

Guy Debord, *Society of the Spectacle* (Detroit: Black and Red Press, 1967).

Jean Baudrillard, "The Precession of Simulacra," in *Art After Modernism,* op. cit., 253–81.

Douglas Crimp, "Pictures," *October* 8 (Spring 1979); reprinted in *Art After Modernism,* op. cit., 175–87.

Kate Linker, "On Richard Prince's Photographs," *Arts Magazine* 57, no. 3 (November 1982), 120–22.

Benjamin Buchloh, "Allegorical Procedures: Appropriation and Montage in Contemporary Art," *Artforum* 21, no. 1 (September 1982), 43–56.

Bruce Ferguson, "Wordsmith: A Conversation with Jenny Holzer," *Art in America* 74, no. 12 (December 1986), 108–15.

V. Representation and Sexuality

Laura Mulvey, "Visual Pleasure and Narrative Cinema," *Screen* 16, no. 3 (Autumn 1975); reprinted in *Art After Modernism*, op. cit., 361–73.

Kate Linker, "Representation and Sexuality," *Parachute*, no. 32 (Fall 1983); reprinted in *Art After Modernism*, op. cit., 391–415.

Kate Linker, "When a Rose Only Appears to Be a Rose: Feminism and Representation," in *Implosion* (exhibition catalogue; Stockholm: Moderna Museet, 1987), 391–415.

Victor Burgin, "Photography, Phantasy, Function," in *Thinking Photography*, ed. Burgin (London: Macmillan, 1982), 177–216.

Tony Godfrey, "Sex, Text, Politics: An Interview with Victor Burgin," *Block*, no. 7 (1982), 2–26.

Mary Kelly, "No Essential Femininity," *Parachute*, no. 26 (Spring 1982), 31–35.

Michel Foucault, "The Eye of Power," in *Power/Knowledge: Selected Interviews and Other Writings, 1972–1977,* ed. Colin Gordon (New York: Pantheon, 1980), 146–65.

The Holy Ghost Writers, "Condensation and Dish Placement," *Real Life Magazine* 9 (Winter 1982–83), 9–13.

VI. Reinventing Documentary

Martha Rosler, "in, around, and afterthoughts (on documentary photography)," in *3 Works* (Halifax: The Press of the Nova Scotia College of Art and Design, 1981).

Martha Gever, "An Interview with Martha Rosler," *Afterimage* (October 1981), 10–17.

Allan Sekula, "Dismantling Modernism, Reinventing Documentary (Notes on the Politics of Representation)," in *Photography Against the Grain: Essays and Photo Works 1973–1983,* ed. Benjamin Buchloh (Halifax: The Press of the Nova Scotia College of Art and Design, 1984).

Abigail Solomon Godeau, "Photography After Art Photography," in *Art After Modernism*, op. cit., 75–85.

Fred Lonidier, "Working with Unions," in *Cultures in Contention*, ed. Douglas Kahn and Diane Neumaier (Seattle: Real Comet Press, 1985).

VII. Revivalism

Benjamin Buchloh, "Figures of Authority, Ciphers of Regression: Notes on the Return of Representation in European Painting," *October* 16 (Spring 1981); reprinted in *Art After Modernism*, op. cit., 107–34.

Thomas Lawson, "Last Exit: Painting," *Artforum* 20, no. 2 (October 1981); reprinted in *Art After Modernism*, op. cit., 153–65.

Hal Foster, "Signs Taken for Wonders," *Art in America* 74, no. 6 (June 1986), 80–91, 139.

Peter Halley, "The Crisis in Geometry," *Arts Magazine* 58, no. 10 (Summer 1984), 111–15.

Seminar in Theory and Criticism

A consideration of the recent displacement of critical practice away from the interpretation and evaluation of individual works of art and onto the analysis of the multiple frames within which artistic production and reception are contained.

I. The Death of the Author

Roland Barthes, "The Death of the Author" and "From Work to Text," in *Image-Music-Text*, trans. Stephen Heath (New York: Hill and Wang, 1977).

Michel Foucault, "What Is an Author?" in *Language, Counter-Memory, Practice*, ed. Donald F. Bouchard (Ithaca, N.Y.: Cornell University Press, 1977).

Griselda Pollock, "Artists, Mythologies, and Media—Genius, Madness, and Art History," *Screen* 21, no. 3 (Fall 1980), 57–96.

II. The Conventional Attitude

Roland Barthes, *S/Z*, trans. Richard Miller (New York: Hill and Wang, 1974).

Jean Baudrillard, "Fetishism and Ideology," in *For a Critique of the Political Economy of the Sign*, trans. Charles Levin (St. Louis: Telos Press, 1981).

Norman Bryson, *Vision and Painting: The Logic of the Gaze* (New Haven: Yale University Press, 1983).

Rosalind Krauss, selections from *The Originality of the Avant-Garde and Other Modernist Myths* (Cambridge, Mass.: MIT Press, 1984): "In the Name of Picasso"; "The Photographic Conditions of Surrealism"; "Photography's Discursive Spaces"; "The Originality of the Avant-Garde"; "Notes on the Index"; "Sculpture in the Expanded Field."

Meyer Schapiro, *Words and Pictures: On the Literal and the Symbolic in the Illustration of the Text* (The Hague: Mouton, 1973).

Michel Foucault, *This Is Not a Pipe*, trans. James Harkness (Berkeley: University of California Press, 1983).

III. From Work to Frame

Peter Bürger, *Theory of the Avant-Garde*, trans. Michael Shaw (Minneapolis: University of Minnesota Press, 1984).

Benjamin Buchloh, "Allegorical Procedures: Appropriation and Montage in Contemporary Art," *Artforum* 21, no. 1 (September 1982), 43–56.

Jacques Lacan, "Seminar on 'The Purloined Letter,'" in *Aesthetics Today*, ed. Morris Philipson and Paul J. Gudel, rev. ed. (New York: New American Library, 1980), 382–412.

Jacques Derrida, "The Purveyor of Truth," *Yale French Studies* 52 (1975), 31–113.

Jacques Derrida, "Tympan" and "Signature Event Context," in *Margins of Philosophy*, trans. Alan Bass (Chicago: University of Chicago Press, 1982).

Jacques Derrida, "The Parergon," *October* 9 (Summer 1979), 3–41.

Jacques Derrida, "Restitutions de la vérité en pointure," in *La vérité en peinture* (Paris: Flammarion, 1978).

Meyer Schapiro, "On Some Problems in the Semiotics of Visual Art: Field and Vehicle in Image-Signs," *Semiotica* 1, no. 3 (1969), 223–42.

IV. The Birth of the Viewer

Louis Marin, "Toward a Theory of Reading in the Visual Arts: Poussin's *The Arcadian Shepherds*," in *The Reader in the Text*, ed. Susan R.

Suleiman and Inge Crosman (Princeton: Princeton University Press, 1980), 293–324.

Michel Foucault, "Las Meninas," in *The Order of Things* (New York: Vintage Books, 1970).

Michel Serres, "Laughs: The Misappropriated Jewels, or a Close Shave for the Prima Donna," *Art & Text* 9 (Autumn 1983).

Leo Steinberg, "Other Criteria," in *Other Criteria: Confrontations with Twentieth-Century Art* (New York: Oxford University Press, 1972).

Leo Steinberg, "The Philosophical Brothel," *Artnews* 71, no. 5 (September 1972), 20–29; 71, no. 6 (October 1972), 38–47.

Leo Steinberg, "Velázquez' *Las Meninas*," *October* 19 (Winter 1982), 45–54.

Michael Fried, *Absorption and Theatricality: Painting and Beholder in the Age of Diderot* (Berkeley: University of California Press, 1980).

Pierre Bourdieu, *Distinction: A Social Critique of the Judgement of Taste*, trans. Richard Nice (Cambridge, Mass.: Harvard University Press, 1984).

Pierre Bourdieu and Alain Darbel, *L'amour de l'art: Les musées d'art européens et leur public* (Paris: Minuit, 1969) [English translation now available: *The Love of Art: European Art Museums and Their Public*, trans. Caroline Beattie and Nick Merriman (Stanford: Stanford University Press, 1990)].

Laura Mulvey, "Visual Pleasure and Narrative Cinema," *Screen* 16, no. 3 (Autumn 1975); reprinted in *Art After Modernism: Rethinking Representation*, ed. Brian Wallis (New York: The New Museum of Contemporary Art, 1984), 361–73.

Laura Mulvey, "Afterthoughts on 'Visual Pleasure and Narrative Cinema' Inspired by *Duel in the Sun*," *Framework* 6, nos. 15–17 (1981), 12–15.

Mary Ann Doane, "Film and the Masquerade—Theorizing the Female Spectator," *Screen* 23, nos. 3–4 (September-October 1982), 74–88.

Jacqueline Rose, *Sexuality in the Field of Vision* (London: Verso, 1986).

Stephen Heath, "Difference," *Screen* 19, no. 3 (Autumn 1978), 51–112.

Christian Metz, "The Fiction Film and its Spectator: A Meta-psychological Study," in *The Imaginary Signifier: Psychoanalysis and the*

Cinema, trans. Celia Britton et al. (Bloomington: Indiana University Press, 1982), 99–147.

Jean-Louis Baudry, "The Apparatus" and "Ideological Effects of the Basic Cinematographic Apparatus," in *Apparatus*, ed. Theresa Hak Kyung Cha (New York: Tanam Press, 1980).

Raymond Bellour, "Hitchcock, the Enunciator," *Camera Obscura* no. 2 (Fall 1977), 66–91.

Raymond Bellour, "Psychosis, Neurosis, Perversion," *Camera Obscura*, nos. 3–4 (1979), 105–32.

Raymond Bellour, "Les Oiseaux: Analyse d'une séquence," *Cahiers du Cinéma* 219 (1969); or see the account by Janet Bergstrom, "Enunciation and Sexual Difference," *Camera Obscura*, nos. 3–4 (1979), 33–70.

V. *"The Eye of Power"*

Leo Bersani and Ulysse Dutoit, *The Forms of Violence: Narrative in Assyrian Art and Modern Culture* (New York: Schocken Books, 1985).

Michel Foucault, *Discipline and Punish: The Birth of the Prison*, trans. Alan Sheridan (New York: Pantheon, 1977).

Michel Foucault, *The Birth of the Clinic*, trans. Alan Sheridan (New York: Pantheon, 1973).

Michel Foucault, "The Eye of Power," in *Power/Knowledge: Selected Interviews and Other Writings, 1972–1977*, ed. Colin Gordon (New York: Pantheon, 1980), 146–65.

Johannes Fabian, *Time and the Other: How Anthropology Makes Its Object* (New York: Columbia University Press, 1983).

Mary Louise Pratt, "Scratches on the Face of the Country; or, What Mr. Barrow Saw in the Land of the Bushmen," *Critical Inquiry* 12, no. 1 (Autumn 1985), 119–43 (special issue, *"Race," Writing, and Difference*, ed. Henry Louis Gates).

James Clifford, "On Ethnographic Surrealism," *Comparative Studies in Society and History* 23 (1981), 539–64.

Michel de Certeau, *The Practice of Everyday Life*, trans. Steven Rendall (Berkeley: University of California Press, 1984).

Claude Lévi-Strauss, *Tristes Tropiques*, trans. John and Doreen Weightman (London: Jonathan Cape, 1973).

Jacques Derrida, "The Violence of the Letter," in *Of Grammatology*, trans. Gayatri Chakravorty Spivak (Baltimore: Johns Hopkins University Press, 1976).

VI. Criticism From the Margin

Michel Foucault and Gilles Deleuze, "Intellectuals and Power," in *Language, Counter-Memory, Practice*, ed. Donald F. Bouchard (Ithaca, N.Y.: Cornell University Press, 1977).

Stuart Hall and Tony Jefferson, eds., *Resistance Through Rituals: Youth Subcultures in Post-War Britain* (London: Hutchinson, 1976).

Dick Hebdige, *Subculture: The Meaning of Style* (London: Methuen, 1979).

Thomas Crow, "Modernism and Mass Culture in the Visual Arts," in *Modernism and Modernity*, ed. Benjamin Buchloh, Serge Guilbaut, and David Solkin (Halifax: The Press of the Nova Scotia College of Art and Design, 1983), 215–64.

Gayatri Chakravorty Spivak, "Can the Subaltern Speak? Speculations on Widow-Sacrifice," *wedge*, nos. 7–8 (Winter-Spring 1985), 120–30 (special issue entitled "The Imperialism of Representation/The Representation of Imperialism").

Gayatri Chakravorty Spivak, "Three Women's Texts and a Critique of Imperialism," *Critical Inquiry*, op. cit., 243–61.

Gayatri Chakravorty Spivak, "Imperialism and Sexual Difference," *Oxford Literary Review* 8, nos. 1–2 (1986), 225–40.

Lata Mani, "The Production of an Official Discourse on *Sati* in Early 19th-Century Bengal," in *Europe and Its Others*, vol. 1, ed. Francis Barker et al. (Colchester: University of Essex, 1984).

Homi Bhabha, "Of Mimicry and Man: The Ambivalence of Colonial Discourse," *October* 28 (Spring 1984), 125–33.

Edward W. Said, *Orientalism* (New York: Pantheon, 1978).

Assia Djebar, "Forbidden Sight, Interrupted Sound," *Discourse* 8 (Fall-Winter 1986–87), 39–56.

Olivier Richon, "Representation, the Despot and the Harem: Some Questions Around the Academic Orientalist Painting by Lecomte-du-Nouij," in *Europe and Its Others*, vol. 1, op. cit.

Linda Nochlin, "The Imaginary Orient," *Art in America* 71, no. 5 (May 1983), 118–32.

Peter Wollen, "Fashion/Orientalism/The Body," *New Formations* 1 (Spring 1987).

Bibliography:
The Political Economy of Culture

Theodor Adorno, *Introduction to the Sociology of Music*, trans. E. B. Ashton (New York: Seabury Press, 1976).

Milton C. Albrecht et al., eds., *The Sociology of Art and Literature* (London: Duckworth, 1970).

Louis Althusser, "Contradiction and Overdetermination," in *For Marx*, trans. Ben Brewster (New York: Pantheon, 1969).

Louis Althusser, "Ideology and Ideological State Apparatuses (Notes Toward an Investigation)" and "A Letter on Art in Response to André Daspré," in *Lenin and Philosophy*, trans. Ben Brewster (New York: Monthly Review Press, 1971).

Andrew Arato and Eike Gebhardt, eds., *The Essential Frankfurt School Reader* (New York: Urizen Books, 1978).

Jacques Attali, *Noise: The Political Economy of Music*, trans. Brian Massumi (Minneapolis: University of Minnesota Press, 1985).

Michèle Barrett et al., eds., *Ideology and Cultural Production* (London: Croom Helm, 1979).

Roland Barthes, *Mythologies*, trans. Annette Lavers (London: Jonathan Cape, 1972).

Jean Baudrillard, *For a Critique of the Political Economy of the Sign*, trans. Charles Levin (St. Louis: Telos Press, 1981).

Jean Baudrillard, *The Mirror of Production*, trans. Mark Poster (St. Louis: Telos Press, 1975).

Jean Baudrillard, "The Beaubourg Effect," *October* 20 (Spring 1982), 3–13.

Howard S. Becker, *Art Worlds* (Berkeley: University of California Press, 1982).

Catherine Belsey, *Critical Practice* (London: Methuen, 1980).

Walter Benjamin, "The Author as Producer," in *Reflections*, trans. E.F.N. Jephcott (New York: Harcourt Brace Jovanovich, 1978), 220–38.

Walter Benjamin, "The Work of Art in the Age of Mechanical Reproduction," in *Illuminations*, trans. Harry Zohn (New York: Schocken Books, 1968), 217–51.

Mark Blaug, ed., *The Economics of the Arts* (Boulder, Colo.: Westview Press, 1976).

Ernst Bloch et al., *Aesthetics and Politics* (London: New Left Books, 1977).

Pierre Bourdieu, *Distinction: A Social Critique of the Judgement of Taste*, trans. Richard Nice (Cambridge, Mass.: Harvard University Press, 1984).

Pierre Bourdieu, *Outline of a Theory of Practice*, trans. Richard Nice (Cambridge: Cambridge University Press, 1977).

Pierre Bourdieu, "The Production of Belief: Contribution to an Economy of Symbolic Goods," *Media, Culture, and Society* 2, no. 3 (July 1980), 261–94.

Pierre Bourdieu and Alain Darbel, *L'amour de l'art: Les musées d'art européens et leur public* (Paris: Minuit, 1969) [English translation now available: *The Love of Art: European Art Museums and Their Public*, trans. Caroline Beattie and Nick Merriman (Stanford: Stanford University Press, 1990)].

Tom Bottomore, ed., *A Dictionary of Marxist Thought* (Cambridge, Mass.: Harvard University Press, 1983).

Harry Braverman, *Labor and Monopoly Capital: The Degradation of Work in the Twentieth Century* (New York: Monthly Review Press, 1974).

Andrew Brighton, "Consensus Painting and the Royal Academy Since 1945," *Studio International* 188 (November 1974), 174–76.

Andrew Brighton, "Official Art and the Tate Gallery," *Studio International* 1 (January-February 1977), 41–44.

Benjamin Buchloh, "Allegorical Procedures: Appropriation and Montage in Contemporary Art," *Artforum* 21, no. 1 (September 1982), 43–56.

Benjamin Buchloh, "Michael Asher and the Conclusion of Modernist Sculpture," in *Performance: Text(e)s & Documents*, ed. Chantal Pontbriand (Montreal: Parachute, 1981), 55–65.

Benjamin Buchloh, Serge Guilbaut, and David Solkin, eds., *Modernism and Modernity* (Halifax: The Press of the Nova Scotia College of Art and Design, 1983).

Martin Bulmer, ed., *Working-Class Images of Society* (London: Routledge & Kegan Paul, 1975).

Peter Bürger, *Theory of the Avant-Garde*, trans. Michael Shaw (Minneapolis: University of Minnesota Press, 1984).

Victor Burgin, *The End of Art Theory: Criticism and Post-Modernity* (Atlantic Highlands, N.J.: Humanities Press, 1986).

David Carrier, "Art and Its Market," in *Theories of Contemporary Art*, ed. Richard Hertz (Englewood Cliffs, N.J.: Prentice-Hall, 1985), 193–206.

Timothy J. Clark, "The Conditions of Artistic Creation," *Times Literary Supplement*, May 24, 1974.

Timothy J. Clark, "The Bar at the Folies-Bergères," in *The Wolf and the Lamb: Popular Culture in France, from the Old Regime to the Twentieth Century*, ed. Jacques Beauroy et al. (Saratoga, Calif.: Anma Libri, 1977), 233–52.

Lorna Simpson, Dividing Lines, *1989. Courtesy Josh Baer Gallery, photograph © 1989 by Ellen Page Wilson.*

Sue Clayton and Jonathan Curling, "On Authorship," *Screen* 20, no. 1 (Spring 1979), 35–61.

Rosalind Coward, "Class, 'Culture,' and the Social Formation," *Screen* 18, no. 1 (Spring 1977), 75–105.

David Craven, "Hans Haacke and the Aesthetics of Legitimation," *Parachute*, no. 23 (Spring 1981), 32–37.

Thomas Crow, "Modernism and Mass Culture in the Visual Arts," in *Modernism and Modernity*, ed. Benjamin Buchloh, Serge Guilbaut, and David Solkin (Halifax: The Press of the Nova Scotia College of Art and Design, 1983), 215–64.

Thomas Crow, *Painters and Public Life in 18th-Century Paris* (New Haven: Yale University Press, 1985).

Arthur Danto, *The Transfiguration of the Commonplace* (Cambridge, Mass.: Harvard University Press, 1981).

Guy Debord, *Society of the Spectacle* (Detroit: Black and Red Press, 1967).

Paul DiMaggio and Michael Useem, "Cultural Democracy in a Period of Cultural Expansion: The Social Composition of Arts Audiences in the United States," *Social Problems* 26, no. 2 (December 1978), 179–97.

Paul DiMaggio and Michael Useem, "Cultural Property and Public Policy: Emerging Tensions in Government Support for the Arts," *Social Research* 45, no. 2 (Summer 1978), 356–89.

Paul DiMaggio and Michael Useem, "Social Class and Arts Consumption," *Theory and Society* 5, no. 2 (March 1978), 141–61.

Richard Dyer et al., "Literature/Society: Mapping the Field," *Working Papers in Cultural Studies* 4 (1973).

Terry Eagleton, *Criticism and Ideology: A Study in Marxist Literary Theory* (London: New Left Books, 1976).

Terry Eagleton, *The Function of Criticism: From the Spectator to Post-Structuralism* (London: Verso, 1984).

Terry Eagleton, *Literary Theory: An Introduction* (Minneapolis: University of Minnesota Press, 1983).

Terry Eagleton, *Marxism and Literary Criticism* (London: Methuen, 1976).

Bernard Edelman, *Ownership of the Image: Elements for a Marxist Theory of Law*, trans. Elizabeth Kingdom (London: Routledge & Kegan Paul, 1979).

Hans Magnus Enzensberger, *Critical Essays*, ed. Reinhold Grimm and Bruce Armstrong (New York: Continuum, 1982).

Hans Magnus Enzensberger, *The Consciousness Industry* (New York: Seabury Press, 1974).

André Frankovits, ed., *Seduced and Abandoned: The Baudrillard Scene* (Glebe, Australia: Stonemoss, 1988).

Simon Frith, *Sound Effects: Youth, Leisure, and the Politics of Rock* (revised version of *The Sociology of Rock*; London: Constable, 1983).

Nicholas Garnham, "Contribution to a Political Economy of Mass-Communication," *Media, Culture, and Society* 1, no. 2 (1979).

Nicholas Garnham, "Subjectivity, Ideology, Class and Historical Materialism," *Screen* 20, no. 1 (Spring 1979), 121–33.

Nicholas Garnham, "Towards a Political Economy of Culture," *New Universities Quarterly* 31, no. 3 (Summer 1977), 341–57.

Jean-Joseph Goux, "Numismatiques," in *Économie et symbolique* (Paris: Seuil, 1973).

Mason Griff, "The Recruitment and Socialization of Artists," in *The Sociology of Art and Literature*, ed. Milton C. Albrecht et al. (London: Duckworth, 1970).

Hans Haacke, *Framing and Being Framed* (Halifax: The Press of the Nova Scotia College of Art and Design, 1977).

Jürgen Habermas, *Communication and the Evolution of Society*, trans. Thomas McCarthy (Boston: Beacon Press, 1979).

Krzysztof Wodiczko, Projection on the Building of the Museum of Man *(California Tower), 1988, San Diego, Balboa Park. Courtesy Josh Baer Gallery.*

Jürgen Habermas, *Legitimation Crisis*, trans. Thomas McCarthy (Boston: Beacon Press, 1973).

Jürgen Habermas, *Knowledge and Human Interests*, trans. Jeremy J. Shapiro (Boston: Beacon Press, 1971).

Nicos Hadjincolaou, *Art History and Class Struggle*, trans. Louise Asmal (London: Pluto Press, 1978).

Stuart Hall and Tony Jefferson, eds., *Resistance Through Rituals: Youth Subculture in Post-War Britain* (London: Hutchinson, 1976).

Stuart Hall, "Some Problems with the Ideology/Subject Couplet," *Ideology & Consciousness* 3 (Spring 1978), 113–21.

Arnold Hauser, *The Social History of Art*, 4 vols. (New York: Vintage, 1958).

Dick Hebdige, *Subculture: The Meaning of Style* (London: Methuen, 1979).

Paul Hirst, *On Law and Ideology* (London: Macmillan, 1979).

Peter Uwe Hohendahl, "Introduction to Reception Aesthetics," *New German Critique*, no. 10 (Winter 1977), 29–63.

Max Horkheimer and Theodor Adorno, *Dialectic of Enlightenment*, trans. John Cumming (New York: Continuum, 1972).

Wolfgang Iser, *The Act of Reading: A Theory of Aesthetic Response* (Baltimore: Johns Hopkins University Press, 1978).

Fredric Jameson, *The Political Unconscious: Narrative as a Socially Symbolic Act* (Ithaca, N.Y.: Cornell University Press, 1981).

Fredric Jameson, "Postmodernism, or The Cultural Logic of Late Capitalism," *New Left Review* 146 (July-August 1984), 53–92.

Fredric Jameson, "Postmodernism and Consumer Society," in *The Anti-Aesthetic: Essays on Postmodern Culture*, ed. Hal Foster (Seattle: Bay Press, 1983), 111–25.

Hans Robert Jauss, *Toward an Aesthetic of Reception*, trans. Timothy Bahti (Minneapolis: University of Minnesota Press, 1982).

Mary Kelly, "Re-viewing Modernist Criticism," in *Art After Modernism: Rethinking Representation*, ed. Brian Wallis (New York: The New Museum of Contemporary Art, 1984), 87–103.

Barbara Kruger, "Work and Money," *Appearances* 7 (Fall 1982), 30.

Annette Kuhn and AnnMarie Wolpe, eds., *Feminism and Materialism: Women and Modes of Production* (London: Routledge & Kegan Paul, 1978).

Theodore Levitt, "The Globalization of Markets," *Harvard Business Review* 61, no. 3 (May-June 1983), 92–102.

Georg Lukàcs, *History and Class Consciousness: Studies in Marxist Dialectics*, trans. Rodney Livingstone (Cambridge, Mass.: MIT Press, 1971).

Jean-François Lyotard, "The *Différend*, the Referent, and the Proper Name," *Diacritics* 14, no. 3 (Fall 1984), 4–14.

Pierre Macherey, *A Theory of Literary Production*, trans. Geoffrey Wall (London: Routledge & Kegan Paul, 1978).

Herbert Marcuse, "The Affirmative Character of Culture," in *Negations: Essays in Critical Theory*, trans. Jeremy J. Shapiro (Boston: Beacon Press, 1968).

Herbert Marcuse, *The Aesthetic Dimension: Toward a Critique of Marxist Aesthetics* (Boston: Beacon Press, 1978).

Louis Marin, "Disneyland: A Degenerate Utopia," *Glyph* 1 (1977), 50–66.

Karl Marx, *Capital*, vols. 1 and 3 (New York: Vintage, 1976–81).

Karl Marx, *Contribution to the Critique of Political Economy* (New York: International Publishers, 1970).

Karl Marx, *Grundrisse: Foundations of the Critique of Political Economy* (New York: Vintage, 1973).

Karl Marx, "Economic and Philosophical Manuscripts," in *Early Writings*, trans. Rodney Livingstone and Gregor Benton (New York: Vintage, 1975).

Armand Mattelart and Seth Siegelaub, eds., *Communication and Class Struggle*, 2 vols. (New York: International General, 1979–83).

Armand Mattelart, *Multinationals and Systems of Communication* (London: Harvester, 1978).

Armand Mattelart, *Transnationals and the Third World: The Struggle for Culture*, trans. David Buxton (South Hadley, Mass.: Bergin & Garvey, 1983).

Armand Mattelart, Xavier Delcourt, and Michèle Mattelart, *International Image Markets* (London: Comedia Publishing, 1984).

Michèle Mattelart, "Can Industrial Culture Be a Culture of Difference?" (unpublished manuscript).

Vladimir Mayakovsky, *How Are Verses Made?* (London: Jonathan Cape, 1962).

June Nash and María Patricia Fernández Kelly, eds., *Women, Men, and the International Division of Labor* (Albany: State University of New York Press, 1983).

Friedrich Nietzsche, *On the Genealogy of Morals and Ecce Homo*, trans. Walter Kaufmann and R. J. Hollingdale (New York: Vintage Books, 1967).

Nicholas M. Pearson, *The State and the Visual Arts: A Discussion of State Intervention in the Visual Arts in Britain, 1760–1981* (Milton Keynes: Open University Press, 1982).

Richard A. Peterson, ed., *The Production of Culture* (Beverly Hills: Sage Publications, 1976).

Nikolaus Pevsner, *Academies of Art, Past and Present* (New York: Da Capo Press, 1973).

Griselda Pollock, "Artists, Mythologies, and Media—Genius, Madness, and Art History," *Screen* 21, no. 3 (Fall 1980), 57–96.

Mark Poster, *Foucault, Marxism, and History: Mode of Production Versus Mode of Information* (Cambridge: Polity Press, 1984).

Kevin Robins, "Althusserian Marxism and Media Studies: The Case of Screen," *Media, Culture, and Society* 1, no. 4 (1979).

Barbara Rosenblum, *Photographers at Work: A Sociology of Photographic Styles* (New York: Holmes & Meier, 1978).

Martha Rosler, "Lookers, Buyers, Dealers, and Makers: Thoughts on Audience," in *Art After Modernism: Rethinking Representation*, ed. Brian Wallis (New York: The New Museum of Contemporary Art, 1984), 311–39.

Martha Rosler, "Theses on Defunding," *Afterimage* 10, nos. 1–2 (Summer 1982), 6–7.

Edward W. Said, *The World, the Text, and the Critic* (Cambridge, Mass.: Harvard University Press, 1983).

Edward W. Said, *Orientalism* (New York: Pantheon, 1978).

Ferdinand de Saussure, *Course in General Linguistics*, trans. Wade Baskin (New York: McGraw-Hill, 1966).

Herbert I. Schiller, *Communication and Cultural Domination* (White Plains, N.Y.: International Arts and Sciences Press, 1976).

Herbert I. Schiller, *The Mind Managers* (Boston: Beacon Press, 1973).

Screen Reader 1: Cinema/Ideology/Politics (London: Society for Education in Film and Television, 1977).

Allan Sekula, *Photography Against the Grain: Essays and Photo Works 1973–1983,* ed. Benjamin Buchloh (Halifax: The Press of the Nova Scotia College of Art and Design, 1984).

Marc Shell, *Money, Language, and Thought: Literary and Philosophical Economies from the Medieval to the Modern Era* (Berkeley: University of California Press, 1982).

Georg Simmel, *The Philosophy of Money*, trans. Tom Bottomore and David Frisby (London: Routledge & Kegan Paul, 1978).

Social Research 45, no. 2 (Summer 1978): special issue on "The Production of Culture," ed. Lewis A. Coser.

Alfred Sohn-Rethel, *Intellectual and Manual Labour: A Critique of Epistemology* (London: Macmillan, 1978).

Gayatri Chakravorty Spivak, "Scattered Speculations on the Question of Value," *Diacritics* 15, no. 4 (Winter 1985), 73–93.

Piero Sraffa, *Production of Commodities by Means of Commodities* (Cambridge: Cambridge University Press, 1960).

John Tagg, "A Socialist Perspective on Photographic Practice," in *Three Perspectives on Photography* (London: Arts Council of Great Britain, 1979).

Hans Haacke, Metro-Mobilitan, 1985. Courtesy John Weber Gallery, New York.

John Tagg, "Marxism and Art History," *Marxism Today* 21, no. 6 (June 1977), 183–92.

Leon Trotsky, *Literature and Revolution* (Ann Arbor: University of Michigan Press, 1960).

Alan Wallach and Carol Duncan, "Ritual and Ideology at the Museum," Proceedings of the Caucus for Marxism and Art at the College Art Association Convention, January 1978, Los Angeles.

Brian Wallis, ed., *Art After Modernism: Rethinking Representation* (New York: The New Museum of Contemporary Art, 1984).

Brian Wallis, ed., *Hans Haacke: Unfinished Business* (New York: The New Museum of Contemporary Art, 1986).

Harrison C. White and Cynthia A. White, *Canvases and Careers: Institutional Change in the French Painting World* (New York: Wiley, 1965).

Raymond Williams, *Culture and Society, 1780–1950* (New York: Columbia University Press, 1983).

Raymond Williams, *Marxism and Literature* (Oxford: Oxford University Press, 1977).

Janet Wolff, *The Social Production of Art* (New York: St. Martin's Press, 1981).

Richard D. Wolff et al., "Marx's (not Ricardo's) 'Transformation Problem': A Radical Reconceptualization," *History of Political Economy* 14, no. 4 (Winter 1982), 564–82.

Visualizing AIDS
(Course taught at the University of Rochester)

A workshop designed to mobilize theories of representation, ideology, and racial and sexual difference in response to the AIDS epidemic. After a review of the recent literature on AIDS and a survey of artistic responses to the crisis, participants will organize an exhibition, addressed to the Rochester community, in which the image of AIDS produced by the media and by legal and medical discourse will be analyzed and deconstructed. Special attention will be paid to the ways AIDS throws into relief the inherent racism, homophobia, and class bias of our society.

BASIC THEORETICAL TEXTS

Michel Foucault, *The History of Sexuality*, vol. 1: *An Introduction*, trans. Robert Hurley (New York: Pantheon, 1978).

Erving Goffman, *Stigma: Notes on the Management of Spoiled Identity* (New York: Aronson, 1963).

Donna Haraway, "The Biological Enterprise: Sex, Mind, and Profit from Human Engineering to Sociobiology," *Radical History Review* 20 (1979), 206–37.

Donna Haraway, "A Manifesto for Cyborgs: Science, Technology, and Socialist Feminism in the 1980s," *Socialist Review* 80 (1985), 65–108.

Gayle Rubin, "Thinking Sex: Notes for a Radical Theory of the Politics of Sexuality," in *Pleasure and Danger: Exploring Female Sexuality*, ed. Carole S. Vance (Boston: Routledge & Kegan Paul, 1984).

Eve Kosofsky Sedgwick, "Epistemology of the Closet," *Raritan* 7, no. 4 (Spring 1988), 39–69; 8, no. 1 (Summer 1988), 102–30.

HISTORY

Allan M. Brandt, *No Magic Bullet: A Social History of Venereal Disease in the United States since 1880,* expanded ed. (New York: Oxford University Press, 1987).

Ludwik Fleck, *Genesis and Development of a Scientific Fact,* trans. Fred Bradley and Thaddeus J. Trenn (Chicago: University of Chicago Press, 1979).

Catherine Gallagher and Thomas Laqueur, eds., *The Making of the Modern Body: Sexuality and Society in the Nineteenth Century* (Berkeley: University of California Press, 1987).

Robert Jay Lifton, *The Nazi Doctors: Medical Killing and the Psychology of Genocide* (New York: Basic Books, 1986).

George L. Mosse, *Nationalism and Sexuality: Respectability and Abnormal Sexuality in Modern Europe* (New York: Fertig, 1985).

ABOUT AIDS—RECOMMENDED

Leo Bersani, "Is the Rectum a Grave?" *October* 43 (Winter 1987), 197–222.

Allan M. Brandt, "AIDS: From Social History to Social Policy," in *AIDS: The Burdens of History,* ed. Elizabeth Fee and Daniel M. Fox (Berkeley: University of California Press, 1988), 147–71.

Jan Zita Grover, "AIDS: Keywords," *October* 43 (Winter 1987), 17–30.

Robert Lederer, "The Origin and Spread of AIDS: Is the West Responsible?" *Covert Action Information Bulletin* 28 (Summer 1987), 43–54; and 29 (Winter 1988), 52–66.

David F. Musto, "Quarantine and the Problems of AIDS," in *AIDS: The Burdens of History,* op. cit., 67–85.

Cindy Patton, *Sex and Germs: The Politics of AIDS* (Boston: South End Press, 1985).

Cindy Patton, "Resistance and the Erotic: Reclaiming History, Setting Strategy as We Face AIDS," *Radical America* 20, no. 6 (November-December 1986), 68–78.

Dorothy Porter and Roy Porter, "The Enforcement of Health: The British Debate," in *AIDS: The Burdens of History*, op. cit., 97–120.

Diane Richardson, *Women and AIDS* (New York: Methuen, 1988).

Paula A. Treichler, "AIDS, Gender, and Biomedical Discourse: Current Contests for Meaning," in *AIDS: The Burdens of History*, op. cit., 190–266.

Paula A. Treichler, "AIDS, Homophobia, and Biomedical Discourse: An Epidemic of Signification," *October* 43 (Winter 1987), 31–70.

Simon Watney, *Policing Desire: Pornography, AIDS, and the Media* (Minneapolis: University of Minnesota Press, 1987).

ABOUT AIDS—ADDITIONAL READINGS

Dennis Altman, *AIDS in the Mind of America* (Garden City, N.Y.: Anchor Press, 1986).

Douglas Crimp, "How to Have Promiscuity in an Epidemic," *October* 43 (Winter 1987), 237–70.

Jacques Leibowitch, *A Strange Virus of Unknown Origin*, trans. Richard Howard (New York: Ballantine Books, 1985).

Randy Shilts, *And the Band Played On: Politics, People, and the AIDS Epidemic* (New York: St. Martin's Press, 1987).

Susan Sontag, *AIDS and Its Metaphors* (New York: Farrar Straus & Giroux, 1988).

Course Bibliography on
Visual AIDS

BOOKS

Dennis Altman, *AIDS in the Mind of America* (Garden City, N.Y.: Anchor Press, 1986).

Ronald Bayer, *Homosexuality and American Psychiatry: The Politics of Diagnosis* (New York: Basic Books, 1981).

David Black, *The Plague Years: A Chronicle of AIDS, the Epidemic of Our Times* (New York: Simon and Schuster, 1985).

Ruth Bleier, *Science and Gender: A Critique of Biology and its Theories on Women* (New York: Pergamon Press, 1984).

Allan M. Brandt, *No Magic Bullet: A Social History of Venereal Disease in the United States since 1880,* expanded ed. (New York: Oxford University Press, 1987).

Raymond Keith Brown, *AIDS, Cancer, and the Medical Establishment* (New York: Robert Speller Publishers, 1986).

Kevin M. Cahill, eds., *The AIDS Epidemic* (New York: St. Martin's Press, 1983).

Michael Callen, ed., *Surviving and Thriving with AIDS: Collected Wisdom,* 2 vols. (New York: PWA Coalition, 1987–88).

J. Edward Chamberlin and Sander L. Gilman, eds., *Degeneration: The Dark Side of Progress* (New York: Columbia University Press, 1985).

Committee on a National Strategy for AIDS of the Institute of Medicine, *Confronting AIDS: Directions for Public Health, Health Care, and Research* (Washington, D.C.: National Academy Press, 1986).

Harlon L. Dalton, Scott Burris, and the Yale AIDS Law Project, eds., *AIDS and the Law: A Guide of the Public* (New Haven: Yale University Press, 1987).

Frédérique Delacoste and Priscilla Alexander, eds., *Sex Work: Writings by Women in the Sex Industry* (Pittsburgh: Cleis Press, 1987).

Jacques Donzelot, *The Policing of Families*, trans. Robert Hurley (New York: Pantheon, 1979).

François Delaporte, *Disease and Civilization: The Cholera in Paris, 1832*, trans. Arthur Goldhammer (Cambridge, Mass.: MIT Press, 1986).

Harry F. Dowling, *Fighting Infection: Conquests of the Twentieth Century* (Cambridge, Mass.: Harvard University Press, 1977).

Elizabeth Fee, ed., *Women and Health: The Politics of Sex in Medicine* (Farmingdale, N.Y.: Baywood Publishing Co., 1982).

Elizabeth Fee and Daniel M. Fox, eds., *AIDS: The Burdens of History* (Berkeley: University of California Press, 1988).

Douglas A. Feldman and Thomas M. Johnson, eds., *The Social Dimensions of AIDS* (New York: Praeger, 1986).

Ann Giudici Fettner and William A. Check, *The Truth About AIDS: Evolution of an Epidemic* (New York: Holt, Rinehart and Winston, 1984).

Frances FitzGerald, *Cities on a Hill: A Journey Through Contemporary American Cultures* (New York: Simon and Schuster, 1986).

Michael Fitzpatrick and Don Miligan, *The Truth About the AIDS Panic* (London: Junius, 1987).

Ludwik Fleck, *Genesis and Development of a Scientific Fact*, trans. Fred Bradley and Thaddeus J. Trenn (Chicago: University of Chicago Press, 1979).

Michel Foucault, *The Birth of the Clinic*, trans. Alan Sheridan (New York: Vintage Books, 1975).

Michel Foucault, *The History of Sexuality*, vol. 1: *An Introduction*, trans. Robert Hurley (New York: Pantheon, 1978).

Daniel M. Fox and Christopher Lawrence, *Photographing Medicine: Images and Power in Britain and America since 1840* (New York: Greenwood Press, 1988).

Catherine Gallagher and Thomas Laqueur, eds., *The Making of the Modern Body: Sexuality and Society in the Nineteenth Century* (Berkeley: University of California Press, 1987).

Sander L. Gilman, *Difference and Pathology: Stereotypes of Sexuality, Race, and Madness* (Ithaca, N.Y.: Cornell University Press, 1985).

Erving Goffman, *Stigma: Notes on the Management of Spoiled Identity* (New York: Aronson, 1963).

Victor Gong and Norman Rudnick, eds., *AIDS, Facts and Issues* (New Brunswick, N.J.: Rutgers University Press, 1986).

John Green and David Miller, *AIDS: The Story of a Disease* (London: Grafton, 1986).

Graham Hancock and Enver Carim, *AIDS: The Deadly Epidemic* (London: Gollancz, 1986).

James H. Jones, *Bad Blood: The Tuskegee Syphilis Experiment* (New York: Free Press, 1981).

Helen Singer Kaplan, *The Real Truth About Women and AIDS: How to Eliminate the Risks Without Giving Up Love and Sex* (New York: Simon and Schuster, 1987).

Diane R. Karp et al., *Ars Medica: Art, Medicine, and the Human Condition* (Philadelphia: Philadelphia Museum of Art, 1985).

Bruno Latour and Steve Woolgar, *Laboratory Life: The Construction of Scientific Facts* (Princeton: Princeton University Press, 1986).

Jacques Leibowitch, *A Strange Virus of Unknown Origin*, trans. Richard Howard (New York: Ballantine Books, 1985).

Richard Liebmann-Smith, *The Question of AIDS* (New York: New York Academy of Sciences, 1985).

Robert Jay Lifton, *The Nazi Doctors: Medical Killing and the Psychology of Genocide* (New York: Basic Books, 1986).

Leon McKusick, ed., *What to Do About AIDS: Physicians and Mental Health Professionals Discuss the Issues* (Berkeley: University of California Press, 1986).

Frank Mort, *Dangerous Sexualities: Medico-Moral Politics in England since 1830* (New York: Routledge & Kegan Paul, 1987).

George L. Mosse, *Nationalism and Sexuality: Respectability and Abnormal Sexuality in Modern Europe* (New York: Fertig, 1985).

David F. Musto, *The American Disease: Origins of Narcotic Control*, expanded ed. (New York: Oxford University Press, 1987).

Eve K. Nichols, *Mobilizing Against AIDS: The Unfinished Story of a Virus* (Cambridge, Mass.: Harvard University Press, 1986); see also Jan Zita Grover's review, "The 'Scientific' Regime of Truth," *In These Times*, December 10–16, 1986, 18–19.

Lon G. Nungesser, *Epidemic of Courage: Facing AIDS in America* (New York: St. Martin's Press, 1986).

Cindy Patton, *Sex and Germs: The Politics of AIDS* (Boston: South End Press, 1985).

Cindy Patton and Janis Kelly, *Making It: A Woman's Guide to Sex in the Age of AIDS* (Ithaca, N.Y.: Firebrand, 1987).

Barbara Peabody, *The Screaming Room: A Mother's Journal of Her Son's Struggle with AIDS* (San Diego: Oak Tree Publishers, 1986).

Richard Plant, *The Pink Triangle: The Nazi War Against Homosexuals* (New York: Holt, 1986).

Diane Richardson, *Women and AIDS* (New York: Methuen, 1988).

Charles E. Rosenberg, *The Cholera Years: The United States in 1932, 1849, and 1866* (Chicago: University of Chicago Press, 1987).

Eve Kosofsky Sedgwick, *Between Men: English Literature and Male Homosocial Desire* (New York: Columbia University Press, 1985).

Earl E. Shelp, Ronald H. Sunderland, and Peter W. H. Mansell, *AIDS: Personal Stories in Pastoral Perspective* (New York: Pilgrim, 1986).

Randy Shilts, *And the Band Played On: Politics, People, and the AIDS Epidemic* (New York: St. Martin's Press, 1987).

Susan Sontag, *AIDS and Its Metaphors* (New York: Farrar Straus & Giroux, 1988).

Susan Rubin Suleiman, ed., *The Female Body in Western Culture* (Cambridge, Mass.: Harvard University Press, 1985).

Surgeon General's Report on Acquired Immune Deficiency Syndrome (Washington, D.C.: U.S. Department of Health and Human Services, 1986).

Bryan S. Turner, *The Body and Society: Explorations in Social Theory* (Oxford: Blackwell, 1984).

Art Ulene, *Safe Sex in a Dangerous World* (New York: Vintage Books, 1987).

Judith R. Walkowitz, *Prostitution and Victorian Society: Women, Class, and the State* (Cambridge: Cambridge University Press, 1980).

Simon Watney, *Policing Desire: Pornography, AIDS, and the Media* (Minneapolis: University of Minnesota Press, 1987).

Jeffrey Weeks, *Sexuality and Its Discontents: Meanings, Myths, and Modern Sexualities* (Boston: Routledge & Kegan Paul, 1985).

Peter Wright and Andrew Treacher, eds., *The Problem of Medical Knowledge: Examining the Social Construction of Medicine* (Edinburgh: Edinburgh University Press, 1982).

ARTICLES

Parveen Adams, "Versions of the Body," *m/f*, nos. 11–12 (1986).

Ronald Bayer, "AIDS and the Gay Community: Between the Specter and the Promise of Medicine," *Social Research* 52, no. 3 (Autumn 1985), 581–606.

Ronald Bayer, "AIDS, Power, and Reason," *Milbank Quarterly* 64, Supplement 1 (1986), 168–82.

Ronald Bayer et al., "Forum: AIDS: What Is to Be Done?" *Harper's* (October 1985), 39–52.

Charles Bernheimer, "Of Whores and Sewers: Parent-Duchâtelet, Engineer of Abjection," *Raritan* 6, no. 3 (Winter 1987), 72–90.

William F. Buckley, "Identify All the Carriers," *New York Times*, March 18, 1986.

Lee Chiaramonte, "Lesbian Safety and AIDS: The Very Last Fairy Tale," *Visibilities* 1 (January-February 1988).

Stephen Durham and Susan Williams, *AIDS Hysteria: A Marxist Analysis* (Seattle: Freedom Socialist Publications, 1986).

Ann Giudici Fettner, "Bad Science Makes Strange Bedfellows," *Village Voice*, February 2, 1988.

Michel Foucault, "Sexual Choice, Sexual Act: An Interview with Michel Foucault," *Salmagundi*, nos. 58–59 (Fall-Winter 1982–83), 10–24.

Robert C. Gallo, "The AIDS Virus," *Scientific American* 256 (1987).

Richard Goldstein, "Heartsick: Fear and Loving in the Gay Community," *Village Voice*, June 28, 1983, 13–16.

Richard Goldstein, "The Hidden Epidemic: AIDS and Race," *Village Voice*, March 10, 1987.

David Green, "Veins of Resemblance: Photography and Eugenics," in *Photography/Politics: Two*, ed. Patricia Holland et al. (London: Methuen, 1986), 9–21.

Pete Hamill, "The Secret Sharers," *Village Voice*, June 23, 1987.

Donna Haraway, "The Biological Enterprise: Sex, Mind, and Profit from Human Engineering to Sociobiology," *Radical History Review* 20 (1979), 206–37.

Donna Haraway, "A Manifesto for Cyborgs: Science, Technology, and Socialist Feminism in the 1980s," *Socialist Review* 80 (1985), 65–108.

Nat Hentoff, "AIDS: A Failure of Intelligence," *Village Voice*, June 23, 1987.

Nat Hentoff, "The New Priesthood of Death," *Village Voice*, June 30, 1987.

Nat Hentoff, "Playing Russian Roulette with AIDS," *Village Voice*, July 7, 1987.

Nat Hentoff, "The AIDS Debate: A Breakthrough," *Village Voice*, November 17, 1987.

Peter Jaret, "Our Immune System: The Wars Within," *National Geographic*, June 1986, 703–35.

Elizabeth Kastor, "The Conflict of a Gay Conservative," *Washington Post National Weekly Edition*, June 8, 1987, 11–12.

Larry Kramer, "1,112 and Counting," *New York Native*, March 1983, 14–27.

Timothy Landers, "Bodies and Anti-Bodies: A Crisis in Representation," *The Independent* 11, no. 1 (January-February 1988), 18–24.

Robert Lederer, "The Origin and Spread of AIDS: Is the West Responsible?" *Covert Action Information Bulletin* 28 (Summer 1987), 43–54; and 29 (Winter 1988), 52–66.

Jonathan Lieberson, "Anatomy of an Epidemic," *New York Review of Books*, August 18, 193, 17–22; see also John Rechy's response, October 13, 1983, 43–45.

Jonathan Lieberson, "The Reality of AIDS," *New York Review of Books*, January 16, 1986.

Michael Lynch, "Living with Kaposi's," *Body Politic* (San Francisco) (November 1982).

Deborah Jones Merritt, "Communicable Disease and Constitutional Law: Controlling AIDS," *New York University Law Journal* (November 1986), 739–99.

Jeff Minson, "The Assertion of Homosexuality," *m/f*, nos. 5–6 (1981).

Richard D. Mohr, "AIDS, Gay Life, State Coercion," *Raritan* 6, no. 1 (Summer 1986), 38–62.

Charles L. Ortleib, "Media Watch," *New York Native*, January 6–12, 1986.

June E. Osborn, "The AIDS Epidemic: An Overview of the Science," *Issues in Science and Technology* 2, no. 2 (Winter 1986), 40–55.

Marcia Paly, "AIDS and the Politics of Despair: Lighting Our Own Funeral Pyre," *The Advocate*, December 24, 1985.

Cindy Patton, "Resistance and the Erotic: Reclaiming History, Setting Strategy as We Face AIDS," *Radical America* 20, no. 6. (November-December 1986), 68–78.

B. Ruby Rich, "Only Human: Sex, Gender, and Other Misrepresentations," 1987 American Film Institute Video Festival, Los Angeles.

Gayle Rubin, "Thinking Sex: Notes for a Radical Theory of the Politics of Sexuality," in *Pleasure and Danger: Exploring Female Sexuality*, ed. Carole S. Vance (Boston: Routledge & Kegan Paul, 1984).

H. Schwartz, "AIDS in the Media," in *Science in the Streets* (New York: Priority Press, 1984).

Eve Kosofsky Sedgwick, "Epistemology of the Closet," *Raritan* 7, no. 4 (Spring 1988), 39–69; 8, no. 1 (Summer 1988), 102–30.

Allan Sekula, "The Body and the Archive," *October* 39 (Winter 1986), 3–64.

Joseph Sonnabend, "Looking at AIDS in Totality: A Conversation," *New York Native*, October 7–13, 1985.

Simon Watney, "The Subject of AIDS," *Copyright* 1 (Fall 1987), 125–32.

Simon Watney, "AIDS: The Outsiders," *Marxism Today* (January 1988), 51.

Dooley Worth and Ruth Rodriguez, "Latina Women and AIDS," *Radical America* 20, no. 6 (November-December 1986), 63–67.

JOURNALS

Morbidity and Mortality Weekly Report (Centers for Disease Control, Atlanta).

PWA Coalition Newsletter (New York).

The Milbank Quarterly 64, supplement 1 (1986): "AIDS: The Public Context of an Epidemic."

Radical America 20, no. 6 (November-December 1986): "Facing AIDS: A Special Issue."

BIBLIOGRAPHY

Writings are presented in chronological order.

"Politics of *Coppélia*." *Christopher Street* (November 1976): 51–2.

"*Einstein on the Beach*: The Primacy of Metaphor." *October* 4 (Fall 1977): 21–32.

"Projects by Alice Aycock." *Skyline* (April 1978): 3.

"Philip Johnson on Philip Johnson." Interview by Martha Carroll and Craig Owens. *Skyline* (May 1978): 8/7.

"Editors' Response." *Skyline* (May 1978): 2.

"Pope + Pei." *Skyline* (June 1978): 6–7.

"Re-vision." *Skyline* (June 1978): 8.

"Tables and Chairs." *Skyline* (June 1978): 8.

"Re: Ward." *Skyline* (June 1978): 8.

"Issues." *Skyline* (June 1978): 8.

"Footnote." *Skyline* (June 1978): 8.

"Photography *en abyme*." *October* 5 (Summer 1978): 73–88.

"Mirrors and Windows." *Skyline* (September 1978): 5.

"Mews." *Skyline* (September 1978): 12.

"Past & Present." *Skyline* (September 1978): 12.

"Hearing." *Skyline* (September 1978): 12.

"Tilt." *Skyline* (September 1978): 12.

"Philip Johnson: History, Genealogy, Historicism." In *Philip Johnson: Processes the Glass House 1949 and the ATT Corporate Headquarters 1978*, exhibition at the Institute for Architecture and Urban Studies (September 12–October 31, 1978). Published in *Catalogue* 9. New York: Institute for Architecture and Urban Studies, 1978, 2–11.

"Beached." *Skyline* (October 1978): 4.

"The Postcard as Fetish." *Skyline* (November 1978): 10.

"Reading." *Skyline* (December 1978): 12.

"Skylights." *Skyline* (January 1979): 12.

"Helmsley Hires Arquitectonica." *Skyline* (March 1979): 12.

"Dog-Killing Machine." *Skyline* (March 1979): 12.

"Ménagerie." *Skyline* (March 1979): 12.

"Black and White." *Skyline* (April 1979): 16.

"Editor's note." *Skyline* (April 1979): 2.

"By the Sea." *Skyline* (May 1979): 8.

"Detachment: from the *parergon*." *October* 9 (Summer 1979): 42–9.

"Earthwords." *October* 10 (Fall 1979): 120–30.

"The Allegorical Impulse: Toward a Theory of Postmodernism." *October* 12 (Spring 1980): 67–86.

"The Allegorical Impulse: Toward a Theory of Postmodernism (Part 2)." *October* 13 (Summer 1980): 58–80.

"Robert Wilson: Tableaux." *Art in America* (November 1980): 114–16.

"Amplifications: Laurie Anderson." *Art in America* (March 1981): 121–3.

"The Pro-Scenic Event." *Art in America* (March 1981): 128–31.

"Robert Longo at Metro Pictures." *Art in America* (March 1981): 125–6.

"Telling Stories." *Art in America* (May 1981): 129–35.

"Sects and Language." *Art in America* (Summer 1981): 11–17.

"The Critic as Realist." *Art in America* (September 1981): 9–11.

"Back to the Studio." *Art in America* (January 1982): 99–107.

"Michael Uhlenkott and Jeffrey Valance at LACE." *Art in America* (March 1982): 155–6.

"Justen Ladda." In *Wave Hill 1982: New Perspectives*, exhibition (May 19–October 1, 1982. New York: Wave Hill, 1982.

"Phantasmagoria of the Media." *Art in America* (May 1982): 98–9.

"Representation, Appropriation and Power." *Art in America* (May 1982): 9–21.

"Sarah Charlesworth at 421 West Broadway." *Art in America* (May 1982): 141.

"Sherrie Levine at A&M Artworks." *Art in America* (Summer 1982): 148.

"Bayreuth '82." *Art in America* (September 1982): 132–9, 191.

"The Discourse of Others: Feminists and Postmodernism." In *The Anti-Aesthetic: Essays on Postmodern Culture*. Ed. Hal Foster. Seattle: Bay Press, 1983, 57–77.

"Honor, Power, and the Love of Women." *Art in America* (January 1983): 9–13.

"Mark Tansey at Borgenicht." *Art in America* (February 1983): 137–8.

"William Wegman's Psychoanalytic Vaudeville." *Art in America* (March 1983): 101–9.

"'The Indignity of Speaking for Others': An Imaginary Interview." in *Art & Social Change*, exhibition at the Allen Memorial Art Museum, Oberlin College (April 19–May 30, 1983). Published in *Bulletin* 40.2 (1982–83): 83–5.

"The Medusa Effect, or, The Specular Ruse." *Art in America* (January 1984): 97–105.

"Commentary: The Problem with Puerilism." *Art in America* (Summer 1984): 162–3.

"Under Arrest." In *The Heroic Figure,* exhibition (September 15–November 19, 1984). Houston: Contemporary Arts Museum, 1984. 13–16.

"Analysis Logical and Ideological." *Art in America* (May 1985): 25–31.

"Posing." In *"Difference": On Representation and Sexuality,* exhibition (December 8, 1984–February 10, 1985). New York: New Museum of Contemporary Art, 1985, 7–17.

"Repetition and Difference." *Art in America* (September 1983): 130–32. Also exhibition catalogue: *Allan McCollum: Surrogates,* (October 3–November 2, 1985). London: Lisson Gallery, 1985, 5–8.

"Improper Names." *Art in America* (October 1986): 126–34, 187.

"Interview with Craig Owens, February 27, 1987." By Anders Stephanson. *Social Text* 27 (1987): 55–71.

"Giulio Paolini." In *Giulio Paolini,* catalogue and exhibition at the Marian Goodman Gallery (October 9–31, 1987). New York: Marian Goodman Gallery, 1987.

"Outlaws: Gay Men in Feminism." In *Men in Feminism.* Eds. Alice Jardine and Paul Smith. New York/London: Methuen, 1987, 219–32.

"The Yen for Art." In *Discussions in Contemporary Culture,* no. 1. Ed. Hal Foster. Seattle: DIA Art Foundation/Bay Press, 1987, 16–23.

"The Global Issue: A Symposium." *Art in America* (July 1989): 88–9.

INDEX

371

Compositor: Prestige Typography
Text: 10/12 Baskerville
Display: Baskerville
Printer: Edwards Brothers, Inc.
Binder: Edwards Brothers, Inc.